3D GRAPHICS
TUTORIAL
COLLECTION

3D GRAPHICS TUTORIAL COLLECTION

Edited by
R. Shamms Mortier

CHARLES RIVER MEDIA, INC.
Rockland, Massachusetts

Production: Publishers' Design and Production Services
Cover Design: The Printed Image
Cover Image: David Anderson
Printer: InterCity Press, Rockland, MA.

CHARLES RIVER MEDIA, INC.
20 Downer Avenue
Suite 3
Hingham, MA 02043
781-740-0400
781-740-8816 (FAX)
www.charlesriver.com

This book is printed on acid-free paper.

3D Graphics Tutorial Collection
Edited by Shamms Mortier
ISBN: 1-58450-010-7
Printed in the U.S.A.

Printed in the United States of America
01 7 6 5 4 3 2 First Edition

Contents

FOREWORD ...xv

INTRODUCTION...xvii

AUTHOR BIOGRAPHIES ..XXIII

SECTION 1	**2D GRAPHICS: WHAT'S IN THIS SECTION** 1

CHAPTER 1	**PHOTOSHOP—IMAGE COMPOSING** 3

CONCEPT, PLEASE ..4

THE ELEMENTS ..4

OH, THE COLORS ..5

BY THE NUMBERS ..7

SHADES OF GRAY AND ADJUSTMENT LAYER JOY7

LAYER MODE MADNESS ..8

ONE PERCENTER ..9

CHAPTER 2	**PHOTOSHOP—PIXEL PUTTY** 11

PUTTY IN OUR HANDS ..11

BUILDING BLOCKS ..11

WELL, WHAT HAVE WE GOT HERE? ...13

SLEIGHT OF HAND ..15

CHAPTER 3	**PHOTOSHOP IN 3D** 18

THE SHOP ..18

JACK OF ALL TRADES ..18

DIVING IN ..19

THE PROOF IS IN THE PUDDING ..22

GLOSSARY ..22

CHAPTER 4 CREATING PATTERNS WITH TEXT IN
 ADOBE ILLUSTRATOR 24
 THE BACKGROUND ...24
 TRUE TEXTURIZING ..24
 USING CAPITAL LETTERS26
 BE A DINGBAT ...27
 WHAT'S IN THIS SECTION?29

SECTION II 3D GRAPHICS & ANIMATION 29

CHAPTER 5 MODELING INSECT ANTENNA WITH
 ANIMATION:MASTER 31
 INTRODUCTION ...31
 MODELING A BEADED ANTENNA31
 MODELING A BRISTLELIKE ANTENNA34
 MODELING A CLUBBED ANTENNA36
 MODELING AN ELBOWED ANTENNA37
 MODELING THREADLIKE AND SAWLIKE ANTENNAE38
 MODELING A FEATHERY ANTENNA39

CHAPTER 6 INSECTS II WITH ANIMATION:MASTER. 40
 INTRODUCTION ...40
 MODELING WASP WINGS40
 MODELING BUTTERFLY WINGS41

CHAPTER 7 CREATING A POSER/ BRYCE SCENE 43
 IN POSER 4 ...43
 THE TABLE ...45
 THE CHAIR ...45
 THE LAMP ..45
 THE DOORWAY ..46
 THE FINAL SCENE ...46

CHAPTER 8 USING THE "CONFORM TO" OPTION IN POSER 48
 FIRST THINGS FIRST ..48
 WHERE IS IT? ...48
 THE COSTUMED BODY RULES49
 TIME TO GET WHACKY ...50

CONTENTS **vii**

CHAPTER 9 **ARTBEATS/CANOMA URBAN ENVIRONMENTS**
 FOR BRYCE . **52**
 CITY SURFACES .52
 IN BRYCE .52
 IN PHOTOSHOP .52
 . . . AND BACK TO BRYCE .54

CHAPTER 10 **BRYCE TO POSER FIGURE PARTS** **56**
 VECTOR GRAYSCALE MAPS FOR BRYCE TERRAINS56

CHAPTER 11 **MEDIA TRANSFORMATION IMAGE MAKING USING**
 BRYCE 3D, PHOTOSHOP, AND
 ANDROMEDA'S CUTLINE FILTER **61**
 THE SOURCE IMAGE .61
 A SOURCE IMAGE IN BRYCE .62
 THE ALTERED IMAGE .64
 THE ANDROMEDA CUTLINES FILTER64

CHAPTER 12 **USING BSMOOTH FOR BRYCE** **66**
 BSMOOTH .66
 IMPORTANT PREFERENCES! .66
 HOW BSMOOTH WORKS .67
 THE BURNED OUT LANDSCAPE .68
 HELIXIA .69
 CRATER LAKE .69
 CANYON OF DREAMS .69

CHAPTER 13 **MODELING GOTHAM CITY IN 3D USING CANOMA** . . . **71**

CHAPTER 14 **RAYDREAM STUDIO TUTORIAL: ALIEN 1** **77**
 HEAD .78
 EYES .78
 HEAD ASSEMBLY .80
 BODY .81
 BODY/HEAD ASSEMBLY .81
 LEGS .82
 TORSO/LEG ASSEMBLY .83

ARMS ...84

HANDS ...85

FINGERS ...86

HAND ASSEMBLY ...87

ARM ASSEMBLY ...88

FINISHING ..88

CHAPTER 15 THE OLD MAN: A RAYDREAM/CARRARA OR POSER
 PROJECT ..89

 THE VERTEX MODELER ...89

 MODELING A HUMAN HEAD89

 POSERATIONS ..91

CHAPTER 16 CARRARA TUTORIAL: SPECIAL FX: EXHAUST93

 TUTORIAL REQUIREMENTS93

 STEP 8: THE POWER OF SPECIAL FX99

CHAPTER 17 ANATOMY OF THE HOP IN CINEMA4D XL V6101

 INTRODUCTION—THE COMPUTER HOP101

 THE MODEL ...101

 MOTION ...103

 STRETCH-ELONGATION AND SQUASH-RECOIL104

 CONCLUSION ...106

CHAPTER 18 HYPERNURBS AND THE ANATOMY OF THE
 FLIGHT CYCLE IN C4D V6107

CHAPTER 19 3D MAX 3.0 TUTORIAL: LEONARDO'S
 FLYING MACHINE118

 BUILDING THE FLAPPING-WING GLIDER118

 THE PILOT'S PLATFORM120

 TEXTURING THE MODEL ..121

CHAPTER 20 ANIMATING LEONARDO'S FLYING MACHINE
 USING 3D'S MAX 3.0123

 SETTING UP THE MODEL FOR ANIMATION123

 LANDING THE FLIER ...126

 CONCLUSION ...127

CHAPTER 21 **CREATING A TALKING ANNOUNCER IN 3D**
STUDIO MAX PART I: MODELING TEMPLATES . . . 128
STEP 1: GETTING YOUR REFERENCE MATERIAL.129
STEP 2: EDITING YOUR REFERENCE MATERIAL.130
STEP 3: CREATING YOUR SPLINE TEMPLATES.131
STEP 4: CREATING THE 3D TEMPLATE.133
STEP 5: EXPLORING OTHER METHODS OF TEMPLATE CREATION. ..135

CHAPTER 22 **CREATING A TALKING ANNOUNCER IN 3D**
STUDIO MAX PART 2: MODELING 138
STEP 1: JUMP IN139

CHAPTER 23 **CLAY CREATIONS IN MAX 149**
THE BASICS149
ABOUT CLAY STUDIO PRO SPLINES150
THE CLAYBIRD150

CHAPTER 24 **ELECTRICIMAGE USE-AS-VALUE OPTION 153**
THINGS TO WATCH OUT FOR156
SHADERS156
DISAPPEARING BLEND MODES156

CHAPTER 25 **ELECTRICIMAGE TESSELLATION AND YOU: PART 1 . 158**

CHAPTER 26 **ELECTRICIMAGE MODELER TESSELLATION**
AND YOU: PART 2 . 163
NORMAL TOLERANCE163
SURFACE TOLERANCE164
MAX GRID LINES164
MAX GRID LINES (BLEND)165
MAX EDGE LENGTH165
CELL ASPECT RATIO165
THE APPROXIMATE WITH SPLINE SURFACES CHECKBOX166
UNIFORM TESSELLATION (ÜBERNURBS)166
ENABLE TESSELLATION CHECKBOX166
TESSELLATION IN U AND V SETTINGS166
WELD VERTICES FOR OUTLINE SHADING166
SPLINE TESSELLATION166

Generate Isoparms167

Export Isoparms167

No. in U Direction / No. in V Direction167

Edge Tolerance168

Segments per Span168

A Final Note Before You Export168

Chapter 27 **Form•Z Modeling Using the Patch Tool** **170**

Chapter 28 **Creating Landscapes Using form•Z** **175**

Part I: Modeling175

Part II: Texturing178

Chapter 29 **Using LightWave 3D Procedural Texture Maps** **182**

The Devils in the Details183

Those Pesky Details!185

Beauty Is in the Eye of the Beholder187

Chapter 30 **Using Lofting to Model Detailed Architecture in LightWave 3D** **188**

Supply and Demand188

A Simple Yet Powerful Technique189

Surface Naming190

Finishing Touches192

Chapter 31 **4th of July Fireworks in Lightwave 6** **194**

The Basic Model194

Setting Up the Scene196

Adding Some Flare197

Making Some Sparks198

Particles in Layout199

Rocket Trail200

Texturing the Smoke Trail201

Texturing the Sparkles202

Chapter 32 **A Tiny Animation with Maya** **203**

Introduction203

Aim203

MODELING THE ORGANISM203

MODELING FROM PRIMITIVES204

SHADING AND LIGHTING THE ORGANISM204

ANIMATING THE ORGANISM206

CONCLUSION ...209

CHAPTER 33 **LANDING FIELD WITH MAYA 210**

AIM ...210

MODELING THE FIELD ...210

FURTHER MODELING ..211

ANIMATION ...213

RENDERING ...214

CONCLUSION ...215

CHAPTER 34 **PIXELS TUTORIAL: CREATING A HEAD**

IN PIXELS:3D . 216

BUILDING THE SPLINES216

IT'S NOW TIME TO LOFT219

CREATING MORPH TARGETS219

CHAPTER 35 **ROTOCRUISER 1200—USING RHINOCEROS 3D . . . 222**

INTRODUCTION: THE STORY222

TRAITS OF THE ROTOCRUISER 1200222

CONCEPT SKETCHES ...222

MODELING IN RHINOCEROS223

MODELING THE BODY ...223

CONCLUSIONS ...229

CHAPTER 36 **A CLOSE-UP ON LOFTING—USING**

RHINOCEROS 3D 230

INTRODUCTION ..230

A BASIC UNDERSTANDING230

SPLINE TYPES ...230

KNOWING FUNCTIONS OF THE LOFT231

STRAIGHT SECTIONS ..232

USING THE LOFT TOOL TO MODEL232

SMALL LOFTING TIPS AND TRICKS234

CONCLUSION ...234

CHAPTER 37 SO MANY DROIDS, SO LITTLE TIME (STRATA
 STUDIOPRO 2.5). 235
 GETTING TO IT ..235
 THE POWER OF THE LATHE235
 CHANGING PROFILES238
 ALIGNING OBJECTS241
 ORGANIZATION ..242
 THE BEAUTY OF THE EXTRUDE244
 THE PLUSES AND MINUSES OF BOOLEAN MODELING245
 ATTACHING PARTS TOGETHER247
 CREATING THE CALF249
 REPLICATE TO AVOID DUPLICATING EFFORT250
 BÉZIER OBJECTS ..251
 THE BEAUTY OF PRIMITIVES252
 FEET CREATION ..253
 SHOOTING FROM THE HIP253
 PREPARING THE PELVIS255
 MIRROR, MIRROR257
 MOVING ON UP! ..257
 SHOULDERS AND ABOVE260
 THE ARMS ..262
 SOME ELBOW ROOM263
 NOW FOR THE HEAD264
 THE RENDER ..268

CHAPTER 38 CREATING REALISTIC OCEAN WATER
 WITH TRUESPACE . 270
 AND THEN HE CREATED WATER—THE BEGINNINGS OF
 OUR OCEAN ..270
 SURFACING THE WAVES272
 SHADER SETTINGS ..273
 BUMP SETTINGS ..274
 COLOR SETTINGS ..274
 TRANSPARENCY SETTINGS275
 REFLECTANCE SETTINGS275
 SUMMARY ..276

CHAPTER 39 **VIC DISCO—A STUDY IN TRUESPACE**
 VISUAL EFFECTS . **277**
 THE TOOLS ...277
 THE TRUESPACE SCENE278
 STREAMING OFF THE NEEDLE279
 VOLUMETRICS ...281
 EXPLODING THE BALL282
 THE LASER SHOW282
 THE DOORWAY ...283
 FINAL EDITING ...283
 WRAPPING IT UP283
 WHAT'S IN THIS SECTION?285

SECTION III **OTHER TOPICS OF INTEREST** **275**

CHAPTER 40 **3D LIGHTING** . **287**

CHAPTER 41 **ON THE WEB, NO ONE CAN HEAR YOU**
 SCREAM: TOOLS FOR WRITING GAMES
 WITH SCRIPT . **297**
 INTRODUCTION ..297
 TO BOLDLY SCRIPT298
 A FEW WORDS OF CAUTION ABOUT GAME CREATION298
 HOW TO LAY OUT A GAME299
 BUILDING A STRUCTURED ENVIRONMENT300
 LOADING THE DICE302
 TRICKS TO MAKE THE GAME APPEAR MORE PROFESSIONAL302
 NOW IT'S YOUR TURN303

SECTION IV **EXTRAS** . **305**

CHAPTER 42 **JACK O'RACHNID (3D STUDIO MAX)** **307**
 MODELING JACK'S HEAD308
 JACK'S BODY ..310

CHAPTER 43 CREATING ELEE PHANTOOSY WITH 3D
 STUDIO MAX . 313
ELEE'S TRUNK313
THE EAR314
THE HEAD314
EYES315
LIPS315
TUSKS316
ELEE'S HEAD316

CHAPTER 44 PRIMITIVE & BOOLEAN MODELING WITH CARRARA . 317
PRIMITIVE MODELING317
IDEAS FOR USING PRIMITIVES317
WHAT YOU NEED TO KNOW FIRST318
THE PRIMBOT318
THE SPHERAPOD321
THE BRIDGE322
DRESSER323
BOOLEAN MODELING324
COMPLEX BOOLEAN MODELING328
ARRAY MODELING WITH PRIMITIVES329
STAIRS329
COLUMNS330
ARRAY MODELING WITH IMPORTED MODELS331

CHAPTER 46 CREATING A 3D TALKING ANNOUNCER IN
 3D STUDIO MAX: PART 3 336
FIGURE-1 / SCENE-1336
FIGURE-2 / SCENE-2338
FIGURE-3 / SCENE-3339
FIGURE-4 / SCENE-4340
FIGURE-5 / SCENE-5342

CHAPTER 47 CREATING A DHTML ANIMATION
 USING NETSCAPE 345
THE ANIMATION RECIPE345
NETSCAPE'S LAYERING346
ADDING THE ANIMATION347

APPENDIX A WHAT'S ON THE CD? 351
 WHAT IS AMAPI? .351
 USING THE FULL VERSION OF AMAPI 4.1 .352
 USING AND EVALUATING AMAPI 5.15 TE .352
 WHAT ABOUT THE 3DS MAX PLUGIN FOR AMAPI?352
 SUPPORT .352

APPENDIX B VENDOR CONTACT INFO 353

 GLOSSARY .355
 INDEX .000

Preface

Welcome to the first annual publication of tutorials from the Charles River Media Graphics Resource Club (http:www.graphicsresourceclub.com), a subscription-based Web site that offers the computer graphics artist and animator monthly step-by-step tutorials on how to use and master a wealth of 2D and 3D graphics and animation software. Since most of the techniques discussed in the tutorials address tools and processes found in most of the 2D and 3D graphics and animation software on the market today, there is truly something here for everyone, from the intermediate user to the professional. These tutorials were written by some of the best professional computer graphics artists in the industry. If your interests include 2D and 3D graphics and animation, then this book is for you!

Shamms Mortier
Editor

Introduction

The book you hold in your hands is the first of its kind, a volume of tutorials by computer graphics artists and animators whose work appears monthly on the Charles River Media Graphics Resource Club Web site (http://www.graphicsresourceclub.com). This is the first "annual" book that offers you a chance to sample a year's worth of content. The GRC is dedicated to teaching and learning, to guiding the novice and alerting the professional to the tools, techniques, and potentials of some of the world's best computer graphics and animation software.

As a viable art form, computer graphics can trace its beginnings back about forty years. It's only been since the 1980's, however, that the software and hardware have become economical enough for the mainstream artist and designer to purchase and use. The explosion of computer art and animation since then has motivated developers to continuously upgrade their offerings, building in more and more options, extending the fields of computer art and animation where no dream has ever gone before. This development has come with a price however, and not in financial terms alone. The stream of more and better creative tools, and their continual upgrading, demands that the users be on a similar continual learning path. To complicate matters, software from competing developers often accomplishes many of the same things in totally different ways. "Standards" are few and far between in this industry, and someone is always overturning the accepted norms. All of this, as well as the revolutionary new applications that steadily enter the fray, make learning essential, a lifelong commitment no less, for the artist and animator who uses electronic tools.

That is exactly where the GRC and this GRC reference volume come in. No single volume, lest it be hundreds of thousands of pages long, can allude to all of the available tools of the craft. By selecting applications that many users have and use as a basis for instruction, however, the computer graphics artist and animator find that they have enough of a head start to make their way with more confidence through any of the new software that comes along. The look of the tools may differ, but the general purpose of the tools is better understood with some dedicated instruction in their use.

Exactly how you use this book depends upon the extent of your involvement in the craft, what tools you use, and what additional interests you have in applying those tools to projects. For instance, you can use this book to zero in on one or more of the software applications covered, or you can target overall topics (like building a human or alien head, for instance). You can also use this book to expand your awareness of what various software is capable of, perhaps informing a future purchase. Computer graphics artists and animators also learn more from their peers than by any other means, and this book is a celebration of your peers. The way one master user does a single thing, even with a piece of software you know nothing about, can change your whole perspective on the craft and your approach for years. So think of this book as a classroom at your continual disposal, with additional resources on the CD-ROM. Other annuals will follow in the course of time, but you might want to access the articles and information even quicker by becoming a member of the GRC. Who knows... you may even find yourself motivated to contribute a tutorial or two yourself.

SOFTWARE

Every computer graphics artist and animator works with a favorite software collection. This may be one central application flanked by other supportive packages, or it may be a group of co-equal tools from different developers. This book covers the following software applications in specific chapters (in alphabetical order):

- **3DS Max (Discreet Logic)** - Chapters 21 to 25, 46, 47, and 50
- **Animation Master (Hash)**- Chapters 7 and 8
- **Canoma (Adobe)** - Chapter 15
- **Cinema 4DXL (Maxon Computers)** - Chapters 19 and 20
- **ElectricImage** - Chapters 26 to 28
- **FormZ(auto*des*sys)** - Chapters 29 and 30
- **Illustrator (Adobe)** - Chapter 5
- **LightWave (NewTek)** - Chapters 31 to 33
- **Maya**- Chapters 34 and 35
- **Photoshop (Adobe)** - Chapters 2 to 4
- **Poser and/or Bryce (CuriousLabs' and Corel)**- Chapters 9 to 14
- **RayDream/Carrara** - Chapters 16 to 18, 48, 49
- **Rhino (Robert McNeel & Associates)** - Chapters 37 and 38

- *Strata Studio* - Chapter 39
- *trueSpace(Caligari)* - Chapters 40 and 41

In addition, three other topics are covered:

- *Game Creation*- Chapter 44
- *Lighting*- Chapter 43
- *HTML Animation* Chapter 51

One way to use this book is to search the software list just detailed first, and then expand your reading to cover related interests. Another way to use the book is to browse the entire volume first, and mark those topics and chapters that are of interest. Yet a third way would be to read about software you might be interested in purchasing. You could even view the color art in the files on the CD-ROM, and then read a chapter based upon your interest about an associated image. No matter which entryway you select, you should at least skim every chapter. Just as the singer learns phrasing from the saxophone player in jazz, so too can you learn some interesting techniques, effects, and project ideas from someone who works with graphics and animation software far different from what you own and use.

OK. Enough preparation. Time to open the door and enter the magical world of computer graphics and animation. Welcome to the first edition of the GRC Annual!

Author Biographies

David Anderson, formerly an in-house artist for auto•des•sys, Inc. is currently working as an artist and can be reached at dander@computelnet.com.

Partik Beck is the president of Electric Crayon Studio, a full-time animator, and is an original LightWave user.

John Donal Carlucci is an artist and writer living in Los Angeles. He has published non-fiction columns for a variety of magazines, and has created a number of short film productions. He is an avid Photoshop user and enthusiast.

Tom Gray is the president of TAG Digital, a computer graphics and animation company in Las Vegas, Nevada.

Arnold Gallardo is a freelance visual content creator, animator, photographer, sculptor and the author of *3D Lighting: History, Concepts, and Techniques.*

Rick Greco is a full-time Photo/Graphics artist for Casino Journal Publishing Group in Las Vegas. He freelances through Ripix Studios as a digital illustrator and photographer, and is a teacher and author of articles on Photoshop and assorted 3D applications.

Sanford Kennedy is a 3D computer animator and author who has worked for the last 20 years in the motion picture industry concentrating on special effects. He has worked on more than 50 movies and numerous commercials, owns his own animation studio in Los Angeles, and teaches at colleges in the LA area. He can be reached at sanken@concentric.net.

Ryan W. Knope is a Macintosh operator and designer at Diamond Packaging, and has been involved in Rhinoceros education for a number of years. You can visit his Web site at www.3dluvr.com/fyrenurbs for more information, news, art, and tutorials.

Steve McArdle, aka the Iguana, is an award-winning artist who for the past several years has been working predominantly in the digital area. He focuses on 3D illustration and animation, and has written, lectured, and educated in the field. Steve's more recent work can be found in *The ElectricImage Handbook* and titles from IDG. He has also written for WIRED. To see more of his work visit http://www.web.directo.com/~gig.

Michael McBride is a writer, director, and 3D animator living in Sarasota, Florida. He is currently the Facility Director at Aston Worldwide Animation, a 3D company producing children's episodic televvision. He can be contacted at michaelmcbride@bigfoot.com.

J. Brook Monroe is a Lead Engineer for Client Software Development at Kinetics, Inc. He is co-author of the *JavaScript CD Cookbook, third edition*, and was also the Java columnist for Visual Developer Magazine.

Shamms Mortier is a successful graphics designer and writer living in Vermont. He has written a number of successful books including *Creating 3D Comix, The Bryce 3D Handbook*, and *The Poser 4 Handbook*. He also contributes regularly to magazines and other online services including the Graphics Resource Club (http://www.graphicsresourceclub.com).

Kian Bee Ng works as a technical director in a production company in Japan. His portfolio includes feature films, console games, and TV animations. He has written several CG articles and is the author of *Digital Effects Animation Using Maya*.

Jeff Paries is a former Hash, Inc. technical specialist and is currently a designer for AGENCY.com. Jeff is also the author of the best-selling *Animation:Master Handbook* and the *Animation:Master 2000 Handbook*.

Nick Robalik runs his own design and animation house called Digital.Soapbox. He uses trueSpace as his main application and is the author of *trueSpace F/X Creations*.

Rick Schrand is the owner of GRFX ByDesign, a firm specializing in 3D design and animation based in the Nashville, Tennessee area. He is also the author of *The 3D Creature Workshop 2nd Edition* and the forthcoming *Macromedia Web Design Handbook*.

John Sledd is a freelance illustrator/animator working mainly in the science fiction (fact and fantasy) and cartoon genres. He is the editor of *The ElectricImage Handbook* and *The Ray Dream Handbook*, second edition.

Kelly Valqui is an instructor of Web development at Miami Dade Community College and is the co-author of *Web Design and Development*.

Darren L. Waschow is a computer graphics hobbyist who has used trueSpace for a number of years. He is a columnist for trueSpace eZine, The Render Engine (www.renderengine.com) and contributed a chapter to *trueSpace F/X Creations* by Nick Robalik.

Adam Watkins is the Director of Computer Arts at the University of the Incarnate Word in San Antonio, Texas where he teaches animation, Web design, and multimedia. He is also the author of *3D Animation: From Models to Movies*.

1 2D Graphics: What's in this Section

What we distinguish as "2D" graphics is really a misnomer, because all computer graphics and animation, except that which appears as a hologram, is in 2D. That means it appears on a flat picture plane for your monitor or a movie screen. Perhaps the best way to define the term as we use it is that in 2D graphics and animation programs, we can only control what happens in two dimensions, though we can use some tricks to emulate an environment that has a perceived "depth", or third dimension. In 3D graphics applications, we can actually adjust the Z, or depth, dimension.

Although we said in the introduction that there are few long-lasting "standards" in the industry, one is certainly the use and existence of Photoshop from Adobe Corporation. You can tell that this is true because most writers and plugin developers will say that something is meant for "Photoshop and anything compatible with it." This tips you off, when you hear or read it constantly, that Photoshop itself has become cross-definable with what it is used for. There are more than a dozen other wonderful 2D applications that do most of what Photoshop does, but not quite. Photoshop gets upgraded more consistently and with more attention to user needs than any other 2D applications. So, it's not surprising that out of the four 2D software chapters in this book, you will find that three are about Photoshop. This does not mean that users who prefer one of the "compatible" applications can't learn things from these chapters, it just means that Photoshop is the most well known 2D standard. See Chapters 1 to 3 by Rick Greco.

Photoshop is a bitmap application. This means that it works by allowing you to alter the pixel data that a bitmap image is based upon. A pixel is literally a Picture Element, a measurable unit of screen and image resolution. An image sized 640 x 480 is based upon 640 pixels wide by 480 pixels tall. The higher the pixel count, the sharper the image looks. If you zoom in on a pixel-based image however, it begins to look jagged and "pixelated", because you are seeing the actual separate pixels. Not so with vector images.

Pixel-based graphics are not the only way of representing image data on a computer screen. There is also Vector data. Vector images are composed of line elements that have two components, a length and a direction. Various formulas can be assigned to vector data to create any image data an artist uses. There are vector applications that target images, and some that are used for animation. The "standard" vector drawing format for addressing images is Adobe Illustrator. The overwhelming standard now in use for addressing vector animation is based upon Macromedia's Flash format. Although this edition of the GRC Annual does not cover Flash, we do offer you an excellent Illustrator tutorial by Rick Schrand (Chapter 4), a master of vector art.

Every 3D artist and animator knows that before mastering 3D realms it is necessary to have a working understanding of 2D applications. This is why you should read this section even if your main interest is in 3D. There are hundreds of ways that 2D can provide content for a 3D scene. Enjoy this section of the book, which guides you carefully through explorations of 2D graphics.

1

Photoshop— Image Composing

—RICK GRECO

This tutorial was done using Photoshop 5.5. It was created on a Power Macintosh 9600/350, OS 8.1, with 352MB of RAM, and two internal hard drives. One hard drive is dedicated to the operating system and applications. The other is partitioned; one partition is used for file storage, the second as a scratch disk. Since Photoshop swaps quite a bit of data back and forth from the scratch disk(s) during many operations, it's important to have at least one dedicated scratch disk that is defragmented and set up for multimedia use. Also, I use a two-monitor setup, typically using one for the working image and one for palettes.

What we'll be doing in this tutorial is something I call "image composing." Essentially, I'm referring to a working method that maximizes creative flexibility and encourages experimentation while building an image from scratch. Tools such as Layers allow us to build element upon element, while keeping each element separate for editing. That in itself is incredibly powerful, and has gone a long way toward providing flexibility and creative possibilities to the artist since their introduction with Photoshop version 3.0 (FWIW, Photoshop was not the first image editing program to implement them). With the advent of Adjustment Layers and Layer Effects in the latter versions of Photoshop, the artist's creative options have increased, and the limitations imposed by limited undos have decreased.

Before I begin the tutorial, I'd like to say a few words about undos, the History Palette, Layers, Adjustment Layers, and how they apply to "image composing." When I started in Photoshop, we had no Layers, and only one undo. Something as basic to us now as a drop shadow required a series of steps using channels; if you messed up at any point, you usually had to revert back to a previous version of the file and start over again (hopefully, you were using a scripting utility that automated much of the process and spared you from careless errors). When Layers came along, at a point still prior to the History Palette, I saw among the added possibilities the power of embedding undos into the Layer scheme. When the Adjustment Layer came along, that just busted that whole concept wide open.

About the History Palette: I am a fan of it, and when taken advantage of via the History Brush and/or Fill command, life gets even more interesting in Photoshop. Generally, though, I don't use the History Palette—it eats RAM like crazy, slows you down, and more often than not is used as an undo to a previous state, rather than as a creative tool. Everyone works differently, of course, but the techniques I'm about to get into here show how you can hold to the same undo information the History Palette does, and, more importantly how to "compose" your image by building up image layers as visual components that can be edited individually at practically any time.

CONCEPT, PLEASE

These steps are a recreation of an actual job I was handed recently. The assignment read something like this: "Feature illustration. A percentage sign with numbers behind it." Not much to go by, I know. Other specifics were that it was to run in a national consumer gambling magazine, and sized for about a half page, square proportions.

THE ELEMENTS

1. Establish the canvas. Open a new document.

Most magazines use a 133 line screen, for which a 300dpi file resolution will suffice—I'll be using a much lower resolution (72dpi) for the tutorial in the interest of efficiency and crispness of the screen shots). Even though the file will end up as a CMYK document, start off in RGB, which is a much larger and forgiving colorspace where gradients will be smooth and all your filters will work. Start off with a transparent background; a Background Layer at this point isn't relevant. Most magazines are 8.5″ × 11″; a canvas of 8.5″ × 8.5″ at 300dpi will give plenty of resolution to allow the image to fit the page properly and print well. See Figure 1.

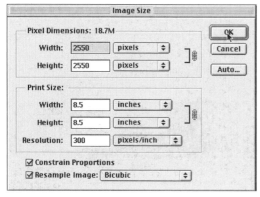

FIGURE 1 *Image size settings.*

2. The fun starts here—we need some fonts. For this example, I first chose Arial Black for the percent sign. Using the standard Text tool from the tool palette will create a text layer above the existing transparent layer created with the document. See Figure 2.

Size your percent symbol to more or less fill the frame. Take note that you can click on and drag the text around in the image window behind the active text window to position it.

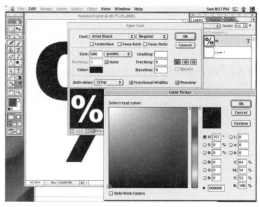

FIGURE 2 *Text tool.*

3. By default, Photoshop will choose the foreground color. Click on the color swatch inside the text window, and select black in the color picker.

I'd like to note here the reason why we're choosing black. It does not have to do with a final choice for the color of the text; it's intentional that we want no color introduced into the image at this stage—at this point, we're just introducing the elements into the document window. We'll come back later and start dealing with color once the rest of the preliminary elements (in this case, just a set of numbers) are added.

OK the text dialog, and note that the new layer is automatically named "%".

4. Hide the "%" layer by clicking on the small eye icon to the right of the "%" icon in the layer palette—this will help you better see the text

layers you're about to add. As you add each successive layer, you can hide each previous layer in the same fashion if you wish.

Using the Text tool in the same manner as in Step 3, add a series of new text layers. Choose some random fractional numbers for each layer; for example, .7255, .109, .23411, and so on. Size them each at about half the document height, using a different font than was used for the "%"—I chose Georgia Bold.

You've now placed the basic elements in the document and it's time to start crafting some sort of illustration.

OH, THE COLORS

At this point, I want to hide all the text elements and start adding some color to the canvas. There's no hard-and-fast rule here—just choose a color that suits your mood (or suits the tone of the magazine, in this case). Magentas reproduce well in print and invoke a warm, inviting feeling, so let's choose something along those lines as a base color.

1. Click on the foreground color in the tool palette. Type in **44% Cyan**, **83% Magenta**, **0% Yellow**, **0% Black**. This is a printable color, but I'll dare say you don't need to be overly concerned with 100% printable colors at this stage. Just keep in mind, the richer and more vibrant your colors get along the way, the greater the chance those colors will turn to mud when converted to the CMYK color mode required for print reproduction.

Photoshop allows you to view an RGB document in CMYK preview "mode." Using Command-Alt-Y will activate it, so you can work in millions of colors while not being fooled into using colors that will never print. I highly recommend this mode if you're not familiar with what will print well. Do not work in CMYK to avoid introducing unprintable colors into your work; the limited color space of CMYK mode will introduce problems such as color banding or other artifacts while you work.

In CMYK preview you'll be seeing the colors as they'll look after being converted, but avoid the image degradation that will occur to the actual image data in literal CMYK mode.

2. A solid color isn't very interesting so, with the aid of a few basic Photoshop tools and filters, we'll break it up into something a little more inspiring.

Under the Filter menu, choose Add Noise, Uniform, Monochromatic. The amount depends on the resolution of your image; for our tutorial, at 72dpi, an amount of 32 works well. You'll require a higher setting to achieve the same effect on a 300dpi image. See Figure 3.

Again, under the Filter menu, choose Crystallize, amount 10 at 72dpi. You'll notice a nice, clean effect, which to me looks a little too clean. At a stage like this, where one step overtakes a previous effect, I often opt for the Fade function. After you've applied effects like filters, levels, curves, gradients, or hue/saturation adjustments, the Fade option becomes available under the Filter menu. Fade is quite a nifty feature I use very often, where you can apply a heavy dose of image adjustment (such as our Crystallize effect), and then in real-time "dial back" completely to the previous state. Fading back 53% works well for us here, yielding a soft, "fuzzy" look to the combination of noise and crystallize effects. See Figure 4.

FIGURE 3 *Add noise option.*

FIGURE 4 *Fade feature.*

A note about the Fade function. You'll notice in the Fade dialog some of what you may recognize as Layer modes—available from a pulldown menu. Experiment with them! They're quite powerful. We're not using them in this step, but we will shortly.

3. Next we're going to use the Gradient tool, so we first need to choose foreground and background colors to suit our needs. Use the Eyedropper tool to sample some colors from the image. I pulled color from a highlight and a shadow area of the image. See Figure 5.

Before proceeding, this is a good place to duplicate this layer by dragging the layer to the "duplicate layer" icon (tiny dog-eared page) at the bottom of the Layer palette. We will use the original layer later on, but we want to work with a copy of what we've done so far.

4. Apply a standard foreground to background gradient, dragging from top left to bottom right of the image to apply. Way too much—we wiped out everything that came before it. Call the Fade function again from the Filter menu. This time we're going to use a transfer mode from the pulldown, Color Burn, and set the percentage to 63%. See Figure 6.

We're getting somewhere at this point, introducing more interest in the background image.

A BRIEF PAUSE

What I wanted to illustrate up to now was how to first add key elements into a blank document, leaving them generic. Then I wanted to show you how to start building from scratch some sort of background elements that will interact through layers with the key items to ultimately create the final image.

FIGURE 5 *Eyedropper tool.*

FIGURE 6 *Fade Function.*

BY THE NUMBERS

It's time to start working with the numbers we created in the beginning. We're not finished with these backgrounds, but before we go further, some sort of integration with the number elements will serve to inspire us a bit more toward the final piece. With "image composing," this type of cause-and-effect inspiration is fundamental.

1. Enable the top layer, which would be the last text layer you created (in my example, the layer labeled ".23411") and use the Move tool to place it as seen in Figure 7. There's nothing special about this placement, it's just a place to start.

FIGURE 7 *Move tool.*

2. Continue to enable the rest of the text layers, but keep the "%" layer hidden for now. Place them as you see fit. Duplicate some of them to fill out areas you feel need it. A bit of scaling and rotation adds interest. Use Command-Alt-T to enable the Resize tool on a specific layer, and use Command-Alt-click on the resize handles to enable freeform resizing.

Well, what we have in this example currently looks like a mess at this point (see Figure 8), but have faith. We've got some tricks up our sleeves that will clean up that mess very quickly. Additional positioning, scaling, and rotation

FIGURE 8 *Current progress.*

will come shortly, but take this opportunity to make the greatest transformational changes.

> *These are still text layers, and they will be rasterized and antialiased later. In effect, don't be too worried about getting jaggies from gross resizing—yet.*
>
> **NOTE**

SHADES OF GRAY AND ADJUSTMENT LAYER JOY

Any item or function in Photoshop that permits nondestructive editing of your image is a good thing. Adjustment Layers, in combination with Layer

Modes, enable a safe yet powerful way to create and edit the color elements in your image.

It starts with shades of gray and an Adjustment Layer.

1. Enable the top text layer; in my example, it's once again layer ".23411". In the Layer pull-down menu, choose Text>Render Layer. Once a text layer is rendered, it becomes a pixel layer and will no longer call up the text dialog when it's double-clicked.

FIGURE 9 *Levels dialogue.*

2. Call up the Levels dialogue: Command-Alt-L. Raise the shadow slider of the Output Level to 114. Your black text is now a shade of gray.
3. From the Layer palette pulldown, choose Add Adjustment Layer. Choose Hue/Saturation, check "Group with previous layer." Click OK.

 By choosing "Group with previous layer," you've told Photoshop that any Hue/Saturation effects you choose will affect only the layer directly below it; in this case, the recently rendered text layer ".23411".
4. After you press OK, the Hue/Saturation dialog will immediately pop up. See Figure 10. Check Colorize. Instantly, your gray text is colorized—this is just a starting point. Adjust the sliders until you find a color you like for now.

 Repeat Steps 1 through 4 for the rest of your enabled text layers. You can, if you wish, skip Step 2—the "Lightness" slider in the Hue/Saturation dialogue approximates the same effect as

levels in this case, and you can control it from within the Hue/Saturation dialog. See Figure 11. Actually, if you choose this method, you don't have to render a text layer into a pixel layer at all, but you won't be able to apply any filters or level or curve adjustments to it.

FIGURE 10 *Adding adjustment layers.*

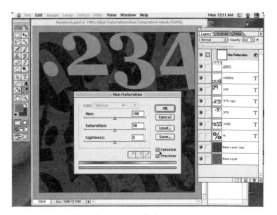

FIGURE 11 *Hue/Saturation dialog.*

LAYER MODE MADNESS

Madness indeed. We've got a ton of layers, quite a bit going on, and this image isn't looking very inspiring. This is where I call on the quiet magician in Photoshop—he lies hidden within Layer Modes.

It's madness in itself to try and define what exactly Layer Modes do technically, although I do recommend spending time with the Photoshop manual

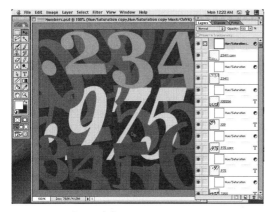

FIGURE 12 *Layered elements.*

reading up on the descriptions. In practice, I generally don't care what math is behind them (although there are times that knowledge is priceless). What I see them as is a way to "pull together" layer elements in an image. They can be used in combination with Adjustment Layers and Layer Transparency to allow the layer elements to interact in some often surprising yet often wonderful ways. See Figure 12.

This is where it's best to stay very loose and experiment. Some guts have been established, creating pixel layers and attaching them to adjustment layers—now have some fun. Changing layer order may offer creative solutions. Duplicating layers and changing the Layer Mode and/or transparency settings on a duplicated layer will offer even more possibilities. Adjustment Layers take advantage of Layer Modes, too—it's a real party in that Layer palette now! See Figure 13.

I'm not going to give you a step by step at this specific stage. Use your eye, and come up with something that pulls together well. This is what I came with at this stage. Not done yet, but it's close. Just one more element to add and a few more tweaks . . .

ONE PERCENTER

Finally, we're ready to add the most significant part of this feature graphic, the percent sign. Click on the "%" layer, which will make it visible as well as enabling it. Drag it to the top of the layer stack—we want this element to ride over what we've done so far.

Following the steps from the "Shades of Gray and Adjustment Layer Joy" section, I came up with what appears in Figure 14. Note that I copied this layer a few times, used different Layer Modes, even added a simple Layer Emboss effect on some of them, and applied Gaussian Blur to the lowest of "%" layer in the stack. You may also notice I didn't render some them into pixel layers—it wasn't necessary for how those layers were used.

This could almost pass for a finished piece. What I'd like to do, however is go back to the background layers underlying this whole piece and add some depth.

FIGURE 13 *Layer palette.*

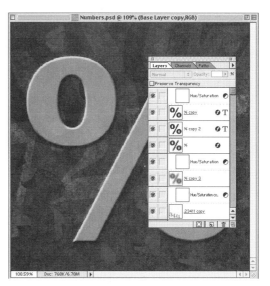

FIGURE 14 *Results of adjustments.*

First, though, remember the original base layer we copied? You can now toss it. Often I'll use a layer like that, a younger version of a more "mature" layer. When using Layer Modes, the information on that young layer can help bring out distinct elements of the mature layer, such as texture or contrast, that would be impossible to call out with control any other way. To be honest, I wanted to use that layer to show you how this works, but I applied a lighting effect that didn't pan out, and I'd saved the file unwittingly before I undid the filter! Normally a "mistake" like this wouldn't be a big deal—I'd just finish it out another way—but it sort of crushed my chance to illustrate a specific point. I suppose I raised a more significant point, something that speaks to the heart of this tutorial: Carelessness strikes even the well initiated when they break their own rules. I should have copied that layer before I applied the lighting effect to the original! But with "image composing," few mistakes are fatal to the final piece.

What I ended up doing was to copy the base layer I did have, applied a diamond foreground to background gradient to it, and used curves to intensify the contrast. With this layer situated below its big sister, big sister was set to a layer mode of Overlay, which created a bit more drama in the overall image. Next a darkened border was added and darkened using levels. See the before and after, with the resulting two layers combined with and without Overlay enabled between them. In Figure 15, Overlay is disabled; in Figure 16, Overlay is enabled.

The tweaking can be endless at this point—that really is the point. If you're not happy, you can adjust most any element in this piece to bring it closer to what will satisfy your creative eye, or your art director's creative eye for that matter. Say he or she wanted sepias instead of magentas—nothing stopping you now, every element is there for the editing.

Happy composing!

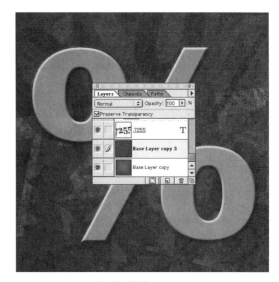

FIGURE 15 *Overlay disabled.*

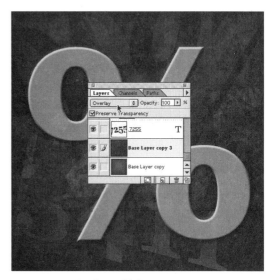

FIGURE 16 *Overlay enabled.*

2 Photoshop—Pixel Putty

—Rick Greco

This tutorial was created using Photoshop 5.5 on a Power Macintosh 9600/350, OS 8.1, with 352MB of RAM, and two internal hard drives. One hard drive is dedicated to the system and applications; the other is partitioned, where one partition is used for file storage and the second as a scratch disk. Since Photoshop swaps quite a bit of data back and forth from the scratch disk(s) during many operations, it's important to have at least one dedicated scratch disk, one that is defragmented and set up for multimedia use. I also use a two-monitor setup, typically using one for the working image and the other for palettes.

PUTTY IN OUR HANDS

Pixels are the stuff that make up digital imagery. In this tutorial, I'll show you how, by considering what happens at a micro level, we can create at the macro level. We'll walk through a series of steps where pixels are applied to a document canvas, and from essentially nothing, the familiar forms.

BUILDING BLOCKS

Most of us know what a pixel is in regard to Photoshop, at least enough to get by. Technically, it's actually an acronym for "picture element." You can think of pixels as atoms in your digital image; within that atom lie the tonal and color qualities that make a pixel look like it does.

Clusters of pixels create patterns, and patterns in the beholder's eye form pictures and art. Not many of us think about pixels in our daily digital adventures; we just use our eye, so to speak. However, there are times when it pays to consider what happens at the pixel level when we do what we do. Understanding more about the building blocks opens up a greater range of possibilities and creative solutions for the artist who works in the digital realm.

VISUAL SLANG

What our eyes recognize as a picture, or a piece of art, is actually an illusion of sorts. It's a basic premise of visual art that the mind will be tricked into seeing familiar shapes if the artist does his or her job well. This is a sort of optical slang, meaning we interpret what we see through the filter of our experience. Rather than seeing the literal, what we see is more so than not contrived in our minds. Without getting too heavy into that whole side of our craft (those of you with formal art training may have already cracked a yawn), it's significant to keep in mind as we work through this tutorial.

STRETCH YOUR COFFEE BREAK

In this first example, we're going to create an organic texture, namely tree bark, something akin to oak or redwood. That's probably not a high-demand

texture for many of you, but this example is all about the thinking process used to first add and then manipulate pixels into a desired result. Since we all know what bark looks like, and since it's a random texture, we can concentrate more on the constructive theory than on the minute visual details of the final image.

Bark generally has a vertical grain, so we need to first find a way to coax some pixels to represent that look.

1. Create a document 360 pixels high by 360 pixels wide. Start with a white background. Normally I prefer to start with a transparent background, but I need to add noise in Step 2. Since you can't add noise to transparency, we'll start with white.
2. Using the Rectangular Marquee tool, draw a small sliver of a marquee at the top of the document as shown in Figure 1.
3. Select the Add Noise filter from the Filter Menu.
4. Add noise, amount 30, choose Monochromatic, Uniform.

 This gives a strip of noise, essentially random pixels sized from a single pixel up to larger groups. Zoom in (see Figure 2), notice the pattern, and consider what will happen if we scale

FIGURE 2 *Strip of noise.*

that noise vertically top to bottom. Yep, there's our answer. Let's try it and see what we get.

5. Summon the Transform tool for the marquee (Command-Alt T) and drag to stretch the noise toward the bottom of the document.

Pause here briefly to notice what you've got (see Figure 3). It doesn't seem to be more than a set of vertical black and white lines. This is because Photoshop hasn't interpolated the pixels for the stretch action yet; it's stretched them, yes, for the preview, but actual interpolation occurs when you apply the transformation.

(I'm assuming for this example that you're Photoshop preferences are set to use Bilinear Interpolation, which is the default. If they aren't, your results will not be the same as we have here, and you'll need to manually change the prefs to Bilinear.)

6. Double-click inside the window to apply the transformation.

FIGURE 1 *Rectangular Marquee tool.*

FIGURE 3 *Noise stretched with Transform tool.*

Looks like Christmas tinsel a bit, doesn't it (see Figure 4)? You can go there if you want, since we've achieved our first "illusion," but we're really looking to make tree bark.

FIGURE 4 *Transformation applied.*

as the value is increased (see Figure 5). The tinsel strands soften up and spread out, and start to look like they maybe *could* take us to where we want to go.

FIGURE 5 *Gaussian Blur effect.*

WELL, WHAT HAVE WE GOT HERE?

Let's briefly examine what happened: Where did the tinsel come from? The answer lies in the pattern of noise we stretched, and in the way Photoshop resolved the stretch through bilinear interpolation and aliasing.

If we had used a different type of pixel source, say a row of pixels with a horizontal motion blur applied, the result would be much different. At the end of this tutorial, I'll show a few examples of different pixel sources, and the type of imagery they can lead to. But let's finish up here first.

We've got a random vertically streaked pattern going, now we need to soften up the streaks. You'll soon see, at least in grayscale, that these vertical streaks are not very far from what our eye will interpret as the bark we're after.

7. Select Gaussian Blur from the Filter menu, and slowly increase the value slider from its lowest setting. Make sure the Preview check box is active, and watch what happens in the document

Why? Well, what makes bark look like it does aside from the vertical patterns inherent to its texture? The darker areas are the crevices, and the lighter areas are the upper crests. The gray areas between are the transitions that help delineate the edges between the crests and crevices. We are literally sculpting algorithmically the pixels we started with.

8. Before we move on, set the radius to 1.3 and click OK.

This same technique with a few tweaks can be used to simulate a pretty cool rock-like texture. See an example at the end of the tutorial.

NOTE

This texture is too soft and smooth. We need to add something that will appear to be tiny pores and detail. There are two things we can do: either use both an additional application of noise plus the Sponge filter, or just one or the other. It depends on the type of tree bark you're looking to simulate. We'll use both,

where the noise will predominantly create the pores and roughness, and the Sponge filter can be used to suggest moss, mold growth, and divots.

9. First, add a little more noise. Select Add Noise from the Filter menu, use the same settings as before: Uniform/Monochromatic, amount 30. Initially, this will be too much—we'll want to use the Fade command in the Filter menu (available after all filter operations and many others as well, such as after applying Curves or Levels). (See Figure 6.)

FIGURE 7 *Fade setting of 80%.*

FIGURE 6 *Adding more noise.*

Why didn't we just apply less noise rather than bother with Fade options? Because here we can call on another one of Photoshop's internal algorithms to not just remove the degree of noise added, but we can interactively combine the before and after states through an application mode.

Application modes are available from the pull-down in the Fade dialog. These are the same type of modes we see in the Layer and Brush palettes: Multiply/Overlay/Lighten/Darken etc. We're going to choose Multiply, then use the preview behind the dialog to help us determine what looks best for our needs. I used a Fade setting of 80% with a Multiply mode to get what we have in Figure 7.

I'm going to suggest a few optional steps here. After you've added this noise, you may want to stretch the contents of the document (not the entire document or canvas). Select All, Command-Alt T, then stretch the contents by 50–100% (see Figure 8). This will stretch the noise you just added, and create more complexity in the texture, namely by adding more levels of vertical grain. Repeat Step 9, adding more noise, which will add back the "pores" we've now stretched into vertical grain.

FIGURE 8 *Contents stretched by 50–100%.*

10. We're going to do the same thing with the Sponge filter. Select the Sponge filter in the Filter menu, Artistic submenu. You don't want to add too much here since the Sponge effect is a much stronger effect than simple Noise, and therefore more difficult to "dial-out" using the Fade command. Brush size 1, Definition 3, Smoothness 2. (See Figure 9.)

FIGURE 9 *Sponge effect.*

FIGURE 10 *Multiply mode.*

11. Using the Fade command as in Step 9, choose Multiply from the application mode pulldown, and set the slider to about 50% (see Figure 10).

SLEIGHT OF HAND

We've laid down the basic pixels, distorted them, modified them, and we're a few short steps from the final keystrokes.

There are a few things preventing the illusion of wood from presenting itself to us at this point. Obviously, color would help, but we'll add that almost dead last. Looking at what we have so far, some things are soft and some are sharp. Bark has these characteristics, but the sharp elements in this case need some softening.

12. Using Gaussian Blur, apply a relatively small amount, radius 1.0, to the image. We just want to soften the noise a bit and help blend the Sponge filter effects into what we did in the first few steps (see Figure 11).

FIGURE 11 *Gaussian Blur.*

It may pay to sharpen what we have by a small degree at this point; we want to tighten up some of the edge transitions. As you can see, except for the addition of color and a final tweak or two, we're about finished.

13. From the Filter menu, choose Unsharp Mask. Apply about 200%, which may seem like a lot, but that will be tempered by the following settings: Radius 1.2, Threshold 3 (see Figure 12). These settings tell Photoshop to be more selective about where to apply the sharpening effect; which in this case, tends to be areas of higher contrast, namely what we visually perceive as edges.

Now it's time to add color. Photoshop gives us a number of ways to do this; we're going to use the Hue/Saturation dialog.

FIGURE 12 *Unsharp mask.*

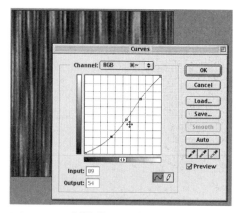

FIGURE 14 *RGB Curve settings.*

14. Since we've sort of decided on an oak/redwood look here, we'll want a deep brown, with not too much saturation (few things in nature are highly saturated with color). From the Image/Adjust pulldowns (Command-Alt-U), choose Hue/Saturation. Set Hue at 20, Saturation at 20, Lightness –30 (see Figure 13).

 Two more tweaks and we're there.

FIGURE 13 *Hue/Saturation setting.*

FIGURE 15 *One more stretch.*

15. Looking like a slab of bark already, I'd say. But, let's refine this more by first tweaking the densities of the image. Refer to Figure 11 to see how the main Curve was set. You can play with the RGB curves here too if you want to further tweak your color (see Figure 14).

16. We could be done here, but one more stretch of the contents in the document window (again,

we're not resizing the document, just the contents in the window), and we're there (see Figure 15). You'll want to eye this—it's difficult to give exact numbers for this transformation, since your document will look slightly different from what you see here (due to the random nature of the Noise and Sponge filters).

That's it. (see Figure 16). Step out of your chair for a moment and look at the screen from a few feet away; or better yet, take a break and come back.

FIGURE 16 *Final texture.*

With a fresh eye, surely you'll agree this is a very passable hunk of oak or redwood bark. Don't be overly critical; this was a simplified procedure. It wasn't my goal to show you how to make a 100% photorealistic wood texture—there are many commercial CDs available to grab the real thing from. But, hopefully, you've learned that pixels really are the clay-stuff of digital art, where Photoshop is the hand that gathers and shapes it. You're the human conductor, of course, and the fun is all yours.

3

Photoshop in 3D

—RICK GRECO

This tutorial was done using Photoshop 5.5 and Strata StudioPro 2.5.3. It was created on a Power Macintosh 9600/350, system 8.1, with 352MB of RAM, and two internal hard drives. One hard drive is dedicated to the system and applications, and the second is partitioned, where one partition is used for file storage, and the second as a scratch disk. Since Photoshop swaps quite a bit of data back and forth from the scratch disk(s) during many operations, it's important to have at least one dedicated scratch disk with Photoshop, one that is defragmented and set up for multimedia use. In addition, I use a two-monitor setup, typically using one for the working image and one for palettes.

THE SHOP

Inside every good 3D artist, you'll find a savvy Photoshop jockey. Whether creating still images, or animation, Photoshop is typically used during one or more stages of the creation process.

Photoshop is a hub in this regard. It literally becomes a virtual pixel "shop" where an artist can create, repair, enhance, composite images, and produce and edit files unique to but common in 3D programs such as texture, clipping, and bump maps.

In this article, we're going to run through some specific tips that touch on the stations within the 3D workflow, from pre-production through post-production. Our goal here is not to talk so much about

3D, but to show very specifically some ways Photoshop is used in a step-by-step fashion you can follow.

JACK OF ALL TRADES

Here are some places where Photoshop is useful in a 3D project:

- **File Conversion** 3D programs are much choosier than Photoshop when it comes to file format compatibility. Out of the box it can open and save to just about any format most artists would run across. Look for freeware and shareware plug-ins, or import modules on the Web to help open proprietary formats like ElectricImage format.
- **Photo Import** Flatbeds, slide scanners, drum scanners, digital cameras. You can't always get what you want, but can you get what you need—Photoshop is there so you can make up the difference.
- **Textures** Say no more! Some people excel at modeling in 3D, some in motion, others in lighting. Textures and texture mapping are extremely important—Photoshop allows the creation and manipulation of textures and their component files such as bump, secularity, reflection, and clipping maps.
- **Painting/Expression** A raw 3D rendering is merely a starting point; the possibilities after that are of course limitless.

- **Enhancements/Sweetening and F/X** This is a little different from painting and expression. This is where you might want to add that highlight to an edge, to saturate the water a little more in your ocean, or to soften some aliased edges.
- No one should expect his or her 3D application to do every little thing. Keep in mind a lot of time can be saved by faking it in Photoshop as well—a lot of F/X-like glows, explosions, fire, laser blasts, even things like bump and reflection can often be done faster and more effectively in Photoshop.
- **Compositing** There are times when it's better to render a piece at a time, and put the elements together later. In fact, there are times when it's not only a better way, but the only way to do certain things. Constantly evaluate your workflow strategy as you go—compositing offers up a lot of practical and creative solutions.

DIVING IN

Good surface textures are actually rendered from a set of specialized image maps for each texture. In the following steps, we're going to create a few image files that can be used in your 3D program of choice. What's important to understand is that we'll build the required texture files and export them all from a single Photoshop file.

The subject is simple, an aluminum can (Figure 1). We want to create a label in Photoshop to wrap around the can with "cylindrical mapping" (see the end of the tutorial for a brief glossary on that and other terms) in your 3D application.

There's a formula here straight from Geometry class used to figure the correct height-to-width ratio for the texture map to completely cover the can top to bottom and around. The end caps are not covered; there are ways to do so, though we won't need to cover them here.

Circumference = 2(pi)r (where the radius is equal to the radius of the cylinder, and pi = 3.14)

1. My 3D cylinder (a.k.a.. an aluminum can) is 2.5 units high by 1.5 units horizontal in my 3D program. Using the formula above, that means we need to create a Photoshop document 2.5 units high by 4.7 units wide—we'll choose inches to represent 3D units at a document resolution of 72dpi (Figure 2). That will suffice for a low-resolution texture map suitable for rendering at screen resolution.

2. Add some text using the Text tool, the color is your choic, and allow it to fill the canvas almost edge to edge and center it horizontally and vertically. I added a Layer Effect from under the Layer pull-down, under Effects (Inner Glow.)

3. Add a new layer and place it below the text layer. Using the Reflective Gradient tool, create a horizontal gradient as in Figure 3.

4. Add another layer, which will appear above the gradient layer. Draw a rectangular marquee

FIGURE 1 *Aluminum can subject.*

FIGURE 2 *Creating the texture map.*

FIGURE 3 *Horizontal gradient.*

horizontally as above centered around the text. We'll fill this with color to serve as a band behind the text. Using the Fill command from under the Edit menu, fill the marquee with a suitable color.

That's our label. Exciting, no, but it will serve.

Now we're going to add the aluminum lips at the top and bottom of the can by painting the metal edge area onto the texture.

5. Add a new layer above the text banner layer, and using the Pen tool, add silver/gray, 5-pixel high horizontal lines at the top and bottom of the canvas (Figure 4).

That takes care of the color map. For photo-realism, you'd want to do what is known as "dirty down" the map by painting in grime, scratches, and dirt. That's a book chapter in itself, so we'll leave our map as is to keep it within the scope of this tutorial.

6. Using Photoshop's "Save a Copy" feature under the File pull-down, and save this map so you recognize it as the color map for the label. Make sure to check "Flatten Image" and "Exclude Non-image Data," choose a file format you

know your 3D application accepts, and click Okay.

This saves a file you need for the color/diffuse shader channel in your 3D application, and at the same time leaves the "master" label file open, with layers intact. We'll take advantage of that right now.

There are two additional maps we want to create. One is the reflection map. Admittedly, aluminum isn't very reflective, but it does reflect some. We want the area of the label and can to be a little bit reflective, and for the lips at the top and bottom to be a little more so. The other map is the bump map, and we'll get to that in just a minute.

The reflection map is easy to make now that we have these separate layers already made. In the texture editors of 3D applications, light and dark areas of an image file can be used to describe "how much," almost like an on/off switch, for a particular shader channel. Black is typically "off" and white is typically "on." With a reflection map in particular, black is used for nonreflective areas, white for 100% reflective, and the grays in between represent "on/off" percentage values.

7. We decided the lips would be the most reflective, so now, with the lip layer selected, fill the two 5-pixel wide strips with 10% black. Be careful not to fill the whole layer. Using Option/Shift then Delete is a shortcut that will fill a layer with the foreground color only where there are pixels on that layer.

We chose 10% black instead, letting it be totally white because we don't want the lips to be completely reflective.

8. The gradient area we want considerably less reflective. Choose that layer, and fill it with 50% black. That will make it 50% reflective, since the black will "turn off" the reflective nature of the label by 50%. It's a converse relationship that this next step helps make clearer.

9. The color band and the text we'll say are not very reflective at all. Merge the text layer down into the banner strip layer by choosing Merge Down from the Layer palette pull-down on the top right-hand side of the Layer palette.

FIGURE 4 *Adding another layer.*

FIGURE 5 *Filling the banner area.*

FIGURE 6 *Softening the bump.*

Fill that layer, using Option/Shift then Delete to fill only the banner area, with 95% black. This tells a 3D program that this area of the map is only 5% reflective (Figure 5).

10. Convert this file to Grayscale mode from under the Mode pull-down. You could have done this when you were finished with the color map, but it was significant to see the step-by-step conversion to values of black and white. Since your 3D application only cares about the gray values in a reflection map, this is why you want to export this map as a grayscale file.

11. Using Photoshop's "Save a Copy" feature under the File pull-down, and save this map so you recognize it as the color map for the label. Make sure to check "Flatten Image" and "Exclude Non-image Data," choose a file format you know your 3D application accepts, and click "Okay."

Last but certainly not least is the bump map. Where the lip could be modeled with geometry in a 3D application, we're going to simulate the ridge with a bump map. Also, we're going to suggest the ramped metal that folds into the crimped lip using the same bump map.

12. Choose the lip layer (almost white). Bump maps work along the same logic as reflection maps when it comes to black/white and off/on. White is "on" and means "high." Black is "off" and means "low." White is a mountain top, black is the base.

In our file, the lip layer is white enough already. To soften the bump transition, and create a softer "bump," under the Filter pull-down

menu select Gaussian Blur. Choose a value of 2 (Figure 6).

13. Select the merged text and banner layer, and fill it with 50% black. That tells your 3D application to place that area's height at about halfway between the lip and what will be the ramped metal that folds into the lip.

14. Select the layer originally assigned to the mirrored color gradient.

Using the standard Gradient tool, with foreground and background colors set to default 50% black and 100% white, respectively, create

FIGURE 7 *Using the Gradient tool.*

a gradient at the top of edge of the canvas as seen in Figure 7.

The gradient should hit 100% black just as it slips under and is blocked by the lighter lip layer above it.

15. Draw a marquee around the transition area of the gradient, and copy it. Paste it and, as seen in Figure 8, flip it vertically using the Flip Vertical command from the under the Edit/Transform

FIGURE 8 *Copying the marquee.*

pull-downs, and place it at the bottom of the document to mirror the top.

16. Flatten this document using the Flatten Image command from under the Layer palette pull-down at the top right of the Layer palette. Save this file and label it as your bump map.

NOTE *You should in a real project save a "Master file" with all the layers you create through the process. In other words, when we moved on from the color map to the reflection and bump maps, rather than destroying those layers to move on, duplicate those layers and modify them, leaving the originals to save in the Master File for that texture. When you "Save As," export the separate maps by activating only those layers that apply to the type of map you are saving. In the end, you'll have a file containing every layer we created in the previous steps. Very convenient.*

THE PROOF IS IN THE PUDDING

Now, after importing these maps into a 3D application, placing them in the proper shader channels,

FIGURE 9 *Final product.*

and creating a quickie environment for the can, we end up with what is shown in Figure 9.

Examine the cans in Figure 10 and compare them to the can in Figure 9. In Figure 10, the can on the right has no reflection applied, and the can on the left has no bump applied. The difference is clear.

As mentioned earlier, this example is only one of the many ways in which Photoshop empowers the 3D artist. If you think 3D, remember to think Photoshop too.

FIGURE 10 *Companion of reflection vs. no reflection.*

GLOSSARY

Ambient The shadow area of an object. The lower this setting is in a 3D program, the less of an object's surface will be seen in shadow.

Ambient color The color of the material when it is in shadow.

Anti-aliasing The blending of adjacent pixels to eliminate the stair stepping associated with pixel-based images. Also known as "jaggies."

Aspect ratio An image's ratio of height to width.

Bitmap An image map.

Blur Reducing contrast between adjacent pixels to create the illusion of a smooth edge.

Brightness One of the terms used to describe the intensity of light. Hue and saturation are the other two.

Bump map A grayscale texture that provides surface relief on an object by adding roughness or bumpiness to an object without actually changing or affecting its geometry.

Color/Texture map The main visual qualities of an object's surface. Some 3D applications use these in the diffuse channel.

Composite The result of taking two or more images and combining them to form one image.

Constrain To restrict the movement of a tool or the proportions of a selection tool or image.

Contrast The difference between the darkest and lightest values of an image.

Cubic mapping Cubic mapping should be used with any shape that is roughly rectangular.

Cylindrical mapping This type of modeling is best used when you're applying a map to something like a soda bottle.

Circumference =2(pi)r (where r is equal to the radius of the cylinder)

Circumference =pd (where d is equal to the diameter of the cylinder)

Diffuse color Diffuse color is what most people would refer to when describing the surface color of a material.

Diffuse map The main visual qualities of an object's surface.

Displacement map A grayscale image map used to displace the actual geometry of a 3D object.

Dynamic range The range of brightness values in an image.

Environment map Defines what areas of an object will reflect its environment.

Reflection map An image map applied to a 3D object that is the reflection on the object's surface.

Reflectivity How reflective a surface is.

Saturation The intensity of a color.

Specular Reflected highlight.

4 Creating Patterns with Text in Adobe Illustrator

—Rick Schrand

The following tutorial explores a technique that can be used in any version of Adobe Illustrator, although this is created in Illustrator 8.0. It uses the basic techniques of turning text into outlines and the option combine features of the program. This is geared toward the intermediate user—although advanced users can use the ideas generated here to expand their creative output. We assume you know where all the basic tools are located in the program (such as the Reflect Tool), so we don't go into any detail regarding where they are. We do give some of the quick key combinations, though.

Adobe Illustrator is available for both Mac and PC, and both are virtually identical in layout and look. A minimum of 32MB of system RAM is recommended, as is the minimum memory allocation suggested for the Illustrator program itself. In our case, we're working on a Macintosh G3 with 256MB RAM and 60MB allocated to Illustrator.

THE BACKGROUND

We've all experienced it. A client calls saying they need a flyer by tomorrow. (OK, I'm being kind here and giving the client the benefit of realizing we actually need some time to put together a design!) You've spent the past hour mulling over ideas for the job, all of which include a background that isn't in your library of saved files or clip art. As you stare at your choices, all you can think is that it all looks the same. How often can you use that paper texture or that gradient? You want something new. Something exciting. Something—dare we say it?—original. How about this: Use your plethora of fonts to create interesting, never-before or rarely seen patterns that will catch the eye of the most jaded designer. Hadn't thought about that before? Now you will!

When you use fonts in this manner, you'll want to consider using some of the more esoteric ones in your collection; all those with the wild curlicues and flourishes that are great to have for those rare occasions, but are all too often unusable in real-world situations. I mean, how often do you really use that Arthurian-style font or that wedding-style script when putting together an ad or packaging for Bubba's Battery Barn? Guess what! Now you can use them whenever you want, and it won't be considered a "frou-frou" element (Figure 1).

TRUE TEXTURIZING

First make sure all those frou-frou and rarely usable fonts you want to experiment with are open and ready for use (assuming you have a program such as Suitcase where you store them). Open Illustrator and begin typing, remembering to look at all the regular and special characters (Option or Option Shift on

FIGURE 1. *Frou-frou fonts? Not anymore.*

the Mac and Ctrl or Ctrl Shift on PC). To accomplish our first background image, we're going to want to use lowercase characters rather than uppercase because, for the most part, the lowercase characters have much more interesting curves and shapes. There are some great-looking uppercase letters that can be used, like the "E" in the first font family (AdineKirnberg), but again, we want to focus on lowercase letters right now (Figure 2). We'll come back to caps in a few pages.

Select a fairly large point size—we used 200-point AdineKirnberg Script for this demo—and the lowercase "g". This allows you to manipulate the objects more easily. Convert the character to an outline/path. Duplicate it, flip it on the vertical plane with the

FIGURE 2 *Explore the regular and special characters to find the one you want.*

FIGURE 3 *Create an outline, flip it vertically, and reposition as shown.*

Reflect tool, then position it so the tips of the "g"s are touching each other as shown in Figure 3.

Select both characters, duplicate them and, again using the Reflect tool, flip them on the Horizontal Plane (Figure 4). Hey, look! It's a Rorsach Test! I see a butterfly! Or a pair of really weird scissors (Figure 5).

FIGURE 4 *Duplicate, flip horizontally, and move into place.*

FIGURE 5 *What does this pattern look like to you?*

Keeping it black and white is rather boring though. If it's not already, open the Pathfinder window (Window > Show Pathfinder), select all the characters and group them. Now color the pattern red and create a square. Move the square behind the pattern, assign a color to it, and prepare for more fun (Figure 6).

FIGURE 6 *The initial pattern using the letter "g".*

Once you've got things in place, you can modify them in numerous ways. You can choose Pathfinder > Exclude to cut out the text portion of the pattern (Figure 7). You can add Hatch Effects (Filter > Pen and ink > Hatch Effects) and create an effect that you like (Figure 8). If you have a second-party filter package like Metacreations' Vector Effects 1.5, you can create 3D images more easily and effectively (Figure 9).

USING CAPITAL LETTERS

It's time to try this technique with a capital letter. Here we'll use the "E" we mentioned earlier. While you probably don't have the exact font we're using, one of your more flowery fonts will work just as well. Modify your work to fit with the outline of your particular font style.

What we want to do this time (after turning the letter into an outline) is rotate the element 180º and flip it on the vertical plane. Move it into place as seen in Figure 10. Right now, it looks like two "E"s

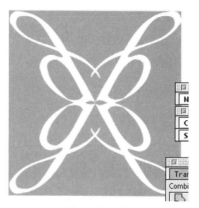

FIGURE 7 *The Exclude function cuts the text from the background.*

FIGURE 8 *The Hatch Effects create some fascinating patterns in the portion you select.*

FIGURE 9 *There are third-party programs that give you the ability to quickly create complex effects.*

FIGURE 10 *E-positioning.*

FIGURE 12 *The final pattern created with the letter "E".*

placed side by side. But, just give it a chance. This is one "kewl" pattern.

Group these two elements, then Copy and Paste In Front and move the new elements above the first two. You could also use the duplication/aligned move quick-key combination by clicking and holding on the original grouping, using Option+Shift combo. Duplicate this one more time and move the new group underneath the original group. The pattern's almost complete (Figure 11).

Select all the elements and use the Divide tool in the Pathfinder options. This will group the elements at the same time as dividing various portions of them. Ungroup and then begin selecting different parts of the image. You can assign different colors to the interior of the image, or just assign a thin, light-colored outline to it. Once you've done what you want to it, group everything and duplicate to fill the screen or use it as a border (Figure 12).

BE A DINGBAT

Now let's try one more thing. How about a dingbat this time? Dingbats, those strange-shaped or picture fonts have been misunderstood for a long time, although they're often used as bullet points or for little decorations on homemade greeting cards. But now, you'll actually have a use for them. Here we're using Zapf Dingbats Option>Shift>8, which produces the character shown in Figure 13.

Duplicate, flip, and position the character, and then repeat to create this pattern (Figure 14). Now

FIGURE 11 *The raw pattern in all its glory.*

FIGURE 13 *Our star dingbat.*

take the fill out of the outlines and create a thin gray stroke. You now have the final pattern to use in your background (Figure 15).

And here's one more for you to take a look at (Figure 16 and Figure 17). Only this time, we'll let

FIGURE 14 *The dingbat pattern.*

FIGURE 15 *The final pattern*

you figure out how it was created. What we'll tell you is it's a Helvetica font.

Of course, you'll want to use more subdued colors if you're using this as a background pattern, or you can use these ideas as logos, banner art, specialized bullets, etc. It's all up to you.

FIGURE 16 *This is a test of the emergency pattern creating system. This is only a test.*

FIGURE 17 *Recreate this pattern using the various techniques we described.*

Modifications can be made in a photo manipulation program such as Adobe Photoshop or Corel Draw. You can add gradients. You can add depth. You can do whatever you need to make original patterns that will stand out in the crowd. The main thing is to break the mold, look beyond the obvious to see things in a different light. Possibilities abound, even with something as common as the font.

SECTION II

3D Graphics & Animation

WHAT'S IN THIS SECTION?

Learning how to create 3D graphics and animation is the core topic of the GRC, so it's little wonder that this 3D section makes up the bulk of this book. We actually live in a 5D world . . . 3 dimensions of space, a dimension of time, and another of sound.

All modern technologies owe their existence to a multitude of forebearers, to a collection of enterprises that have preceded them. 3D graphics and animation is no exception. The industries that have sprung up over the years to develop the continuing stream of products that form the ocean of 3D endeavors is fed by many channels of the past that have culminated in what we now enjoy.

Television is one of the sources of computer graphics. Television gave us the monitor screen and the 24/7 TV that bombards our senses today has also become a medium of communication (although one-way) that offers many 3D artists and animators a venue for the display of their endeavors. Television, of course, is wed to movies, and before that to live entertainment like Vaudeville, medieval puppet shows, plays, and perhaps even the individual who was somehow disposed to start speaking, singing, or dancing in a crowd. Computer graphics and animation is a way to interact with a monitor, and after the skills of production and display are mastered, to control exactly what appears on that monitor. Using 3D graphics and animation, you can carry on the art of the storyteller, presenting your story on a display screen.

3D graphics and animation owes a huge debt to the movies, as mentioned earlier. To be more specific, there are two individual movie sources that deserve special attention . . . Walt Disney and George Lucas. In some ways, America's attraction to the storytelling art was underlined by the work of Disney. What child has not been caught in rapture (and sometime abject fear) by a Disney story. With the ability to tap into historical and cultural archetypes, Disney created the environment in which 3D storytelling continues to flourish. George Lucas gave us Star Wars, and was the first to explore (in a major way) the use of 3D graphics and animation as integral to story telling. The artists and animators who broke new ground with their creative work on Lucas' films, and those of others, forced the creation of new software that could do more and better things realistically. Lucas also pushed things farther ahead by creating Jar-Jar Binks, the first completely 3D-animated character to achieve a starring role in a major film. No matter what you think of the story, this event is so important that it surpasses any criticisms of the film. A series of publicly available software applications, like those alluded to in the tutorials that follow, owe their root motivating existence to Disney and Lucas.

Strange as it may seem, 3D graphics and animation is also indebted to the early twentieth century psychologists Sigmund Freud and Carl Jung. Before these two giants came upon the scene, dreaming had little mention in public or private. They brought dreams, and therapies based upon dreams, into common parlance. That fact supersedes any discourse that pretends to debunk either or both of their actual work in these areas. Dreams and dreaming are no longer forbidden, no longer said to be non-existent (or worse yet, the work of the devil.) Because we all recognize that we dream, and that dreaming is based upon visual and symbolic explorations that somehow tie things together, the potential of 3D graphics and animation as a child of dream making was allowed a space to enter the world. It is not technology alone, but the welcome mat prepared for a technology that is also important and necessary for perception and creativity to evolve.

And what of art, visual art in particular? Here and there, throughout history, there have been artists who have explored the infinite and sometimes terrible parameters of the dream world. From the strange medieval chimeras to the visions of Dali, these explorers have marked a path through the woods that 3D graphics artists and animators have widened and taken deeper, on a continual attempt to push back the edge of what is real and what is possible.

There are other sources as well that could be mentioned as seminal to the flowering of 3D graphics and animation: the mathematical work of Mandelbrot; the visionary theoretical work of Einstein and Heidegger and Stephen Hawkings; the love people have for games and role playing; the need humans have to make pictures of things, to fool the eye and challenge what is perceived as real; the love of magic and all things magical. All of this and more came together in a flash of improbability not that many years ago to form the beginnings of computer graphics and animation, driving the development of hardware, software, and human thought.

Keep all of this in mind as you delve into the tutorials in this section. The worlds of magic are real, and revealing themselves at every turn. Just thought I'd mention it. . . .

5

Modeling Insect Antenna with Animation:Master

JEFF PARIES

INTRODUCTION

Insects. Love 'em or hate 'em, they're all over the place.

In fact, insects make up over 80% of all the known living organisms on the planet. With about 800,000 known species, it's no wonder they are difficult to get away from. From the gentle buzz of a bumble-bee on a hot summer afternoon, to the bite of a mosquito on a warm evening, everyone deals with insects.

Because of this, insects have become standard fare in sci-fi, horror, comedy, and even children's movies. Generally, the effects houses that produce such movie creatures create some type of mutant variation of an existing insect to add to the appeal of the film. Such variations may include a human with insectlike features, or a combination of different insects' anatomy to create a new, hybrid super critter.

This tutorial kicks off a series that describes how to model different parts of insect anatomy, and continues with how to model different types of insects.

Hopefully, this will give you some ideas for creating your own insect variations. The program used throughout these exercises is Animation:Master from Hash, Inc., although the tutorials should be fairly easy to adapt to other 3D packages.

There are at least 12 types of insect antennae that help separate them (along with other features) into groups. This tutorial describes techniques used to create seven of them. Three of the remaining five are variations on the seven you will learn.

MODELING A BEADED ANTENNA

1. Begin by starting Animation:Master.
2. Click the NEW button, then select Model, and click OK.
3. Right-click the Model1 item in the Project Workspace and select New, Rotoscope, click Browse, and locate the Beaded.JPG image shown in Figure 1.

FIGURE 1 *A rotoscope of a beaded antenna.*

4. Expand the Images folder in the Project Work-space by clicking the plus (+) to the left of it. Click the Beaded item in the Images folder, and on the General tab of the Properties panel, click the Bk Color chip. Select the bright green color swatch from the default color palette that opens.

5. From the Tools menu, select Options, and click the Modeling tab. Enter 8 in the Lathe cross sections field.

6. Click the Rotoscope1 item in the Project Workspace, and on the General tab of the Prop-erties panel, uncheck the Pickable checkbox so that you don't inadvertently drag the rotoscope image out of position.

7. Right-click the Project name and select Save As. When the save file dialog opens, save the project as Beaded.prj.

8. Click the ADD LOCK button, and trace around the right-hand side of the fourth antenna bead up from the bottom with five control points, as shown in Figure 2. Press ESC after the fifth point to return to Edit mode.

9. Click any point of the five that were just added and click the LATHE button.

10. The shape that is created is close to the shape of one of the beads on the antenna, but not exact, as shown in Figure 3.

11. Shape the piece by grouping the individual cross sections of the model and scaling them or

FIGURE 3 *The first bead shape after lathing.*

dragging them as necessary until they match the shape of the rotoscoped image.

12. Drag the bottom cross section of the model downward so it intersects with the section below it, giving the antenna a "socketed" feel.

13. On the top cross sections, notice how the lathed shape forms a socket for the piece that goes above it. Be careful not to drag the inside cross sections down too far, as it will create a sharp edge along the socket.

Figure 4 shows both the wireframe and shaded views of the final shape for this piece.

14. Click any point on the existing piece, and press the / key to Group Connected. Press CTRL+C

FIGURE 2 *The five-point spline used to begin creating a beaded antenna.*

FIGURE 4 *The first bead shape after lathing.*

to copy, then CTRL+V to paste a copy of this piece.

15. Drag the newly pasted copy downward, and roughly line it up with the next bead immediately below the completed one.

16. Click the LOCK button on the toolbar to lock the nonselected control points so they aren't selected inadvertently.

17. Use the Group tool to select the cross sections of the newly copied bead, and shape them to the rotoscoped image. Notice that this piece is a little narrower and tapers in faster at the bottom than the previous one.

18. In positioning the top cross sections (the ones that form the "socket" for the adjoining piece), drag them to the left slightly so that the middle control points are aligned with those from the bottom cross section of the previous piece. Use Figure 5 for reference.

19. Select any point on the second bead and press the / key to Group Connected. Press CTRL+C to copy and CTRL+V to paste a copy of this piece.

20. Drag it downward and align it with the next bead down in the antenna model. Scale the new piece down to roughly match the rotoscoped image.

21. Select each cross section and shape it to the rotoscoped image. Figure 6 shows this bead upon completion.

FIGURE 6 *The shape of the next bead.*

22. Continue creating the beads for this model until the entire antenna is completed. For the topmost bead, the closing cross section should be selected and scaled to 0,0,0 and positioned similarly to the one shown in Figure 7.

23. Press the 6 key on the numeric keypad to change to a right-hand view of the model.

24. Right-click in the modeling window and select Draw Mode, Shaded.

25. Zoom in on the model and examine each joint section closely. In some cases, scaling of the model sections to create the bead shape may have caused a "hole" in the top of the bead. If you find any of these, select the appropriate control points and scale or drag them to close the hole.

The final model should look similar to Figure 8.

FIGURE 5 *The shape of the second bead.*

FIGURE 7 *The shape of the top bead in the antenna.*

FIGURE 8 *Shaded front and side views of the completed antenna model.*

MODELING A BRISTLELIKE ANTENNA

You will notice that most all of the antenna models are created in a similar manner. After working through a couple of the models, it should become both faster and easier for you to build them.

1. Begin by starting Animation:Master.
2. Click the NEW button, then select Model, and click OK.
3. Right-click the Model1 item in the Project Workspace and select New, Rotoscope, click Browse, and locate the Bristlelike.JPG image shown in Figure 9.

FIGURE 9 *A rotoscope of a Bristlelike antenna.*

4. Expand the Images folder in the Project Workspace by clicking the plus (+) to the left of it. Click the Bristlelike item in the Images folder, and on the General tab of the Properties panel, click the Bk Color chip. Select the bright green color swatch from the default color palette that opens.
5. From the Tools menu, select Options, and click the Modeling tab. Enter 8 in the Lathe cross sections field.
6. Click the Rotoscope1 item in the Project Workspace, and on the General tab of the Properties panel, uncheck the Pickable checkbox so that you don't inadvertently drag the rotoscope image out of position.
7. Right-click the Project name and select Save As. When the save file dialog opens, save the project as Bristlelike.prj.
8. Click the ADD LOCK button, and create a shape with five control points similar to the one shown in Figure 10. Notice that the spline is positioned to the right of the green Y-axis marker. Press ESC after the fifth point to return to Edit mode.
9. Click any point along the newly created spline and click the LATHE button.
10. The shape that is created is roughly a cone similar to the shape of one of the antenna sections,

FIGURE 10 *The five-point spline used to begin creating a bristlelike antenna.*

but not exact, and positioned to the right of the rotoscoped image.

11. Use the Group tool to drag a bounding box around the entire lathed shape, and position it over the rotoscope.

12. Begin shaping the piece by grouping the individual cross sections of the model and scaling or dragging them as necessary until they match the shape of the rotoscoped image.

13. Drag the bottom cross section of the model downward so that it intersects with the section below it, giving the antenna a "socketed" feel.

Figure 11 shows both the wireframe and shaded views of the final shape for this piece.

FIGURE 11 *A shaped section of a bristlelike antenna section.*

14. Click any point on the existing piece, and press the / key to Group Connected. Press CTRL+C to copy, then CTRL+V to paste a copy of this piece.

15. Drag the newly pasted copy upward, and roughly line it up with the next section of the antenna on the rotoscoped image.

16. Click the LOCK button on the toolbar to lock the nonselected control points so they aren't selected inadvertently.

17. The newly pasted antenna section is quite a bit larger than the rotoscoped image. Use the Group tool to select the cross sections of the

FIGURE 12 *A wireframe and shaded view of the second antenna section.*

newly pasted piece and shape them to the rotoscoped image. Use Figure 12 for reference.

18. Select any point on the second section and press the / key to Group Connected. Press CTRL+C to copy and CTRL+V to paste a copy of this piece.

19. Drag it upward and align it with the next section in the antenna model. Right-click inside the yellow manipulator box and select Flip, X-Axis to flip the shape. This will more closely match the rotoscoped image.

20. Shift-click the LOCK button to lock nonselected control points.

21. Select each cross section of the newly pasted piece and shape it to match the rotoscoped image. Figure 13 shows this section upon completion.

FIGURE 13 *The shape of the next antenna section.*

22. Continue creating the cross sections for this model until the entire antenna is completed. For the topmost section, the closing cross section was simply scaled to 0,0,0 and positioned appropriately. The bottommost section of the antenna is modeled the same as all the others, only it is larger in circumference.

23. While it isn't necessary to closely examine this antenna from a side view to fix any discrepancies in the model like it was with the beaded antenna type, it is still a good idea.

The final model should look similar to Figure 14.

FIGURE 14 *Shaded front and side views of the completed bristlelike antenna model.*

MODELING A CLUBBED ANTENNA

1. Begin by starting Animation:Master.
2. Click the New button, then select Model, and click Ok.
3. Right-click the Model1 item in the Project Workspace and select New, Rotoscope, click Browse, and locate the Clubbed.JPG image shown in Figure 15.
4. Expand the Images folder in the Project Workspace by clicking the plus (+) to the left of it. Click the Clubbed item in the Images folder, and on the General tab of the Properties panel, click the Bk Color chip. Select the bright green color swatch from the default color palette that opens.

FIGURE 15 *A rotoscope of a clubbed antenna.*

5. From the Tools menu, select Options, and click the Modeling tab. Enter 8 in the Lathe cross sections field.
6. Click the Rotoscope1 item in the Project Workspace, and on the General tab of the Properties panel, uncheck the Pickable checkbox so that you don't inadvertently drag the rotoscope image out of position.
7. Right-click the Project name and select Save As. When the save file dialog opens, save the project as Clubbed.prj.
8. By this point, you should have no troubles building the model all the way to the end sections near the top. For these, create an eight-point spline similar to the one shown in Figure 16.

FIGURE 16 *The eight-point spline used to form the end sections of a clubbed antenna.*

9. Click any point along the newly created spline and click the LATHE button.
10. Use the Group tool to drag a bounding box around the entire lathed shape, and position it over the rotoscope. Press the R key to enter rotate mode. Drag one of the blue handles on the outside ring of the manipulator until the angle of the model roughly matches that of the rotoscope.
11. At this point, the model can be shaped cross section by cross section, similarly to the other parts of the antenna.
12. Make the additional parts of the clubbed ending by copying the original piece, and scaling and shaping the copies as necessary.

Figure 17 shows both the front and side shaded views of the final model.

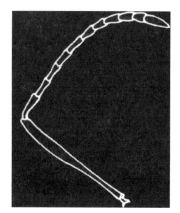

FIGURE 18 *A rotoscope of an elbowed antenna.*

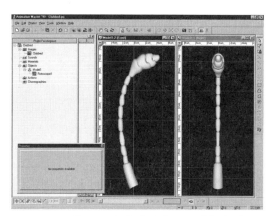

FIGURE 17 *Front and side shaded views of the final clubbed antenna model.*

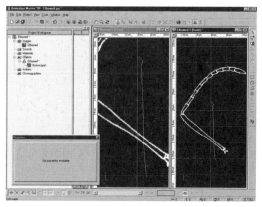

FIGURE 19 *The nine-point spline used to form the elongated segment near the base of an elbowed antenna.*

MODELING AN ELBOWED ANTENNA

Elbowed antennae are created exactly like the other models in this tutorial, with the exception of the elongated piece toward the bottom of the antenna.

Set up the Elbowed project as you have the previous three, using the elbowed rotoscope, shown in Figure 18.

1. Create a nine-point spline similar to the one shown in Figure 19.

2. Click any point along the newly created spline and click the LATHE button.
3. Use the Group tool to drag a bounding box around the entire lathed shape, and position it over the rotoscope. Press the R key to enter rotate mode, and drag any of the blue handles on the outside ring of the manipulator until the model's rotation is close to that of the rotoscoped image.
4. At this point, the model can be shaped cross section by cross section, similarly to the other segments of the antenna. When completed, this segment should look similar to the one shown in Figure 20.

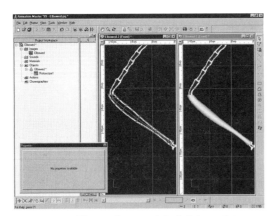

FIGURE 20 *The wireframe and shaded views of the lower section of an elbowed antenna.*

5. From this point, continue making the antenna sections similar to those of the previous models created in this tutorial.

Figure 21 shows both the front and side shaded views of the final elbowed antenna model.

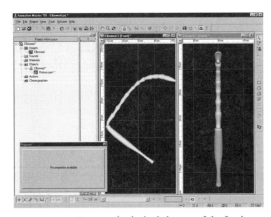

FIGURE 21 *Front and side shaded views of the final elbowed antenna model.*

MODELING THREADLIKE AND SAWLIKE ANTENNAE

Both threadlike and sawlike antennae (shown in Figures 22 and 23, respectively) are created similarly to others in this tutorial. Use the other antenna types in this exercise to guide you in constructing them.

FIGURE 22 *Threadlike antenna rotoscope image.*

FIGURE 23 *Sawlike antenna rotoscope image.*

Figure 24 shows the completed threadlike antenna model.

Figure 25 shows the completed sawlike antenna model.

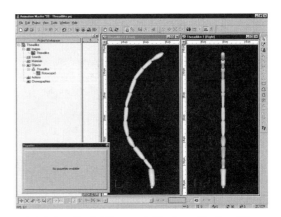

FIGURE 24 *Shaded front and side views of a threadlike antenna type.*

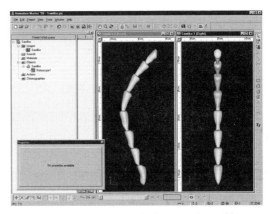

FIGURE 25 *Shaded front and side views of a sawlike antenna type.*

MODELING A FEATHERY ANTENNA

The feathery antenna type is a little different from the others in this tutorial, in that it has the addition of line geometry to create the feathering along the edges of the antenna.

Figure 26 shows the completed center part of the feathery antenna model. Notice that it is comprised of segments shaped like elongated teardrops.

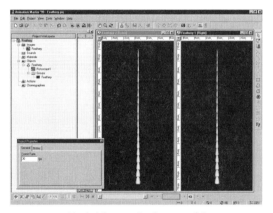

FIGURE 26 *Shaded front and side views of the center part of a feathery antenna type.*

1. Once the center part of the model is completed, change back to a front view by pressing the 2 key on the numeric keypad.
2. Create as many three-point splines as are needed to trace the feathery edges of the model, as shown in Figure 27. Don't worry if the splines are not alined perfectly with the rotoscope, just be sure to roughly estimate the curve.
3. Use the Group tool to select only the outside points of the splines that were just added. Press the / key to Group Connected, which should result in only the three-point splines being selected.
4. Click the Untitled group name in the Project Workspace and press the F2 key to edit the name. Type in "Feathery" and press ENTER.
5. With the Feathery group still selected, place a check in the "Render group as lines" checkbox on the Options tab of the Properties panel.

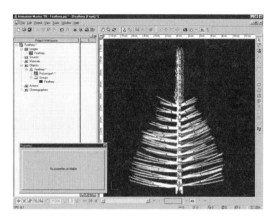

FIGURE 27 *After the feathered edges of the antenna have been added.*

6. The settings for the line geometry can be left at their defaults for this model. However, be aware that the color of the line geometry defaults to black, so if your background color is set to black, you won't be able to see it when you render.

Figure 28 shows a final quality render of the completed feathery type antenna. Keep in mind that line geometry does not show up in Progressive Render Mode or the real-time mode.

FIGURE 28 *The completed feathery antenna.*

CHAPTER 6

Insects II with Animation:Master

—Jeff Paries

INTRODUCTION

In general, most adult winged insects have two pairs of wings, referred to as the fore wings and hind wings. Chances are good that you have come across them at some point in your life. The most common wing types are those found on butterflies or moths, and those found on wasps.

This tutorial will continue the series on creating insects with Animation:Master by describing how to create two different styles of insect wings.

MODELING WASP WINGS

1. Begin by starting Animation:Master.
2. Click the New button, then select Model, and click OK.
3. Right-click the "Model1" item in the Project Workspace, and select New, Rotoscope, click Browse, and locate the "wingrotoa.JPG" image shown in Figure 1.
4. Click the "Rotoscope1" item in the Project Workspace, and on the General tab of the Properties panel, uncheck the "Pickable" checkbox so that you don't inadvertently drag the rotoscope image out of position.
5. Right-click the Project name and select "Save As." When the Save File dialog opens, save the project as "waspwings.prj."

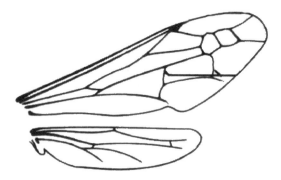

FIGURE 1 *A rotoscope of wings like those on a wasp.*

6. Click the Add Lock button, and trace around the outside edge of the wings. Refer to Figure 2 to see the placement of the control points. The figure seems to have extra resolution. This is to allow for closing of the model with all four-point patches.
7. Click the Add Lock button, and create a four-point spline that is not connected to any part of the wing.
8. Attach one of the two center points of the four-point spline to the first control point on the top of the wing model, and the other center point to the bottom, as shown in Figure 3.
9. Continue adding points in this manner until both the top and bottom wings are closed with legal patches.
10. When you're finished, the model should look similar to the one shown in Figure 4.

FIGURE 2 *The traced outline of the wing shape.*

FIGURE 3 *Adding splines to begin closing the face of the wing.*

FIGURE 4 *The wing model after closing the faces.*

That's all there is to it!

Building wings for flying insects is fairly straightforward, but for some practice, continue on to the next section on modeling butterfly wings.

MODELING BUTTERFLY WINGS

1. Click the New button, then select Model, and click OK.
2. Right-click the "Model2" item in the Project Workspace and select New, Rotoscope, click Browse, and locate the "wingrotob.JPG" image shown in Figure 5.
3. Click the "Rotoscope1" item in the Project Workspace, and on the General tab of the Properties Panel, uncheck the "Pickable" checkbox so that you don't inadvertently drag the rotoscope image out of position.
4. Click the Save icon to save your project.
5. As in the section on wasp wings, click the Add Lock button, and trace around the outside edge of the wings. Refer to Figure 6 to see the placement of the control points. Once again, the figure is shown with the extra control points that are necessary to close the surfaces of the model with four-point patches.
6. Use the same technique as described in the previous section to close the surfaces of these wings. When you're finished, the model will look similar to Figure 7.

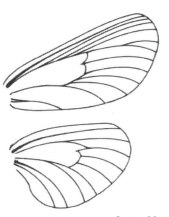

FIGURE 5 *A rotoscope of wings like those on a butterfly.*

FIGURE 6 *The traced outline of the wing shape.*

One of the main reasons why the wings for insects are so easy to build (at least in these cases) is because they don't really have any thickness. They are more or less "paper thin," making them well-suited to the way that Animation:Master handles patches.

The actual geometry of the model doesn't need to be anything that is overly spectacular looking; it just has to get the job done without causing any creases or other undesirable effects once the model is textured.

Until next time . . .

FIGURE 7 *The final wing model for a butterfly type wing.*

Creating a Poser/ Bryce Scene

R. Shamms Mortier

Greetings from the Green Mountains. This is the first in a series of online tutorials that will target either or both MetaCreations' Poser 4 and/or Bryce 4 applications. To make use of these tutorials, you will have to have worked through the documentation in whichever application is being discussed, and you should have at least a few weeks (if not months) of exploration time under your belt. That way, when a tool or process is mentioned, you won't have to spend time looking in the documentation index to discover what is meant—you'll just get right to the creative process. You should also have the Zygote Character Library, which you can purchase from Zygote.

In this first tutorial, we are going to use both Poser 4 and Bryce 4, so if you want to follow along, you'll obviously need both applications installed on your system. Poser and Bryce work on both Windows and the Mac with the same basic interface. This means you shouldn't care if we present a screen shot that depicts one platform or the other, since the tools and techniques are cross-platform. In this tutorial, we will use a selection of Poser figures as both prop and figure elements for a Bryce scene. Here we go . . .

IN POSER 4

1. Open Poser 4, and load the Poser 4 Nude Male. Go to the Classic Poses/Pose Library,

and double-click on the Atlas Pose. This pose is good for showing a figure holding up a large sphere, although we will modify it. See Figure 1.

FIGURE 1 *The Atlas Pose is applied to the Nude Male in Poser 4.*

2. In the Front Camera, realign the arms so they are both the same, resembling those shown in Figure 2.
3. The geometry is then saved out as a WaveFront OBJ file for export later to Bryce. We will use this figure as the support for a table. After doing this, delete the Nude Male, and load a Left Hand from the Additional Figures Library. We are going to use this model for a chair, so using the Parameter Dials, pose it as displayed in Figure 3. When finished, save it out as a Wave-

FIGURE 2 *The arms are realigned as shown.*

FIGURE 4 *The Flee pose is used on the Zygote Faerie.*

Front OBJ model, and delete it from the Document window.

4. Load the Zygote Faerie from the Zygote Characters Library (purchased separately). We are going to pose this figure for a lamp ornament. Go to the Comic Sets Poses, and use the Flee pose. Your Faerie should now resemble the pose shown in Figure 4. Save the posed Faerie to disk as a WaveFront OBJ file.

5. Now for an interesting doorway frame. Place a Female Head from the Additional Figures Library in your Poser 4 Document window. Elongate it on the Y axis to 140%, and Taper it so that it looks like Figure 5. Save it out to disk as

a WaveFront OBJ File, but not the eyes. Remove them from the Hierarchy list before the file is saved (if you don't know how to do this, read the docs).

6. OK. One more Poser element to go before we start to put things together in Bryce. You will have to have the Zygote Dragon in your New Figures Library to do this. Load the Dragon, and open its wings as displayed in Figure 6. They don't respond to Symmetry commands, so each will have to be rotated separately. Resize the head to 200%. Now save it out as an OBJ file, but not the following parts: back legs and tail. We won't need these.

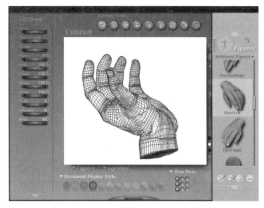

FIGURE 3 *The Left Hand is posed to emulate a chair for a Bryce scene.*

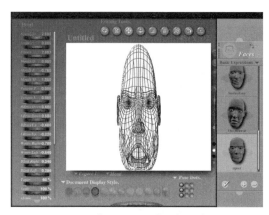

FIGURE 5 *A Head is customized and saved out as an OBJ file.*

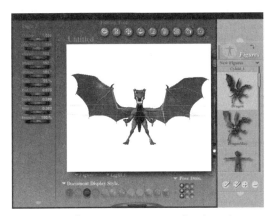

FIGURE 6 *The Zygote Dragon is posed and saved out as an OBJ file.*

THE TABLE

7. Open Bryce 4. Import the Naked Man object with the Atlas Pose you saved. Duplicate it twice so there are three. From the Top View, space them out so they barely touch, and so that each faces outward. Attach a flattened cylinder base to one, and duplicate it twice for the other two. Create another flattened cylinder for the table top. Use a Rustic Vein Material from the Wild & Fun Materials Library for the three cylindrical bases and the top with a 40% Reflection, and a Polished Bronze Material from the Metals Library for the figures themselves. Group everything together, and save the table to your Bryce Objects Library. See Figure 7.

FIGURE 7 *The finished table uses the Atlas Pose as a stand.*

THE CHAIR

8. Import the posed Hand OBJ file you saved out. Use a Cube as its base, with the Y axis shortened. Import the Dragon, and place it on the center of the fingers facing the front. Group everything, and use the Easter Egg Dye #2 Material from the Wild & Fun Library on it. Save it to your Objects Library as "ChairX." See Figure 8.

FIGURE 8 *The finished chair uses the Hand and the Dragon as elements in its composite construction.*

THE LAMP

9. To add more mysterious atmosphere to our scene, we'll create a special lamp using the Faerie figure as a component. Import the Faerie and duplicate it in Bryce, then mirror it on the X axis (as seen in the Front View). Refer to Figure 9 for the completed lamp. Notice that an elongated cylinder is placed between the Faerie components, and that a flattened cylinder is used as the base. At the very top of the central cylindrical column, place Organic Boolean #3 from the Boolean Objects Library. This is a bowl-shaped object. Everything is centered in the Top View, Grouped, and Textured with a Warm Gold Material from the Simple & Fast Materials Library. Save the completed lamp to disk.

FIGURE 9　*The posed Faerie components of the lamp are grouped to form one object.*

THE DOORWAY

10. One more thing to do before we put the scene together, the doorway. For the doorway, import and duplicate the elongated Head for the sides, and place a Dragon object on the top spanning the width. Add rectangular blocks in the back to square it up, and another for the door. Texture the Heads with the Pitted Concrete Material from the Rocks & Stones Materials Library. Use a Corroded Granite on the Back Walls, and a Plank Wood on the door. Place bright red spheres in the eye sockets. Use a Blue Metal Material on the Dragon. Group everything and save to disk. That's it. See Figure 10.

FIGURE 10　*The doorway is composed of two elongated Heads and a Dragon at the top.*

THE FINAL SCENE

This is where your creative instincts come in. You can look at Figure 11 to see how I put all of these elements together in Bryce, but this is only one example of how a scene can be constructed using these same components. For instance, you could use the Faerie lamp as a large floor lamp or as a table lamp, and populate the chairs with Poser figures or leave the scene as a still life. You could also use any number of Materials on the floor, to make the scene look like a dungeon or a palace. I always like to do an initial loose arrangement of the scene to get an idea of what I am working with before I configure the final scene. See Figure 11.

FIGURE 11　*This rendering represents my first attempt at placing all of the elements together, just to get a feel for what the narrative of the image might be. I cut a circular hole in the back wall with a Boolean Cylinder just for effect.*

After looking at your first experimental render, you can finalize element placement in the scene. Figure 12 was my solution. Note that I changed the Chair materials to a greenish gold, and made the Table a solid Warm Gold. The Floor is a solid 50% reflective black. The Fire in the lamp is the Fire Material from the Complex Materials Library mapped to an elongated sphere. I used Dali Marble on the Rear Wall.

FIGURE 12 *This was my solution for the final placement of the elements in the scene.*

You can either leave the scene as a still life, allowing the viewer to place imaginary figures in it, or you can populate it yourself with other Poser figures. I decided upon the latter. The Zygote Abominable Snowman was used for the poor bowing being spread on the floor, while the Zygote Gremlin was used for the guard. The King is the Zygote Warped Human from the Extra Figures Library. His hat is a cone mapped with the Christmas Ball #1 Material from the Metals Library. You can add any figures you like to tell a story. See Figure 13.

FIGURE 13 *The final scene tells a story in a glimpse.*

8

Using the "Conform To" Option in Poser

—R. SHAMMS MORTIER

Once again into the breech, or more accurately, the britches. In this tutorial, we'll examine Zygote's Costume Shop CD for Poser 4, what it is and how to use it. If you are a Poser 4 user, you are at least somewhat familiar with the concept of animatable clothes. If you are thinking about purchasing or upgrading to Poser 4, then a basic description of this new feature is in order. Zygote's Costume Shop has to be purchased separately from Poser 4. Check the details at http://www. zygote.com.

FIRST THINGS FIRST

The first thing to do after receiving your copy of Costume Shop is to install it into the proper folders in Poser 4. Remember that this is a Poser 4 utility, and is not meant for earlier Poser versions. When you open the Zygote Costume Shop CD, you will see that the installation can be automatic or manual. I had no luck with the automatic installation, since the system reported that I had already installed the items (I hadn't). I would suggest you opt for the manual installation. There are just six items to drag and drop, and a clear and detailed set of instructions is provided so you can do it easily. It's right here . . .

WHERE IS IT?

If you have followed the manual installation instructions carefully, everything should be in place when you open Poser 4. In the Poser 4 Figures Library, go to a new folder called "Zygote Costumes." This is where all of your new poseable costumes will be located. (See Figure 1.)

The new Costumes include Socks, Shoes, Boots, Armbands, Capes, Skirts, Dresses, Halters, Robes,

FIGURE 1 *Opening the new Zygote Costumes folder allows you to view all of the contents, represented by thumbnail previews.*

Hats, Hair, Pants, Jackets, and Tunics. Poser Costumes are very different from Props. A Dress Prop, for example, is a one-piece object that does not respond when the underlying body parts move. A Costume Dress has poseable parts, just like the body it fits over, so it can bend and in many cases show natural folds. A Costume comes in as a Figure, just as if it were a Figure of a person, character, or animal. With the new Figure of the Costume selected, you attach it to a Poser Body Figure by selecting Conform To from the Figure menu. Then simply select the underlying Figure that the Costume is to be placed over and connected to. (See Figure 2.)

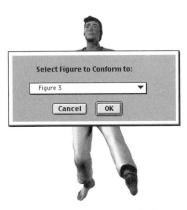

FIGURE 2 *Costumes are attached to suitable Figures by using the "Conform To" command in the Figure menu.*

THE COSTUMED BODY RULES

In general, follow these rules when applying a Costume to a Poser Figure:

- Select Nude Human Models most of the time. If you do this, you can always apply Transparency Maps to the overlying Costume, and the underlying body of the model will show through. Rips, tears, and more risqué show-throughs can be effective in defining a character when used in this manner.
- If you have to apply a Costume to a clothed Figure because no Nude Example of that Figure is

available, then consider making the underlying body parts invisible. This gets rid of any strange show-throughs; for example, a suit and tie under a Tunic. Of course, if you need to see these anomalies for effect, then the option is yours.
- Know that you can pose and animate Costumes on their own without attaching them to any underlying Figure. This gives you the possibility of creating what seems like an invisible person, or an animated stand-alone Costume. (See Figure 3.)

FIGURE 3 *Costumes have their own Parameter Dials, so they can be posed and animated by themselves.*

- Add selective Wave and Magnet Deformers to Costume parts to emulate fabric in motion. There are no exact rules to follow when doing this, so explore the possibilities until these effects can be applied intuitively. If you plan to use Deforms on the Costume parts, be sure to make the underlying Figure elements invisible (if there are any). (See Figure 4.)
- If you select an underlying Figure and apply a Pose, the Costume will not automatically adjust to the new pose. You will have to select the Costume, and do another "Conform To" again to move the Costume into place. Manually adjusting the underlying Figure, or doing it with the Parameter Dials, will automatically alter the position of the Conforming Costume. Using applied Poses to craft an animation that shows a Costume

FIGURE 4　*If the Costume is either attached to an underlying Figure or used as a stand-alone model, Wave and Magnet Deforms can be applied to Costume parts to generate animated effects.*

FIGURE 5　*With a Nude Male as the underlying Figure, the Hooded Cloak doesn't leave much to speculation. Use either clothed models with this Costume, or clothe them with other Costume elements first.*

Figure in motion, when the underlying Figure elements have not been made invisible, can cause unwanted "poke-throughs" at different parts of the animation. If you intend to use applied poses with a Costumed Figure animation, either make the underlying elements invisible or simply animate the Figure manually or with the Parameter Dials. Each case may require different adjustments.

- Note that the new Zygote "Hooded Cloak" Costume is open in front, so it reveals whatever Figure elements are exposed. Take care not to use it on a Nude Figure, unless that is the effect you are looking for. (See Figures 5 and 6.)

- By now, you may realize that the Zygote Chimp can be used as a proxy for a human Figure, making it a perfect target for some (not all) of the new Zygote Costumes. Try Conforming the Halter, Slip, and Fez to the Chimp, and you'll wind up with a Figure that resembles the one depicted in Figure 7.

FIGURE 6　*Using a Skeleton as the Figure being costumed by the Zygote Hooded Cloak is more effective.*

TIME TO GET WHACKY

Now think a minute. If Poseable clothes enter a Document as a Figure, and Figures can be Conformed to other Figures, then what's to prevent you

FIGURE 7　*Here's the Zygote Chimp, wearing the Halter, Fez, and Slip from the new Zygote Costume Shop collection.*

from Conforming any Figure to another? Answer: Absolutely nothing. Well, that's almost true. Figures of different types, like human and animal, twist in strange and unwanted ways when conformed outside of their type, so it's best to attach them by Parenting various elements. Here's one example that will work. It requires that you have the Zygote Baby Sumo and the Zygote Bunny in your collection. Do the following:

1. Import the Baby Sumo, and don't move any of the body parts except to switch Inverse Kinematics Off for both legs.

2. Import the Zygote Bunny. With the Bunny selected (it will be listed as Figure 2), go to the Conform command in the Figures menu. Conform Figure 2 to Figure 1.

3. Open the Hierarchy Editor. On Figure 1 (the Baby Sumo), make the Head and Eyes invisible by clicking on the Eye Icon next to those selections. Using the same process, make everything on Figure 2 (the Bunny) invisible except for the Head, Ear Parts, and the Eyes.

4. Do some test renders, and adjust any parts as necessary. Pose the new conglomerate Figure as

you like, and export it as a WaveFront model. When the Hierarchy window pops up, make the same components invisible for export that you did previously.

5. Import the new Figure into Bryce, compose a scene, and render it. All manner of new beasties, including ones with poseable clothes, can be created in the same manner. (See Figure 8.)

FIGURE 8 *Three Sumbies (combination Sumo Babies and Bunnies) cavort in the twilight on a Bryce rock in the middle of the sea.*

9 ArtBeats/Canoma Urban Environments for Bryce

—Shamms Mortier

In this tutorial, you will discover how to use a great library of textures from ArtBeats: City Surfaces. We'll explore how these bitmaps can be manipulated in MetaCreations' Canoma for eventual Bryce rendering. You will need the following Mac or Windows software to emulate the tutorial: Adobe Photoshop (or a compatible bitmap editing application), MetaCreations' Canoma and Bryce, and ArtBeats' City Surfaces CD volume.

CITY SURFACES

ArtBeats' City Surfaces CD is packed with valuable content that no serious 3D artist should be without. These bitmaps are designed specifically to allow you to create urban environments that look real enough to walk around in. The bitmap images vary in size from 256 × 256 pixels, 512 × 512, and 1,024 × 1,024. This CD contains five content folders:

- Materials. Over 44 separate materials are represented, from concrete and cast aggregate to marble and granite. In addition, separate folders hold Bump and Reflection maps.
- Accessories. This folder is loaded with a wide selection of signs and other needed bitmaps for urban accessory content. In addition, separate folders are included for Bump, Glow, Reflection, and Selection maps.
- High Rise. Skyscraper bitmaps thematically related to a wide selection of cities are included here. In addition, separate folders are added for Bump and Reflection maps.
- Ground Floor. A large number of bitmaps for single-story dwellings and storefronts are included in this folder. Separate Bump, Glow, and Reflection map folders are also addressed.
- Streets/Sidewalks. Bitmaps for parking lots, streets, and sidewalks exist in this folder, with separate Bump and Reflection map folders.

IN BRYCE . . .

1. Open Bryce, and place a Cube Primitive on the screen. Rotate it as displayed in Figure 1. Check High-Antialiasing rendering. Use the Simple & Fast/Flat White material on it. Render and save as BldgTmpl.TIF. Close Bryce.

IN PHOTOSHOP . . .

We'll use Photoshop to create a very simple Canoma template. Do the following:

FIGURE 1 *The Cube Primitive should resemble these rotations.*

1. Import the Bryce BldgTmpl.TIF image you just created. Resize the image so that it is 300 pixels per inch. This image of the rotated cube is going to serve as the basic template for a series of 3D buildings.
2. Create your first building by first creating a new layer. This layer will hold the City Surfaces bitmaps to be placed on the cube for a number of buildings.
3. Use the Edit/Transform/Distort operation to place your selection of any three textures from the City Surfaces CD onto the top layer, matching each face of the cube. (See Figure 2.)
4. Layer/Flatten Image. After this has been done, save the image as Bldg_01. Do this as many times with as many different textures as you

like, saving the resulting image as Bldg_02, Bldg_03, etc. You are creating image maps that Canoma can read as 3D objects. (See Figure 3.)

FIGURE 3 *The images you will end up with may resemble some of these.*

IN CANOMA . . .

5. Close Photoshop and open Canoma. Canoma is a miraculous application when it comes to creating ready-mapped basic objects. Import one of the building images you just created in Photoshop into Canoma. (See Figure 4.)
6. Click on Create and then on the Cube Primitive at the bottom of the Canoma screen. A cubic wireframe will appear in the workspace. Resize its three visible faces to fit over the three visible faces in the image. Go to the Textures menu and Apply Quality Textures. You should now have a quality mapped cubic object that

FIGURE 2 *The textures are shaped to the underlying cube.*

FIGURE 4 *The building image is imported into Canoma.*

should rotate as expected when you use the Bryce-like controls on the left of the Canoma interface. If you left Mirror Textures on in the Textures menu, the three invisible sides of the cube are now mapped with "stolen" textures from the opposite sides. (See Figure 5.)

FIGURE 5 *Now you have an actual 3D object mapped with the City Surfaces image maps!*

7. File/Export as a WaveFront (OBJ) to disk for later import to Bryce. Repeat for all of the building images you created in Photoshop.

Important Note! *Because all of your images used the same template in Photoshop, creating the additional objects couldn't be easier. Click on the Edit button under Camera Controls to return to the original image display. Then load another of the building images. The cubic wireframe should be in perfect position, so just delete the previous image and do a Quality Render and save the Wave-Front OBJ to disk. Repeat for the other image maps. If for some reason this refuses to work (not enough memory or another glitch), simply select New each time and repeat configuring the wireframe before rendering Quality Textures and saving the OBJ.*

. . . AND BACK TO BRYCE

When you import the finished Canoma buildings back into Bryce, they appear with their image maps

intact, so no material mapping is needed. It's always a good idea to intermix your Canoma output with Bryce elements, perhaps a Bryce roof or dome when possible. Of course, if you were working on a photographic representation of a real cityscape from a collection of photos, you'd want to create all of the separate elements in Canoma, and just use Bryce to put things in place. This project, however, references a fantasy city, so we are free to experiment.

You may find that it's far too energy intensive to design and place dozens of Canoma buildings in Bryce, so you may need to search out other alternatives to give the impression of a busy urban environment. Bryce offers you excellent alternatives that render quickly and are easy to configure. In the background, just use a Terrain Object with one of the Citymap terrain maps in place. Use one of the preset Building materials (from the Wild & Fun materials Library) to map the terrain. Voilà! Instant background city. Now place your Canoma building in the foreground, and you'll have a pretty convincing urban composite. Adding ground fog and haze always helps to cement the elements together in long shots, while you can zoom in very close on the Canoma building for more dramatic footage. (See Figures 6 through 10).

FIGURE 6 *A wide shot of the composited environment, with terrain-mapped buildings in the background and Canoma structures up front.*

FIGURE 7

FIGURE 8

FIGURE 9

FIGURE 10

FIGURES 7 THROUGH 10 *A selection of more dramatic close-ups showing the Canoma buildings in place in a Bryce scene.*

10 Bryce to Poser Figure Parts

—SHAMMS MORTIER

One of the deficiencies of Bryce 4 is that you can't export its models, except when they are Terrain-based. At first glance, this seems like a great drawback for anything but mountains and the other standard Terrain models in Bryce, but when you realize that the Terrain Editor in Bryce is amazingly deep, it turns out to be a rather interesting way to develop models of all sorts. Bryce 4's Terrain Editor is almost full featured enough to be a separate piece of software. All of the models that the Terrain Editor allows you to develop reference grayscale height maps, so the secret of mastering Terrain Editor models and model parts is to learn how to create the grayscale height maps in the first place.

For this tutorial, we'll look at developing some interesting grayscale height maps in Macromedia FreeHand (you can also use Adobe Illustrator) and Photoshop (you can use any 2D bitmap application just as well). For the second step, you'll need Bryce 4, and you'll need Poser if you want to import the finished models and model parts.

VECTOR GRAYSCALE MAPS FOR BRYCE TERRAINS

If you would rather use Illustrator or another vector drawing application to develop these Terrain Maps, then select the tools in that application that compare to the FreeHand tools mentioned here. We will cre-

ate a Terrain Map in FreeHand. Use FreeHand 7 or higher (these examples use FreeHand 8). You should be familiar with Freehand or the optional vector application you are using before attempting these tutorials.

1. Open FreeHand, and select New from the File menu.
2. Create an oval of any size you like, and fill it with a grayscale radial gradient that is white at the center and a 75% gray at the edges.
3. Duplicate the oval, and rotate the duplicate 90 degrees. Join the two ovals. Remove any border from the shape. You should now have an image that resembles Figure 1.

FIGURE 1 *The first step on the way to a vector image map.*

4. Export the image as a 32-bit PICT (Mac) or BMP (Windows) with an Alpha Channel. If you are using FreeHand, increase the Anti-aliasing to 4 before the image is saved to disk.

5. After saving the image as described, quit Free-Hand and open Photoshop. Import the saved image. Open the Image/Canvas Size window and give the image more room on all sides. See Figure 2.

FIGURE 3 *Expand the background by 1 pixel.*

FIGURE 2 *Give the image more room on all sides by enlarging the Canvas from the center.*

FIGURE 4 *The image map with a black background.*

6. The background has to be changed to solid black, because Bryce reads the black on an image map in the Terrain Editor as a drop-out color. Use the Magic Wand tool in Photoshop to select the white background color. With the background selected, go to the Select/Modify/Expand menu and expand the selected outline by 1 pixel. This gets rid of any unwanted outline. Click OK. (See Figure 3.)

7. With the enlarged background selected, fill it with a solid black. Use a Blur filter four times on the image to reduce the jagged border. Now you have an image resembling Figure 4. Save to disk.

8. Quit Photoshop and open Bryce 4. In the Create tools, click the Symmetrical Lattice icon. A default Symmetrical Lattice will appear on the screen. I always use the Symmetrical Lattice rather than a standard Terrain model because it is easier to drop out the background. (See Figure 5.)

FIGURE 5 *A Symmetrical Lattice appears in Bryce.*

9. With the default Symmetrical Lattice selected, click the Terrain Editor icon in the Edit Tools list. The Terrain Editor appears. Click the Pictures tab at the top, and Load the image you saved in the first slot. Copy it and paste it in the second slot. Click Apply, and the image map is translated into a 3D model. (See Figure 6.)

FIGURE 6 *The image map is transformed into a 3D model.*

10. Use the Gaussian Edges tool under the Elevation tab in the Terrain Editor to smooth the edges of the new model. (See Figure 7.)

11. Click the check mark to write the new 3D model to the Bryce Document Window. Apply any Material you like to the model (I used a simple Light Blue Metal). Note that most Terrain models show defects on the edges. That's because these models were originally intended to be natural terrains. For me, this is great, because it adds a bit of wear and tear appearance to the model. (See Figure 8.)

12. At this point, save the project as a Bryce 4 file. You can use this and any other vector-based

FIGURE 7 *Gaussian Edges are applied.*

FIGURE 8 *The new model in Bryce.*

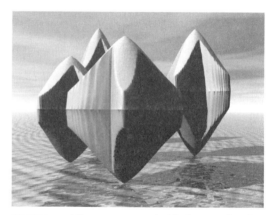

FIGURE 9 *A Bryce scene created with the vector-based Terrain Map model.*

model to create interesting Bryce scenes. (See Figure 9.)

13. We're not done yet. We want to get this model into Poser. Any model created in the Bryce Terrain Editor can be exported in a wide array of formats. With the model selected, select Export Object from the File menu. When the save window appears, select the WaveFront MetaStream item from the types list, and name the object. After you do this, the Export Terrain window will appear. (See Figure 10.)

14. Save the object as an OBJ file, quit Bryce, and open Poser. Go to the File/Import/WaveFront OBJ selection, and import the model into

FIGURE 10 *The Export Terrain window.*

Poser. When the Prop Import Options window appears, select to load it in at 25% of its original size. Notice how fast it loads in.

15. After it loads, copy it to the Poser Props Library. That way, you can easily add duplicates of the object to the scene.

16. Load in duplicates of the object to construct a figure that resembles that shown in Figure 11. It is created from eight of the resized imported models, with two small Balls from the default Poser Library for eyes.

17. Name the parts as follows: Body for the large model element, L&R Shoulder, Upper_Arm and Lower_Arm for the Arms, and Head for the head element. Name the spheres L_Eye and

R_Eye. Open the Hierarchy Window and Link everything as follows: Head, R_Shoulder and L_Shoulder to Body, Head to Body, and L_Eye and R_Eye to Head. (See Figure 12.)

FIGURE 12 *This is how the hierarchy list should look.*

18. To animate and render, you may select Poser, Bryce, or any other suitable 3D application. If you plan to animate and render °outside of Poser, save out the hierarchy as an OBJ file. That's what I did in order to import into Bryce for the final animation and rendering. (See Figure 13.)

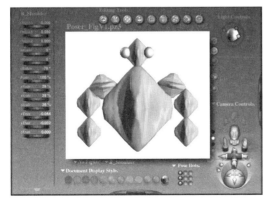

FIGURE 11 *Duplicate objects are used to construct a figure.*

FIGURE 13 *The Poser model exported as an OBJ and reimported into Bryce for final rendering.*

Obviously, this model is very basic. What is important is that you understand the process. From there, you can create more complex figure elements in the Bryce Terrain Editor for use and hierarchical gluing in Poser. The ray emanating from the arm of the figure on the left in Figure 13 was created in Photoshop with a combination of the internal Lens Flare filter and Knoll Lens Flare Pro. In a future piece, we'll look at other ways to shape content for the Terrain Editor. See you next time . . .

11

Media Transformation Image Making Using Bryce 3D, Photoshop, and Andromeda's Cutline Filter

—SHAMMS MORTIER

Have you ever drooled over images that move from one media look to another right before your eyes? One example would be the "Wave" painting popular a few years back that showed a painting of a giant wave, starting as an oil painting on the left and transiting to a collection of pixels on the right. There were thousands of prints of that image distributed around the world. Here's one way to create a similar effect, although it concerns different media looks. In this tutorial, we'll go from a Bryce 3D rendered image to a pseudo woodcut look, all in one image. This tutorial references Bryce, Photoshop, and the startling new Cutline Photoshop filter from Andromeda Effects (http://www.andromeda.com).

THE SOURCE IMAGE

You can use any 3D rendered graphic for this first step. You can even use a scanned photograph. I prefer Bryce because of its high-quality rendering output, and because I take every opportunity to use it as an image-maker. Whatever source image you use or create, it should have the following.

- Well-defined image content.
- Foreground that contrasts with the background.

I have also found that using an image with a lot of light or even white areas helps.

A SOURCE IMAGE IN BRYCE

When I set out to create my Source image for this project in Bryce, it was with the points previously mentioned in mind. I wanted a majestic mountain set against a majestic sky. The first thing that I created was the sky. I selected the Candy Shop preset in the Sky & Fog menu. (See Figure 1.)

When I did a test render, the sky took up only half of the image area, with the other half occupied by the ground plane. This was unsatisfactory for my needs. This is the standard way Bryce operates, so you have to perform some tricks to get it to render a full frame image of the sky. One trick is to mask the ground plane with the foreground image, but that is not what I wanted in this case, so I chose another option. First, however, I needed to place my mountain in the scene. I clicked on the Mountain icon, and jumped to the Terrain Editor. Once there, I loaded the Erosion3 image from the Terrain Maps library. This mountain has some nice eroded features, which stand out when placed against the blanket of the sky. (See Figure 2.)

Most times, the Terrain Map you select will have to be tweaked to get the exact structure you want, but I lucked out this time-no tweaking was necessary. Mountains also come with their own textures, selected by the computer. Here again, you may want to explore and alter the texture preset. The preset texture that appeared was not what I wanted;

FIGURE 2 *In the Terrain Editor, the Erosion 3 map was selected as the mountain form.*

it was more like a mountain in the Amazon–too green. I wanted a wintry snowy peak. So with the mountain object selected, I opened the Materials Lab, and selected the Mid-Winter material as a start. (See Figure 3.)

Once that was loaded, I applied it and did a test render. Nope. Not enough snow. I opened the Materials Lab again, and opened the Deep Texture Editor for the preset. Once there, I activated the Filter window. I changed the Snow Puddles option to Xb+a (Altitude-Slope). The only way to understand what you might get beforehand here is to explore over time. It turned out that this was exactly the

FIGURE 1 *The Sky & Fog menu, showing the Candy Shop sky (row 4, column 6).*

FIGURE 3 *The Mid-Winter preset texture was selected.*

right choice. I used ADD to combine Components 1 and 2 instead of the MAXIMUM option it was set at. (See Figure 4.)

Once back in the Materials Lab, I changed the size of the texture to 8% in the Edit Texture window. This was after a number of test renders of the mountain. (See Figure 5.)

OK. The texture on the mountain finally looked right. Now for solving the sky problem mentioned earlier. This is a general trick you can use when you want larger clouds, and when you want only a sky and no ground plane in the image. Select both the Camera and the Terrain object (mountain in this case) and group them. Using the Right View, rotate them so both are at about a 30-degree angle. If you

look in the nano-Preview window, you will see that only the sky fills the background, and that the clouds are larger. The clouds are larger because the Camera is looking up at them, so they don't get crunched by the standard horizon view. (See Figure 6.)

One last item. The sky I selected was backlit, showing the mountain as a dark silhouette with no texture features. That means it could as well have been a cardboard cutout as a 3D object. To delineate the 3D features and texture, I added a spherical light source at the front left of the image. The light has an intensity value of 50. (See Figure 7.)

With all parameters set, the image was then rendered with Antialiasing (Fine Art) selected. This created the Source image displayed in Figure 8.

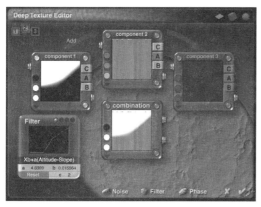

FIGURE 4 *The Deep Texture Editor allows you to fine-tune an object's texture.*

FIGURE 5 *The size of the texture was changed to 8%.*

FIGURE 6 *Both Camera and Terrain are grouped and rotated in the Right View.*

FIGURE 7 *Placement of the light from the Top View.*

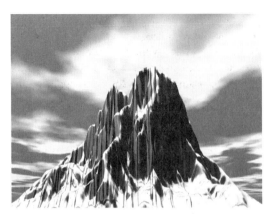

FIGURE 8 *The final Bryce rendering of the Source image.*

THE ALTERED IMAGE

The Source image was then sent to Photoshop for image processing to create the altered image. The first thing I did with this image was to increase the Brightness (Image/Adjust/Brightness-Contrast) to 30. This lightens the areas I will apply the filter to. Next, I performed a Photoshop trick. I used the Image/Mode/Grayscale command to change the image into Grayscale, and then selected Image/Mode/RGB to change it back to an RGB image. Why? Because I wanted a grayscale image, but the filter I was going to use doesn't work on grayscale formats. The grayscale image is displayed in Figure 9.

THE ANDROMEDA CUTLINES FILTER

I have always loved the nineteenth-century book illustrations that used cutlines to define the image. Cutlines are also evident in the illustrations of William Blake. Cutlines are a series of curved lines that are used to define the 3D shading of image content. Andromeda Effects (www.andromeda.com) has just released a filter that has already become one of my favorite image-processing effects in Photoshop: Cutlines. Cutlines is part of Andromeda's Mezzotint collection, and allows you to create lovely cutlined illustrations from any source image. (See Figure 10.)

The Cutlines parameters I used were:

Shadows = 67-100%
LPI = 15
Wavy Cutlines

I then clicked OK to apply the Cutline settings. The result can be seen in Figure 11.

Next, I selected the Lasso tool, and outlined an area that took in the left diagonal part of the image. I selected Feather from the Select menu, and input a value of 15. Then I selected Edit/Clear. The result can be seen in Figure 12. The left diagonal part of the image is removed, but with a feathered edge.

The Source image was treated exactly the opposite. (See Figure 13.)

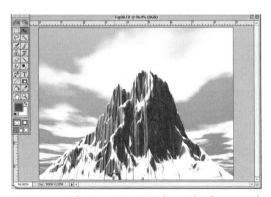

FIGURE 9 *The image is in RGB, but with color removed.*

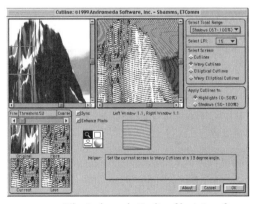

FIGURE 10 *The Andromeda Cutline filter's interface.*

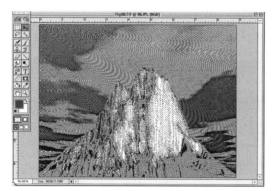

FIGURE 11 *The Sky & Fog menu, showing the Candy Shop sky (row 4, column 6).*

The altered Cutlined image was then dragged onto the Source image, creating a layer over the Source. The Magic Wand tool (with a setting of 2) was then clicked on the left white area of the Cutline image. A feathering of 200 was applied, and Edit/Clear chosen (with the background color set to pure white). This erased the left area of the Cutlined image, displaying the Source below. Where the two images met, the edge was feathered, making a smooth transition from Color Source to the Cutline graphic. The two images were then composited (Layers/Flatten Image) to form one image as displayed in Figure 14.

FIGURE 12 *The left diagonal part of the image is removed, leaving a feathered edge as a transition.*

FIGURE 14 *The final image displays a transition from color to Cutline grayscale, a Media Transformation*

FIGURE 13 *The Source image is altered.*

CHAPTER

12

Using BSmooth for Bryce

—SHAMMS MORTIER

This tutorial will introduce you to BSmooth, unless you already know it. Bryce without BSmooth is like candy without sugar; there's definitely something missing. Experienced Bryce users know that the heart and soul of Bryce is the Terrain Editor, the place where you craft and customize terrains. Terrains are usually used as what they are: landforms that are placed in a Bryce world environment. But terrains can also be used as other elements in a 3D scene, like mechanical parts for a wide array of object constructs.

BSMOOTH

Let' take a look at BSmooth first. When I first encountered it, BSmooth was a shareware product on the Kagi site (www.kagi.com). Recently, however, it has moved to its own site at www.BSmooth.de. It's no longer shareware, but can be purchased for around $25.00 US. Without paying anything, you can download it as a demo version, meaning that its effectiveness is severely limited. BSmooth is a Mac utility, but a Windows version is under construction, and may be available by the time you read this. Klauss Busse, the developer, is constantly upgrading the utility, so it's best to stay tuned to the site every two weeks or so to see what's new. Once you purchase the software key (which is placed in the same folder as the application), it will be good for all future versions of the software. Mr. Busse also main-

tains a great Bryce hints and tips page, which lists secrets about Bryce you'll probably never run into anywhere else. BSmooth is always called "beta" software, but don't be dismayed by this. It is probable that this is just to alert you to the fact that it's constantly being worked on, and that new stuff is being added all the time. The version I am working with currently is 3.3b5.

IMPORTANT PREFERENCES!

When you first activate the software, and anytime thereafter that you want to alter input and output settings, the Preferences window pops up. See Figure 1.

What's so important about the BSmooth Preferences options? In terms of Bryce handshaking, you can set to create either a Terrain or a Lattice model, and set the resolution as well. But it's in the output

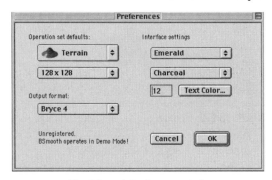

FIGURE 1 *The BSmooth Preferences window.*

options that BSmooth surpasses the expected. As far as Bryce output options, you can output Bryce 2, Bryce 3D, or Bryce 4 (new) project files. These load quickly into the appropriate Bryce application. But get this... you can also output to DXF or to a 16-bit Photoshop image! What does this mean? It means that any model created in BSmooth can be imported as a DXF into any 3D application (LightWave, 3D Studio Max, Carrara, Pixels 3D, Maya . . . whatever), though DXF files can be pretty big. Allowing for export to a Photoshop image file allows you to customize the map further. This creates a topographic terrain map that any 3D application that allows for the transformation of bitmap data into height data can use (and every 3D application that is worth a dollar allows for this possibility). So, although BSmooth is advertised as a Bryce associated utility, it is unmasked as a 3D modeling application for every known 3D art and animation program! That's pretty awesome for a tiny product that few people even know about.

HOW BSMOOTH WORKS

BSmooth creates models or terrain maps by allowing you to combine various elements ("Operators") in a hierarchical pipeline. When you initiate the final step, all of the Operators are combined, in order, to shape the final model. A preview screen is available in each Operator, and another global Preview is included that shows you the topographical map for the entire string of Operators. You can move any Operator to a different position in the stack, which alters the final model or terrain map created. Each Operator has its own parameter settings. The Operators include:

- **Extrude.** This operator creates cylindrical maps, as seen in the top view. You control the quantity in power of 2 multiples, from 1 to 128 and the rotation on the vertical axis. Data can also be taken from an Adobe Illustrator file that has a curve and a reference frame.
- **Vertical Lathe.** You control the quantity on both the X and Y axes, as seen from the top. Data can

also be taken from an Adobe Illustrator file that has a curve and a reference frame.

- **Horizontal Lathe.** You control the quantity of operations and also are able to adjust the ways that the lathing is applied.
- **Daisy.** This is a stupendous 3D modeler in itself, though I would have named it Sunflower. Using this Operator, you can create forms that emulate the double-helix pattern of the sunflower, with integrated 3D components. A large number of parameter controls increase the possible variations, and Illustrator shapes can be used as the source curve.
- **Condensation.** This Operator creates droplet-like shapes, in which you have a number of size and other parameter choices.
- **Mandelbrot.** The standard Mandelbrot fractal shape is the target of this Operator. You have control over all of the parameters, including Fractal Type, Iterations, Escape radius, and Method.
- **Wave**. This Operator is brand new to the 3.3 version, and is also the topic we'll focus on later in this article. Wave propagation creates awesome terrains in Bryce, as you'll see. You can control all of the necessary parameters. In addition, you can use any PICT or TARGA image on file that is square (32 × 32, 64 × 64 pixels).
- **Gaussian Blur.** Apply a suitable blur to all preceding Operators in the stack.
- **Mirror.** Mirror the results of the combination of all preceding Operators in the stack in a variety of ways. Multiple Mirror Operators can also be considered.
- **Sweep.** Input an Adobe Illustrator shape file, and create a 3D object by sweeping it in space.
- **Lines Per Curve Segment.** Alter the smoothness of the model.
- **Pixel Layer.** Alter the number of layer steps in a Terrain model.
- **Bryce 3D Terrain Import.** Bryce 3D did not allow for the export of its Terrain models, while Bryce 4 does. This Operator fixes that, and allows the imported model to be altered with the other BSmooth Operators as well.

- **GEOPO30 and 1 Degree DEM Options.** Apply DEM Operators to DEM files. This capability is noticeably absent from Bryce 4.
- **Invert.** Invert the grayscale terrain map.
- **Amplify.** Amplify all of the previous Operators in the stack by a factor of .1 to 15 in increments of 1/10.
- **Polar.** Apply Polar Mapping coordinates to all previous compiled Operators in the stack. This creates very kaleidoscopic designs when preceded by one or more Wave Operators.

See Figure 2.

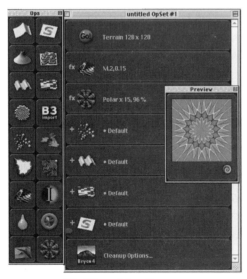

FIGURE 2 *The BSmooth Interface.*

In future GRC tutorials, we'll look at a number of ways to create complex terrain map content with BSmooth. This tutorial is aimed at introducing you to this wonderful utility, and getting you started by creating a few Bryce terrains with a few BSmooth steps, so you can appreciate what even a basic BSmooth operation can provide.

THE BURNED OUT LANDSCAPE

Here's a Bryce BSmooth project that generates a scorched earth terrain scene. Do the following:

1. Open BSmooth, and place two Mandelbrot Operators in the stack. Alter each of them any way you want. Select Go to save the resulting Terrain model to disk as a Bryce file (for whatever version of Bryce you are using). See Figure 3.
2. Open the Terrain model in Bryce, and adjust the camera to get the view you want. Place an intersecting water plane to form a lake in the center of the model, and use the Swimming Pool material with a Bump of 45%.
3. Apply a Rustic Vein material to the terrain. Place some colored spheres in the water to give the picture some interest. Your rendered image should look something like Figure 4.

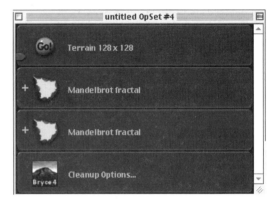

FIGURE 3 *The BSmooth Operator stack includes two Mandelbrot Operators.*

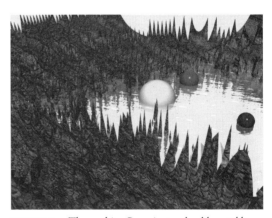

FIGURE 4 *The resulting Bryce image should resemble this one.*

HELIXIA

Do the following:

1. Open BSmooth, and place a Daisy operator in the stack; use the Daisy defaults for now. Click Go, and save the resulting Terrain model as a Bryce file. See Figure 5.
2. Import the Daisy into Bryce, and create any scene you like with it. One possibility is displayed in Figure 6.

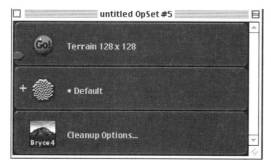

FIGURE 5 *Place one Daisy Operator in the stack, and Go.*

FIGURE 6 *Multiple Daisy terrains are set on end to form this scene.*

CRATER LAKE

Let's create a basic crater lake. Do the following:

1. Place a Wave Operator in the stack, and configure it as shown in Figure 7. Go and save to disk.

FIGURE 7 *Use these Wave Operator parameters.*

FIGURE 8 *One possible result in Bryce.*

2. Import into Bryce and explore, assigning various materials and setting the camera. See Figure 8.

CANYON OF DREAMS

To create the Canyon of Dreams, do the following:

1. Place a Wave Operator in the stack, and configure it as shown in Figure 9. Go and save to disk.
2. Import into Bryce, and explore assigning various materials and setting the camera. See Figure 10.

We'll demonstrate the creation of more complex Bryce Terrain models using combinations of BSmooth Operators in future GRC tutorials. Stay healthy and RAMbunctious.

FIGURE 9 *Use these Wave Operator parameters.*

FIGURE 10 *One possible result in Bryce, when the camera is placed looking out from the center of the terrain, and a water plane is added.*

CHAPTER

13 Modeling Gotham City in 3D Using Canoma

JOHN DONALD CARLUCCI

To construct the final moody shoot of Gotham City, I used Adobe Photoshop, Poser 4, Bryce 3d, and Canoma, of course. The filters used on the final piece are standard with Photoshop, and all needed images have been included in the support package for the article.

Being a huge Batman fan, I always thought it would be very neat to model the city of Gotham in 3D. To do this, I chose to use Canoma from Adobe because I really wanted to work with an actual photo from a Batman film. Finding useable images was pretty difficult and took a great deal of Net surfing to come up with a suitable piece. I finally lucked out when checking the site of Pacific Data Images

(www.pdi.com), the company that did special effects work on *Batman Forever*, and came up with a city shot of Batman swinging across Gotham on a chain. The problem was I needed Gotham without the Dark Knight. So, to use the image, Batman had to go.

I started by booting up Adobe Photoshop and opened the Gotham *image*. After choosing the cloning tool, I zoomed in (Figure 1) and started erasing the chain by replacing it with nearby building facade. I placed the clone origin point close, but not too close, to the chain and started painting. When doing this type of detailed work, I like to choose the smallest brush available. It takes extra

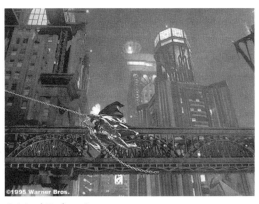

Original Gotham Image

FIGURE 1 *Cloning tool.*

71

time and patience, but the results are worth it. If done carefully, you should end up with a result similar to Figure 2. We also have to remove the Warner Brothers trademark and the scaffolding on the right edge of the image (Figure 3).

I then selected and copied a section of the bridge girder and slid it into place over the chain covering the bottom girder (Figure 4). After a little trimming, the chain disappeared nicely. As for Batman's torso, I placed the clone tool's origin point far to the left on the upper girder and carefully cloned it over the top of Batman. Since the girder is a straight line left to right, it cloned just fine with little orientation problem. You may want to do some additional cloning and smearing to change the new girder's appearance

FIGURE 4 *Coping bridge sections.*

FIGURE 2 *Painting the chain.*

FIGURE 5 *Adjusting the shadows.*

slightly. I also had to tinker a bit with the shadow under the top lip of the girder (Figure 5).

The curve of the bridge where Batman's leg and cape rest is a real problem. I tried cutting and pasting a section of the bridge over it, and wasn't thrilled with the results. I experimented and finally decided that, once again, cloning was the best tool for the job. I placed the cloning tool on the trestle on the far left and started painting (Figure 6) it over Batman's leg. The result was pretty dead on, and I helped it with some extra smudging just to change the final effect a bit.

For the next step, we need to remove the Batman sign from the sky above the bridge. I thought this would be pretty easy, but it wasn't. I first selected the

FIGURE 3 *Removing parts of image.*

FIGURE 6 *Cloning tool.*

quarter-circle light source and copied it, then flipped it over and pasted it in place over the Batman sign to form a half circle. This was the easy part; the hard part was filling in the rest of the sky. To do this, I switched back to the clone tool and cloned some of the nearby sky into the remainder of Batman's body. The resulting sky didn't flow well, so I switched between the Smudge tool and the Blur tool to get the right effect (Figure 7). We still have Batman under the bridge with the chain visible to deal with. I selected a section of the underbelly of the bridge on the right side of the image and copied it. I then pasted it in place over the last of the Batman segments to replace, and changed the layer options to Hardlight and 65% opacity. Double-check the picture for any cleanup and you should end up with something sim-

ilar to Figure 8. Save it to Gotham.psd, and now its time to build.

To start off, in Canoma, I loaded my image (Gotham.Psd) and saved the project under the title Gotham. I then selected a box from the creation menu and pinned it to the building farthest back in the image. At the bottom I pinned only the left front corner, and allowed the box to align itself (Figure 9) rather than force it into place. While keeping the box selected, I pressed the stack button before choosing the truncated pyramid from the creation menu (Figure 10). I then glued the three visible corners of the truncated pyramid to the box. I also pinned the top corner of the pyramid in place so I wouldn't lose it while gluing in the previous step (Figure 11). After gluing, I pinned the top corners of the pyramid to

FIGURE 8 *Cleaning up the picture.*

FIGURE 7 *Smudge and Blur tools.*

FIGURE 9 *Aligning the box.*

FIGURE 10 *Using Stack button.*

FIGURE 12 *Pinning the points of the pyramid.*

FIGURE 11 *Gluing the corners.*

FIGURE 13 *Creating a cylinder.*

the relative points of the inverted pyramid on top of the building (Figure 12).

To put the water tower on top of the building, I selected the truncated pyramid and pressed the Stack button again. After creating a cylinder, I pinned it in place before using glue to adhere the edge of the cylinder front panel to the leading edge of the truncated pyramid (Figure 13). After a quick test render for errors and stress points, I moved on to the building in the foreground right edge of the image.

I placed a new box on the screen and pinned the top visible corners in place. I pinned the back left corner to the leading edge of the first building I constructed to keep the leading building in the foreground. I then pinned the remaining visible corners

(Figure 14) and checked the stress points. Placing this building is really difficult, since the edges are not entirely visible due to the boxes on all four corners of the building in the image. You have to make your best guess on this one.

To tackle this problem, I placed a new box on the screen and glued both corners to the main building (Figure 15) before pinning the visible corners in place. Since this worked, I repeated it with the other two visible corners of the main building with decent results.

When placing the second water tower, I just selected the main building box and pressed the Stack button before creating a new cylinder. I glued the front point of the cylinder to the leading edge of the

FIGURE 14 *Pinning remaining corners.*

FIGURE 16 *Gluing the front point of the cylinder.*

FIGURE 15 *Adding a new box.*

FIGURE 17 *Pulling the right edge into place.*

building (Figure 16) before pinning the top edges in place. It did not fit perfectly, but was close enough for modeling purposes.

Constructing the last building was tricky because it doesn't quite follow the vanishing point. After pinning the box, I used a bead of glue to pull the right edge into place (Figure 17) so it lined up with the building edge. Once the box was secured in place, I pressed the Information button (i) before deleting all orientation and unfixing the box parameters. I then spent some time tweaking the building in place (Figure 18 and Figure 19).

I placed the final box for the bridge on screen and deleted all parameters and orientation before pinning it in place. Using two beads of glue, I fixed the

FIGURE 18 *Positioning the building.*

FIGURE 19 *Final positioning.*

box to the front of both leading buildings. This way, the bridge was secured in the foreground of the scene and not in the background (Figure 20).

Now that the construction of Gotham was complete, I exported the whole scene as a Poser Project file (pp2) and moved to the generation phase.

After importing the whole scene into Poser, I tweaked the angles slightly for a better view and saved the project. I still needed a good background, so I opened Bryce 3d and generated a new one using a purple storm background. This I saved as a .bmp file (GothamSky.bmp) and imported it as a background file to Poser.

Back in Poser, I opened the render options and set up a new window at 800 × 800 with background

picture selected (Figure 21). After rendering and saving the image, I moved on to Adobe Photoshop again.

FIGURE 21 *Render options in Poser.*

After opening the image, I added a second layer to the render and selected Clouds under Filters on the toolbar. I then opened the Layers options and reduced the opacity to 65% for the cloud layer. Since I now had a more moody view of Gotham, I realized something was missing. I selected lens flares and placed some new lights on the water towers and the bridge. With the new lighting in place, I now had the Gotham City I was looking for.

FIGURE 20 *Securing the bridge in the foreground.*

GOTHAM CITY

CHAPTER

14

RayDream Studio Tutorial: Alien 1

—Steve McArdle

System Requirements:

Ray Dream Studio 4.2 or higher running on a PC or Mac. This tutorial can also be used with Carrara.

Since its inception, RayDream has been a strong illustration tool for digital illustrators and animators alike. Many of its features and tools allow you to put your imagination into a tangible form quickly and easily. With this being our starting point, in this month's tutorial, we are going to take a look at creating a character for a digital illustration.

To start any project, it is a good idea to rough out your ideas on paper first as a way of organizing your thoughts. As creative people, we are always thinking of new things, and transforming one idea into another. This mental chaos makes it hard to keep track

FIGURE 1

and visualize our thoughts. To combat this, I use my sketch book by drawing my ideas as I think about them until I dump the one on paper that I am happy with and want to use as the basis for my project. It's a good way to plan and organize yourself instead of working it out on the screen.

Before we start getting into the nitty-gritty of constructing our character, we need to set up our working environment. I like to work in two different screen layouts depending if I am modeling/composing or animating. Seeing as we are not animating in this particular tutorial, we will set up RDS into a modeling-conducive layout. Load up Ray-Dream Studio, and start a new document (if one isn't automatically started for you). Drag your main window so that it takes up most of the screen, leaving a column of space at the right-hand side. Now select your Hierarchy window (the window with the objects/timelines on it) and drag it so that it sits vertically in the bottom half of the open column of space at the right of your scene window. Now press Ctrl-T to open up the Properties dialog box and fit it into the remaining open space beside the scene window and above the hierarchy window. Refer to Figure 2 to match your layout to mine.

Once we have this layout set up, go to WINDOWS > WORKSPACE > "Save Current", and call this workspace "Modeling Space." You now can automatically select this workspace anytime in RDS by selecting it from the list of workspaces.

FIGURE 2 *Properties dialog box.*

FIGURE 3 *Draw Oval tool.*

HEAD

Now that we have ourselves organized, our job in this tutorial is to build this character so that we can compose and arrange him later in our illustration. I always begin by creating the head, and that is where we will start here. Go to INSERT > "Free Form", and you will jump into the Free Form modeler. You will be prompted for a name of the object; type Head. From the menu at the side, select the Draw Oval tool and draw a small circle, by dragging the cursor while holding SHIFT (to constrain the oval to a circle), in the middle of the highlighted drawing plane. Press Ctrl-SHIFT-C to center the circle in the middle of the drawing plane (Figure 3).

Once you have the circle centered, we need to set the type of extrusion Envelope to use on our shape. Go to GEOMETRY >EXTRUSION ENVELOPE >"Symmetrical" and you will see an envelope appear on the walls of the modeler. About half-way along the Extrusion of your circle, add a point with the Add Point tool. Now take that point on the Extrusion Envelope and move it up away from the Extrusion midline with the Selection tool. Now manipulate this point and its resulting handles by dragging on it with the Convert Points tool so that it becomes a smooth arc instead of the hard angle it currently is. Once you have done this, use the Convert Points tool on the two end Extrusion points to

FIGURE 4 *Convert Points tool.*

smooth them out so that you arrive at an object similar to that shown in Figure 4.

Click Done at the bottom left of your modeling window and you will jump back to your scene window. Select the head, and in the Properties dialog box, make sure positions X, Y, and Z all equal 0. Change its size to X=14.00, Y=16.00, Z=14.00. We now have the foundation for our head, so we will move on to the eyes.

EYES

Go to INSERT > Free Form, and when prompted, name this object "Eyelid." Again select the Draw

Oval tool and drag the cursor while holding down SHIFT to draw a small circle. Again center it by pressing Ctrl-SHIFT-C, and again set your Extrusion Envelope to Symmetrical with GEOMETRY > EXTRUSION ENVELOPE > "Symmetrical". On your envelope add two points evenly between the first and last using the Add Point tool. Move the points around with the Selection tool until you have them arranged similar to Figure 5.

If you need to view your emerging object from the side to better align your points, press Ctrl-4 for side view, or Ctrl-8 for the top view. You can return to the perspective view by pressing CTRL-0. All of these views can also be selected from the VIEW > "Preset position" drop-down menu. Once you have your points arranged, smooth them out with the Convert Points tool so that you end up with an object similar to Figure 6.

When you are happy with the object, click Done at the bottom left of your modeling window to jump back out to the scene window. You now have two objects in your scene window, which are overlapping each other. Click on the Eyelid object with the selection tool, or select its name in the hierarchy window, and drag it away from the head. In the Properties dialog, click on the Transform tab, and change its size to X=8.00, Y=5.00, and Z=8.00. We now need to add the eyeball. Select INSERT > Sphere. Click and hold the Sphere name in the hierarchy window and a

FIGURE 6 *Convert Points tool.*

dialog box will pop up asking for a new name; type in Eyeball.

This is how I rename things in RayDream, so throughout the rest of this tutorial when I refer to changing an object's name, this is how we will do it.

Resize the eyeball to X=7.00, Y=6.00, Z=7.00. As you can see, the eyelid and eyeball are separated even though they are in a group, so we will now fix that. We need to align the eyeball inside the eyelid now, and to do that we first select the eyelid and SHIFT-click on the eyeball. With them both selected, select ARRANGE > Align objects (or Ctrl-K). This will open the Alignment dialog box. In the bottom corner of the Alignment dialog box there is a small key icon, which you need to click to open the full dialog box. Once you have done that, select X : Align : Center, and Z : Align : Center, leave Y alone, and click Apply to execute the alignment. You will notice that the eyeball is still in front of the eyelid, but is aligned in the X and Z axes now. Change your view to the side by pressing Ctrl-4 and using the Zoom tool to isolate the eyelid and eyeball. Select the Eyeball object and, holding down SHIFT (to constrain its movement along a single axis), slide it so that it is just inside the eyelid, similar to what appears in Figure 7.

FIGURE 5 *Selection tool.*

FIGURE 7 *Select the Eyeball object.*

We need to group the eyeball and eyelid so that we can deal with them as one object, so we will group them now. Click on the eyeball, SHIFT-click on the eyelid, and click Ctrl-G to group them. In the hierarchy window, you will they have both disappeared and the object "Group 1" is there instead. Rename this to "Eye."

HEAD ASSEMBLY

We only have one eye at the moment, so we need to make another—I don't think we're going to make a Cyclops today (grin). Select the Eye group object and press Ctrl-D to duplicate it. You will see another "Eye" appear in the hierarchy window. Rename this to "Eye2." Select both eyes and open the alignment dialog box, Ctrl-K. Select X: Contact : Sides, leave the Y and Z dialogs alone, and click Apply. With both of Eyes still selected, click Ctrl-G to group them. We don't need to rename this group because we are using it temporarily to make the positioning of both the eyes at the same time easier. Change the view to the front by pressing Ctrl-1, and use the Zoom tool to isolate the Head and Eye objects. Select both the Head object and the temporary Eye group by SHIFT-clicking, and then open the alignment dialog, Ctrl-K. Select X : Align : Center, Y : Align : Box Max, and Z : Align : Box Max. This will center the eyes on the head and raise them so that

their top matches the topmost and frontmost part of the head (see Figure 8).

Change the view to the side (Ctrl-4) so that you can see both the head and eye groups. Select the eye group, and in the Properties dialog change the Roll= -30.00. Hit Ctrl-U to ungroup the temporary eye group, and change to the Perspective view by pressing Ctrl-0. To help us differentiate the objects, we are going to temporarily color the eyeballs. Select WINDOWS > Current Shader Editor. Select the Color tab, and double-click on the red square until your color picker appears. Choose the color white, and drag the small preview sphere onto each of the Eyeball objects. Your head should now look like Figure 9.

FIGURE 8 *Centering the eyes.*

FIGURE 9 *How the head should appear.*

Our main head is pretty much set up now, so we will move on to the next part: the body.

BODY

Select INSERT > Free Form, and name it "Body." Use the Draw Oval tool to draw a small circle by holding down SHIFT, and center it on the drawing plane. Set the Extrusion Envelope to "Symmetrical." Press Ctrl-4 for a side view, and add three points between the first and last points with the Add Point tool. Manipulate these points so that you get a teardrop shape similar to Figure 10.

Now use the Convert Points tool to smooth out the points including the two endpoints similar to Figure 10b. We need to bend this shape a little so that the thinner part of the object curves into a more natural position for a neck. To do this, we click on the Extrusion path, the midline between the two Extrusion Envelopes. Select the second point and move it down slightly, and then select the third point and move it up slightly. Use the Convert Points tool to smooth out the curves between these points so that your object looks like Figure 11.

Once you are happy with the object, click Done to jump back into the scene window.

FIGURE 11 *Smoothing out the curves.*

BODY/HEAD ASSEMBLY

Select the Body and move it below the head and eyes. Go to the Properties dialog and change the body's Roll= –90, and change its size to X=16.50, Y=35.00, Z=16.50. Click on the Head object, and then SHIFT-Click on the Body object and press Ctrl-K to open the Alignment dialog box. Set X : Align : Center, Y : Align : Center, leave Z alone, and click Apply. Change your view to the side with Ctrl-4, and while holding SHIFT, align the body along the Z plane so that it looks roughly like Figure 12.

At this point, we'll verify some coordinates to make sure things are where they should be more pre-

FIGURE 10 *Teardrop Shape.*

FIGURE 12 *Aligning the body.*

cisely. If you select the Head object, its position should still be at X=0, Y=0, Z=0 where we put it before. For the body to be in the correct position as shown in Figure 12, change its Z position value to −19.00, so that its overall position is located at X=0, Y=0, Z= −19.00. Things are looking good so far, so let's move on to the next part: the legs.

LEGS

Select INSERT > Free Form, and name it "Leg." Use the Draw Oval tool to draw small oval that is slightly wider than it is tall. You don't need to hold down SHIFT this time because we don't want to constrain it to a circle, and don't forget to center it (Ctrl-SHIFT-C). Set the Extrusion Envelope to "Symmetrical," and press Ctrl-4 for a side view. Add five points evenly spaced between the first and last points using the Add Point tool. Manipulate and smooth out the points so that you create a thigh bulge, knee indent, calf bulge, ankle indent, and foot bulge. Refer to Figure 13a.

Go back up to the Extrusion Envelope selector and change it to Symmetrical in Plane with GEOMETRY > EXTRUSION ENVELOPE > Symmetrical in Plane. Now change your view to the top by pressing CTRL-8. Adjust your points so that your Leg object corresponds to the positioning in Figure 13b.

FIGURE 13B *Adjusting the points.*

We now need to take our generalized leg shape and articulate it into a proportional shape and position. Return to the side view (Ctrl-4), and click on the Extrusion path in the middle between the two Extrusion Envelopes. Manipulate the points up and down so that they correspond to the positions shown in Figure 14a.

We have only adjusted the Extrusion path in the side view, and if we left it here our Leg object would perfectly straight vertically. We know this won't look right, so we need to make some further adjustments from the top view to make it more organic. Change your view to the top again (Ctrl-8), and adjust the positions of the points on the Extrusion path so that they correspond to the points in Figure14b. Once

FIGURE 13A *Creating a thigh, bulge, knee indent, calfbulge, ankle indent, and foot bulge.*

FIGURE 14A *Leg object.*

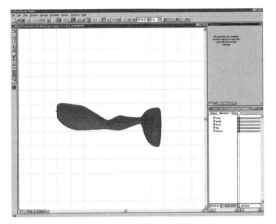

FIGURE 14B *Final view of leg.*

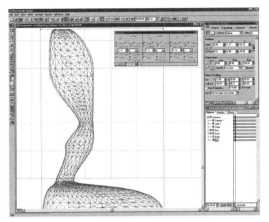

FIGURE 15A *Dragging the object.*

you are satisfied that your object matches Figures13–14b, click Done to jump back to our scene window.

TORSO/LEG ASSEMBLY

Select the Leg object and move it below the Body object. In the Properties dialog box, change the size of the Leg object to X=12.50, Y=28.00, Z=18.50, and the Roll= –90.00. We now are going to move the Leg object's "hot-point," which is its virtual center. To do this, we need change our view to the side (Ctrl-4), use the Zoom tool to isolate the Leg object, and change our viewing mode to Wireframe. To change the mode, click on the small wireframe sphere icon on the toolbar, or select VIEW > Wireframe. In the center of the bounding box around the Leg object is a small circle, which is your hot-point. With the Selection tool, drag it to the top center of the thigh in the same position as shown in Figure 15a.

Now change your view to the front (Ctrl-1) and use your Zoom tool to again isolate the leg. Move the hot-point in this view to the center of the thigh from this angle in the same position as shown in Figure 15b. Now we need to position the leg, so go back to the side view (Ctrl-4), select the Body object, and SHIFT-Click to select the Leg object as well. Select Y : Align : Hot Point, leaving X and Z alone, and

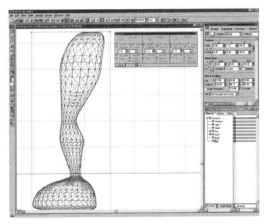

FIGURE 15B *Moving hot point to center.*

click Apply. You will see the leg move under the body so that the thigh is relatively centered under the torso. Select the Leg object and while holding SHIFT down, move it up so that the top of the thigh disappears into the stomach of the Body object until you are about to mid thigh as seen in Figure 16a.

Now change your view to the front (Ctrl-1), and move the leg to the left side of the body until the innermost edge of the leg's bounding box (the right side) is positioned just slightly less than the midline of the body as seen in Figure 16b. Now that we have our leg roughly in the right place, we are going to position it more precisely in the Properties dialog box. In the Properties box, change the position of

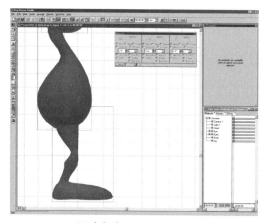

FIGURE 16A *Mid thigh.*

FIGURE 16B *Front view positioning.*

the leg to X=5.00, Y=6.00, Z= −43.00. This will fine-tune the position into a nice set of round numbers, which we will need to use again in a moment. We now need the second leg. To do this, we need to duplicate our current leg and mirror it. To do this, you have two options. You can use the Duplicate with Symmetry tool under EDIT > Duplicate with Symmetry, or you can simply duplicate your object (EDIT > Duplicate) and mirror it. I usually just mirror my duplicates, and that is what we will do here. Click on the Leg object to select it, and press Ctrl-D (as you can see, there are several ways to access the same command in RayDream). Change the name of this new leg to "Leg2." In the Properties dialog box,

in the Orientation section you will see a checkbox for Mirror—enable it. You will now see where your leg is, a second leg that is a mirror object of the first leg. We want to position this new leg so that it just the opposite of the original. To do this, we go back to the Properties dialog box, and with the new leg selected, change its position properties to, X= -5.00, Yaw= -180.00, and Roll=90.00. This will position the Leg2 in the same position as the other leg, but on the other side of the body as seen in Figure 17.

FIGURE 17 *Positioning leg 2.*

Now that our first set of limbs is done, we need to create the next. So, on to . . . the arms.

ARMS

Select INSERT > Free Form, and name it "Arm." Use the Draw Oval tool to draw a circle and center it. Add four points between the first and last points, and set your Extrusion Envelope to Symmetrical. Manipulate your points so that they match up as shown in Figure 18a.

This is your arm straight. Now select the fourth point in from the left and pull it down. This is your elbow joint. Move the other points to smooth out any rough edges at the shoulder and the wrist. Your object should look like Figure 18b. Click Done to get back to your scene window. In the Properties window, set the size of the Arm object to X=4.00,

FIGURE 18A *Adding and manipulating points.*

FIGURE 18B *Smoothing the edges.*

Y=25.00, Z=8.00, and place it around the top of the belly off to the left side (your left while looking at him straight on). Move the hot-point of the Arm object to the center of the shoulder knuckle so that when we want to move it later, it will rotate around the shoulder. Before we position it, we are going to create the hand and attach it to the wrist, so that is our next objective.

HANDS

Select INSERT > Free Form, and name it "palm." Use the Draw Oval tool to create an oval that is wider than it is high, and set the Extrusion Envelope to Symmetrical. Press Ctrl-1 so that you see the Extrusion plane straight on (you should see your oval directly). Click on the oval shape so that it becomes selected, and press Ctrl-U to ungroup the shape. You will now see your oval with four control points that will allow you to manipulate its shape. Select the two lower handles of the two outside points and, with the Selection tool, pull them down. Now select the lower middle point, and again with the Selection tool, pull it up so that the bottom of your oval becomes flat. You should now have an oval that is round on the top and flat on the bottom—this will be the basis for the palm of our hand. Make sure you center this shape on the drawing plane, and press Ctrl-4 to get a side view. Add two points between the first and last points with the Add Point tool, and raise those second and third points slightly higher than the first and last points. Now take the third point and raise it slightly higher still so that your palm is a little fatter at the right end than the left. Smooth your points out with the Convert Points tool, and you should end up with a shape similar to that shown in Figure 19.

Click Done to return to the scene window.

FIGURE 19 *Using Convert Points tool.*

FINGERS

We're almost there now, we just have to add the fingers. Select INSERT > Free Form, and name it "finger." Use the Draw Oval tool to create a circle (remember to hold down SHIFT), and center it on the drawing plane. Set the Extrusion Method to Pipeline, set the Extrusion Envelope to Symmetrical, and change your view to the side (Ctrl-4). Add four points between the first and last points, and manipulate the second last and last points with the Selection and Convert Points tools so that you end up with a rounded end at the right end of the object similar to Figure 20.

Smooth the transition between the points with the Convert Points tool, and change the Extrusion Envelope to Free. You can now move the points on the top and bottom of the Extrusion Envelope free of each other vertically (they will still move together if you move them horizontally). The second and fourth points from the left will act as knuckles, and the third and fifth points will be the fleshy parts between the knuckles. Manipulate the points to illustrate this articulation in the finger using the Selection tool, and smooth out the resulting points using the Convert Points tool, using Figure 21 as a reference.

Next we need to add a natural bend to the fingers. Click on the center Extrusion line and pull

FIGURE 21　*Creating the finger.*

down the first and last points so that they result in a bending of the finger. You will notice something a little funky at the fingertip with the second point from the end. Click on that point second from the end, and pull it down about halfway between the endpoint and the one third from the end. You will need to smooth this point out with the Convert Points tool so that the handles you smooth the point out with follow diagonally the direction of the Extrusion line (this will keep the Extrusion following the direction of the finger). Your finger should resemble that shown in Figure 22.

Click Done to return to the scene window.

FIGURE 20　*Adding and Converting more points.*

FIGURE 22　*Final finger.*

HAND ASSEMBLY

We now have to put the fingers and the palm together to create our hand. Click on the finger and the palm and press Ctrl-G to group them together. Once they are grouped, rename the group to "Hand," and then double-click on it. This will cause you to jump into the group so you can work on it independently of the other objects in the scene. Change your view to the top (Ctrl-8) and position the finger at the front of the palm so that it is extending outward, but is not attached. With the finger selected, duplicate it (Ctrl-D) and move it beside the other finger. Our hand is going to consist of two fingers and one thumb, so position your objects with that in mind. Next we need to create our thumb. Click on the original finger and duplicate it again. Rename it to "Thumb" and move it away from the other fingers. Now that we have all our elements, we are going to size them so that they are in proportion to one another. Click on the palm and change its size in the Properties dialog to X=5.50, Y=7.00, Z=3.50. Next, click on the fingers and change them both to X=2.50, Y=9.50, Z=3.50. Last but not least, click on the thumb and resize it to X=2.00, Y=6.50, Z=3.00. Now move the thumb into position so that it is rotated 90 degrees counterclockwise using the Rotation tool and holding down SHIFT to turn it in 15-degree increments. When you're finished, you should have something similar to Figure 23.

Now that the appendages are all in their relative position, move the hot-points to the end of the finger closest to the palm. This will help you later when you want to pose them. Next, move the fingers and thumb so that the bases are submerged into the palm. With the Rotation tool, rotate the fingers so that they are spread apart, forming a slight "V" as our fingers naturally do, and bend the thumb so that it falls down to the side of the hand, again much the way our thumbs do. The positioning of the fingers and thumb is really to taste, and when you pose them later you may want to reposition them to more expressive gestures. You may need to change your view often to position the fingers and thumb exactly how you want. Hands are a key component of body language, so the position of them is relative to what you want your character to be expressing. Take a look at Figure 24 to see how I've positioned my hand.

I've used a relaxed natural pose to illustrate the general positioning of the fingers and thumb. I've manipulated the screen shot so that you can see the hand from all angles to give you a better understanding of the layout. Once you've positioned everything how you like it, click Done to return to the scene layout window.

FIGURE 24 *Positioning the hand.*

FIGURE 23 *Assembling the hand.*

ARM ASSEMBLY

You will now see your hand in nice group, a little disjointed from the arm, and off scale—but nice, nonetheless. Let's rectify those problems now. We already have our Arm object to scale, so we will click on the Hand object and change its size in the Properties dialog to Y=14.50. The other values will adjust in proportion to the value you input at Y because this object is a group. You cannot change the size of a group nonuniformly in RayDream unless you use a deformer. We don't need to use a deformer here, so just changing the Y value will do the job for what we need. We now want to move the hand over the wrist of the arm so that the wrist partially submerges into the palm of the hand. Once you have done that, move the hot-point of the Hand object so that it is where the hand and wrist intersect. This is so that when you pose your hand later, it will bend around the wrist instead of the center of the hand. Now select both the hand and arm and press Ctrl-G to group them together, and rename them to "arm and hand." Change your view to the side (Ctrl-4) and move the new arm group hot-point to the center of the shoulder. Now move the whole Arm object so that it sits just above the abdomen, with the shoulder just slightly embedded into the torso similar to Figure 25.

Once you've done this, duplicate the Arm/Hand object and click Mirrored in the Properties dialog to flip it. Change its Orientation in the Properties dia-

log to PITCH= -180, YAW=0, ROLL=180. Now move it so that it is in a similar position as the other Arm/Hand object, but on the other side of the body similar to Figure 26.

FIGURE 26 *Positioning the other arm.*

You can now use the Virtual Trackball tool (under the Rotation tool) to move the arms around. Because we have already moved the hot-points of the arms to the shoulder, the arms will rotate around the shoulder, making them easy to position. You can also open the arm group by clicking on the + sign beside its name in the hierarchy window to rotate the Hand object as well. Remember to close the group back up by clicking on the – sign after you have opened it when you are finished.

FINISHING

You now have your alien built. You can now add to him, dress him up, texture him, populate worlds with him and his kin, and position him into different poses as you want. I've taken the liberty of rendering our little alien into a scene to see what sorts of things you can now do with him. Remember, we set this up for illustration purposes so we don't have to worry about animating movement in this tutorial. So, remember three things—"Pose, Compose, and Render"—and you are on your way to creating great 3D illustration with RayDream Studio. Have fun and keep dreaming.

FIGURE 25 *Positioning the arm.*

15

The Old Man: A RayDream/ Carrara or Poser Project

—SHAMMS MORTIER

THE VERTEX MODELER

There are two uses for the Vertex Modeler in Carrara (also known as the Meshform Modeler in Ray-Dream): creating new 3D objects, and editing and customizing models created outside of the Vertex environment. You can use Carrara/ RayDream quite effectively without ever turning to the Vertex Modeler to create original content, but you will be missing a very exciting creative opportunity. There is no other module in Carrara/RayDream that allows you to get down to the basic polygon component level of a 3D model in order to delete, add, subdivide, and otherwise create and reshape vertices, edges, polylines, and polygons. The Vertex Modeler contains a number of unique tools and techniques, each of which must be fully explored and mastered. Taking on the challenge of designing a human head from scratch in the Vertex Modeler is rather daunting. Certainly, you can design the components by using Metaballs in Carrara, and "jumping" the model into the Vertex Modeler for fine-tuning. This is the accepted way to work, and we'll look at Metaball modeling in general in a future tutorial. For now, however, it's time to dive into the Vertex Modeler itself.

Please note that we are using the term "Vertex Modeler" as it refers to Carrara. If you are a Ray-Dream user, this means the Meshform Modeler. The Vertex Modeler in Carrara is a direct port from the Meshform Modeler in RayDream, so no matter which application you are using, this tutorial will suffice.

MODELING A HUMAN HEAD

Creating a 3D digital head, human or otherwise, is one of the most artistically satisfying endeavors a computer graphics artist can accomplish, and one of the most challenging. the Vertex Modeler has the right tools for the task, right down to the individual vertex level, though you will need some practice to get the hang of its use. There are some important cautions to take when using the Vertex Modeler for creating a head:

- Start a 3D head by inserting a sphere or cylinder in the Vertex Modeler. Some 3D designers prefer one of these basic forms over another, so there is some argument over which is best. I prefer a sphere in the Vertex Modeler, but I often use a **89**

cylinder in other applications. You should explore both ways.

- Use *Subdivision* in the Vertex Modeler on those polygons that represent the detailed aspects, such as nose, lips, and eyes. These are the areas of a model that will often require the most tweaking and fine-tuning. If you find that you have too many polygons in any selected area after a part has been shaped, you can always select that area and Decimate the Polygons. Decimation is what other applications call Optimization, allowing you to selectively reduce the number of polygons. You have to be careful when doing this operation, since it does alter the shape of the selected part. Start with a percentage of just 10% polygon reduction, and proceed from there. The more polygons, the more disk space needed to store the model.

- For sharp features like the edges of the lips and nose, use Creasing; otherwise, smooth the polygons. *Creasing* does what it says, making edges more prominent.

- Use the *Sphere of Attraction* tool before working on individual polygons to sculpt the overall features, and use grouped polygons and smaller selections to refine the features afterward.

- Use the *Add Thickness* operation extensively to pull out and push in selected elements. This operation is one of the best ways to sculpt the general forms, since you can use it on an area or on any number and placement of selected polygons. Positive values extrude polys out, and negative values push the polys inward.

- Use *Boolean Subtraction Operations* to create larger cavities in the head (Mouth, Eye Sockets, and Nostrils). Remember, however, that Booleans in the Vertex Modeler work differently from the Boolean Operations performed in the document window. In the Vertex Modeler, Boolean Subtraction Operations result in empty areas that show a hollow cavity.

(See Figures 1 to 7.) Name every part you create. This may seem like an unnecessary chore when you are beginning the model, but you'll be very thankful you did it later on. Named groups of polygons can always be easily reselected and manipulated.

FIGURE 1 *For the start of the head, define the general skull shape from a sphere and extrude the neck, as shown here in the side and front views. The neck is named, and resized at 70% on the X-axis.*

FIGURE 2 *The chin area is selected and named, then SubDivided. The Sphere of Attraction with the Bump option is used to extrude it, and the polys on the front of the face are SubDivided for further work.*

FIGURE 3 *The lips are given more definition and edges are Creased.*

FIGURE 4 *The nose is added by Thickness Extrusion and named, and eye sockets are created with the negative Add Thickness tool set at –1.3.a*

FIGURE 5 *Next, another Vertex Modeler is opened, and an eye socket is created from a sphere. The front polygons are "emptied" by using the Empty Polygon command, and a Z size of 70% is used to squash the sphere. Two of these will be Linked to the holes in the head.*

FIGURE 6 *These ears are rather stylized, but you are free to make them as real as you like. They are simply polylines given Thickness and Subdivision in the Vertex Modeler, and backed up with a reshaped oval.*

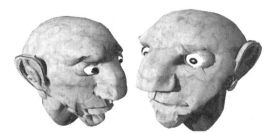

FIGURE 7 *Here's the Old guy—warts, creases, and all. A Pink Marble Shader (from the Shades of Reality collection) was used on his skin to look like veins underneath.*

POSERATIONS

OK. Now it's time for Poser work. Export the model from RayDream or Carrara as an OBJ. Make sure that everything is Grouped, and that the textures are translated from Procedurals to Bitmaps in the Export menu. Close RayDream or Carrara, and open Poser. Import the model. You will have to reassign all of the textures in Poser's Materials Editor. Once that is complete, the model will appear textured in Poser's Document Window. (See Figure 8.)

Load in a suitable Poser Figure. For this example, I selected the Zygote Heavy Man module (available separately from Zygote). Replace the Figure's Head

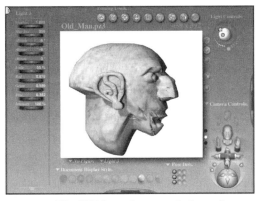

FIGURE 8 *The Old Man as he appears in Poser after textures are assigned.*

with the Old Man Prop, and adjust size and position to fit. Place a hat on the head if you like, and pose and render away. You have created a new Poser personality by modeling a unique head. You'll need to develop Morph targets separately if you want to animate the facial features. (See Figure 9.)

FIGURE 9 *The Old Man has a body, and can be animated as you like.*

CHAPTER

16

Carrara Tutorial: Special FX: Exhaust

—STEVE MCARDLE

TUTORIAL REQUIREMENTS

Carrara v1, v1.0.1. PC or Mac (This tutorial is useable for RayDream Studio5 users, but the dialogs and the references will be different, even though most of the same features are available in RayDream Studio 5).

One of the things in 3D illustration and animation that people have come to expect is special FX. Many images are taken into post-processing programs to add lighting, glows, flares, etc. In Carrara, you have a vast number of special FX tools at your disposal within the program itself. You might be surprised at how you can take some of these features of Carrara and combine them to create very dynamic and robust special FX.

In this tutorial, we are going to look at how to create interesting, dynamic, and convincing particle exhaust coming from rockets. See Figure 1. People often like to create space scenes in 3D illustration and animation, and often ask me how to enhance the scene to make it more dynamic—so let's explore just that.

STEP 1: CREATING THE PARTICLE FOUNDATION

When you create an exhaust, you have to have some kind of substrate that emits from the rocket or engine. To do this, we are going to use one of the two

FIGURE 1 *The rocket exhaust.*

types of particle primitives offered in Carrara, the Fountain primitive. In Carrara, go to the Insert menu, and select the Fountain primitive. This will insert the Fountain into your scene at the origin (X=0, Y=0, Z=0) of your Assembly room. It will then jump you to the Model room (the wrench icon at the upper right of the screen) to define the initial parameters of your fountain object.

If you look at your fountain object in the accompanying preview window, (See Figure 2) you will see that it is a series of particles spraying up into the air from a single point at the origin. As you can see, this primitive is called a Fountain primitive because it looks and works the same way a water fountain **93**

FIGURE 2 *Fountain primitive.*

would. Because these particles can be animated, you can change these setting over time and have your fountain generate new particles and dynamically change its shape, direction, and size. We are going to set up this fountain so that it starts from the moment of ignition to full blast over 10 seconds. You can adjust this timeframe to suit your certain project by putting more time between the keyframes we are going to create, or by adding more keyframes with different fountain settings.

STEP 2: DEFINING THE FOUNTAIN'S PARAMETERS

While still in the Model room, open your Animation drawer at the bottom of the screen and make sure that your timeline indicator is at zero hour. *Zero hour* is a term used for the very beginning of the timeline and means 00:00:00, so from now on when I refer to zero hour, that's what I'm talking about. In the fountain parameter dialog box, change your settings to the following:

Completion: 0%
Number of Particles: 0
Maximum Dispersion: 100
Maximum Swirl: 0
Initial Velocity: 0
Gravity: 0
Particle Size: 0.25

You will see in your preview window that the Fountain primitive disappears to a tiny point at the origin of the universe. That's exactly what we want, because we want our exhaust special FX to start from

nothing (no ignition), and go to full-blown exhaust stream (maximum ignition). We are now going to move our timeline indicator in the Animation drawer to 10 seconds (00:10:00). This will give us the room to have our exhaust grow from none to full over 10 seconds as we had mentioned earlier. At 10 seconds, change the fountain parameters to the following. . . .

Completion: 100%
Number of Particles: 5000
Maximum Dispersion: 25
Maximum Swirl: 0
Initial Velocity: 4.50
Gravity: 3
Particle Size: 0.25

You will see that a keyframe has been created on the timeline at 10 seconds, reflecting the changes you have made to the fountain primitives settings. Now set the timeline indicator back to zero hour by either dragging the timeline marker back, pressing Rewind, or pressing the Previous KeyFrame button. You can now press Play and see that your fountain object grows over the 10-second duration. The fountain grows downward because we have set the gravity attribute to strengthen from 0 to 3 over the 10 seconds, which pulls the particles downward over time. (See Figure 3)

FIGURE 3 *Fountain object timeline.*

STEP 3: BRINGING THE FOUNTAIN TO LIFE

Return to the Assembly room (the hand icon at the upper right of the screen), and return the timeline to zero hour. Because our fountain is in its non-ignition state at zero hour, you won't be able to see it. That's okay, though, because we are going to give it its visual properties now that will last its whole life. To do that, we need to create its shader. Make sure the fountain primitive is selected by highlighting it in the object hierarchy at the left-hand side of the Animation drawer. Once it is selected, go to the Texture room (the paint brush icon at the upper right of the screen). The shader we are going to apply is pretty simple, but after the tutorial, you might want to experiment with different shaders to see how they affect the appearance of your exhaust. We want to make sure the Top Shader is set to Multi Channel, and from there we are going to put in the following parameters:

Color: Color (using the default HLS wheel, H: 0, L: 50, S: 100)
Highlight: Value (0%)
Shininess: Value (0%)
Bump: None
Reflection: Value (0%)
Transparency: Value (100%)
Refraction: None
Glow: Color (using the default HLS wheel, H: 8, L: 50, S: 100)

What we've done here might seem a little confusing at first because we have given this shader full transparency. We did this is so that we rely on the glow attribute and color tint of the shader for our usable information. Once you have created the shader, return to the Assembly room.

At this point, you can test your fountain by doing a test render. The first thing we are going to do is make sure that we are rendering on a black background. This is set in the scene properties. Go to the Edit menu and select Edit Scene Effects. In the Properties drawer at the right of the screen, click the Effects button and set your Backdrop to Color.

Click on the color swatch and change all the values to 0% to give you black. Go back to the top and change the Brightness of the Ambient setting to 0% to make sure that we aren't using any external lights to view our fountain. Next, go to the Render room (the film strip icon in the upper right of the screen). Pull out the drawer on the right-hand side of the screen and click the Output Settings button. Make sure the File Format is set to Movie, the start is 00:00:00, and the end is 00:10:00. You can leave the frame rate at 6fps to speed things up. Click the Render button in the drawer at the bottom of the screen, and after a minute or so of rendering, you will have a 60-frame test animation of your fountain.

You can see where we are so far(Figure 4) . . . this is where a little extra work makes things much more interesting.

FIGURE 4 *Status so far.*

STEP 4: ADDING SPECIAL FX NUMBER 1

Go back to the Assembly room, and make sure our time marker is at zero-hour. We are going to apply a filter to our scene that will transform our fountain in a pretty cool way. Go to Edit and select Edit Scene Effects. In the Properties drawer at the right, click Filters. You will see a + (plus) and a – (minus) sign in the top box right below the Filters button. Click on the + (plus) and select 3D Aura. A 3D Aura dialog box will open that will allow us to input our Aura pa-

rameters. The 3D Aura filter works by adding a radiating glow to any object in the scene that has a Glow parameter set in its shader properties. That is why we were focusing on the Glow aspect of our fountain shader earlier in this tutorial. Enter the following parameters in the 3D Aura dialog box:

Radius: 20

Intensity: 100%

Color: (using the default HLS wheel, H: 12, L: 50, S: 100)

You will see in the preview window that a radiating glow appears around your particle fountain (Figure 5).

At the moment, it looks a little squared off. That is because it is in its lowest performance mode. Under the Radius slider, there is a check box called Distance Attenuation. Click that and you will see the aura quality increase and conform to your shapes more appropriately. This will put a small increase in your rendering times, but the payoff is worth it. If you have some time, you might want to try a test render with the Distance Attenuation on, and another test render with it off so that you can see the differences yourself.

At this point, it would be good to do another test render to see how the Aura affected your fountain. Just jump back to the Render room and press Render (Figure 6).

FIGURE 6 *Rendering.*

Once you've done that, go back to the Assembly room.

STEP 5: AERODYNAMICS OF EXHAUST

Now that we have our basic exhaust element in our fountain primitive set, we are going to customize it further by adding a second fountain to the mix. We are going to add an inner core to the exhaust stream that is narrower and more condensed than the outer and more dispersed blast we currently have. Fortunately, this is pretty easy to do.

While in the Assembly room, click on our fountain object in the object hierarchy list in the lower Animation drawer. We are now going to duplicate it by going to the Edit menu and selecting Duplicate. In the object hierarchy list, you will now see another instance of the fountain object. We need to make that a master object, so that we can edit it independently of the other fountain, because if we currently edit one, we will edit the other simultaneously. With our new fountain selected, go to the Edit menu and select Promote To Master. You will now see the object called "Fountain 1" in the object hierarchy. With "Fountain 1" selected, go to the Model room. Move your timeline indicator in the animation timeline drawer to our zero-hour mark, and change the properties for "Fountain 1" to the following:

Completion: 0

Number of Particles: 0

FIGURE 5 *Radiating glow.*

Maximum Dispersion: 25
Maximum Swirl: 0
Initial Velocity: 0
Gravity: 0
Particle Size: 0.15

Now change the timeline indicator to our 10-second mark, and change the properties for "Fountain 1" to the following:

Completion: 100%
Number of Particles: 1000
Maximum Dispersion: 10
Maximum Swirl: 0
Initial Velocity: 3
Gravity: 4
Particle Size: 0.15

This will now give us an inner core to our exhaust that is more intense and dense than our broader initial exhaust stream. You can take this opportunity to render out another test if you are interested in seeing how this secondary fountain affects your exhaust stream (Figure 7).

FIGURE 7 *Effect of secondary exhaust stream.*

STEP 6: PUTTING THE EXHAUST INTO CONTEXT

We're now going to take our fountains and put them into context instead of sitting in mid air. The first thing we need to do is take the fountain primitives and put them into a single usable object for assembly purposes. Make sure you are in the Assembly room, and in the object hierarchy, select "Fountain." Now open the Properties drawer at the right of the screen, and with the General tab selected, change its name to "Outer Exhaust." Now select the "Fountain 2" object and change its name to "Inner Exhaust." They are now named for easy identification, and we will now group them into a single object to make them easier to manipulate. In the object hierarchy list in the Animation drawer, select both "Outer Exhaust" and "Inner Exhaust" by shift-clicking on them. Once you have them both selected, go to the Edit menu and select Group. You will now have a group object in your hierarchy list called, funny enough, "Group." Following the same procedure you used with the fountains, rename this to "Exhaust." The last thing we need to do is rename the shader we are using. In the objects hierarchy, scroll down to the section titled "Master Shaders." Click on the shader called "Shader," and in the Properties drawer at the right, change its name to "Exhaust shader." Now that we have our Exhaust object and shader set, we need to give it some context to emit from. For the purpose of this tutorial, I am taking the Space Shuttle object that was included with Carrara, on disk 2. Feel free to use your own spaceship, or whatever object you want to have radiating exhaust from. Bring this object into the scene by Importing it instead of Opening it under the File menu from the directory Objects: AIRCRAFT2 : SPCSHUTL. When the shuttle object loads, you will find that it is slightly rotated. We are going to need to correct this. Make sure your timeline indicator is set to zero-hour. Under the "Spcshutl." object you will see a subgroup called "Shuttle and rockets"; make sure you select this. In the Properties dialog at the right, click the Motion/Transform button and set the YAW value to –90. Now that our shuttle is centered and facing us properly, select the "Exhaust" group. You won't be able to see the actual particles at this point, because we are on zero-hour of the timeline, and they are not visible yet. What you will see is the bounding box edges of our exhaust object. Use this to align the exhaust object under the right fuel rocket of the space shuttle (Figure 8).

FIGURE 8 *Aligning the exhaust object.*

FIGURE 9 *Right exhaust.*

Once you have this in place, drag your timeline indicator in the Animation drawer toward 10 seconds. This will let you know if you have positioned it correctly. If you have been referring to the diagrams, it should be in the right place. DO NOT move the exhaust object if you are not at zero-hour, as this will cause the exhaust object as a whole to do a transform over time, and we don't want that. Once you have the exhaust object placed where you want it below the right fuel rocket, make sure you are at zero-hour and then duplicate the "Exhaust" object. With the duplicate selected, change your view to the Left, and holding Shift down, drag your exhaust object under the left fuel rocket. Holding Shift will constrain it to the same height as your other exhaust object.

With the duplicate exhaust object under the left fuel rocket selected, go to the Properties drawer and rename this group "Left Exhaust." Then go and rename the exhaust object under the right fuel rocket "Right Exhaust (Figure 9)."

We're nearly there; we now have to add a few helper elements to our scene to make it just that bit more convincing.

STEP 7: LIGHTING CONTROL

They say you can always fake it with good lighting, and that point isn't any more true than it is here. Our radiating exhaust isn't real; it is a series of special filter and geometric manipulations to simulate visibility and volumetrics. However, it doesn't interact with any other objects in that the glow doesn't cast light at all. To simulate this, we could put a light bulb in the middle of the particle fountains, and cross our fingers. However, in reality, that won't help in our illusion, because the light source would be emitting from a single point of light in the exhaust streams, and not from all of the exhaust itself. Because Carrara doesn't support radiosity rendering, we are going to have to fake it through careful placement of external light sources. First, make sure you are at zero-hour, and then insert a spotlight into the scene by going to the Insert menu and selecting Spot. In the Properties drawer at the right, change the General properties of the light to the following:

Brightness: 200%
Half Angle: 45
Angular Falloff: 0
Range: 400 in.
Cast Shadows: On
Shadow Intensity 100%

Once you have done that, click the Effects button in the Properties drawer, and change the Shadow type to Soft Shadows, leaving the default settings intact. Our light is now ready to use. The exhaust coming from the shuttle will be very intense, so we are going to use more than one instance of this light to light

the underside of the shuttle and rockets to look like the exhaust is radiating light onto them. To do this, we are going to duplicate our light three times, so that there are four spotlights. Move each light to the four corners surrounding the shuttle and slightly lower than the shuttle and rockets. Select one of the lights, and then select the shuttle object by Shift-clicking on the "Shuttle and rockets" object in the object hierarchy. With them both selected, go to the Edit menu and select Point At; this will aim the light at the shuttle for you. Do this for each light, so that you have them arranged similar to Figure 10.

Now that are lights are arranged, we need to introduce them as the exhaust intensifies; otherwise, at zero-hour there would be a strong light radiating onto the shuttle, but no exhaust. What we need to do is set up a keyframe at the 10-second mark with our current light settings, and then work backward. To do this, select all the spotlights by Shift-clicking them in the object hierarchy, and move the timeline indicator to our 10-second mark. Once you are there, click the Create Key Frames button at the upper left of the Animation drawer, (the key icon). You will see four keyframes added, one for each spotlight. Now, if you scrub through our animation by dragging the timeline indicator, you will see that the exhaust doesn't really kick in until about 4 seconds, so we will add another set of keyframes at 4 seconds exactly the same way we did at the 10-second mark. Now we need to create our light fade-in. Move the

timeline indicator to zero-hour and click on each spotlight individually, and in the Properties drawer at the right, change the Brightness of each light to 0%. This will cause the lights to go from 0% intensity to 200% intensity over the first 4 seconds of the animation, matching the intensity of the exhaust streams.

We are nearly there . . . so close. The very last thing we need to do is add one more special filter to our scene. Making sure you are at zero-hour, go to the Edit menu and select Edit Scene Effects. Click the Effects button, click on the + (plus) sign, and add the Motion Blur filter. Set the Intensity to 150% and make sure that Blur and Render First Frames are enabled. It is very important that the 3D Aura filter is before the Motion Blur filter in the list, or your effect will not look as good as it can. If you have followed everything correctly, they should be in the right order.

Go back to the hierarchy list and select all the objects except for Camera 1 and Light 1. Once they are all selected, group them by going to the Edit menu and selecting Group. Change this group's name to "Animated Shuttle" and save your project.

STEP 8: THE POWER OF SPECIAL FX

Make sure you are at zero-hour, and click on Camera 1 in your view port. Use your camera controls to frame your shuttle in an interesting way. A good suggestion is to make it so that it looks like it is coming at you. Once you find a shot you are comfortable with, go to the View menu and select Show Production Frame. Position the production frame so that your shuttle is framed inside it, and go to the Render room (the film strip icon in the upper right of the screen). In the Properties drawer at the right-hand side, select the Output Settings button. Set the Image Size Width to 640, the Height to 480, and click the Keep Proportions button (in case you decide to change the size so that it still is in proportion to how you set your production frame). Make sure the Rendering Camera is set to "Camera 1" and the File Format is set to Movie. Make sure the Start time

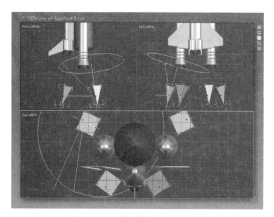

FIGURE 10 *Arranging the lights.*

is 00:00:00 and the End time is 00:10:00 with the Frame rate at 30fps (you can make this lower if you want to speed things up at the cost of a little smoothness). Next, click the Render button in the lower Animation drawer, sit back, and watch your 10-second Carrara Particle Exhaust come to life (Figure 11).

This effect has many uses, and I am sure you will find many more on your own. Don't be afraid to experiment with some of the settings we have laid out here and see what happens. All these settings can be animated so you can create pretty much any modification to this effect you want.

Have Fun.

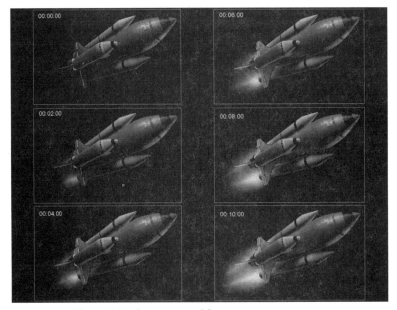

FIGURE 11 *The particle exhaust comes to life.*

17 Anatomy of the Hop In Cinema4D XL v6

—Adam Watkins

The purpose of this tutorial is to examine what the anatomy of the "hop" really is, and then how to keyframe such a hop within a computer animation application. The application I'll be using to demonstrate this is Cinema4D XL v6. I'll be relying heavily on C4D's HyperNURBS modeling capabilities and its bones functions. However, since the focus is on the motion, and many other applications have similar bone and modeling capabilities, this tutorial is useful in a variety of applications.

INTRODUCTION—THE COMPUTER HOP

One of the big advantages of using computers in animation is the ability to easily find rhythms. Frames are neatly labeled on a palette, and if you can count, you can make events occur at very even intervals; your running character's foot hits the ground every x frames, your bouncing ball hits the ground every two seconds, etc. The problem is, within those segments of evenly spaced instances are fairly unevenly spaced series of motions. Perhaps one of the biggest instances is the "hop."

One sure sign of a beginning animator is the "computer hop"; the object jumps, crests, and lands all in the same fluid motion at the same speed. It's easy to do. All the animator has to do is keyframe the moment the object leaves the ground, crests, and

then when it hits. Too often, this same evenly hopping object also remains fixed, hard, and looking more like a ball bearing than an animated object.

THE MODEL

The model I'm using to illustrate proper hopping is the one-legged creature shown in Figure 1. I created Figure 2 using HyperNURBS. Since I will cover HNs fairly extensively in the next tutorial, I'm going to forgo the extended discussion of creating the shape except to mention the trick of Inner Extrude/Extrude combinations.

FIGURE 1 *Model to Animate Hopping.*

FIGURE 2 *Extruded Box before HN.*

FIGURE 4 *Inner Extrude Tool.*

Typically, when extruding a polygon or face of a cube, a smooth transition is created, even if the new face is larger or smaller than the face before it. Sometimes, a sharper transition is needed. In areas like the waist and all the joints, I needed just such a transition. To achieve this, I first selected a face (Figure 3) and then used the Inner Extrude tool (Figure 4) to shrink the new polygon that remains on the surface of the face where it originated (Figure 5). Then, without moving this new face, I used the Extrude tool (Figure 6) to extrude a new face (Figure 7), thus creating a nice, sharp transition between regions.

FIGURE 5 *Inner Extrude Tool in Action Poly stays on parent poly.*

FIGURE 3 *Selected Polygon Face.*

FIGURE 6 *Extrude Tool.*

FIGURE 7 *New Extruded Fact with Crisp Transition.*

I'm using one leg because it just simplifies the process visually; however, these cycles will work with bipedal or quadrapedal characters as well.

For this jump cycle, I'll be using a fairly unconventional bone structure setup. This structure lends itself well to creating jump cycles. Figure 8 shows the bone structure that has been fixed in place, and the hierarchy in which they are arranged. Notice in the object manager that the bone structure is at the same hierarchical level as the mesh, both of which are placed within a Null object. I've assigned a Bone Function of 1r^8 so that our form bends like a joint and not like a noodle.

MOTION

Eadweard Muybridge was a 19th-century photographer who in 1850 set up shop in San Francisco and worked on landscape pictures. In 1872, railroad tycoon Leland Stanford, former Governor of California, asked him to photograph his famous horse, Occident, to settle a long-time debate over whether or not a running horse ever had all four feet off the ground. Muybridge used a series of glass-plated cameras triggered by rubber bands and wire to photograph the animal. His photographs of the "flying horse" made him an international sensation. As his setup became more complex, he was able to capture more and more series of motion, including human motion. His subsequent discovery that these series of images, when flipped through like a book, produced what looked to be motion, earned him the title of "Father of Motion Pictures." His exhibits inspired the likes of Thomas Edison, who soon began his own work on motion picture photography.

Among Muybridge's photography are several series of people in the act of jumping. Through analysis of these series of photographs, we can get a good idea of the mechanics behind a body in motion. This sort of study is very important in depicting a self-propelled body.

Figure 9 is a great photograph that shows all the important stages of the hop. This is definitely a

FIGURE 8 *Bone Structure for Given Model Mesh.*

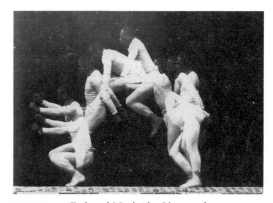

FIGURE 9 *Eadward Muybridge Photograph.*

"high hop," and it should be noted that the steps we'll cover should be altered for hops that are meant to show distance.

STRETCH-ELONGATION AND SQUASH-RECOIL

To begin, make sure that the Hierarchy Record is on in C4D and record (by adding a keyframe) your figure standing straight up with its arms at its side (Figure 10).

Some very important concepts can be learned from the Muybridge series of photographs. Notice at the beginning of the hop, we can see what is known as Stretch-Elongation and Squash-Recoil principles in animation. The jumping figure prepares for his jump by recoiling like a spring. In fact, that is really what is happening with the muscles in his body.

To translate this Squash information, move your time marker ahead about 15 frames (½ second) and pose your figure into a pose similar to the photograph and similar to Figure 11. Record a keyframe.

A key element behind Stretch and Squash is that when an object is in motion, it will orient itself in the direction that it is moving. In the case of our hopping photograph, all the extremities that the jumper has (his arms, legs, and torso) all point in a diagonal direction as he lifts off in the direction of the height of his jump—this is the stretch part.

FIGURE 11 *Initial Squash Position.*

Figure 12 shows the moment right before the figure leaves the ground (about 20 frames into the animation). Notice the strong line of all of the body pointing toward the hop's crest. This line continues as the figure rises from the ground (Figure 13) another 5 frames into the animation (about frame 25). Note that this initial lift-off carries a lot of force, and as such, the speed of the jumper is quite fast.

At the top or crest of the hop, our photograph tells us that there is a mini-squash again as the force of gravity begins to catch up with the body and overtake the upward force initially exerted by the muscles. Additionally, there is a change in direction as the body begins to anticipate the landing that in-

FIGURE 10 *Starting Position.*

FIGURE 12 *First Stretch.*

FIGURE 13 *Lift-Off.*

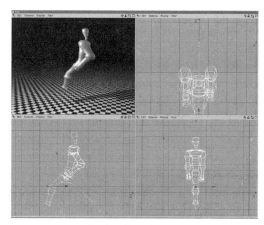

FIGURE 15 *Pre-landing Stretch.*

evitably comes. An important thing to notice about the crest of the hop is that since it is the beginning of a change in direction, there is a dramatic slowdown in the speed of the moving object (at about frame 35 now). Figure 14 shows the squash at the very crest of the hop. Notice that not only is the figure squashing again, but the feet are beginning to swing around into position to catch the form when it falls.

As the figure begins to descend, first the arms anticipate the downward diagonal motion, and then the feet and the rest of the body catch up; all pointing downward toward the landing spot. This second stretch is shown in Figure 15—the time between hop crest and landing where the extremities are all in anticipation of landing. Note that immediately after

this, the hands fall a little behind. During this time, the speed of the hopper increases again, as gravity becomes the dominating force.

Upon impact with the ground, the final squash occurs as all the downward weight comes to bear against the surface stopping it's travel. Initially, this squash is essentially in the direction that the object has just come (Figure 16), but as the forward momentum also must be accounted for, this squash shifts forward (Figure 17) until the figure begins to stand upright. However, before the figure stands upright, the previously trailing arms catch up and pass the body as it regains its balance (Figure 18). Then, at last, back to standing again (Figure 19).

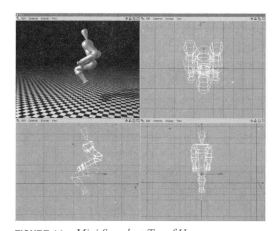

FIGURE 14 *Mini-Squash at Top of Hop.*

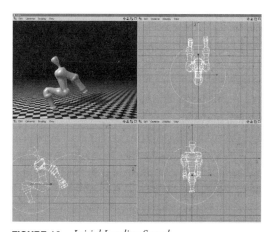

FIGURE 16 *Initial Landing Squash.*

FIGURE 17 *Forward Momentum.*

FIGURE 18 *Secondary Arm Motion.*

FIGURE 19 *Back to Standing,*

CONCLUSION

There are an amazing amount of other details that could be covered here—movements of arcs, specific timing issues, and muscle distortions, to name a few. However, many of the finishing touches are things that you'll want to experiment with yourself. Perhaps a tutorial in the future could cover some of these. Don't forget that animating believable motion requires a lot of tweaking time. Take time to render quick Editor-version animations to see how the movement plays out. Tweak, render, and tweak again. Jump around yourself to get the feel of what you are trying to animate. Above all, have fun with it as you fine-tune your movement.

A multitude of other character-establishing touches could be added to this particular animation. Objects can actually hop will all sorts of attitudes that express power, diminutiveness, attitude, and so forth. However, good hops and motion in general are based on some important principles that can be learned from real-world examination. Even if the animated object is far from real world, a viewer will only buy into the motion presented if he can relate it (even on a subconscious level) to what he knows in reality.

These concepts presented here aren't new or revolutionary; they've been around as long as motion animation has been on the screen. From dancing hippos to running coyotes, the ideas of stretch-squash and weight are present in all good animation. Watch for it next time you are viewing a well-done cartoon.

18

HyperNurbs and the Anatomy of the Flight Cycle in C4D V6

—ADAM WATKINS

The following tutorial uses Maxon's Cinema4D V6. This software is cross platform and all the information listed in this tutorial is applicable to both PC and Mac users. C4D handles complex models fairly well, so you won't need a supercomputer to complete this tutorial. The principles discussed in regard to bone organization, placement, and bird motion are, in fact, applicable to any 3D application on any platform.

Birds seem an odd place to begin a study of weight. These seemingly weightless creatures seem to defy gravity as they glide effortlessly through the air. The truth of the matter is that the flight of birds is actually hard work; there is a lot of energy expelled and some fairly dynamic shifts in weight occur as a bird creates enough lift through its wings to overcome gravity.

Before we can delve into the specifics of the physics of flight, let's first create the bird. To do this, we'll use the newly implemented Hyper NURBS functions within Cinema4D. Hyper NURBS (HN) is a form of "cage" modeling. The idea is that a cage can be placed around an object that influences the object it encloses. If you bend or stretch parts of the cage, the shape within bends or stretches with it.

Start by creating a primitive cube (Figure 1). Although primitives can be placed within HN objects, we can't edit a primitive shape the way we'll need to to turn the block into a bird (Figure 2). Go to Structure->Make Editable or press C (Figure 3). In the Objects Manager you'll see an extra icon (Figure 4) signifying that you are free to move parts of the polygon about the cabin.

Now what we'll do is take facets (or faces) of this newly created cube and extrude them out in new directions to form the bird. Select the Polygon tool (Figure 5), and with the Selection tool, select the front face of the cube (Figure 6). If we were to just drag this face, we'd just be making the cube longer. What we want to do is create a whole new extension of the cube. To do this, go to Structure->Extrude (Figure 7). The mouse will change to indicate you

FIGURE 1 *Creation of primitive cube.*

FIGURE 2 *Primitive symbol.*

FIGURE 3 *Make Editable command.*

FIGURE 4 *New Editable icon.*

FIGURE 5 *Polygon tool.*

FIGURE 6 *Selection of one face.*

FIGURE 7 *Extrude command.*

have the Extrude tool active. Click and drag the se-
lected polygon face out until you have a new exten-
sion of the cube about the size shown in Figure 8.
Now, using the Resize tool (Figure 9), resize this
newly extruded face and then use the Move tool
(Figure 10) to slide it up into place to begin to make
the neck of the bird (Figure 11).

Before you start to wonder what kind of strange
bird made of right angles we're creating, let's create

FIGURE 8 *Extruded face.*

an HN and round off those edges. Create a new Hyper NURBS object (Figure 12). Take the cube we've been altering and place it within the HN object in the Objects Manager (Figure 13). Figure 14 shows the resultant HN form. Using the View Rotate tool (Figure 15) in the top right-hand corner of the editor window, you can rotate the view around the shape. We'll need to do so now as we continue building the neck out to the head. Again, select the Extrude tool and extrude a new extension off the front of the shape. This time, after extruding the shape, rotate the face using the Rotate tool (Figure 16) so that you get a shape similar to Figure 17.

FIGURE 9 *Resize tool.*

FIGURE 12 *Hyper NURBS object.*

FIGURE 10 *Move tool.*

FIGURE 13 *Object Manager—hierarchical organization.*

FIGURE 11 *Neck created.*

FIGURE 14 *Resulting HN form.*

FIGURE 15 *View Rotate tool.*

FIGURE 16 *Rotated extruded shape.*

FIGURE 17 *Resultant shape.*

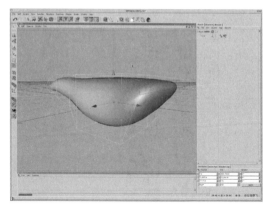

FIGURE 18 *Resized tail.*

FIGURE 19 *Inner Extrude tool.*

FIGURE 20 *Split views.*

Continue this process by extruding the shape off the backside in anticipation of the tail. After the back face is extruded, resize it so that it is a long thin shape (Figure 18). To create the very thin feeling of the tail, we'll use the Inner Extrude tool (Figure 19) to create an extruded face that doesn't have the same gradual shift from one face to another. When this tool is used, it creates a new face that stays on the surface of its parent face. By shifting this new face up and then extruding it again, we can get a shape similar to Figure 21.

At this point, it would be helpful to be able to see our wingless bird from more than one viewpoint at a time. To do this, select the rightmost icon in the editor window (Figure 20) and your view will be split into four windows showing a top, front, and side views (Figure 21). Now as we begin to build the wings, we'll use the new Symmetry functions in C4D so that we only have to manually build one wing.

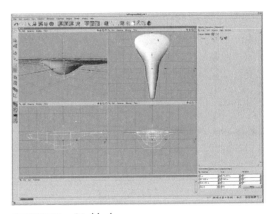

FIGURE 21 *Bird body.*

Make a Symmetry object (Figure 22) and then double-click on it in the Object Manager and select ZY as the mirror plane (Figure 23). Now place the HN object beneath the Symmetry object in the Objects Manager (Figure 24).

Now, select the cube within the Objects Manager (Figure 25) and extrude a face off the side of the side of the bird to begin the wing (Figure 26). In the editor window, change the top view to a bottom view (Figure 27). We're going to cut this newly extruded form so that we can give this new wing a rounder shape. Select the Knife tool (Figure 28) and holding the Shift key down (to keep the cut straight), cut the

FIGURE 22 *Symmetry object.*

FIGURE 23 *Selected mirror plane.*

FIGURE 24 *HN object within Symmetry object.*

FIGURE 25 *Cube selected.*

FIGURE 26 *Extruded wing.*

FIGURE 27 *Bottom view.*

FIGURE 28 *Knife tool.*

FIGURE 30 *New face created.*

wing as shown in Figure 29. The result (Figure 30) shows a new face has been created. Extrude out one more face (Figure 31), and then select the Point and Selection tools (Figure 32).

In the bottom right-hand corner of the interface, you can set some characteristics for the Selection tool. We want to select points of the faces we've been creating and bend them to match the shape we wish to create. Deselect the "Only Select Visible Elements" so that when we select points from the top view, it selects the points on the opposite end as well (Figure 33). Select the Points at the front ends of the wings and adjust them (using the Move tool) to look like Figure 34.

FIGURE 31 *Continued extruded wing.*

FIGURE 29 *Cut wing.*

FIGURE 32 *Point Selection tool.*

FIGURE 33 *Only Select Visible Elements dialog.*

FIGURE 35 *Bird thus far.*

FIGURE 34 *Adjusted wing tips.*

FIGURE 36 *New HN object.*

Now let's create the beak. Making sure that the head of your bird appears similar to Figure 35, create and resize another cube and an HN object, and place the new combination as shown in Figure 36.

Now, to make the two sides of the beak, we could knife the shape, or by double-clicking on the new cube within the Objects Manager, we can simply tell C4D to make the cube have two segments to begin with (Figure 37). Using the same techniques covered to create the body, refine the shape of the beak (Figures 38, 39, and 40).

Now it's time to place the bones. Create a Bone object (Figure 41). The default placement will probably be incorrect, but by grabbing the orange dot at the end of the bone, you can rotate the bone into place (Figure 42). CNTRL-click this same orange dot to create a new bone that is a child and extended

Cube		
	Size	Segments
Width (X)	200 m	2
Height (Y)	200 m	1
Depth (Z)	200 m	1
☐ Fillet	40 m	5
☐ Separate Surfaces		
	Cancel	OK

FIGURE 37 *Two segments of cube.*

FIGURE 38 *Refined beak shape 1.*

FIGURE 39 *Refined beak shape 2.*

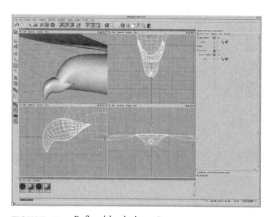

FIGURE 40 *Refined beak shape 3.*

off the first. Repeat and continue this process to create more bones as desired.

Before we begin looking at a bird's weight shifting up and down, let's look at ways to structure an IK or FK structure within a bird mesh. One strategy is to place a series of bones along the spine of the bird, with wing bones extruding from the appropriate locations. How many bones need to go into this spine is completely dependent on how detailed you wish to animate your bird. Along this spine, you may wish to have 10–20 bones, or simply one for the head, one for the body, and one for the neck. Or, in simplest terms, an IK structure for a bird can be simplified down to three bones in either wing without any bones for the body. Figure 43 uses this strategy. One of the reasons that this works is that Cinema4D (which is what is used to create this tutorial) uses

FIGURE 41 *Create Bone object.*

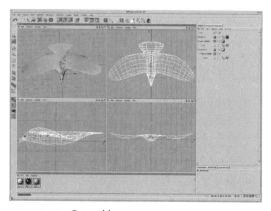

FIGURE 42 *Rotated bone.*

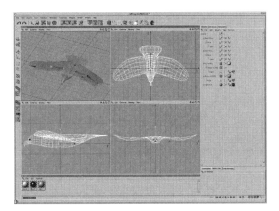

FIGURE 43 *Simplified wing bone structure.*

FIGURE 44 *Changed bone function.*

bones with spheres of influence. So, the bones of the wings also affect the middle of the body as well as the wings. As the polygons get further away from the bones, the influence of the bones on the polys weaken. Thus, the head and tail always lag a bit behind the middle of the body, which is fairly close to what happens with a real bird in flight.

Before we go much further, I need to mention some housecleaning apparent in Figure 43. I've created a Null object, named it "Bird," and placed all the objects we have thus far created within this new object. This places the new bones at the same hierarchical level of the bird shape. We want to make sure that the bones bend like joints and not like wet noodles. To do this, we need to adjust the bone function.

Double-click on the bone icon next to the parent-most bone of each wing. The dialog box that appears allows for the alteration of the "Function" field. The default creates a very soft bend. Change the setting so that it matches Figure 44. Now affix these bones to the bird by first selecting the new Null Parent object and then going to Objects->Fix Bones within the Objects Manager (Figure 45). Click "Yes" when asked to include subobjects.

Now that we've discussed structure, let's take a look at weight. To analyze this idea of weight rising and falling, let's create an imaginary plane through the middle of a bird with its wings outstretched straight to its side (Figure 46). If you plan to animate at this point, record a keyframe here for the bird (make sure Hierarchy is turned on).

FIGURE 45 *Fix bones to mesh.*

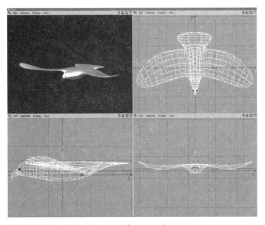

FIGURE 46 *Imaginary reference plane.*

As a bird pulls its bent wings up in anticipation of a downstroke, gravity catches up with these seemingly weightless creatures for a second and their body drops slightly (Figure 47). An important thing to notice about this part of the flight cycle is that the bird bends its wings in toward its body to minimize surface area and pulls them upward quickly to minimize the time needed to prepare for downstroke.

To create this pose, you can use the Rotation tool and select each bone and rotate into place, or you can simply grab the orange dot on the end of the bones and move it into place. If all the bones are correct in their place in the hierarchy, they'll behave like, well, real bones. Record a keyframe at this point.

When the bird starts its downstroke, things really start happening. First, the bird becomes more aerodynamic by pulling its wing tips back. In addition, it spreads its wings as far out as it can, thus maximizing the surface area under the wings to give it lift. With this powerful downstroke, the weight of its body rises in accordance with the upward lift (Figure 48). A nice touch during this phase of the flight is to leave the last bone on either wing turned slightly upward in an attitude of secondary motion. Record a keyframe.

How far down these wings go largely depends on the species of bird. Some have downstrokes that barely break the horizontal plane of their body, while

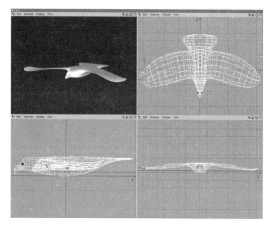

FIGURE 48 *Downstroke—notice body lift.*

others bring the wings so far down that the edges nearly touch. As this downstroke continues, the bird as a whole rises higher and higher until, at the point that the bird begins to bring its wings back up in preparation of another downstroke, its at the highest point relative to the flight cycle (Figure 49). Record a keyframe.

The steps then just reverse. You can copy and paste the already created keyframes in reverse order. As the bird pulls its wings back up, they fold in closer to the body to minimize wing drag, during which the body of the bird drops in the air. Then at the top

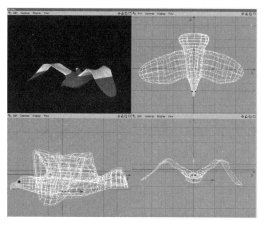

FIGURE 47 *Upstroke—notice drop in body.*

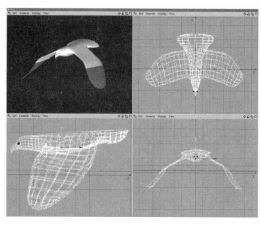

FIGURE 49 *End of flight cycle.*

of the upswing, the bird spreads its wings again as it begins its downstroke.

There are other interesting parts of a bird's flight that are largely part of establishing character in the bird. For instance, if on the downstroke the head and tail dip wildly, the bird has a much more labored look. Likewise, the tips of the wings of any winged animal can easily be adjusted to give the interpretation of hands. How these wing tips react in flight helps establish aviary character. So, even though there are lots of other important details, if you keep to the basics outlined above, you'll always create a bird whose flight is believable.

CHAPTER

19

3D MAX 3.0 Tutorial: Leonardo's Flying Machine

—BY SANFORD KENNEDY

SYSTEM REQUIREMENTS

MAX 2.5 or 3.0, at least a Pentium 200, and 64MB of RAM. The model was built on a Dell Dual 450 Pentium II with 256MB of RAM using 3DS MAX 3.0.

Leonardo da Vinci designed several flying machines between the years 1480 and 1500. Many of them were impractical and were powered with a variety of paddles, levers, flapping wings, and even a giant revolving helical propeller like a helicopter. His most practical design was a simple one-man flapping-wing glider, made with ribs of wood and covered with taffeta cloth. The plane was not a true glider, and relied on pilot's muscle power to move it through the air. Leonardo believed that if he could figure out the right mechanism, he could make a flying machine that imitated a bird. Unfortunately, he never succeeded, and it wasn't until the early 1800s that fixed wing gliders were successfully flown in Europe.

I decided to build Leonardo's flier in 3D MAX 3.0 using NURBS. NURBS surfaces are excellent for simulating cloth because the surface always remains smooth even when distorted or stretched, and you

can animate the control vertices (CVs) to create the flapping of the cloth. In the following tutorial, I will explain how I built and surfaced the model. There will be a follow-up tutorial where I explain how to animate the model taking off from a cliff with a pilot flapping the wings.

BUILDING THE FLAPPING-WING GLIDER

I started the project by scanning a photo of a large-scale model of Leonardo's flyer from a museum. I loaded the photo into MAX's top viewport as a background image. Right on top of the photo I drew NURBS CV curves for the right wing, starting with the wing's leading edge. Then I drew a second curve that was scalloped to form the wing's trailing edge. I decided to use UV Lofting to generate the wing surface so that I could create the thin NURBS airfoil shape between the ribs. In real life, the soft cloth attached to the ribs would catch the air and billow up as it stretches in flight. The leading and trailing edges became the U curves, and the curves I drew over the ribs became the V curves, as shown in Figure 1. Using the UV Loft tool, I selected first the U curves,

then the V curves in sequence, which generated the NURBS surface for the cloth wing covering.

To create the wooden wing ribs and leading-edge spar, I cloned my original CV curves, and hid the wing cloth NURBS surface. To create the individual ribs, I first selected a long rib curve, then I created two small circular cross-section curves. These formed the beginning and end shapes, and would result in a tapered rib. Because I had 10 ribs to make in each wing, I cloned the two cross-section curves 10 times and positioned them next to the ends of all the rib curves. Then I selected one cross-section curve at a time and rotated them, making sure that they were perpendicular to the ends of their respective rib curve. I moved them into position so that one edge touched the curve, as shown in the right half of Figure 2. Next, I attached the two cross-section curves to the appropriate rib curve using the NURBS Curve/Attach command.

To create the rib surface, I used the NURBS 1 Rail Sweep tool. I selected the long curve, then the two cross-sections. Once the curved tubular NURBS surface was generated for all 10 ribs and the wing leading edge, the next step was to match the ends of the ribs evenly with the leading edge of the wing. I selected the end curve of the rib using NURBS Curve/Sub object/Curve and moved it along the rib curve to center the rib end inside the leading edge, as shown in the right half of Figure 2. Finally, I attached the entire right wing rib assembly together as shown in Figure 3

FIGURE 2 *Moving into position.*

FIGURE 3 *Attaching the wing.*

I un-hid the NURBS wing surface and positioned it just above the ribs. Then, because I wanted to modify the shape of both the ribs and the cloth surface into a curved airfoil shape, I attached the ribs to the wing surface using the Modify/NURBS surface/Attach command. Now, when I moved the CVs around to shape the wing, the ribs and the cloth would be moved together. In the NURBS/ Sub object/Surface CV level, I selected different groups of CVs across the center and the trailing edges of the wing, and translated them up or down in Y as necessary to create a curved airfoil shape that curved down across both the length and width of the wing, as shown in Figure 4. The final operation was to turn off Sub object mode, and then to Mirror/Copy the

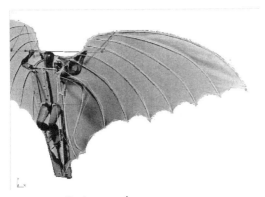

FIGURE 1 *Getting started.*

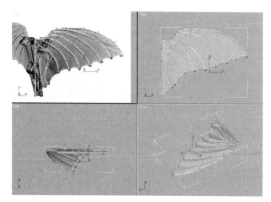

FIGURE 4　*Creating the airfoil shape.*

FIGURE 5　*Adding support boards and a central rail.*

wing in the top view in the X axis to create the left wing.

THE PILOT'S PLATFORM

The next step was to create the wooden platform on which the pilot would lay as he flew. Leonardo designed the platform with three strong wooden hoops to mount the wing hinges. The pilot climbed inside these hoops to operate the craft by grasping a bar and rod linkage that hung in front of him to move the wings up and down. He secured himself to the platform with a leather strap. The platform itself was made from tapered flat boards. The area where the pilot lays is cut away below his waist to allow him to bend his legs down, and use them as landing gear. Unfortunately, there does not seem to be any structure to protect his face or neck in the event of a crash.

To build the platform, I started by creating one of the long side rails from a polygonal box primitive. I gave it nine height segments and then converted to Editable Mesh and sculpted a curve on its inner edge to form the leg cutout area. Then I Mirror Cloned the box to create the opposite side rail. I added two flat boxes to form the body support boards and added a third central rail, and tapered them so they fit together, as shown in Figure 5.

The next task was to create three wooden wing support hoops that are used to attach the wings to the platform. I applied the Bend modifier to one thin cylinder primitive to form a half circle, then I Cloned it, Scaled and Translated it twice, and positioned the resulting objects on top of the platform. Next, I added a thin rail to connect the tops of hoops and tie the whole construction together forming a mount for the wing hinges. I turned my attention at this point to the fastenings and details of the platform, creating small cylinders and placing them along the rails to represent the wooden screw heads that fastened the platform boards together, and flaring the bottoms of the hoops to match Leonardo's design, as shown in Figure 6. I could not find any detailed photos of the wing hinges, so I devised a simple plate and pin arrangement for the wing hinges and mounted them on top of the wing support. Finally, I positioned the wings on top of the hoops.

The wing operating rods extend down from the wing spars and attach to a long wooden cross bar that the pilot grasps with his hands and moves up and down to flap the wings. The ends of these rods are formed into loops that surround the wooded bar. I built the wing rods and the bar from cylinder prim-

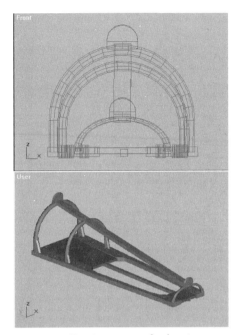

FIGURE 6 *Forming a mount for the wings.*

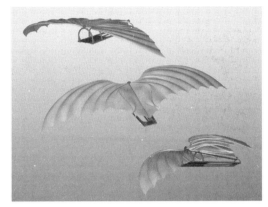

FIGURE 7 *Three views of the model.*

itives, then added two small torus primitives to the ends to simulate the loops.

TEXTURING THE MODEL

The wings were covered with taffeta cloth, and sewn onto to the wing ribs with thin cord, according to the book: *The Inventions of Leonardo Da Vinci by Margaret Cooper*, published by Macmillan. The UV Lofted NURBS wing surface of my model was completely smooth and really looked more like plastic than cloth. Figure 7 shows three views of the model with the default "plastic" materials applied. I wanted to apply a texture to the NURBS wing surface that would make it look like real cloth. I reasoned that some creases and wrinkles would be present at the cloth attachment points. I decided to use a combination of layered Texture maps, with a Noise map to make it slightly dirty, and a Bump map to add the creases and irregularities that a real hand-sewn cloth wing would have. In addition, I wanted to make the trailing edge of the wing cloth a

little bumpy, so it would look like it had a cord sewn into the seam.

My first step was to Render a Top View Image of the finished wing surface. I brought the image into Adobe Photoshop and painted over it with a sepia tone. I duplicated it, and then turned the copy into a painted grayscale "crease and wrinkle" Bump map. Returning to MAX's Materials Editor, I used a MIX map texture in the Diffuse map channel and combined the sepia toned diffuse Color map with a blotchy Noise map to make it a little dirty. In the Bump map channel I loaded the Grayscale Bump map with a strength setting of 70 and applied the material to both wings.

The wing ribs, spars, and the platform were all originally made of smoothed wood. I decided to create a dark, rubbed-oil wood Texture map for these surfaces. I again used a two-layer MIX texture and combined an Old Wood map with a Grainy Noise map to give the wood a rich, weathered appearance.

The last detail was to add the metal material to the wing operating rods and wood texture to the cross bar. The final rendered model is shown in Figure 8.

The NURBS tools of 3D Studio MAX 3.0 are greatly improved over version 2.5, and made the construction of this model quick and easy. In the next tutorial of this series, I will add a pilot and animate Leonardo's flier as the pilot casts himself off a

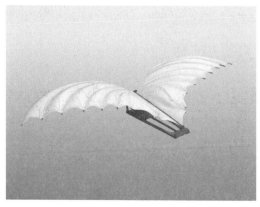

FIGURE 8 *Final view.*

cliff, catches a thermal updraft, and flaps his wings like a bird through the air.

Leonardo da Vinci was a student of aeronautics before there was a science called "Aeronautics." He observed, drew, and dissected numerous birds trying to understand their structure and how they flew. Even though his inventions never flew, he came very close to the mark nearly 400 years before the Wright Brothers. If he had built this flier as a fixed-wing glider, using lightweight modern materials and methods, he probably would have succeeded.

CHAPTER 20

Animating Leonardo's Flying Machine Using 3D's MAX 3.0

—SANFORD KENNEDY

SYSTEM REQUIREMENTS:

Max 2.5 or 3.0, at least a Pentium 200, and 6MB of RAM. This animation was done on a Dell dual Pentium 450 with 396MB of RAM.

I n the previous tutorial, I described how I built Leonardo da Vinci's flapping-wing flying machine using NURBS in 3DS MAX 3.0, as shown in Figure 1. The historical record is unclear about whether Leonardo ever actually tested any of his flying machines. I wanted to create an animation showing one of his young assistants risking his life for the privilege of being the first man in history to fly. In this tutorial, I explain how I set up the flier model for animation, and how I created and animated the pilot. The animation sequence consists of a running take-off, a circling flight, and a rough landing in the field. The pilot runs toward the edge of the cliff carrying the flier, while flapping its wings as powerfully as he can, and then dives off into space.

To create a setting for the flight, I modeled a cliff with a field below where the flier could land. The cliff was made by drawing a spline shape in the top viewport, then using the Bevel modifier to extrude it upward in three stages to form a cliff with rounded

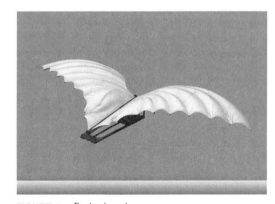

FIGURE 1 *Beginning view.*

contours. I created the field from a Quad Patch and applied a Noise modifier with a strength of 60 in the Z axis to give the surface a soft mounded appearance.

SETTING UP THE MODEL FOR ANIMATION

To set up the wings for animation, I started by creating two dummy (or null) objects to serve as wing pivot points. Each wing of the flier was built from NURBS surfaces, and was designed so that its **123**

associated wing ribs were attached to the cloth covering to form one complete wing assembly. The left and right wings were then linked to separate Dummies positioned at their root (the edge where the wings meet) to act as rotational pivots for the flapping wing action, as shown in Figure 2. These two dummies were, in turn, linked to the main wing support rib that runs along the center of the pilot's wooden platform. Leonardo's design for the wing operating levers required that the pilot pull down to lower the wings and raise up his arms to raise the wings. This was accomplished by using levers hinged at the wing center and pull rods attached to the wing leading edge. Once all the parts were in place, as shown in Figure 3, I selected each wing dummy and rotated it to test the pivoting wing action.

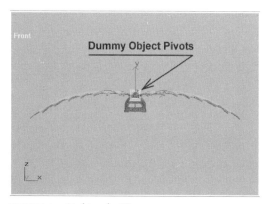

FIGURE 2 *Linking the Wings.*

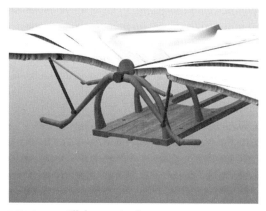

FIGURE 3 *All the parts in place.*

The greatest error in Leonardo's wing mechanism design was that there was nothing to keep the wings from folding back on themselves except the strength of the arms of the pilot. When the pilot got tired, he could no longer keep the wings held in position, so he would crash to the ground. For my own peace of mind, I added a wooden bar that stuck out from both sides of the platform. Then I attached two ropes from the bar to the wing's leading edges to limit their upward travel so that they stopped at the correct angle for gliding flight. That way, the pilot could relax and glide without effort once he was in the air. He could then concentrate on shifting his weight to guide the craft like a modern hang glider, and resume flapping the wings when he needed to gain altitude or avoid an obstacle.

To create the test pilot, I decided to use a low polygon model. A high-resolution model would have looked better in a close-up shot, but the high face count would slow down both the animation playback and rendering. I chose to use the Casual Man model from Character Studio 2.2 that already was attached to a biped skeleton. I merged in the model, and discovered that it was too small for the flier. Instead of scaling up the character and its biped, I scaled down the flier to fit the pilot.

I decided to animate the pilot using the Freeform animation mode instead of the default Character Studio Footstep animation mode because he would be spending most of his time with his feet off the ground. I have found that Footstep animations are not easy to control when they have extensive sections where the feet leave the ground. Freeform mode is entered by turning on the Animate button and moving any part of the biped to create a key. You then get a warning stating that you cannot create a footstep animation once you start a freeform animation without footsteps. I moved the time slider to frame 5, turned on the Animate button, and then started rotating his arms and body to the correct position. At first I had trouble making the parts stay where I put them. When I saved and reloaded the file, the pilot popped back to his starting position as if I had never moved him. The solution was to go into the Motion/Biped Animation Properties menu and

switch all keys from Biped Dynamics to Spline Dynamics, turning off Character Studio's built-in figure dynamics. This allowed me to position the figure anywhere I wanted.

To place the pilot, and to fit him into the flier platform, I bent him over at the waist and brought his legs forward so that he was standing bent, with the flier positioned on his back, as shown in Figure 4. I rotated his arms and wrists to place his hands on the wing lever handles. Unfortunately, the low-resolution Casual Man model had no fingers, so I applied an Edit Mesh modifier after Physique on the Stack and reshaped the hands so that they had simple fingers and thumbs. The hands would not be seen in a close-up shot. Once I had the pilot placed correctly in the flier, I moved the flier to the top of the cliff.

I linked the biped's Center of Mass (Bip01) to the Flier's platform. To link the hands to the wing levers so that they moved smoothly with the wing animation I used Character Studio's IK Blend settings. IK Blend lets you use an external object, such as the wing levers, to move the hands of the Biped using Inverse Kinematics (IK). This setting was applied to each hand separately at frame 0 in the Motion/Biped Key Info drop-down menu. After selecting the first hand to link to a wing lever, I clicked the Kinematics/Object button. Next I clicked on the white arrow labeled "Object space Object," as shown in Figure 5. Finally, I zoomed in

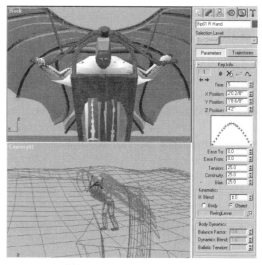

FIGURE 5 *Object space.*

close to the wing levers in the viewport and clicked on the right lever for the right hand. This linked the hand to the lever so it would follow it from then on. I repeated the process for the left hand and lever. I was now ready to animate the wings flapping.

I used a 20-frame cycle to animate the wings moving up and down so that they were in the up position every 40 frames. This worked well for the take-off section of the animation. I created a flight path by drawing a curved spline in the top viewport. Then I set the animation duration to 900 frames, attached a Dummy object to the spline with a Path Controller, and turned on Follow and Bank set to 10 degrees. When I clicked Play, the Path controller moved the dummy along the length of the spline in 900 frames. Finally, I linked the Flier platform to the dummy, and watched the flier sail off the cliff, circle smoothly, and then spiral down for a landing in the field below.

Since the wings would be locked in the glide position for most of the flight, I did not need to animate the wing covering except at the take-off where the camera is fairly close to the model. I did animate the cloth to flap up and down in the opposite direction from the wing movement in the beginning of the pilot's running takeoff. There was no rushing air to stretch the cloth, so during that time, the cloth

FIGURE 4 *Positioning the flier.*

would remain relatively flat and loose. Once the air filled the wings, the cloth would billow up and stretch tight.

The cloth animation process consisted of moving to a frame where the first wing flapping starts, then setting a position key for each of the control vertices on the trailing edge of the wing between the wing ribs. In this way, I could flatten out the cloth, or make it hang down between the ribs, as shown in Figure 6. At the wing's up position, I reversed the direction of the CVs, so that as the wing started to move down, the cloth billowed upward. For the medium shots of the take-off and entire flight sequence, I left the CVs in the "billowed up" position.

pounds, that would mean a mass of 225 pounds traveling at 50 to 70 miles an hour when it hit the ground. Since he had never flown before, there is no way that he could know how to stall the flier and bring down his feet for a dead-stick landing. That means that his head would create an impact crater in the dirt and raise a small cloud of dust.

I animated the crash sequence using an atmospheric combustion apparatus at the point of impact, colored brownish gray to simulate a cloud of dust. I caused the flier to disintegrate by moving vertices and CVs to distort the wing surfaces while rotating them in a chaotic crazy angle, and then laying them in a heap on the ground, as shown in Figure 8. I did not animate the pilot getting up.

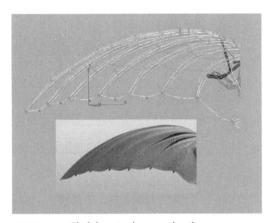

FIGURE 6 *Cloth hanging between the ribs.*

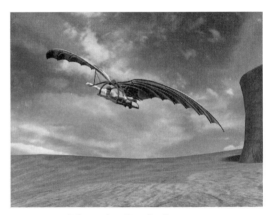

FIGURE 7 *Pilot circling for a landing.*

LANDING THE FLIER

In the final section of the animation, the pilot circles in for a landing, as shown in Figure 7. It was the first flight of Leonardo's flier, so I animated the pilot crashing to the ground head first, flipping over and tearing the wings off. This is logical because neither the pilot nor anybody else in the world at that time had ever flown before, and he wouldn't know how to land the first time. Second, there was no provision for any landing gear, and no protection for the pilot's head. Assuming the pilot weighed 150 pounds and the plane weighed at least another 75

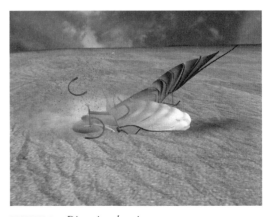

FIGURE 8 *Distorting the wings.*

CONCLUSION

Despite the complicated steps involved in creating and animating this model and the pilot character, I enjoyed the recreation of this historical event in 3D Studio MAX. The Leonardo Flier is an elegant model with its swept wing shape that reminds me of a bat more than a bird. It is amazing how close to a modern glider it is. I have always been fascinated by the courage of modern test pilots, but I never really wanted to try it myself. The fact that Leonardo didn't kill himself in one of his flying machines tells me that he let someone else be the test pilot!

Creating a Talking Announcer in 3D Studio Max Part I: Modeling Templates

—Tom Gray

SYSTEM REQUIREMENTS

For this tutorial, you will need a Pentium 200 or better computer, a video capture card, a camcorder, a camera, a scanner, Media Studio Pro or any non-linear video editing software, Photoshop 5.5, and 3D Studio Max r3. I also used the Camtasia Recorder (by Techsmith) to capture all the animated screen shots.

I n this multi-part tutorial, I am going to show you how I created "MAXINE HEADROOM," a talking announcer that I will be using as a fill between live broadcast video streaming. Part I will cover setting up to capture the reference material and creating the templates. I will combine three separate techniques and explain the strengths and shortcomings of each. In Part II, I will cover the modeling, animating, and lip-syncing the character with the recorded speech in the final parts. So, let's get started.

There are lots of ways you can begin a 3D-character project, and over the years, I have tried my share of them. Although I almost never approach a project in exactly the same way, I do have a few favorite techniques that I use more than most. The

FIGURE 1 *Getting started.*

first step in any project is to define your idea. In a more complex animation, a storyboard would be the place to start, but for this project, all we need is a basic idea of what we are shooting for. I wanted to use elements of one of my favorite computer-generated characters, "Max Headroom." Figure 1 shows the image I created in Photoshop to give me a jumping off point.

As a reference for the face, I'm going to use one of my favorite subjects—my youngest daughter, Allison. Starting with an actual face will make the end result much more convincing and provide a great reference for lip motion and facial expressions. I will be using a video camera to capture a 90-degree turn of the face, from a full front view to a side view. Then I'll capture Allison saying the actual speech we are going to use; this way, I have the reference to use when creating the speech animation. With this technique I could get away with just using the video footage for everything, but I like a lot tighter resolution for creating my splines, so I am going to use a 35mm camera to take better resolution photos to create my spline templates. I will also use these photos for the textures on the face.

STEP 1: GETTING YOUR REFERENCE MATERIAL.

First, find a chair or barstool that swivels. If you have a tripod, set up your video camera so that it is level with your subject. If you don't have a tripod, find a table, and stack some books or anything that you can find to prop the camera up so your subject's face is parallel and fills a good 80% of the frame. Make sure you have adequate lighting, and set your computer up for capturing. Position your subject toward the camera to give you a full front shot. See Figure 2. Make sure the head of your model lines up with the pivot point of the chair, or the head will not stay centered to the camera while turning Figure 3. Start your video capture and start slowly turning the chair 90 degrees until you have a good side shot. You should try and time it so it takes about 5 seconds from 0 to 90 degrees. You could keep going a full 180 degrees to get the back of the head, but the

model isn't going to be seen from the back, so we are only going to need the 90 degree turn. See Figure 4. Ok, great. So now you have an excellent reference of the face for modeling, but while we're at it, let's get the actual voice, lip movement, and expressions too. We are going to have Allison (Maxine) say "HEY, TH…THIS T…TUTORIAL STUFF IS PRETTY COOOOL!" I want the little stutter in there to mimic the old MAX HEADROOM style that this is obviously a blatant rip-off of…uh…I mean that was a great artistic influence for this project See Figure 5. Now another little trick I use here is I am going to have Allison YELL the phrase instead of just saying it. This way, the facial expressions and lip motions are automatically exaggerated and you will get a much more interesting animation. So you

FIGURE 2 *Positioning the subject.*

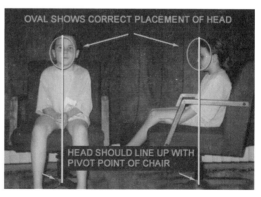

FIGURE 3 *Lining up the head.*

FIGURE 4 *90 degree turn.*

FIGURE 5 *Adding speech.*

can go ahead and have the person sitting in as your model try out the phrase. This can be a lot of fun—you can play director here and try and coax a lot of expression from him or her. (My daughter thinks I'm absolutely nuts.) Go ahead and start the capture. Don't forget to enable the sound this time if it isn't already. If you have enough hard drive space, let it go for three or four takes; you can edit it later and cut out the stuff you don't want. Once you get the take you want, stop the capture. That's it for the video reference.

Now set up your regular camera for a good front and side view shot. I used the same tripod, which works with both my video camera and my 35mm camera. Set up the shot so your model's head fills at least 80% of the frame. Once you get the shots, you're done with bringing in the reference material.

All you have to do now is take the film down to get developed. If there is film left, it's a good time to go texture hunting to fill up the roll. While the film is being developed, you can start editing the video footage.

STEP 2: EDITING YOUR REFERENCE MATERIAL.

Ok, now that we have our reference footage captured, we need to edit it to get rid of the unwanted footage. I'll use Ulead's Media Studio for the simple reason that it came with my video capture card. You can use Adobe Premiere, After Effects, or any non-linear video editing program for this. First we'll find the best footage to edit. I'm going to load in all the takes of the 90-degree turn and compare them to find the best one. After I find the one I like, I'll delete the takes I don't want and continue editing the best take. What I want to do is get rid of the extra footage before and after the turn. See Figure 6. Find the frame in the footage just before the turn starts, and use your Scissors tool to cut the footage. Delete all the footage before your cut. Then find the frame just after the turn stops, keeping a good full side view, and cut just after that frame. Delete all the footage after it. If you captured audio with this footage, you can get rid of it also since you won't need audio for this part of the demo. Now resave your edited footage.

FIGURE 6 *Removing extra footage.*

I used to save out the first and last frames of the video separately, load the photo references into 3D Studio Max, map them onto planes, and use them to trace out my spline templates. However, I hated the way the reference would distort and become pixilated when zooming in on the details. What I would end up with, though, was poor quality around the eyes, nose, and ears, which is exactly where I needed it to be the best. So, to get around this I'll take reference photos and scan them in at 300 dpi. Figure 7 shows the difference between a scanned photo at 300 dpi and the captured video at 72 dpi. This image will look even worse when viewed in a 3D Studio Max view port. But before we do this, close the 90-degree turn footage file and open the video footage with the talking. Edit this the same way, by getting rid of all the extra frames before and after the actual talking. Save out the edited footage, because we will use this in Part III of this tutorial. We're now done editing the video reference.

FIGURE 7 *300 dpi vs 72 dpi photo.*

STEP 3: CREATING YOUR SPLINE TEMPLATES.

Now that you have your developed film back and have scanned in your images, start Photoshop. First, load in your front view image, then load your side view image. See Figure 8. While holding down your Shift key, click on the Move tool and drag the side

FIGURE 8 *Front view/side view.*

view image into the front view image. This will copy the side view image into a new layer in the front view file. The reason you hold down the Shift key first is so the image that is being dragged into the new file will automatically center on the canvas. You can now close the file that contains just the side view image, because both images are in the same file. Now I'm going to use a much-overlooked tool in Photoshop that works great with 3D Studio Max—Paths. If you haven't used Photoshop Paths before, don't worry, they are not that different from 3D Studio Max Splines, and basically work the same way. You can trace your reference in Photoshop, zooming in and out to your heart's content. It's much easier to see the details this way.

Before we start creating our paths, we want to make sure the front view and side view are closely aligned, or our front and side paths won't be as accurate. Click on the top layer that has the side view in it. Adjust the transparency slider above the layer to about 50%. Now you can see your front image underneath. Go up to the menu bar to VIEW and click on Show Rulers. Now you have a ruler on the top and left of your image. Click in the top ruler, hold and drag down. See Figure 9. This will give you a guideline that you can use to align the front and side views. Drag the line to a good reference spot—the bottom of the nose or the center of the eyes should work. Now look at the difference between the placement of the nose and eyes on the side view compared to the front view. Click on the image (the top layer

FIGURE 9 *Adjusting the transparency layer.*

FIGURE 10 *Creating a side view path.*

should still be selected) and move it up or down to better align to the front view. Now you're ready to create the paths.

We'll start creating the side view path first. See Figure 10. Paths in Photoshop are a little different from Max Splines, but they are basically the same. You should be able to get the hang of them pretty quickly. Click on your Pen tool and drag out to create the shape of the back of the neck. Placement of the nodes are up to you, but as a rule of thumb, you want to use as few nodes as possible to get an accurate representation of the shape. Continue until you have drawn an outline of the face profile, stopping at the bottom of the neck. Now zoom in to the eyes

and trace around the edge of the eyelids, then trace the top of the eyelid and continue all the way around the eye. Zoom in to the mouth and trace from the top of the upper lip around to the bottom of the lower lip. Now trace the shape of the opening of the mouth. You should also trace in a line following the curve of the cheek, starting from the corner of the mouth up to the edge of the base of the nose. At the base of the nose, finish out the curve that makes up the flair of the nostrils. You should have something that looks like Figure 11. You now have your template for your side profile. Before we start the paths for the front view, let's save the paths we just created. Go down to the Paths tab next to your Layers tab and click on it. You will see a small thumbnail of the path you just created. Go to the small arrow in the upper right of the tab panel and click it. You will see a menu item that says Save Path. Click on it. A requestor will come up asking for a name for your path. Type in SIDE PROFILE and press Enter. You now have your path saved so you can continue creating the front view path. But first, this would be a good time to save your work. Now click on the small arrow again in the Paths tab panel and click Turn Off Path. This will hide the path out of the way— it's still there, just hidden. Now click on New Path, and when the requestor comes up asking for a name, type in FRONT PROFILE. Click on your Layers tab and hide the side image by clicking on the small

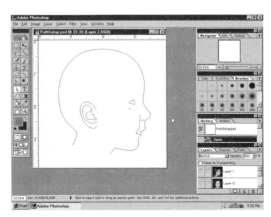

FIGURE 11 *Traced face.*

eye to the left. We only need to outline half of the face, since we will only be modeling half the face and then mirroring it. Before we start to draw out the path, drag out a guide from the left ruler and place it right at the center of the nose. See Figure 12. Now grab the Pen tool and start drawing out your path. Start at the bottom of the chin and work your way up. Ignore the ear for now. Once the face is outlined, click on your Direct Selection tool or press your "a" key on your keyboard, and click away from the path you just created to deselect it. Now click on your Path tool or press your "p" key on your keyboard to start tracing around the eye. Zoom in on the eye for tighter detail. Draw around the eye just at the opening, and finish it by clicking on the first node. This will close the path. Press your "a" on the keyboard to select the Direct Selection tool. This time we are going to duplicate the path we just drew around the eye for the eyelid. Click on the path for the eye, hold down your Alt key, and Draw the path up. This will make a duplicate of the eye path. Now go to your Edit menu, select Transform Path, and click on Scale. This will give you a Transform box that lets you scale the path without having to move around the nodes. Scale the new path to outline the eyelid. Now click on the Direct Selection tool. A requestor will pop up asking you if you want to Apply the transformation, click on Apply. Repeat the process for the mouth, outlining the outside of the

lips and the inside of the lips. Then using Transform Path, Duplicate the outside of the lips and scale it up a bit. Now trace the nose, but leave the nostrils for later and just outline the bottom of the nose and continue up and around to get the side of the nose. Stop just at the top of the curve. Now trace out the ear. Turn off View Layer so that you can see your results. You should have something that looks like Figure 13.

Ok, now we need to export the paths so we can bring them into 3D Studio Max. Click on the Paths tab. The Front Profile path should be highlighted. Go to the File menu, select Export, click on Paths To Illustrator, and Save the path as frontview.ai. Now in your Paths tab panel, click on SIDE PROFILE, and export it as sideview.ai.

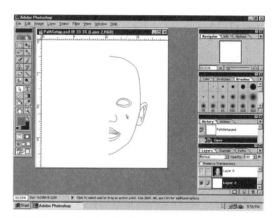

FIGURE 13 *Tracing the face.*

STEP 4: CREATING THE 3D TEMPLATE.

Finally, we are going to start up 3D Studio Max! Bet you thought we'd never get here! So, let's import the paths that we saved out from Photoshop. Go up to the File menu and select Import. Find where you saved the paths, and in the file requestor, change the file type to Adobe Illustrator (*.AI). Import the front view path. A requestor will come up asking if you want to merge objects with the current scene or

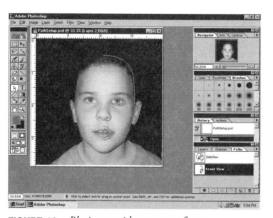

FIGURE 12 *Placing a guide at center of nose.*

completely replace the scene. Click on Merge Objects with current scene, and click OK. Now another requestor will come up asking if you want to import objects as a single object or multiple objects. Click on Single Object. This will make it easier to work with—we can break it apart later. Now Import the Side View Path using the same procedure as the first. You'll notice that the paths come in flat in the top view. See Figure 14. We'll need to line them up with Max world coordinates, but first make sure that they are aligned with themselves. Check the placement of the eyes, nose, and mouth. Move the front or side view path as needed to line them up. Don't worry if the head doesn't line up perfectly, we can fix that in a minute. Now that the two paths are aligned, Rotate them together 90 degrees in X first, then Rotate the side path 90 degrees in Z.

Next, Move the side path over so that it lines up with the edge of the front path. See Figure 15. From here we need to Freeze the side view template and start moving the vertices in the front view template only in Y. But first, we have to detach the individual pieces. Select your front view template. Right-click on the template and go to Sub-object-spline. Drag a selection box around the both parts of the eye, and then move down the Modify panel until you see Detach. Click on Detach. When the name requestor pops up, type in FRONT EYE. Now click Sub-object off and select FRONT EYE. Click on the Hierarchy tab, click Affect Pivot Only, then Center to

Object. Click off Affect Pivot Only. Now while watching the Right view port, drag the eye out from the top view port until it lines up to the eye in the Side view template. Click Rotate and rotate the eye in Z until it matches the side view template eye more closely. Now click Sub-object-vertex and drag the vertices around in Y until you have a slight curve in the top view. Change the vertices to "smooth" before moving them; that way, the handles won't get in the way, and moving the vertices will automatically smooth out the splines in a more natural way. You can switch back to Bezier later, if necessary for fine-tuning. Continue the same procedure with the rest of the splines in the front view template until you have something that looks like Figure 16. Once you

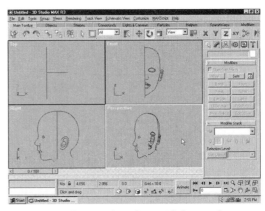

FIGURE 15 *Lining side path up with front path.*

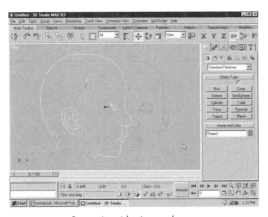

FIGURE 14 *Importing side view path.*

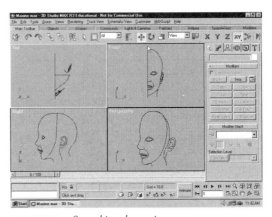

FIGURE 16 *Smoothing the vertices.*

have the front view template splines lined up with the side view template splines, you can delete the counterparts in the side view template. You now have a very clean 3D template for the head without cluttering the view ports with pixilated mapped cross planes used in other methods.

STEP 5: EXPLORING OTHER METHODS OF TEMPLATE CREATION.

Now we are going to start incorporating pieces of those other methods to explore how we can use them to enhance the modeling process. First, let's create the typical cross planes. Figure 17 shows two planes criss-crossed in a method you have probably seen before, only instead of mapping a bitmap to them with the image of the head, we are just turning them a solid color. We will make them white here, but a dark color will actually be more useful, since the splines will turn white when selected. This can help modeling in two ways. First the solid color enables you to create a strong contrast between the splines and the background, and second, you can use them to hide parts of the splines while working to reduce clutter.

For example, looking at the front view in Figure 17, you'll notice that the plane obscures the ear and a portion of the head—this can help quite a bit. By

mapping the planes with a two-sided solid material, you can rotate around keeping only the foreground splines visible. That being said, let's take a look at the difference between this and mapping the actual bitmap templates to the planes. So, for the moment, Duplicate these planes, Hide a set of them and Re-map the new ones with the bitmaps used to create our paths in Photoshop. Figure 18 shows the traditional way of mapping the planes for modeling. The downside of this method is that, as already mentioned, you lose detail when zooming in. However, since we already have created some tight detail in the main areas where we need it, we don't really care about that at this point. Another downside is that the varying contrast of the image can make it difficult to see certain areas of the splines. Again, we don't care about that at this point, because we have created our solid color planes. Another thing worth mentioning here is that rotating the view around these planes doesn't help much because when you start to rotate, you loose perspective, because you're only looking at a flat side and front view even at the view of, say, 45 degrees. For example, look at the perspective view in Figure 18. The view is only rotated 20 degrees or so, but you can see that it has already lost any real perspective. So what's the solution? Well, for one, we still need to create the important areas around the brow, nose, and nostrils that don't really require zooming in to a tight view, and

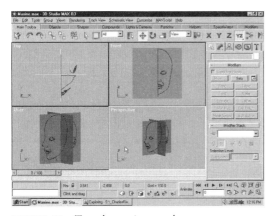

FIGURE 17 *Two planes criss-crossed.*

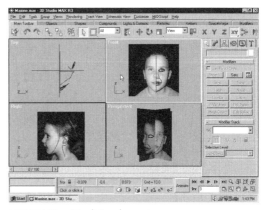

FIGURE 18 *Traditional mapping.*

we don't have any other reference in Max but these planes to get them from. Also, the shadows help to show the high and low points that will be useful when pushing and pulling vertices around. We'll keep these planes around for a visual reference, switching between these and the solid color planes, and hiding and unhiding them as needed. So what's still missing? A way to check perspective at varying degrees of rotation! Remember the 90-degree video footage we shot way back at the beginning of this? First hide the planes with the bitmaps on them. Click on your Front View Port and Maximize it by pressing the "w" key. Now go to your Views menu. See Figure 19. Click on it and go to View port background, or press your Alt+b keys on the keyboard. In the background source area, click on Files and find the video with the 90-degree rotation. You might have to change the file type to see it. Double-click on the file to load. In the Animation Synchronization area, look where is says "Use Frame 0 to 74." This last number tells you how many frames are in the animation. In this case, it's 75 since 0 is included in the count.

Write this number down, because you will use it to match the length of the animation in Max. In the Start Processing area, click on Hold Before Start. In the End Processing area, click on Hold After End. Look down in the Aspect Ratio area and click on Match Bitmap to the right, click on Display Background, Lock Zoom/Pan, and Animate Background. In Apply Source and Display to, click on Active Only. Now click OK. The first frame of the animation will appear in the Front view port. Let's change the length of our Max animation to match the 90-degree turn animation. Click on the Time Configuration icon at the bottom of the animation panel. In the animation area, set the Length to 75 and click OK. We're going to change the spline a bit for the purpose of this demonstration, so let's resave the file with a different name so we don't mess up the template we've already created. Since the model is rotating to the right, we'll have to mirror the template to view it correctly as it turns. Now Size the spline templates to match the animation in the view port. Since the image is different, it won't match exactly, but it should be pretty close. Attach all the splines together into one object, and Center the pivot. Figure 20 shows the edited splines with the pivot in the correct position. Now let's go to the last frame in the animation. Click on your spline and rotate it in Y 90 degrees to match the image. If the rotation is way off, move the pivot point back a little before rotating. This might take a little playing around with. Once it rotates correctly, go back to frame 0 and Rotate the spline back to 0 degrees, click on the Animation button, go to the last frame, and Rotate the spline again 90 degrees. Turn off the Animate button and step through the frames one at a time. It might take the

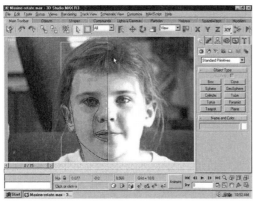

FIGURE 19　*Front View Port.*

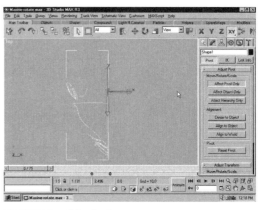

FIGURE 20　*Edited splines.*

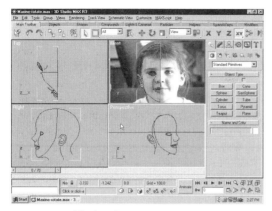

FIGURE 21 *Final version.*

backdrop images a few seconds to update, so step through them slowly. You should see what we're looking for here. See Figure 21. With the splines in the correct position, we should have a pretty close match at any angle we view it from. Like any of the methods, this one could be used alone to create your template, even though it does have drawbacks. But if you use it as yet another tool, it can give you a reference that the other two methods can't.

That's it for Template Creation. Happy 3Deeing.

22

Creating a Talking Announcer in 3D Studio Max Part 2: Modeling

—TOM GRAY

SYSTEM USED

Pentium 233, 256 megs sdram, AccelGraphics AccelSTAR II graphics card, Soundblaster live sound card, 3D Studio Max r3, Photoshop 5.5, and Camtasia Recorder and SnagIt (from Techsmith—www.techsmith.com) for capturing live demos and single screens.

All right, now the fun starts: Turning this into a moving, eye-blinking, ear-wiggling, mouth-moving Virtual Announcer (Figure 1). There are a few things you need to think about:

- You need good reference—having a solid, clean outline to start with will take a lot of guesswork out of the modeling and save you lots of time—we did that in the last tutorial.
- The model needs to be as simple as possible. Try and get the main details of the face with as few splines as possible. This will make it not only easier on the system, it will be easier for you to animate.

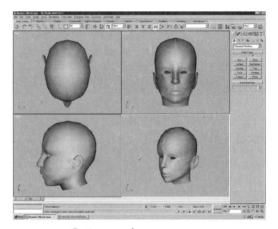

FIGURE 1 *Getting started.*

- What modeling method are you going to use? I have chosen to use splines and surface tools—it's more personal preference than anything else. Box modeling or nurbs could be used also.
- How are you going to texture it, what kind of look are you going for: realistic, cartoony, a little of both?

138

So, after you get all that out of the way, it's time to get your hands dirty.

STEP 1: JUMP IN

The first thing I'm going to do is hide the planes. I'm not going to need them yet, and it will be easier to see what's going on without them. Now I'm going to combine all the separate splines into one. This will let me see all the vertices at once so I can use them as reference for my new splines.

Select the face spline, then go to the Edit menu and select Clone. When the requestor comes up, select Copy, and change the name to "Face template." Select OK. Now press the 6 key to freeze selected. You now have a wireframe template to use for reference that won't get accidentally edited. Select the face splines and choose a color that contrasts the dark-gray frozen template. Now right-click to bring up the menu and select Properties to bring up the Object Properties dialog box. In the Display Properties section, click on Vertex Ticks. Click OK. This will allow us to see the existing vertices while adding new splines. (Figure 2.)

FIGURE 2 *Adding new splines.*

THE EYE

Now I'm going to start modeling at the eye. I've found that it's easier to get the opening of the eye, the mouth, and the nose done before anything else,

and then fill in the gaps. This will enable you to see the finer details without all the geometry from the rest of the head getting in the way. So, let's start at the eye. Zoom in all viewports. Right-click to bring up the Object menu, and under Sub Object, select Spline. Select the splines that make up the eye and click on Zoom Selected. In the top viewport, create a sphere that is roughly the diameter of the span of the eye splines. Select the splines that make up the eye opening, and in Sub-Object Vertex mode, drag the vertices around until they closely match the radius of the sphere (Figure 3).

Now, right-click on the 3D Snap toggle button to bring up the Grid and Snap Settings dialog box. Clear all and click on Vertex. Close the dialog box and select the 3D Snap toggle, or press your S key on the keyboard to turn it on. Now, right-click for the Object menu and select Create Line. Starting at the outside spline, click on an existing vertex to start a new spline, click to the corresponding vertex on the inside spline, then right-click to complete the spline. If a requestor comes up asking you if you want to close the spline, click No. Watch in the other viewports while working in the front viewport. I found it easier to create straight lines first and then go back and edit the new splines to create the necessary curves. So, work your way around the eye, creating splines to join the outside spline to the inside spline. After you have all the splines created, turn off 3D Snap (S key), change the sub-object selection to Ver-

FIGURE 3 *Dragging the vertices.*

tex, and edit the new splines to create more of a curve shape as in Figure 4. You might have to right-click on the vertices to change their type to Bezier or Bezier Corner, and then manipulate the handles to create the curves. That's it for the eye for now. Next, we'll do the nose.

FIGURE 4 *Editing the splines.*

THE NOSE

Before we start to model the nose, we need to set up our planes for reference. I have the material already set up in the material editor, so bring up the material editor by pressing M on the keyboard. Click on the Front Plane. In the Modify panel, click on UVW Map. Scroll down to the Alignment section and click Bitmap Fit. This will assure that when the bitmap is applied, it won't be stretched or distorted. A requestor will come up for you to select the image. Select Ali-Front.jpg. You will see an orange outline representing the size of the bitmap. Now drag the Front View Plane material onto the Front Plane object. You should now see the image in the viewport applied to the front plane. You will need to line it up with our template, so click on the UVW Map sub-object to select the gizmo. Click on the Front View and press the W key to bring the Front View to full screen (Figure 5). Select the Move tool and move the gizmo until the image lines up with our splines. You might have to scale it also to get a good fit. Click on the Scale tool and then right-click on it again to

FIGURE 5 *Front view.*

bring up the Scale Transform Type In requestor. Click on the up/down arrows to fine-tune the scaling. Get it as close as you can. You might have to switch back and forth between the Scale and Move tools to get it right. Now repeat the same process for the Side View Plane. If after you drag the "Side View" material on to the Side Plane the image is facing the wrong direction, just click Flip under the mapping parameters in the Modify panel next to "U tile". When finished, you should have something like Figure 6. I've changed the splines to a bright color so they will be easier to see on the dark image.

Now we are going to hide all the splines that we don't need to give us a clearer view. Select the "Face-

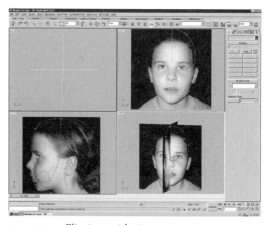

FIGURE 6 *Flipping to side view.*

Outline," select sub-object segments. Select all the segments that don't belong to the nose, scroll down in the Modify panel under Geometry, and click Hide. I've also temporarily hidden our frozen "Spline Template." Now the only splines that you should see are the ones that make up the outline of the nose. Zoom in all viewports so you have a clear view of the nose splines.

First, let's start in the front view. Move the existing vertices around to better match the shape of the nose. Then switch to the side view and drag them into place. Keep in mind that the images won't be in exact proportions to each other because her face was not in the exact pose from one view to the next.

Now let's create some new splines to further define the nose. With Sub-Object Vertex still selected, scroll down the Modify panel to create line. In the front view, draw out an outline for the opening of the nostril. When the requestor comes up asking you if you want to close the spline, select No. After you create the shape in the front view, go to the side view, and drag the new vertices in place. A requestor will probably come up asking if you want to "Weld Coincident end points." Click No.

Before we continue adding lines, let's set up some snap options. Right-click on the Snap toggle button at the bottom of the screen to bring up the Grid and Snap Settings requestor. Clear all and then select Vertex and Edge. Close the requestor. Make sure snap toggle is set to 3D Snap, and that the toggle is on. Figure 7 shows the requestor with the correct settings. Now let's add some more lines. Click on Create Line if it isn't already, and starting at the bottom of the nose, click on the vertex just right of the bottom left one. The cursor should turn into a blue box indicating that it is snapped to a vertex. Click on it and move to the Vertex above it at the bottom of the nostril. When the blue box appears, click again to add the line, then right-click to finish the line. Repeat the same process for the next two vertices to the right. Don't worry so much if the new splines don't have the right curve in them in the top or side views—we'll go back and fix that later. It's much easier to define the basic outlines first, and then go back and refine it.

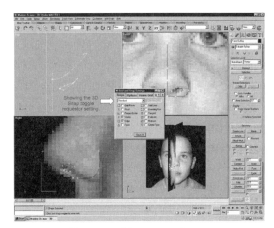

FIGURE 7 *Requestor with correct settings.*

Now let's expand the line that defines the outside of the nose, making it continue up to the corner of the eye. Start at the end vertex and draw a line up along the shadow of the nose and then over to the corner of the eye. Again, draw it out in the front view, then go to the side view, and drag the vertices in place. Now let's add another line up from the top of the nostril to the top of the nose. Keep the vertex count the same as the line you just drew for the outside line. Go to the side view and drag them in place. Refine the shape to fit the side view also. I usually convert the vertices to smooth by selecting them, right-clicking, and selecting smooth from the pop-up menu. Then I'll drag them into place and change them into a different type only if needed. Now let's change the sub-object selection to spline. Select the last spline you created. Hold down the Shift key and drag over a new spline. Line it up to the next vertex to the right on the nostril. Select Sub-Object Vertex mode again, and from your side view, move the vertices in place. You could have just drawn out a new spline, but I wanted to show you that there is any number of ways to achieve the same results. The key is to be aware of what's available so you can use what works best for you in any given situation. Copy one more spline and move it over to the right. This one will connect to the corner of the nostril and complete the vertical splines for the nose (Figure 8).

FIGURE 8 *Vertical splines for the nose.*

Now let's fill in the horizontal splines. We're going to create two new vertices and splines at the tip of the nose. Click on the Connect check box next to the Refine button under the geometry section in the Modify panel (say that 10 times fast). Click on the Refine button. Click on the tip of the nose and draw a line across to the vertex on the left end of the nostril. Right-click to end the line, and create one more the same way right above it.

Now click on 3D Snap (or press your S key) and draw lines to connect all the vertices all the way up the nose (Figure 9). When all the lines are drawn, zoom in on the vertices and look for vertices that are

FIGURE 9 *Connecting the vertices.*

supposed to be on top of each other but aren't. If you find some, drag a selection box around the vertices and click on the Fuse button. (You should be in Sub-Object Vertex mode). This will bring the vertices together to occupy the same space. After you do that, examine the nose from different angles and edit the splines as needed. When you are finished, you

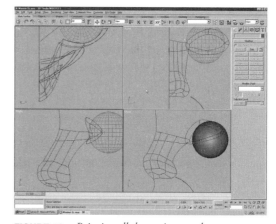

FIGURE 10 *Bringing all the vertices together.*

should have something like Figure 10. I temporarily hid the templates to make it easier to see.

THE MOUTH

Ok, after the nose, the mouth will be easy and it will give us a little break before we start the ear. First, we can get the eyeball out of the way, so hide it for now. Then maximize the front viewport and zoom in on the lips. Turn on Sub-Object Vertex mode and start moving the vertices around to tighten in on the shape of the lips. We don't have the same number of vertices on the inside spline as we do the outside spline, so let's add a couple. Still in Vertex mode under the Geometry panel, click on the Refine button. Now move the cursor over the inside spline of the lips and click just above the corner of the mouth to add a vertex. Add one more just below and to the left of the corner of the mouth. Right-click to turn off the Refine button and drag the new vertices until

you have them aligned. While you're at it, select both vertices that make up the corner of the mouth, and change the type to Bezier Corner to create a sharper angle.

Now let's get more of these splines out of our way to clear up the top view. Switch to Segment mode and click all the segments that make up the nose, the eye, and anything else that is in the way of getting a clear view of the lip splines in the top view. Go ahead and hide the front and side bitmapped planes so you can see what you're doing a little better. Watching all views, move the vertices around, adding more vertices where needed with refine until you have something that looks like Figure 11. Now let's connect them with vertical splines as we did with the eye area and the nose. Press the S key to turn on Vertex Snap and add lines to the lips. You'll need to add one horizontal spline to connect the corner of the mouth.

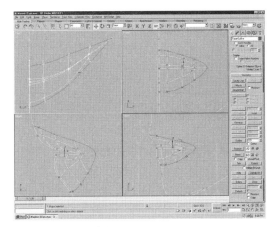

FIGURE 12 *Final lips.*

ing cocky, its time to be humbled and take on . . . THE EAR!

THE EAR

The ear is a real challenge to create with splines. But, if you just take it a step at a time, it can be achieved without having a nervous breakdown. The first thing I do is get everything else out of the way. Keeping it simple and clean will make your life much easier as you progress. That said, let's hide everything but the splines making up the outline of the ear. To do that, detach the ear splines from the rest of the head by going into Sub-Object Spline mode, select just the splines that make up the ear outline, and click on Detach from the bottom of the Modify panel. When prompted for a name, type in "Ear" and select OK. Now get out of Sub-Object mode and hide all but the ear splines. Select the ear splines and Zoom all selected. Figure 13 shows what we have so far.

Now let's draw out a spline to represent where the ear joins the head. Maximize the right view, select the ear, and right-click to choose Sub-Object Vertex mode. Now under the Modify Geometry panel, select Create Line. Starting at the left center, draw out a spline. When asked if you want to weld the vertices, select No. Now switch to Sub-Object Spline mode and move the new spline closer to the ear, then switch to Vertex mode and position the

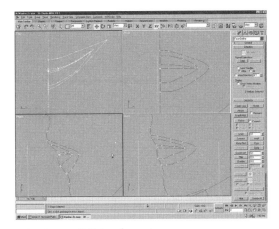

FIGURE 11 *Refining the vertices.*

Once the splines are drawn out, turn off 3D Snap and fuse the new spline vertices with Fuse as we did with the nose. Then change the vertex type as needed to shape the curves in the lips.

When finished, you will have something like Figure 12. That's it for the lips for now. Don't worry about the opening in the mouth—we'll come back later and add it and the opening in the nostril. Now that we've breezed through the lips and you're feel-

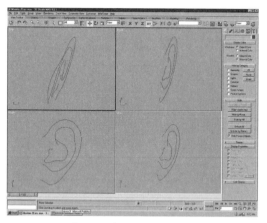

FIGURE 13 *Creating the ear.*

FIGURE 15 *Sub-object segment mode.*

vertices as in Figure 14. I have selected it to make it easier to see.

After the vertices are in place, go back to Sub-Object Spline mode again and name the new spline "Ear to Head" by typing it in the Named Selection Set box in the Main Toolbar tab panel. We will use this later to reattach the ear to the head. Now let's hide the inside splines of the ear. In Sub-Object Segment mode, select just the inside pieces of the ear, and select Hide. You will be left with the pieces shown in Figure 15. Switch the Right View to Left View so you can work from the backside of the ear. Before we start to create new splines, let's duplicate the outside outline to give us a better frame to work

with. In Sub-Object Spline mode, select the outside spline. Hold down the Shift key while scaling the selected spline. This will give you a duplicate and scale it at the same time. Then move it closer to the "Ear to Head" spline. Move the first and last vertices of the new spline to the vertices on the "Ear to Head" spline. Examine Figure 16 before going on. Fuse the vertices that you have just lined up.

Now let's connect the splines with adjoining lines. Press your S key to put you in Snap mode. Make sure you have Vertex selected in your snap settings. Now start creating new lines. Again, connect the lines first, fuse the vertices, and then add the curve to the new lines creating the desired shape.

FIGURE 14 *Vertex mode.*

FIGURE 16 *Ear to head spline.*

Make sure you are satisfied with this step before going on; it will be much more difficult to edit it later when all the splines are in place.

Compare your work with Figure 17. This should complete the back of the ear, but before we go on, let's test it by applying the Surface modifier. Get out of Sub-Object mode and select the visible section of the ear we just worked on. Now under Modifiers, click the More button to bring up the list of modifiers. Select Surface. This applies the surface modifier, which attempts to create faces from the splines. You probably won't see much yet, so let's change some of the parameters. Under the Parameters section in the Surface Modifier panel, change the Threshold Spinner to 0.02. Change Patch Topology to 2. In the Left Viewport, change the view to Smooth + Highlights by right-clicking on the viewport label and selecting it from the drop-down menu. A shaded image of the back of the ear should appear. If not, try clicking on Flip Normals under the Surface Parameters section. If all is well, you should have something that looks like Figure 17. If you don't, look closely for vertices that aren't fused or splines that don't make up tri or quad areas. You don't want to go to the next step before this is done, so take your time.

Now we have the back of the ear done, but before we go on, we don't need the surface modifier anymore, so delete it from the stack. Select Sub-object

spline and unhide the rest of the splines of the ear. We are now going to create the front part of the ear, so hide all the splines that we just made for the back of the ear. This time, start with the same two splines that we started with when doing the back of the ear, only this time, hide the segments that are part of the back "Ear to Head" spline.

We will now create new splines for the front of the ear. First let's add a vertex to the inside spline at the top of the ear so we have a better alignment for the mesh. Click Sub-Object Vertex mode, and select Refine. Click on the inside spline just below the vertex on the outside spline, create one more down and to the left so we have something to attach the stray vertex to. Right-click to end the Refine operation. Now drag the vertices of the inside spline to create a more defined cage structure. Refer to Figure 18.

Now press the S key to enter 3D Snap and click on Create Line. Start creating lines to make the rest of the ear. When all the lines are created, again use Fuse to pull the vertices together, and edit the new lines to create the desired curves. It will help to convert some to smooth type and let the splines create their own natural curves first, then go back and switch to Bezier or Bezier Corner to fine-tune them. Figure 19 shows what I've got after editing the curves. Again, I will add the surface modifier to check my work before I go on. If all the patches fill in and are a good definition of the shape, delete the

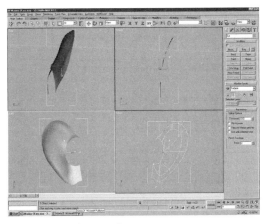

FIGURE 17 *The ear so far.*

FIGURE 18 *Defining the cage structure.*

FIGURE 19 *Bezier corner fine-tuning.*

surface modifier and unhide the rest of the ear splines. You can edit the splines further to get a better approximation of the ear if you'd like. I prefer to get the basic shape defined and do my final editing after it is converted to a mesh. I will also add more detail to it when I apply the textures, but that will be done in Part 3 of this tutorial. Figure 20 shows the complete ear with the surface modifier applied. We can now reattach the ear spline with the rest of the head. Unhide the Face Outline and select it. Then in the Modify panel, click Attach and select

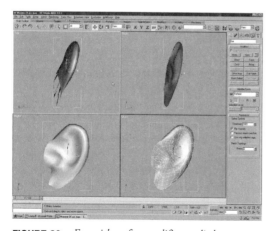

FIGURE 20 *Ear with surface modifier applied.*

the ear splines. They are now one spline again. We are now ready to build the structure of the face.

THE FACE

The rest is downhill from here. First, we'll hide splines that make up the back of the head. So, select the segments that make up the back of the head including the ear, and hide them. Now zoom in on the face. Start with a brow line. With 3D Snap on, create a new line from the vertex above where the nose splines end to the vertex straight across at the side of the head. Before you go on, edit the new spline in the top view to bring out the desired curve (Figure 21). Now, using the same techniques, start creating new splines to start building a spline cage that connects all the pieces we've already created. Add vertices with Refine as needed. Don't forget to fuse the vertices as you go. Working a section at a time, apply the Surface modifier once in awhile to check how the splines are working. It's a great way to show where the problem areas are. After you see what needs to be fixed or where more detail is required, delete the Surface modifier from the stack and continue working. Try to keep it as simple as possible. Figure 22 shows the front view of the completed Spline cage for the front of the face. Figure 23 shows the side view of the completed Spline cage of the front of the face. I have unhidden the "Ear to Head" spline and the back of the head splines. Now

FIGURE 21 *Editing the new spline.*

FIGURE 22 *Front view of spline cage.*

FIGURE 24 *Head cage with ear hidden.*

FIGURE 23 *Side view of spline cage.*

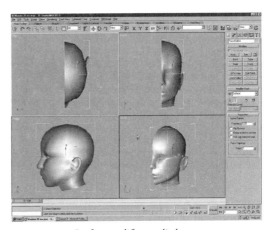

FIGURE 25 *Surface modifier applied.*

just continue with the same process until the whole head is enclosed with a spline cage. Figure 24 shows the completed head cage with the ear still hidden. Figure 25 shows what it looks like with the surface modifier applied. The few rough spots left can be cleaned up after we convert the finished splines into a mesh. Now all we have to do is Mirror the head and weld all the vertices down the center to create a seamless head.

You can unhide the ear now. Then select the head and click on the Mirror button. When the requestor comes up, select Mirror Axis X and click on Copy in the Clone section. Then, using the offset

slider, move the new half until the open edges are on top of each other. Close the requestor. Now click on the first half of the face, and in the Modify panel under Geometry, select Attach, and click on the new half. The head is now one object. To make it seamless, go to Sub-Object Vertex and zoom in close to the center of the head. Draw a selection box around each set of vertices and click on Fuse from the Modify panel. Repeat this all the way down the head. Keep the side viewport open so you can see if you have any vertices selected from both the front and the back of the head. If you do, just hold down your ALT key on the keyboard, and in the side view, draw

a box around the unwanted vertices—then you can fuse just the ones you want. Repeat the process until all the vertices are fused. Now apply the Surface Modifier and if all has gone well, the head will be complete. From here, you can collapse the stack if you want and continue fine-tuning the mesh as long as you like. Make sure to save a version of the spline head separately, just in case you want to come back to where you started.

Hope you got something from this. Happy 3Dee'ing.

CHAPTER 23

Clay Creations in Max

—SHAMMS MORTIER

One of the most useful plug-ins I have found for Max 3.1 is Clay Studio Pro from Digimation. Clay Studio Pro is the enhanced version of the less-endowed Clay Studio. I have spent a fair amount of time writing about another favorite application of mine, Organica from Impulse, a super Metaball/MetaBlock modeler that writes out to many 3D model formats (including 3DS). But having a full-featured Metaball modeler as a Max plug-in is far easier, saving time and confusion.

THE BASICS

Before I walk through an example modeling project with you, allow me to detail how Clay Studio Pro works. I mentioned Organica previously, because it set a new paradigm for the way Metaball modelers are crafted. Specifically, instead of spheres alone being the basic building blocks, Organica set a precedent by allowing for a wide array of shapes to be incorporated. While Clay Studio Pro is a little more parsimonious with its components, it does expand the Metaball structures beyond the limited sphere. To be precise, Clay Studio Pro allows three basic Metaball types: Spheres, Ellipsoids, and Splined constructs. Through the setting of various parameters, these basic Metaball components can also be smooth or sharp edged, so that Ellipsoids can be set to re-

semble sharper-edged Diamonds on one end, and Cubic volumes on the other.

The basic way that Clay Studio Pro works is as follows:

- Clay Studio Pro is selected from the drop-down list in the Create Geometry Rollout (you'll have to have installed and authorized it first, of course).
- Select Clay Sphere or Clay Spline, and draw the associated form in a view window. You can set some of the options first if you like, or set them after you draw the form, with the form still selected.
- Other forms are created, so that together, they form the elements of a Metaball model.
- Clay Surface is selected, and the Clay Surface Gizmo is placed in the scene. With the Clay Surface Gizmo selected, the Modify panel is brought up. Absurd Free Primitives is then clicked on, which allows the forms to be "skinned" in the shaded Perspective view.
- Adjustments are made as necessary, and the model is translated into an Editable Mesh for further effects and customization work. See Figure 1.

150

3D GRAPHIC TUTORIAL COLLECTION

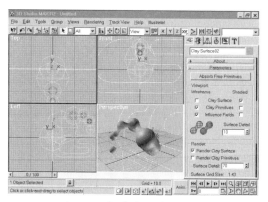

FIGURE 1 *An example of what a basic Clay Studio Pro project might look like in Max, after the Clay Surface creates the skinned Metaball elements of a model. Note the single "floating" disconnected Metaball, which is too distant from the rest to be attached by a skin.*

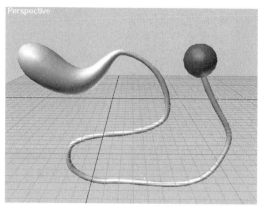

FIGURE 2 *Here, a Clay Sphere is attached to the end of the "tail" of a Clay Splined form after transforming and connecting both with a Clay Surface.*

This becomes an extremely intuitive form of editing very quickly.

ABOUT CLAY STUDIO PRO SPLINES

Only the Pro version of Clay Studio has Clay Splines. Clay Splines are used to construct "stringy" objects, like snakes, ropes, tadpoles, or any similar forms. Clay Splines can also be used to construct elongated organic forms that will act as elements of a larger Clay form, like the fingers of a hand. The segments of a Clay Spline are controlled by adjusting the size, position, and rotation of the Clay Knots, the nodes on the Clay Spline. The smoothness of the Clay Spline can also be adjusted, and the Clay Spline can be grouped with Clay Spheres and/or Ellipsoids to form a composite 3D model by first using the Clay Surface Gizmo on all of the Clay primitives. See Figure 2.

After you create the first Clay Knot of a Clay Spline, moving the mouse in any direction adds another section, following the direction of the mouse. If you click/drag the mouse at the same time that you move it, you resize the next Clay Knot. It takes a little time to get the hang of the process, but the reward is a very fluid modeling technique. It feels like you're modeling with nodules of mercury. When you right-click, the Clay Spline ends. You can return, however, and reposition, resize, or rotate any of the Knots to completely reshape the Clay Spline.

THE CLAYBIRD

In future GRC tutorials, we'll explore more of the features of Clay Studio Pro. But even though we haven't detailed every- thing, you already have the capability of understanding and following along, just by what has been explained so far, to create this model that I call a ClayBird. Here's what to do (obviously, you'll have to have Max and Clay Studio Pro to do this):

- Open Clay Studio Pro, and create a form in the Front View with a Clay Spline that resembles the profile shown in Figure 3. It's OK if your form varies a bit from this one. Work to gain confidence in the Clay Spline modeling process.
- When the form is complete, you will have one "foot and toes" of our model. With this element selected, go to the Utilities Rollout. Select Clay Primitive Snapshot (you may have to find it by clicking More first if it isn't already assigned to a button). When the parameters appear, click on Snapshot Selected Primitive. This duplicates the Clay Spline, and creates a Mesh with the same shape. Delete the Spline, leaving only the new Mesh.

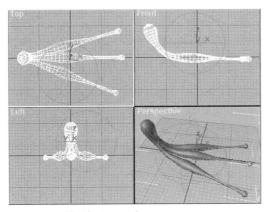

FIGURE 3 *The foot is complete.*

• Go to the Hierarchy Rollout and select Effect Pivot Only, and move the Pivot Point to the knob at the top of the foot. From the Top View, Shift/Rotate another toe. Select Copy and OK when the dialog appears. Repeat this process again to wind up with a three-toed foot. Group all three toes, and call the collective form Foot_1. See Figure 3.

• In the Front View, using the Foot as a guide, create a leg with another Clay Spline. Look at Figure 4 for reference, or design your own form. Make sure it is in place relative to the Foot, and Snapshot Selected Primitive. Delete the original Clay Spline. Now you have a Leg. Link the Foot Group to the Leg.

• Multiple-Select both the Leg and Foot, and Shift Rotate in the Top view to create a copy of the second Leg/Foot. Move the second Leg/Foot into place in the Top view. Now our model has two legs to stand on. See Figure 4.

• Go to the Front view, and create a Clay Splined Body/Neck/Head, loosely following the form shown in Figure 5. The Head is simply a Knot that is a little larger than the Neck section. Snapshot Selected Primitive, and delete the original Clay Spline. Move this element into place, and Link both Legs to the Body. See Figure 5.

• Now for some fancy tail feathers. In a blank area of the Front view, create a Clay Spline that resembles the form in Figure 6. Snapshot Selected Primitive, and delete the Clay Spline. Create a cluster of three of these tail feathers, Group, and name the Group Tail. See Figure 6 and Figure 7.

• Next, we'll create a rather stylized beak with another Clay Spline. Use your own design, or loosely emulate the one displayed in Figure 8. Snapshot Selected Primitive, delete the original, and position it for Linking to the Head. See Figure 8.

• The last elements are the wings. In this case, I just drew a closed linear Spline, and Extruded it by a value of 3, giving it some depth. The Wing was then Cloned, and both Wings were Linked to the Body. See Figure 9.

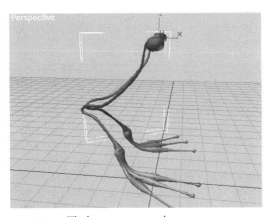

FIGURE 4 *The legs are now complete.*

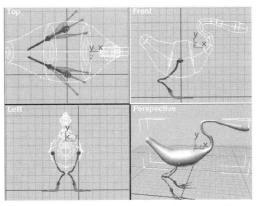

FIGURE 5 *The Body, Neck, and Head are created from one Clay Spline.*

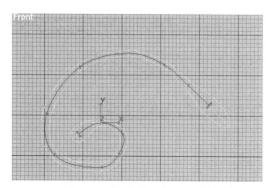

FIGURE 6　*Create a Clay Spline that resembles this one for the first tail feather.*

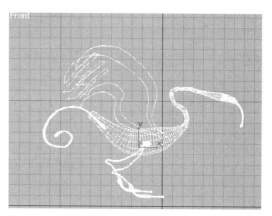

FIGURE 9　*The Wings are added.*

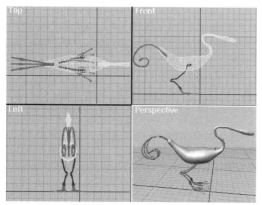

FIGURE 7　*The Tail Feather group is then moved into place and linked to the Body.*

FIGURE 10　*Black spherical eyes complete the Max Clay Studio Pro ClayBird.*

FIGURE 8　*The finished Beak is linked to the Head.*

FIGURE 11　*The Max ClayBird, saved as a 3DS object and ported to Bryce for rendering.*

CHAPTER 24

ElectricImage Use-as-Value Option

BY JOHN SLEDD

The purpose of this article is to shed some light on the often misunderstood Use As Value checkbox in the Filter Tab of the ElectricImage Texture Info Window in ElectricImage 2.9CD (see Figure 1). If you don't quite have the hang of it, don't feel bad. Use As Value and the BlendModes are currently in a state of flux. They are behaving a tad goofy, and some aspects of them are a little redundant. Fear not, however, because the EI engineers are working on a way to streamline this excellent feature, so it's sure to shape up nicely. In the meantime, we still need to have some idea of what's going on.

Since there is a bit of upheaval in this area, it's going to be a little difficult for me to explain, but I'll do my best. The plan I've come up with is to take Use As Value back to a time before BlendModes, describe how it worked there, then bring in the new BlendModes and attempt to make a connection. Once that's done, I'll cover some of the awkwardness that currently exists, and how to get around it.

At its most basic, Use As Value means that EI will extract the grayscale values of your image, even if your image is color, and use each value as essentially a separate value setting for the particular channel. To clear that up a bit (since what I just said doesn't make much sense to me either), basically you have to think of the levels of gray in your image or shader as

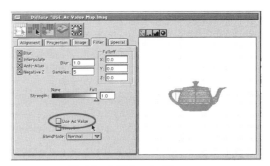

FIGURE 1 *The Use As Value checkbox.*

points on your value slider. This is an easy enough concept to grasp since all of the sliders in EI are represented as grayscale ramps. When your slider is at 100% black (0.0), you have 0% of the channel's effect. When it is at 50% black/gray (0.5), you have 50% of the channel's effect. When it's at 0% Black (aka 100% White or 1.0), you have 100% of the channel's effect.

(One place where this might get a little confusing is in the Transparency channel where your value slider at 1.0 is actually totally opaque. Given the logic of the other channels, one might think that the Transparency channel at 1.0 would be fully transparent, but it doesn't work quite that way. If you actually think about it, it makes perfect sense because, as in Photoshop, the black areas of your mask are what

153

become transparent, so the blacker the value, the more transparent the object.)

So, the result here is that if you apply a map or shader and use it as a value, the areas of the object that are covered by the black areas of the map will behave as if the value slider for that particular channel is at 0.0. The areas of 50% gray will behave as though the value slider is at 0.5, and the areas that are covered by white will behave as though the value slider is at 1.0. Figure 2 should give you a good representation of what's going on here. Don't let the fact that I used sliders from different channels confuse you. I did so to illustrate that no matter what channel the image is in, the effect on the value is the same.

In Figure 3, I've mapped this Use As Value image onto a teapot in the Diffuse channel with the Use As Value box checked. Notice how the areas of the image that are totally black are totally black on the teapot, but as the map gets lighter, so does the underlying color of the teapot. This is because where the map is black, the diffuse value is 0.0, and where it is white, the diffuse value is 1.0. Areas outside the

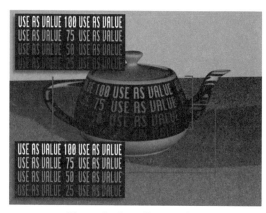

FIGURE 3　*The result of a Diffuse map being used as a value.*

map are untouched and remain at the setting of the main value slider.

It is important to note that in some channels, such as the Diffuse or Reflection channels, your map totally overrides the value slider across the area that the map occupies. In Figure 4, I've decreased the Value slider in the Diffuse channel to 0.5. The white areas of the map still stay at 100%, but the areas not covered by the map take on the value of the slider. If you want to adjust the overall effect of the map, use the Map Strength slider as shown in Figure 5. This allows you to control the levels of the map as shown in Figure 6.

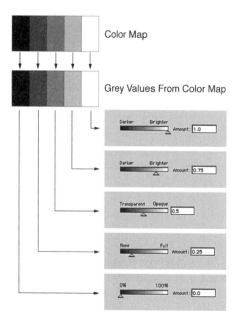

FIGURE 2　*This is what happens to an image when you check the Use As Value checkbox.*

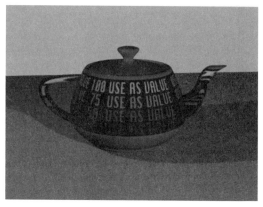

FIGURE 4　*Even with the main value slider set to 0.5, the white areas of the map still maintain a setting of 1.0.*

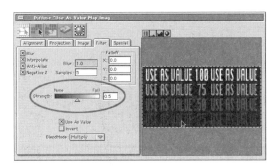

FIGURE 5 *To adjust the overall effect of the map, use the Map Strength slider.*

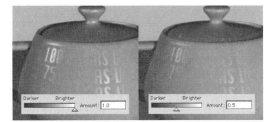

FIGURE 7 *When the map is used in the Specular channel, the value slider controls the high-end of the map as well.*

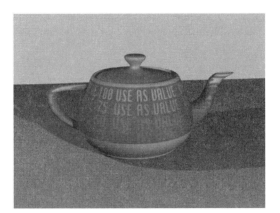

FIGURE 6 *Doing so reduces the effect of the map as a whole.*

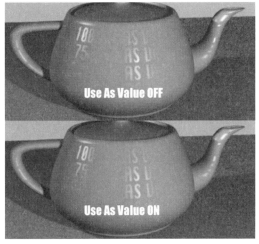

FIGURE 8 *In the Specular channel, not checking the Use As Value box results in a tinted specular highlight, but when the box is checked, the color is removed and only the value is used.*

In other channels, such as the Specular or Transparency channels, the map's high-end is controlled by the main value slider. Take a look at Figure 7 for an example of the map in the Specular channel, but with two different settings for the value slider. As you can see, the white areas of the map maintain the same level of specularity as the areas that are not covered by the map.

In most channels, maps are always used as value generators (with the main exception being Diffuse—I'll get to that in a moment). In the case of grayscale maps, only the value is taken because that's all there is to take. In the case of color maps, however, the color goes along with the value and affects the end result. See Figure 8 for an example of our teapot and map with and without Use As Value checked. In the

top version, Use As Value is not checked, so the color information is used to tint the highlight. In the bottom version, Use As Value is checked and the color information is ignored.

OK. So that's how Use As Value worked before the introduction of BlendModes. The concepts are still the same for most channels, so you're not losing anything by learning the old way first. What Blending Modes do is offer you more options for how the map affects the values in the channel by giving you more control over how the map reacts not only to the object, but also to other maps that are placed underneath it in the Maps list. There is absolutely no way I could possibly cover all of the options that you

can get by using various BlendModes in various channels, but I will say that they are pretty much identical to the blending modes in Adobe Photoshop, so they can make for some interesting effects. A little experimentation in this area will go a long way.

What we really need to know here is what they do in conjunction with Use As Value. For most channels, it's pretty simple. They work just like they would work with non Use As Value images, but they just do it in grayscale instead of color. One of the big differences, however, comes when you're working with Diffuse maps. Back in the days before Blending Modes, popping a map into the Diffuse Map list and checking the Use As Value box got you a map that controlled the Diffuse value across the surface of your object. With the addition of the Blending Modes, checking the Use As Value box gets you nothing but a grayscale map. In order to get the map to behave like an actual value generator, you must choose a blending mode. The mode that gets you an effect that most closely resembles the older method is Multiply. Choose Use As Value and then a Multiply BlendMode and you should have your effect. If you need to soften the effect of the BlendMode, decrease the Map Strength slider.

THINGS TO WATCH OUT FOR

Remember how I mentioned earlier that there was some goofiness in the current implementation of Use As Value and BlendModes? Well, here is where I'll try to address those.

SHADERS

Shaders now come up without a Use As Value checkbox, or at least they are supposed to. I'm not entirely sure how this will ultimately be addressed, but my current theory (somewhat corroborated by the folks at Play) is that Shaders should not have a Use As Value option. The reason for this is because you have total control over the colors of your shaders and can therefore have the shader control whether it

is a Value Only shader or not by simply adjusting the Saturation and Value of your colors in the color picker as shown in Figure 9.

FIGURE 9 *With shaders, you have complete control over your values.*

DISAPPEARING BLEND MODES

The other problem that you might run into are disappearing BlendModes. If you're working on a texture map in the Diffuse channel, for instance, you'll probably have blending modes available. If you go into a channel, like the Bump channel, which currently does not support BlendModes, and then come back into your Diffuse channel, the BlendMode options will be gone for the Diffuse channel map as well. The EI engineers are aware of this issue and are working on it. In the meantime, however, you can get your blending modes back by quitting and then relaunching EI.

Oh, and although I did say that BlendModes are not currently supported in the Bump channel, you

may find that if you add a shader to the Bump channel, the BlendMode options will become available. I don't think they will do anything if you choose something other than Normal, but you can try if you like. Just consider yourself forewarned that they are likely to be gone the next time you enter the Geometry tab.

So there it is. A quick primer on what Use As Value and BlendModes can do for you, and some of the troubles you're likely to run into when working with them. These features can save you tons of time bouncing back and forth between EI and Photoshop, and also open up several new creative avenues for your imagery.

Have fun and happy rendering.

CHAPTER

25

ElectricImage Tessellation and You: Part 1

JOHN SLEDD

This month, I'm going to try to uncover some of the mysteries of the Tessellation settings in the ElectricImage Modeler. Understanding these settings is, in my opinion, the most important thing you can do to make sure your EIM experience is as pleasant as possible. There certainly are other very important things to get a handle on, but I think this should be your first priority. Not being familiar with what the Tessellation settings do can quickly lead to crashes, ridiculously slow workflow, and models that are either too chunky and faceted, or too large and resource-hogging. Understanding them, however, can smooth out and speed up your workflow, and allow you to create models that are just right for your intended use.

For this exercise, you'll need the ElectricImage Modeler and a computer to run it on. Currently, the only computer it will run on is a Mac, but that should change in the not-too-distant future. For now, though, let's say you'll need a Mac.

Let's take a moment to check out the Tessellation settings window in Figure 1. Choose Document Preferences from the Edit menu, and click the Tessellation tab. This is where you determine the Tessellation settings for every object you create, either before you create them or after. Any object created takes on the Tessellation settings stored in these preferences at the time of its creation, so if you have a

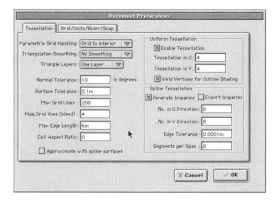

FIGURE 1 *The Tessellation settings can be found in the Document Preferences.*

good idea of the settings you want the object to have, you can set up your preferences first, and then create the object. If these settings aren't what you want for your final output, you can change them here and then click on the models using the Regenerate tool shown in Figure 2 to change their resolutions.

There are many reasons why you might want to change your Tessellation settings. The main reason I can think of is to speed up your workflow. In order for the EIM to give you a shaded or mesh wireframe preview, it must "rasterize" your model. By "rasterize," I mean that it must take the ACIS information and build a polygon representation of it to give you a preview, just like it does when you export a FACT.

FIGURE 2 *You can change the Tessellation settings for any model at any time using the Regenerate tool.*

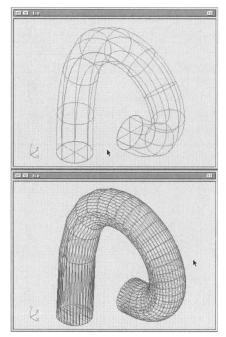

FIGURE 3 *These two images show how ACIS sees your object, and the polygonal representation created from that information.*

Look at Figure 3. The image on the top is a simple wireframe view of an ACIS object. This is the actual object's structure. The image on the bottom, however, is the polygon mesh created from the ACIS geometry. What you see is what you'll get upon ex-

port, so your first tip for working with Tessellation is to do so in Mesh Wireframe preview mode.

Think of the relationship between EIM's native geometry and polygons as you would think of the relationship between PostScript vector art and bitmaps. As with ACIS, PostScript art is resolution independent, so you must convert it to a bitmap form before you can use it in an animation or illustration. The more pixels you use in this conversion, the smoother your art will be, but the larger the file will be and the longer it will take to process. Likewise, with the ACIS-to-polygon conversion, the more polygons you have, the smoother your models will be, but they will get larger and more difficult to process. Sometimes, however, a higher resolution is what you need. Luckily, EIAS handles large polygon counts very well, but higher resolutions can get extremely time-consuming while working in the EI modeler. The solution for many, including me, is to work at a much lower resolution than you'll need for the final model. This will speed up your workflow considerably and then, as a last step before exporting, you increase your Tessellation settings and regenerate your model to create the high-resolution version for rendering.

Some objects might even require different Tessellation settings than other objects in the same scene. The reason for this would be that smaller objects might require a lower Tessellation setting than larger objects. For example, you wouldn't want the body of your rocket to have the same Tessellation level as the rivets on your rocket. You'd simply be wasting polygons to create a perfectly round rivet that's likely to not take up more than a couple of pixels in your final render, whereas any facets in the curvature of your rocket's body would be very noticeable. In this case, you'd want the rivets to be as coarse as possible, while giving the rocket body as many polygons as necessary to give it a nice, smooth form.

Now that we know what Tessellation does, let's talk about how to get it to do what we want. Unlike the aforementioned PostScript-to-pixel conversion, we get a lot more options for our ACIS-to-polygon conversion. These options are a good thing, but they do seem daunting at first. Heck, I'd used the mod-

eler for almost a year before I got brave enough to really tackle the Tessellation settings. I'm not a technically minded person, and I learn much better from doing than from reading. The EIM manual gives a good explanation of what these options do. However, reading about what they do only makes sense to me if I have some form of experience and visual picture in my head of what's actually taking place so I'll have something to base the new information on. Therefore, that's the approach I'm taking in this article. Let's start playing, shall we?

Let's begin with the Parametric Grid Handling Options since, well, they are the first thing in the box. This option basically tells the modeler whether to apply a subdividing grid to your objects' faces for meshing purposes and, if so, how to apply it. The choices are No Grids, Grid to Edges, and Grid to Interior. The manual pretty much covers what these things do, so make sure you read it. If you really understand it, great, but to be honest, I really didn't "get" what the manual is talking about. I do, however, understand what I see, so let's look at Figure 4. Here we have the exact same object with the different grid options. From left to right it goes No Grid, Grid to Edges, and Grid to Interior. Grid to Edges and Grid to Interior produce pretty much the same result, but obviously No Grid is not what you'd want to use here. Honestly, I can't think of a reason why you'd ever not want a grid. There must be a reason, but I certainly haven't run into it yet.

Although Grid to Edges and Grid to Interior look similar at first glance, they're a bit different. Grid to Edges runs the grid right up to the edges of the model, and since the edges of the grid and the edges of the faces may not correspond exactly, the fringe polygons need to be triangulated (also referred to as "tripled") or will result in n-sided polygons. Look at the zoomed-in view of our Grid to Edges object in Figure 5 and you'll see what I mean. The red line indicates where the edges of the grid meet the edges of the face. The red circles indicate the points of the edge, so it's easy to see how the last row of polygons (highlighted in blue) needs to be split in order for the points to match up properly. If the polygons are not tripled, you will end up with n-sided polygons as shown in Figure 6. Here, the polygons are not tripled, and the red circles show where the additional points that make the fringe polygons n-sided are located.

The difference between Grid to Edges and Grid to Interior is illustrated in Figure 7. They look basically the same; the difference is that the grid doesn't actually go to the edge of the face, but rather stops just inside the perimeter of the face. All of the polygons in the blue area are created (instead of divided as they are in Grid to Edges) to bridge the gap between the grid and the edge. These polygons will always be tripled regardless of what your Triangle

FIGURE 5 *Notice how the polygons around the edge of our face need to be created in order to match up with the edge's geometry.*

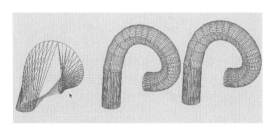

FIGURE 4 *Three different objects with different Parametric Grid options: No Grid, Grid to Edges, and Grid to Interior.*

FIGURE 6 *If your polygons are not tripled, you will end up with n-sided polygons, which can cause shading problems.*

FIGURE 7 *The Grid to Interior option creates polygons from scratch to fill the area between the parametric grid and the edge of the face. All polygons are automatically tripled to avoid the n-sided problem.*

Layers setting is—we'll get to those settings in a moment.

To sum this all up, look at Figure 8. This is a simplified way of understanding what's going on with the Parametric Grid options. In Grid to Edges, the last row of polygons (called Fringe Polygons) should be tripled to avoid n-sided polygons. With Grid to Interior, polygons will be created to bridge the gap between the grid and the edges of the face, and these polygons will always be tripled.

Next in line are the Triangulation Smoothing options. What Triangulation Smoothing does is reposition the vertices of the created triangles to smooth the geometry if needed. No Smoothing obviously doesn't attempt to smooth out the polygons at all, so that one should be easy enough. In Figure 9, I've jumped ahead a little and set the Triangle Layers to All Triangles. You don't really need to worry about that just yet. I only did so to help illustrate what the

FIGURE 8 *This illustrates a simplified idea of what's going on with all of this Parametric Grid business.*

FIGURE 9 *This shows a surface object with Triangle Smoothing set to No Smoothing.*

Triangulation Smoothing Options do. This one is set to No Smoothing. As you can see, all of the triangles are pretty even. In Figure 10, however, I've set the Triangulation Smoothing to Smooth at Edges. Now you can see that some of the triangles are still pretty uniform, but the points of many of them have been shifted to create a smoother mesh. In Figure 11, Smooth Everywhere was chosen and the rearranging of the points is even more pronounced. It's difficult to see here since Smooth at Edges smoothed most of the polygons, but if you create your own ob-

FIGURE 10 *When you change the setting to Smooth at Edges, you can see how the points are shifted to form a smoother surface.*

FIGURE 11 *The Smooth Everywhere setting takes Smooth at Edges one step further and attempts to smooth the entire surface of the object.*

ject and play with these settings, you'll be able to see the difference.

Finally, we have the Triangle Layers setting. Simply put, this setting determines how many of our model's polygons will be triangulated. No Triangles simply means that none of the polygons will be triangulated. The exception to this, as I mentioned earlier, is when Grid to Interior is selected as your Parametric Grid Handling Option, in which case the first layer of fringe polygons will ALWAYS be triangulated. Look at Figure 12. This is what our model

FIGURE 13 *Each setting triangulates one more row of polygons.*

FIGURE 12 *The Triangle Layers setting of One Layer triangulates the one fringe layer of polygons between the parametric grid and the edge of the face.*

would look like with One Layer of triangulation. Likewise, Figure 13 shows a setting of Two Layers of triangulation. Each level of triangulation begins with the fringe layer and works backward layer by layer until you reach the All Triangles option, in which case, like it says, all polygons will be triangulated as we saw in Figure 9.

Now we know how and why the ElectricImage Modeler creates its polygons. In the next tutorial, I'll get into controlling how your object tessellates. Until then, get to work.

26

ElectricImage Modeler Tessellation and You: Part 2

By John Sledd

In the last article, I covered the Parametric Grid creation section of the Tessellation settings in the ElectricImage Modeler (Figure 1), and this time, I want to finish explaining the rest of the options. Basically, Parametric Grid Handling determines how your surface will be defined and, for the most part, the rest of the options determine how closely your polygonal mesh will follow that surface.

Let's drop straight down to the Normal Tolerance field and begin there. To get to the Tessellation

FIGURE 1 *Last time, we covered the Parametric Grid Handling options.*

settings, go to Edit Menu | Document Preferences |Tessellation tab.

NORMAL TOLERANCE

To help you understand what's going on with Normal Tolerance, let's think of the face of a clock. Some clocks don't have any numbers at all, which forces you to pretty much guess what time it is. Some have numbers at 12, 3, 6, and 9, which still makes you guess what time it is, but at least you'll get closer than with no numbers at all. Some have a number for each hour, giving you even better accuracy, and some have minute/second marks in between the hours that give you a very good idea of the time.

If you think of your model as that clock face, the Normal Tolerance would be equivalent to the level of detail in this clock face, because the face would be divided at the specified degrees. Take a look at Figure 2. This is a Mesh Wireframe preview of a swept object with the default Tessellation settings, except for Normal Tolerance, which is (left to right) 20, 10, and 5, respectively. Notice that the more curved sections increase more in detail than the straighter sections. This is because, if the angle

163

FIGURE 2 *Swept objects with Normal Tolerance settings of 20, 10, and 5. The lower the setting, the smoother the mesh.*

between the normals is less than your setting for normal tolerance, no polygons are added. If the angle between normals is more than the specified setting, then polygons will be added to bring the angle down to the specified setting. Simple enough. And it's a great way to quickly add more resolution to your model. But what if Normal Tolerance isn't the perfect solution? What if the resulting mesh isn't quite up to snuff? Enter Surface Tolerance.

SURFACE TOLERANCE

Surface Tolerance is very similar to Normal Tolerance, but it gives you a bit more control over the amount of polygons used to represent your surface. Figure 3 illustrates what's happening with the Surface Tolerance setting; the lower the number, the more closely the facets follow the spline on which

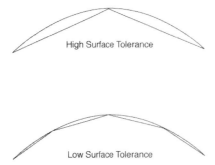

FIGURE 3 *Surface Tolerance controls how closely your polygon mesh follows your model's actual surface.*

they are based. Unlike Normal Tolerance, the best setting for Surface Tolerance depends on the size of your model. The smaller the model, the smaller the number you'll have to use to get a smoother mesh. Take a look at Figure 4. This shows the same three objects in Figure 2, but with changes in their Surface Tolerance instead of Normal Tolerance (Normal Tolerance is at the default value of 15). The figure on the left has a default Surface Tolerance of 0. A setting of .01 yielded no result on the middle object because of its size, but bumping it down to .005 yielded the result you see here. The object on the right has a Surface Tolerance setting of .001. When working with my own objects, I usually start with some random number and then keep decreasing it by half until I get the desired resolution.

FIGURE 4 *Lower numbers in the Surface Tolerance field create meshes that more closely follow the original model information.*

MAX GRID LINES

This value determines the maximum number of grid lines in your parametric grid. What this means is that you can set your maximum number of grid lines here, and regardless of what you set your Normal or Surface Tolerance to, the number of polygons will never be greater than the limit established by your Max Grid Lines setting. Take a look at Figure 5. All of these objects have the same Tessellation settings, except for the Max Grid Lines setting. The object on the left has a default Max Grid Lines setting of 300, which is more than enough for this object at these settings. I kept decreasing the Max Grid Lines until I

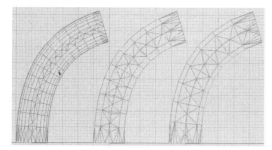

FIGURE 5 *Even though all of the other Tessellation settings are identical on each of these three objects, a limit is placed on the mesh density by using the Max Grid Lines setting.*

noticed a change in the number of polygons. I stopped at a setting of 10. I gave the object on the right a Max Grid Lines setting of 5. As you can see, even though the Normal Tolerance and Surface Tolerance settings stayed the same, the cap imposed on the number of polygons by the Max Grid Lines setting kept the resolution from going any higher.

MAX GRID LINES (BLEND)

This option does nothing, and will most likely be removed in a future version of the modeler. So, don't spend any time trying to figure it out.

MAX EDGE LENGTH

Max Edge Length determines the maximum allowable edge length for a face. If an edge is longer than the maximum specified in this box, it will be split and a denser mesh will be created. In Figure 6, the cube on the left has a default Max Edge Length set-

FIGURE 6 *Max Edge Length determines just how long an edge can be before it gets subdivided automatically, regardless of your other Tessellation settings.*

ting of 0m. The one in the middle is set to .5m, and the one on the right is set to .1m. No other settings were altered from their defaults. This is basically just a dicer of sorts.

CELL ASPECT RATIO

Use this option to determine the Aspect Ratio of your Cell. OK. Just kidding. What this number does is determine the symmetry of your parametric grid. A setting of 0 lets the faceter do the most polygon-efficient job that it deems necessary, but that can result in a less-than-desirable mesh, as shown in Figure 7. However, by setting it to 1, you will force the grid to be as square as possible, and you'll wind up with a much better-looking mesh like the one in Figure 8. This option comes in very handy for skinned objects and other objects where you want to use UV mapping.

FIGURE 7 *A setting of 0 for the Cell Aspect ratio lets EI try to decide, based on your current settings, the best way to spread out an object's parametric grid.*

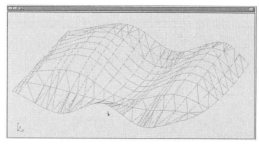

FIGURE 8 *Setting the Cell Aspect Ratio to 1, however, forces it to create a very even grid, albeit at the expense of polygon overhead.*

THE APPROXIMATE WITH SPLINE SURFACES CHECKBOX

If your version of modeler has this option, ignore it—it doesn't do anything. It had a purpose at one time, but now it does nothing. Purge its existence from your mind—it will only use up valuable brain cells. If it's not in your version of modeler, forget this paragraph ever existed.

UNIFORM TESSELLATION (üBerNURBS)

The Uniform Tessellation settings affect your über-NURBS objects only, and are used when you wish to morph your überNURBS objects in EI. What Uniform Tessellation does is ensure that all of your morphed models have the same number of vertices, and that they will all be in the same order. Very important stuff if you intend on morphing anything.

If you were to turn off Enable Tessellation, your model would be recalculated for every morph target, and the faceter would alter the number of polygons according to the topography of each target. With Enable Tessellation on, the number of polygons and their order always stay the same. So let's cover what the options under here do.

ENABLE TESSELLATION CHECKBOX

This is simple enough. The Enable Tessellation checkbox determines whether you are or are not using Uniform Tessellation. You should be aware here, though, that if you are using Semi-Converted überNURBS objects (that is, üN objects that have not been fully converted to ACIS), you MUST have Enable Tessellation on.

TESSELLATION IN U AND V SETTINGS

This setting determines the resolution of your üN cage by dividing each of the faces that make up the

üN object. If you read the manual, you should know that each überNURBS object is made up of several different NURBS faces, and this setting determines how many divisions each face has. In Figure 9, The top üN object has the default Tessellation settings of 4×4, whereas the bottom one has a Tessellation setting of 2×2 and, obviously, a much lower resolution.

FIGURE 9 *Tessellating überNURBS objects is a relatively straight-forward process. The more divisions along the U and V directions, the denser the mesh.*

WELD VERTICES FOR OUTLINE SHADING

This option simply welds vertices that are close together so when you use your outline shading options in EIAS, you will get better results. This can, however, interfere with morphing, so try turning it off at first (it defaults to on), and only turn it on if you are having geometry outline shading problems. If you're not doing any morphing or outline shading, you can leave it on.

SPLINE TESSELLATION

All of the controls in the Spline Tessellation section are for adjusting your onscreen spline previews only (with one exception, and I'll get to that).

Just as with your shaded 3D objects, a spline is a resolution-independent object, but in order for you

to see it, it must be divided into segments before being displayed on the screen, and here is where we have the settings for that.

GENERATE ISOPARMS

This does basically the same thing as the "Show Isoparms" checkbox in the System Preferences> System Tab. The main functionality difference is that this option can be used on an object-by-object basis, since it requires you to regenerate the model to implement the new settings, whereas the Show Isoparms checkbox is global and affects all objects at once. Therefore, if you have one object that you don't wish to see the Isoparms on, uncheck the Generate Isoparms checkbox here and regenerate the object. If you want to disable the Isoparm previews for the entire scene, use the Show Isoparms option in the System Prefs as shown in Figure 10.

FIGURE 10 *Unlike the Generate Isoparms checkbox in the Tessellation tab, the Show Isoparms option in the system preferences toggles Isoparm previews on and off for the entire scene.*

EXPORT ISOPARMS

This is the "one exception" I mentioned earlier. Export Isoparms determines whether or not the generated Isoparms are exported with the model. This is most-often not preferable, as it creates a wire cage preview of your object in EIAS that cannot be

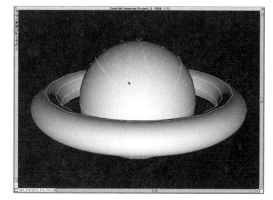

FIGURE 11 *Exporting Isoparms gives your objects renderable Isoparm previews within EIAS.*

turned off. If you're looking for a certain wireframe effect, however, you may want to leave these on. See Figure 11.

NO. IN U DIRECTION / NO. IN V DIRECTION

These are easy enough as well. They determine how many Isoparms are generated for the preview. Figure 12 shows the difference between an object generated with the settings of 4 and one generated with settings of 8 in both the U and V fields. The same exact object as far as Tessellation settings are concerned; the

FIGURE 12 *The more Isoparms you have, the more detailed your Simple Wireframe previews will be, but less is often better.*

only difference is in how it is previewed in Simple Wireframe.

Sometimes you may find that, with the default settings, you don't get enough visual information on a model. For instance, you may get a full outline of the model in one view but not in another view. This is when you'd want to add Isoparms. Contrarily, you may have a scene that takes too long to preview, even in Simple Wireframe mode. In that case, you can turn down the number of Isoparms. You would still get a better preview than turning off Isoparms, but with less information being redrawn.

EDGE TOLERANCE

The Edge Tolerance setting is very similar to the Surface Tolerance setting we went over earlier. Instead of determining how close the polygon mesh of the model represents the actual ACIS surface, this setting determines how closely the generated Isoparms and edges follow the interior edges of the model. Figure 13 shows the difference between the default settings (left) and a coarser setting (right). As with Surface Tolerance, these settings depend on the size of your model. In most cases, the default settings work fine, but should you ever need to change them, you now know how.

FIGURE 13 *Similar to Surface Tolerance, Edge Tolerance controls how closely the generated previews follow the actual geometry of your object.*

Keep in mind that these settings are for display purposes only. Any polygon meshes generated from these models will be based on the model's Tessellation settings. Figure 14 shows a Mesh Wireframe preview of these same two objects. Notice that they are identical. That is because only the Spline Tessellation settings were changed between the two objects; the object Tessellation settings remained the same.

FIGURE 14 *Notice that even though the Simple Wireframe previews differ, the actual polygon geometry stays the same.*

SEGMENTS PER SPAN

Each spline must be divided into straight-line segments in order to be viewed onscreen. A Segment is the distance between any two knots on a spline. So this setting controls how many straight-line segments are used to represent the area between any two given knots.

A FINAL NOTE BEFORE YOU EXPORT

One final bit of very important info here. The ability to have separate Tessellation settings on each object in the EIM is only good while you are in the EIM. When you export, all objects are exported using the

current Tessellation settings. Therefore, if you have three objects with a Normal Tolerance of 5, and four objects with a Normal Tolerance of 10, and your current Normal Tolerance is set to 20, when you export, all objects will be exported with a Normal Tolerance of 20. They will maintain their settings in the EIM as long as you don't regenerate them, but the exported model will be tessellated with the current settings.

If you really want separate objects to have separate settings (which is often very desirable), export your models in separate pieces. For example, if you have a spaceship with tons of tiny rivets all over it, you could export the main part of the spaceship with a more dense polygon mesh, and then export the rivets in a separate file with a much lower density polygon mesh. You can do this by checking the Export Visible Only box in the export prefs (Edit>System Prefs>Export Tab), as shown in Figure 15. Then you can hide whatever you don't want to export, change your Tessellation settings, per-

FIGURE 15 *By Exporting Visible Only, you can control the polygon resolution of individual objects for use within EIAS.*

form the export, and then repeat the process for the next group of objects.

OK. That wraps up our coverage of the Tessellation settings in the EI Modeler. Learn them, love them. They are the key to whether your EIM experience is a pleasant one or an exercise in frustration.

CHAPTER

27

form•Z Modeling Using the Patch Tool

BY DAVID ANDERSON

For this tutorial, we are going to use form•Z and the Patch tool along with simple geometry construction to model the head of a cartoon lion. The Patch tool, with its ability to smooth low polygon objects, is ideal for these types of models. The technique would not be too unlike using the metanurbs feature for Lightwave or smoothmesh in 3D Studio Max. You could even export your cage object to these programs to apply the smoothing there. A PII 450 with 128MB of RAM was used to create this model. (See Figure 1.)

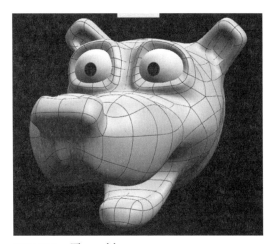

FIGURE 1 *The model.*

To build the low polygon "cage" for the head, we start with what I call the "flat-mesh" technique. The concept is to basically draw the cage in 2D, and then move the vertices perpendicular to their proper height to bring the 2D cage into 3D. You may find that working with a sketch makes the creation process easier. In this tutorial, however, we will just start from scratch.

To begin, go to the Side view, and with the Vector Line tool draw the profile shape of the head. We will add protrusions such as the ears and nose later, so don't include these yet.

Once we have the outline, we need to subdivide it into multiple faces. Remember, these faces are going to comprise your 3D model, so we have to consider how we construct these faces. When modeling a character, you should have your lines follow the contours and also build around openings. The mouth, for example, will deform easier and better when the polygons around the opening are arranged in a radial fashion. Knowing how to lay out these faces is the key to the "flat-mesh" technique. Try to create only four-sided polygons—three sided if necessary—and try to avoid making long, thin faces. Also keep in mind that we will be smoothing inward with the Patch tool, so the cage will be built to compensate for that fact.

Continue roughing in the contours. Notice that even at this early stage, the placement of the eyes and

mouth are considered and suggested by the placement of our vector lines. To create this framework, use the Insert Segment tool, along with the Split and Stitch with Line tool. Use Split and Stitch to insert segments through the entire object. Draw enough lines so that you will be able to pull the vertices out and form a rough version of the head in 3D. (See Figure 2.)

Now that we have the rough form of the head, we can pull the points out to give the head shape. To do this, switch to the y axis in a 3D view and use the Perpendicular Switch to move the points away from the reference plane. We will only make half of the head until the very end, when we will Copy Mirror to create the other half. The points around the edge of the mouth will be pulled off of the reference plane so that the inside of the mouth can be made. (The "flat-mesh" technique does not work well when geometry doubles back on itself; for example, the inside of a mouth when looking from a Side view.)

You may find it helpful to work in Quickpaint view when moving the points. It will effectively hide points that are not in full view, show the model with basic shading, and will update almost immediately to show you the results. The reason that we do not use OpenGL is that while in the initial stage when the mesh is still flat, it is not possible to see the individual points of the mesh in order to pull them outward.. (See Figure 3.)

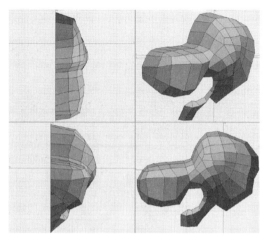

FIGURE 3 *Bringing the mesh into 3D.*

To create the inside of the mouth, select those segments around the edge of the mouth that were pulled off of the reference plane. Use the 2D Derivative tool set to selected segments with Status of Objects set to Keep to create what will be our initial control line. Project a copy of this line to the (y,z) reference plane.

Use these two lines to make a plain c-mesh. Set to at Points and Lines with No Smoothing in the c-mesh options. (See Figure 4.)

Stitch the resultant object to the head. (See Figure 5.)

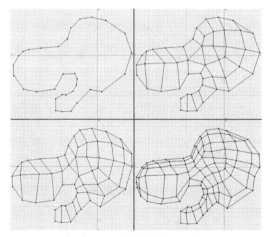

FIGURE 2 *Laying out the initial flat mesh.*

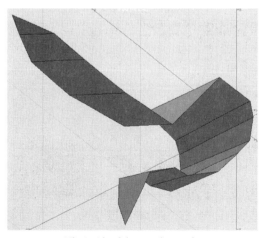

FIGURE 4 *The inside of the mouth c-mesh.*

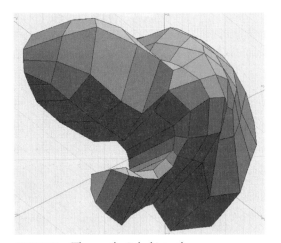

FIGURE 5 *The mouth stitched into place.*

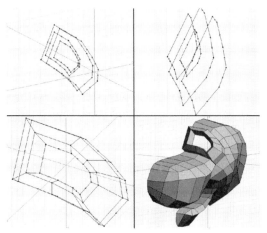

FIGURE 7 *The eye c-mesh stitched into place.*

Next we will work on the eye. We are going for a protruding and bulging look à la Homer Simpson.

Start by deleting faces for where the eye socket will go. (See Figure 6.)

Select the segments around the perimeter of the hole. Derive those segments using the 2D Derivative tool. Use the Close Line tool set to Connect to convert the open shape to a closed shape. This is your first control line. Create three more lines by copying and scaling the original line, and place them in position. Use these lines for a c-mesh using the same settings as previously. Stitch the resulting object to the head. (See Figure 7.)

Once it is stitched into place, we can go in and refine the shape of the eye area by inserting more segments and moving points.

Notice that in the upper-left and lower-left corners of the socket we inserted segments, but it created a five-sided polygon. To maintain three- or four-sided polygons, we can triangulate the face or continue the line through the head. In this case, we are going to continue the line so that we can further shape the chin and snout. (See Figure 8.)

Insert segments from the eye all the way around the back of the head to the bottom of the chin, and from the bottom of the eye to the upper lip. Adjust

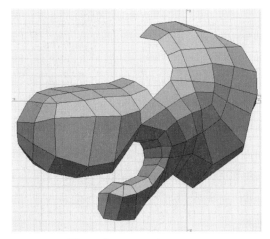

FIGURE 6 *The eye faces removed.*

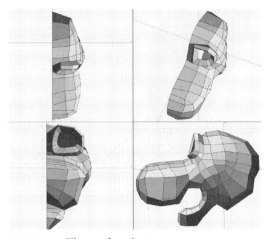

FIGURE 8 *The eye after adjustments.*

these new segments. For the snout, we are going to have a groove between the left and right snout, so pull the points in the center of the snout upward. (See Figure 9.)

Next we can construct the ear. This will be easier if we build it separately and then stitch it to the head. The process will be similar to the one we used to create the eye socket. However, in this case, we will build it from simple geometry instead of from control lines.

First we need to create an opening in the head for the ear to go. Delete a couple of faces from the side of the head. Use this opening to approximate the size that the ear will need to be. (See Figure 10.)

To create the ear, draw out two cuboids, one larger for the outer ear, and one smaller for the inner ear. Place the two cuboids in such a way that the smaller one is halfway intersecting the larger one. Use the Difference tool to difference the smaller from the larger. Since we deleted two faces from the head, we will need to subdivide our ear in two. From a Top view, draw a vector straight through the middle of the ear. Use Split and Stitch with Line to drop the vector line into the ear object. Delete the bottom face, and using the Vector Line tool and Point Snap, draw a rectangle for the bottom of the inner ear. Stitch this object into place, and then insert a segment through the middle of this new face. (See Figure 11.)

Rotate and move this ear into position. With Point Snap on, snap the points along the bottom edge of the ear to the corresponding points of the hole in the head. On the left side of the hole you will need to insert two points, one in the middle of each segment. These will be to match with the inner edge of the outer ear. Stitch the ear to the head. If the point matching was done correctly, you should not see any arrows around where the ear attaches to the head when you turn on Show Direction in the Wireframe options. Once the ear is stitched into place, insert a couple of segments from the front middle point of the ear to diagonal corners of the adjoining faces. This will turn the five-point face into three- and four-point faces instead. (See Figure 12.)

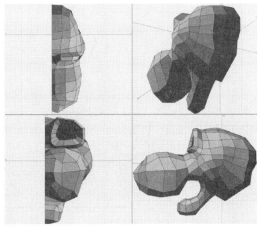

FIGURE 9 *Creating the snout groove.*

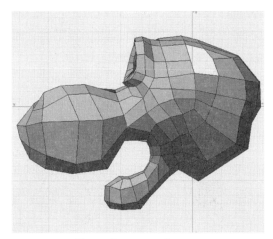

FIGURE 10 *The ear faces removed.*

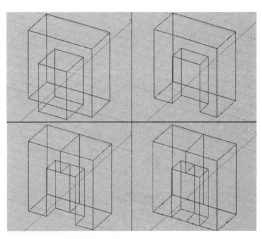

FIGURE 11 *Building the ear.*

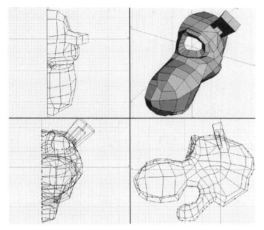

FIGURE 12 *The ear stitched into place.*

The last bit of construction will be for the nose. Again, we will use the same technique that we used for the eye socket. First we will delete the faces on the head where the nose will go. Then we will derive the segments of the opening to be used as a control line for a c-mesh. Make a copy of this line to be used as the second control line. Use the same c-mesh settings as before. Delete the bottom face and the faces along the mid-seam. Stitch the nose object into place. Stitch a face into the top of the nose if it doesn't already exist, and then insert segments to divide the top face. Move points and segments to sculpt the nose. (See Figure 13.)

One half of the head should now be completed. You can continue to insert segments, etc., to add details to your cage. Copy Mirror the cage object to create the other half. Stitch the two halves together using the Stitch tool.

You can now convert the head to a patch object. Click on the Patch Derive tool and set to Smooth In, Equal Portions, and set the Max # of Facets to 3. Click on the head. You will get a smoothly blended surface, derived from the lo-res cage object. If you are not happy with the results, undo the Patch Derive, adjust the geometry, and try again. When you are satisfied, create a couple of eyes using parametric spheres. That's it, we're done! (See Figure 14.)

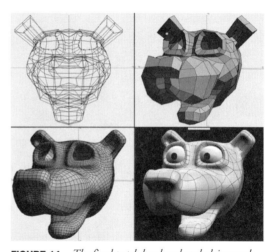

FIGURE 14 *The final patch head and underlying mesh.*

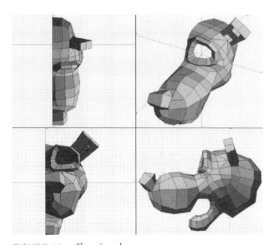

FIGURE 13 *Creating the nose.*

CHAPTER

28

Creating Landscapes Using form•Z

DAVID ANDERSON

This tutorial will cover how to create natural forms inside of form•Z and apply textures to them to create a photorealistic scene (Figure 1). For this tutorial, we will be using form•Z RenderZone 3.5. Earlier versions will work, but you should have at least 3.x to complete this tutorial. Also, you will want a system that has a good bit of RAM. As a minimum, 128MB will be required. Additional memory will allow more to be added to the scene. The techniques involved can be used in almost any 3D program.

A favorite pursuit for artists through the centuries has been among other things, the interpretation of their environment, including the natural landscape around them. From an artist's point of view, interpretation of the natural environment using the tools of a 3d program should also be possible and pursued. Eventually, it could be just as rewarding as any experience with more traditional creative mediums. In that spirit we should approach this tutorial.

PART I: MODELING

In the scene pictured, there are various elements to be considered. I have tried to include most types of objects that can be found in nature, including rocks, trees, grass, water, and dirt. Usually a good place to start is from the ground up, so let's take a look at the terrain in this scene. The terrain is built by constructing a series of contour lines along with a site line, then generating a mesh using the Terrain tool (Figure 2). You can keep the contours fairly simple. In fact, you can see from the ones I created that there are only a few, and they are not overly complex in their shape.

Generate a mesh terrain. Use the Mesh Disturb tool set to random disturbance along point normals to add unevenness to the terrain mesh. Also, check the triangulate option in this dialog to prevent non-planar artifacts when it comes time to render. The scale of your terrain and personal taste will determine how much of a disturbance you will want.

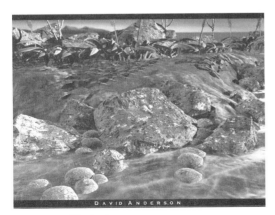

FIGURE 1 *The landscape scene.*

175

FIGURE 2 *Contours and site line for terrain mesh.*

Once the disturbance has been applied, we can call the terrain mesh done (Figure 3).

The next object to model is the water. First, generate a rectangle, and using the Mesh tool, mesh the rectangle. Then using the Mesh Disturb tool, apply a linear wave disturbance to the mesh. Place the water so that the waves somewhat line up with the shoreline and intersect the terrain. If you already have a view picked out for the final render, make the view visible, and in the wireframe options dialog, check the Show Camera Cones option. From a top view in wireframe mode, use vector lines and the Trim and Stitch tool to trim with line to the outside of the cone to get rid of extraneous geometry (Figure 4).

FIGURE 3 *Complete disturbed terrain mesh.*

FIGURE 4 *Water mesh trimmed and placed into position.*

The next objects are the rocks. These can start out as simple cubes. Use the Smooth Mesh tool with max segment length and max face angle unchecked and curvature set to zero. Immediately drop controls using the Drop Control tool. This will allow for subsequent smooth operations and nonuniform scaling. Move the points around to start to form the rock. Use smooth mesh two more times for a total of three, dropping controls each time (Figure 5). My scene actually is only one rock that has been copied, rotated, scaled etc., so that they all look different. (The smaller rocks are cubes that were smoothed once with a 50% curvature angle.)

The next objects are the grass and clover. The objects are created initially from very simple control lines (Figure 6).

These control lines were then used to create a nurb surface (Figure 7). The reason for using nurbs is that you get a smooth surface without having to create all the faces, it is easy to modify using the

FIGURE 5 *Creating a rock using smooth mesh.*

FIGURE 6 *Control lines for grass and clover.*

FIGURE 7 *Grass and clover nurb surfaces.*

Pick/Edit tool, and in the end we can use parametric mapping (more on that later). To save on memory, keep the number of underlying facets of the nurb surface down by changing the max number of facets in the wires and facets dialog to 4×4.

Once the nurb surface is created, use the Create Symbol tool to create a symbol out of the object. The reason for this is that there are going to be quite a few copies of them, and it will be easier if you decide to make a change to the shape to modify the symbol and have the instances update automatically. If a library has not already been loaded or created, form•Z will prompt you to create one. Notice that there are three variations of grass in the symbol library. This is so they all do not look exactly alike. Also, notice there are three copies of the clover object to create the complete clover symbol (Figure 8).

One thing you will want to make sure of after the symbol is created is to place the origin at the middle of the base of the object. You can do this by using the Edit Symbol tool and moving the red origin icon into position (Figure 9).

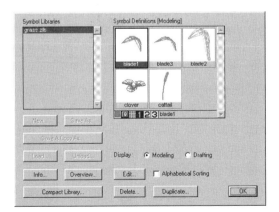

FIGURE 8 *The vegetation symbol library.*

FIGURE 9 *The edit symbol dialog window.*

To modify a symbol, go to the file pull-down and open the symbol library. The first symbol in the library will appear in the center of the screen. Since these are nurb objects, use the Pick/Edit tool to modify their shape. Open the Symbols palette to make changes to other symbols in the library by highlighting the symbol in the palette. Once the changes have been made, save the library and close the file. When you return to the model window containing the symbols, the symbols will automatically update (Figure 10).

There are also a couple of patch objects used in this scene. They are the reed-like objects and the small tree branches. These were made by creating a low-polygon cage and then converting the cage into a patch object. The reed was just a plain c-mesh constructed from square control lines that was then converted to a patch object. A radial bend deform was then applied (Figure 11).

Now you will want to plant your vegetation using the Place Symbol tool. Do not overdo the number of instances of the grass and clover symbols; these will

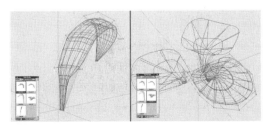

FIGURE 10 *Modifying symbols with the Pick/Edit tool.*

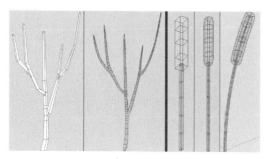

FIGURE 11 *Creating the patch objects of the scene.*

eat up your memory and increase the render times. You will want to strategically place them so that there are none outside the field of view, and also none that overlap. In my scene, I made a wall of grass around the rocks on top to cut down on the number of blades needed. To avoid a repeating look, I rotated the grass in different directions, and mirrored some. If you use the local coordinates when rotating (new feature of 3.5), this job will go much faster. Remember, I also made three different grass symbols that were scattered throughout the scene, so use each one. Here's a tip on placing the clover: Notice that the clover follows the contour of the terrain. Use your object snaps and snap to the center of the faces on the terrain and at various points using point snap. Rotate using the local coordinates so they aren't all going in the same direction. Figure 12 shows the completed scene without textures.

PART II: TEXTURING

For this tutorial, we will be using the procedural materials inside form•Z to add textures to our objects. We will use procedurals because they are resolution independent (will not pixelate), and also because they make more or less seamless textures. Besides, you can get some good results using them. Procedural textures are essentially mathematically defined patterns that have various parameters to control them. They differ in that you do not need an image map in order to use them.

One of the keys to realistic and natural procedural textures is layering. We can use this technique for the dirt and the rocks. What you do is color the object with an overall texture and then use decals overlaid on top to add additional detail. Let's start from the ground up again and look at the terrain object. Included with form•Z 3.x are various predefined procedural textures that are divided into categories. From a surface style parameters window, click on the predefined button to access the materials (Figure 13). From the predefined window, scroll down the category list and find "ground." Scroll through the materials until you find "dirt decal 2." This will be our base texture (Figure 14).

What we are going to do is modify this texture to suit our needs. You can use my settings or experiment with them to get the look you want. The scales

FIGURE 12 *The untextured scene.*

FIGURE 13 *The surface style parameters window.*

FIGURE 14 *Predefined materials window.*

FIGURE 16 *Mapping the base ground texture.*

may be different according to the size of your scene. I got rid of the transparency of the original by setting the transparency shader to none, and also gave it a bump using the rough solid bump procedural. The bump will further enhance the rough organic look of the terrain (Figure 15).

Map this texture to the terrain using the Texture Map tool and set the size of the tiles to a fairly large number (Figure 16). The reason we want to use a large number is that we are going to place decals on top of this texture. We will want to layer them in such a way that the smallest details/decals are on top, so we will organize the layers from largest (the base texture) to the smallest.

Once the texture has been applied, we can add additional details through our decals. On my terrain, I applied two decals. The first is for additional color variation. Copy the base texture and modify the colors of it (Figure 17). Apply a 50% simple transparency to it so the base color will show through. Apply this surface style as a decal using the Decal tool. Note I am using the transparency shader of this decal so I will want to make sure that there is a checkmark next to the word "opacity" in this dialog. Also note that the size of the tiles is smaller than the base texture (Figure 18).

FIGURE 15 *Dirt decal 2 modified settings.*

FIGURE 17 *Modified base texture for the first decal.*

FIGURE 18 *Decal window for first ground decal.*

FIGURE 19 *Grey rock 2 modified settings for base rock texture.*

The second decal is to add scattered small green vegetation on the ground. We will again modify an existing predefined texture. In the same "ground" category select "dirt decal." Change the colors to greenish colors and adjust the scale of the transparency to 500%. This will give more space between each "clump" of vegetation. Apply this as a decal and adjust the size to suit your tastes—I made mine smaller still. Also, make sure that since we will be using a bump shader from the decal, you will want to make sure there is a checkmark next to the word "bump" in the decal dialog window. Also, in the decals list, the decal that is listed on top is the one that is placed on top, so make sure that they are listed in the proper order.

The big rocks are pretty much done the same way. The base texture started from a predefined material. Select the "rocks" category and choose "grey rock 2." The only things changed were the colors and the scales in the color and bump maps (Figure 19).

The first decal is the same as the base, but it has a 50% transparency applied to it with slightly different coloring, the same as the first decal of the terrain object. Apply this decal the same way as the first decal was applied for the terrain object. The second decal is the same as the second decal for the ground, except the colors are slightly different, the scale of the transparency is slightly smaller, and the bump scale is half

size. A third decal is used for the white flakes in the rocks. It is the same as the second decal, but with scales and colors adjusted. Again, make sure you have the proper checkmarks included in the decal dialog along with proper sizing. The water has only a single texture applied to it (no decals). The settings I used are provided here, but I encourage you to experiment with them (Figure 20).

FIGURE 20 *Surface style settings for the water object.*

This brings us to the vegetation. The vegetation started from a predefined material again. This time I used the "wood" category, and from there I selected "wood 1." The colors were changed and the bumps were changed so that instead of being recessed, the bump is coming out of the surface. Each of the grasses (in my case, three) had different color variations so that they did not all look the same. Also, the clover had the bump map removed all together.

Remember, to edit a symbol, open the symbol library and modify the object as you normally would. So in order to change the surface style of the grasses, you will need to open the symbol library. In the texture map dialog, we are going to use parametric mapping for these symbols. The advantage of using this type of mapping is that the texture will follow the shape of the object. In other words, we will able to get the texture to follow the bent shape of the grass. You should experiment with different sizes for horizontal and vertical tiles (make the vertical narrow, for example). To get different sizes in the horizontal and vertical directions, make sure that you have locked the size to "none" (Figure 21).

FIGURE 21 *Parametric mapping of the grass objects.*

The trees were derived from the "bark" predefined material located in the "wood" category. The only thing that was changed was the color to a more ashen grey color.

There is actually one more procedural included in the scene, and that is the sky. In your RenderZone options, set the background to sky. Click on the options to change the parameters. One thing you should notice is that match horizon is unchecked; instead, use the horizon slider (Figure 22).

FIGURE 22 *Sky background settings.*

As you can see, you get pretty amazing results from just a couple of procedural textures (brick textured and marbled textured). I am sure that with future versions of form•Z, even more procedurals will be included. Hopefully, you will be able to apply and use these textures in your own creations.

CHAPTER
29

Using LightWave 3D Procedural Texture Maps

MICHAEL MCBRIDE

SYSTEM REQUIREMENTS:

This tutorial is broad enough that any 3D program that includes procedural textures will work. I use LightWave3D because, in my experience, it is the best program for the job. To complete this tutorial you will need LightWave 5.0 or greater, and Photoshop (or a comparable program).

When I was a child, my family moved into a new house. To my delight, installed in a huge pecan tree in the backyard, was a knotted rope swing. One day, I decided I was going to swing from the tree all the way across the yard and land on top of our wooden fence. My mother, foreseeing the danger (as mothers often do), demanded that I come down immediately, exclaiming that it was impossible to reach all the way to the fence. This triggered something in my six-year-old mind, and as I pushed out from the limb, I heard myself responding, "Oh, really? Watch me!" Unfortunately, she was right (as mothers often are) and I smashed into the side of the house. However, I had come very close, and as soon as my wounds healed, I tried again. This time, I succeeded. My mother, I discovered many years later, had watched my second attempt silently from the window, and afterward, instead of scolding me for defying her, praised my courage, stating that

she had always known I could do it. Aren't mothers great that way! That pecan tree swing changed my life forever. I ceased fearing failure and began seeking out challenges in my life. In fact, it has become something of an obsession.

Ultimately, I became an independent 3D animator and video production specialist. During one job for IBM, I was given the task of creating a three-dimensional courtroom (see Figures 1 and 2) for a CD training program. At that time, there were no digital cameras, and flatbed scanners were out of the price range of most independent artists, or small companies. Furthermore, no texture CDs for pur-

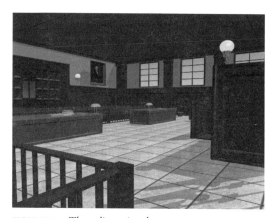

FIGURE 1 *Three dimensional court room.*

FIGURE 2 *Different view of court room.*

chase yet existed. My only choice was procedural textures, which I felt could be used to create convincing wood and marble surfaces. LightWave is known for its superb texturing capabilities. Therefore, when I read in the LightWave manual a sidebar stating that procedural textures were not a good choice for simulating wood or marble, I thought to myself, "Huh?" Then I heard, as I often had since that fateful day in the pecan tree, a small child's voice in the back of my head saying, "Oh, really? Watch me!" Here is how I did it.

THE DEVIL'S IN THE DETAILS

As is often the case when creating convincing surfaces, the realism comes not from the use of a single texture map, but from the blending of several maps and surface attributes. In this tutorial, I will use not only wood procedural textures, but also fractal noise and images for bump maps.

You may have noticed that I have twice used the word "convincing" when referring to realistic surfacing. It is my opinion that the eye can be fooled rather easily. An effective animator will consider this fact when creating object surfaces. In other words, "photo-realism," the catch phrase in 3D today, may not be necessary for all situations. Often it is simply overkill. A good 3D artist, or animator, will first find out to what degree a producer, or director, is even interested in photo-realism. If, as was the case during

the IBM job, the producers do not need it, then the effort would be a waste of time. Producing photo-realistic images requires an expert's understanding of the way light operates in specific environments, just as sound engineers understand the different acoustics in various types of rooms and halls. LightWave, in the current version, does not include radiosity, which calculates for indirect light as it bounces from diffuse, reflective, and refractive surfaces. It must be simulated if the rendered image is to be truly photo-realistic. This is not impossible; however, it is very time consuming, and could cause one to miss a deadline. Find out in advance if it is even a necessity. Radiosity is scheduled to be included in LightWave 6.0.

Once, for an animation set in a forest, I needed sawed-off tree stumps. It took me hours to figure out the relationship between the various value settings in the Color Texture window so I could create the proper rings. (I won't go into detail on why I chose to use the Color rather than Diffuse texture panel. That involves a discussion on lighting and is a subject for another tutorial.)

As I stated, Newtek believes procedural textures are not a good choice for wood textures; however, photographing and scanning a tree stump just wasn't an option at the time. Plus, I couldn't be sure how close to the surface of the stumps the director would choose to move the camera. One major plus with procedural textures is they don't become pixilated when the camera moves close to the surface, as do image maps.

In Figure 3, I have created a simple object to represent a cut-away of a tree trunk. It is a single polygon with 44 points. I created this polygon with the surface onto which I will apply the wood texture facing -Z. The object is also 40 inches in diameter. I like to work in real-world dimensions and that's a little over three feet across, which is a good size for a tree stump.

Those of you who have been animating with LightWave for some time already know that the software prefers to apply image maps on the Z-axis. The animator must then orient the object into its proper position within Layout. However, procedural textures have no such requirements, and will happily

FIGURE 3　*Object representing tree trunk.*

apply equally on any axis. Therefore, in order for your procedural texture maps to apply correctly, you will have to choose the proper axis from the Texture panel (see Figure 4).

With today's digital cameras and inexpensive scanners at our disposal, it behooves us to use procedural textures as well as image maps on our objects. For the tree stump's cross-section surface, I chose the following values in the Color Texture control panel:

- Texture Opacity: 100%
- Axis: Z
- Texture Color: 0
- Frequencies: 10
- Turbulence: 5.0

FIGURE 4　*Texture panel.*

- Ring Spacing: 0.025
- Ring Sharpness: 5.0

Figure 5 shows how this looks when rendered. As an example of how sensitive these settings can be, I have re-rendered the scene with the Ring Spacing reduced to 0.015 (see Figure 6). As you can see, with a reduction in the Ring Spacing setting of only 0.010, the rings render much smaller and more tightly spaced. You'll find in your manual a detailed explanation of why this is so, plus the mathematical formulas for calculating the proper settings in advance. However, I found those settings resulted in rings that were too perfectly spaced and round. By using values well over what the manual recommends, I was

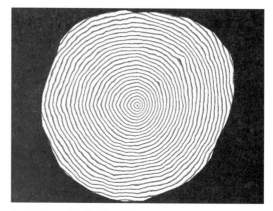

FIGURE 5　*Rendered version.*

FIGURE 6　*Ring Spacing reduced to 0.015.*

able to produce variations in the rings that, to my eyes, made them appear more realistic.

THOSE PESKY DETAILS!

One of the reasons cheap furniture sometimes looks . . . well, cheap, is that the genuine artificial wood grain vinyl the manufacturer used instead of real wood veneer has no real texture. That is, even though a photographic process may have been used to create the illusion of a real wood grain, the surface is perfectly smooth, showing no bumps or grooves of any kind. Therefore, when we see a surface that our mind tells us should be bumpy, and yet is smooth, it looks wrong. There are very few surfaces like that in nature. That principle also applies to 3D, which is why it is essential to take the extra step of creating a bump map. In LightWave, the Bump Map panel uses images and procedurals. However, the wood procedural is not included, so the image must be created separately.

Be sure your object is centered properly in Layout. If not, then reload it into Modeler and use the Center button under the Objects/Custom menu to center it on the axis. Resave it over your original and reload it into your scene. If the camera was moved, then reload the scene altogether. What we are doing is aligning the camera and cut-away object on the Z-axis, so our bump map image will map properly when it is applied.

Set your camera options to square pixels. This way the final image will be square, allowing us to resize the image (if necessary) without distorting it. Move your camera toward the object on the Z-axis until the object fills the screen, but is within the Action Safe Area (see Figure 7), and create a keyframe for it to lock it in place. Before rendering the image, be sure your surface color is set to pure white (255,255,255) and your texture color is set to pure black (0,0,0). Also, set Diffuse to 100%, and set all the other surface attributes (luminosity, specularity, reflectivity, plus, transparency) to 0%.

In the finished image, the white rings will appear to be raised, while the black rings will appear to be indented. I use the word "appear" because, unlike a

FIGURE 7 *Resizing the image.*

deformation map, a bump map merely creates the illusion of texture, fooling the eye, without actually deforming the polygon. This has advantages and disadvantages. You must decide for yourself which mapping technique is best for your images. Keep in mind that deformation mapping uses up system resources to a much greater degree, since, in order for the polygon to deform properly, it must be heavily subdivided and converted into triangles. Plus, deformation mapping requires more rendering time. It is another situation where the animator must decided whether it is enough to simply "convince" the viewer that the surface has texture, rather than actually giving it one. I used no anti-alias setting for the final rendering of this bump map, since wood that had been cut with a saw would not be perfectly smooth. That way, the rings would appear somewhat jaggy. Now render and save your image as Ring_bump.iff.

Before it can be applied to the object, we must remove the black background, leaving only the image of the rings itself. This is easily done, but requires the use of an image manipulation program to strip away the black background. Then the image of the rings will fit precisely onto the polygon. I used Adobe Photoshop, but any program that can select and separate sections of an image will do.

Import Ring_bump.iff into Photoshop. Select the Magic Wand tool and click on the black background. This will highlight the black area; however, you need to highlight the object itself. To do this, open the Select menu and click on Inverse. This will reverse the

selection in the window and you should see only the object surrounded by the dotted line. Next, open a New window that is the same size as the other. Be sure to select Transparent Background; otherwise, you'll simply be replacing one background with another. Use the Cut and Paste command to move only the rings image from one window to the other (see Figure 8), leaving the black behind. Be sure to select Preserve Transparency in the Layers requestor; otherwise, Photoshop will add a background color, and when you import the image into LightWave, it will be distorted. Now save the new image as Rings_bump.iff, overwriting your original image. When the bump map image is applied, it should line up perfectly underneath the wood procedural color texture. Since we are using the exact same settings for both, they should be identical.

In Layout, open the Images panel and select Load Image. Load Ring_bump.iff. Don't worry if it appears distorted in the preview window; it has just been crushed to fit into that tiny thing. Next, open the Surfaces panel and click on the "T" next to Bump to open the Bump Map window. It will default to Planer Image Map. If it doesn't, simply select it from the Texture Type requester. Next, in the Texture Image requester, select Ring_bump.iff. You've now loaded your bump map image into the Bump Map panel. Select Auto Sizing and, if all has gone well, it should fit your object exactly. From here, much of the final object's appearance will be up to you.

In Figure 9, you can see the results of what I chose to do. First, I used the same rings image as a color texture map. Second, I gave it a weathered appearance by adding a second texture of Fractal Noise in the Color Texture panel, in addition to Fractal Bumps as a second texture in the Bump Map panel. I stretched the size of the Fractal Bumps texture very long on the X-axis and very small on the Y-axis, adding the cross-hatching effect, which to me, looks like saw marks. Remember to use your Texture Opacity value to blend multiple textures in the same panel. For a perfect blend of layers, the manual recommends 100% for the first layer, 50% for the second, 25% for the third, and so on. However, many possibilities exist, so experiment with abandon.

FIGURE 9 *Final results.*

The particular values I gave these addition procedural textures are irrelevant. You will need to experiment further to find the look you are after. As I showed earlier in this tutorial, even small changes in the settings can have a huge effect on the way a procedural texture renders.

In the end, the client loved the stumps. He didn't know how many hours I'd spent creating them. How could he? I hadn't told him. It didn't matter. For me, it was a labor of love.

FIGURE 8 *Cut and paste to move rings.*

BEAUTY IS IN THE EYE OF THE BEHOLDER

In LightWave, when working with surface attributes in the Surfaces panel, it is important to remember that it is all about the relationship of one value to another, or others, in the window. There is no single value that will give the animator the perfect surface. That is why experimentation is so important in animation. The surface settings I would use to create what I believe to be the best wood texture are un-likely to be those you would choose. LightWave gives the modeler dozens of ways to create and affect a surface. This can be both a dream and a nightmare. You may, after reading this tutorial, have the recipe for an excellent procedural wood texture; however, you won't be able to call it your own until you experiment and improve upon it. Never be afraid to experiment, and always trust your own instincts. Some of LightWave's best procedural textures are probably as yet undiscovered. Often, yours are the best eyes for the job.

30 Using Lofting to Model Detailed Architecture in LightWave 3D

MICHAEL MCBRIDE

This tutorial was completed entirely in Light-Wave 3D. However, any 3D software that includes Lofting tools will work. It just so happens that LightWave's modeling tools are particularly suited to these techniques. (Note: Since the lines of the wireframe objects are extremely thin, it is recommended that the reader click on the Figures to review the larger-sized images in detail.)

SUPPLY AND DEMAND

Much attention is paid to today's character animators, and rightly so. Character animation is extremely challenging, and to those who excel at it, there is high pay and an endless string of clients. Each year, more and more live-action feature films are released starring digital characters. As the audience's expectation in sophisticated 3D animation grows, so does the need for more realistic digital characters. Many colleges and animation academies have answered the call by emphasizing Character Animation in their curriculums. And, for a time, this will probably be a good thing. However, just around the corner are several soon-to-be-released films that

will have neither live actors nor physical sets—the productions are entirely digital. This will open the door to a wave of Sci-fi and Fantasy films that will be created, produced, and delivered entirely in the digital domain.

In live theater, it is the actors and the directors on which audiences primarily lavish their attention. The technical and lighting directors, costume designers, set designers, set builders/dressers/painters, not to mention the assistants to these folks, usually go unnoticed by the crowd. The fact is, behind every actor are dozens, even hundreds, of technical specialists who are largely not recognized for their contributions to the show. These are the unsung heroes of the entertainment industry. There are unsung specialists in the animation industry as well. However, as fully digital productions gain in popularity, the attention paid to these modelers, lighting TDs, background and texture artists, as well as environmental TDs and artists, will also grow. These hardworking individuals are about to have their day. My point is, as audience demand grows for these types of movies, the demand for these types of specialists will grow as well.

A SIMPLE YET POWERFUL TECHNIQUE

One of the more powerful modeling techniques when creating architectures is called "lofting." Lofting is a technique that combines Extruding, Beveling, and Smooth Shifting. Animation platforms may achieve the lofted surface in different ways; however, the results are usually the same. This tutorial describes this simple and powerful modeling tool.

On one job, I used lofting to create the buildings for a virtual college campus. The client was IBM and I was the primary animator on the project. I created six buildings in all, two of which you can see in Figure 1 and Figure 2. Fantasy architecture was the goal—believable, but not recognizable. After photographing several local buildings for reference material, I began modeling. It took me about an hour to create each building. This would have taken a great deal longer if it were not for the way in which LightWave handles Surface Naming. LightWave's surface naming convention makes a lot of sense, as you will see.

I'll demonstrate this technique by creating a simple architectural structure. The tools we will use to loft our surfaces are primarily Extrude, Bevel, and Smooth-shift. First, it is necessary to create a basic flat object, from which we will create all of our lofted surfaces.

In Modeler, create a rectangular three-segmented flat object. See Figure 3. Select Polygon mode and

FIGURE 2 *Building for project.*

FIGURE 3 *Using modeler to create a rectangular object.*

click on the leftmost polygon. Next, select the Rotate tool and click and hold on the second from the left point on the –Z side of the polygon. Rotate the polygon about 15 degrees. Now do the same to the rightmost polygon. Next, we need to make the three polygons into a single polygon. Do this by selecting all of the points, and then cut them from the layer. Now paste them back into the layer and you will find the polygon removed. You are left with only the points. Select each one in a clockwise pattern, and press P on your keyboard. This will make a single eight-sided polygon with the Surface Normal facing toward +Y. The importance of doing this will become evident later in the tutorial. Your finished object should look like Figure 4. This is the base or foundation of the building. Now comes the lofting.

FIGURE 1 *Building for project.*

FIGURE 4 *Finished object.*

SURFACE NAMING

This is where Surface Naming becomes very important. When lofting a surface in LightWave, the animator must anticipate the next surface's needs, and name it in advance of the lofting. To demonstrate: select the polygon and make sure the Surface Normal is facing toward +Y. See Figure 5. If it is facing the wrong direction, simply use the Flip command under the Polygon menu, or press the F key.

Most buildings have about three feet of exposed foundation; therefore, we will loft the first surface to that height using the Bevel tool. However, before doing that we need to name this surface what our

FIGURE 5 *Lofting the surface.*

next surfaces will need to be named. Get that? When a surface is lofted in LightWave, the current surface is automatically applied to the new surfaces. You may be thinking, HUH?! But this is truly the best way, and Newtek figured it out first. In other 3D programs I've used, one must first select the surface to be lofted, then loft it, then select the points that make up the individual polygons, one at a time (there may be dozens, even hundreds!), make the polygons, then the select each polygon that represents a particular surface, or group of surfaces, and then name them. That's six steps! In LightWave, the same is achieved in only two. I'm not selling stock in Newtek; I simply like things to be easy. Easy usually means fast. And modeling in LightWave is very fast.

So, let's click on Surface under the Polygon menu and type "Foundation" over the word "Default" in the dialog box. If you want to apply a distinct color or surface attribute, now is the time. I selected a cement-like color, set diffusion to 80% and Specularity to 0%.

Next, we loft the surface using the Bevel tool. One can also use Extrude; however, I prefer Bevel. There are more tools to alter the surface's shape. Type 3′ (feet) into the Shift dialog box, then, leaving all other boxes at 0, click OK. The surface has been lofted to a height of three feet, and the really neat thing is, unlike some other 3D programs, you don't have to go back and create polygons out of the vertices you've just created. LightWave has done it for you and named the surface to boot! You can see in Figure 6 that you now have a three-dimensional object.

Once again, we must name the top surface (which should still be selected) what we want the next lofted surface to be called. The next section of the building we are going to loft is the sides. Open the Surfaces window and type "Sides" over the word "Foundation" in the dialog box. Click OK (change the surface color and attributes if you want the next surface to look different from the last), and open the Bevel tool window. Change the Shift setting to 50′ and click OK. The top surface will loft to 50 feet above the foundation. Your object should now look like Figure 7.

FIGURE 6 *Bevel tool.*

FIGURE 7 *Status of object so far.*

Next, we loft the sides of the flat roof. Since most roofs on industrial buildings protrude from the side of the building, we will use the Bevel tool to make ours about a foot larger than the building all the way around. With the top polygon still selected, and with its surface once again renamed (this time to Roof_Sides), plus surface attributes reassigned, reenter the Bevel tool window and type -1' in the Inset dialog box. Type 0 in the Shift dialog box. This will simply enlarge the top polygon by 1"; however, it will also apply the new surface attributes to the underside of the polygon. See Figure 8. Here is why we made the original three polygons into a single polygon. If not, whenever we used the Inset function of

the Bevel tool in this way, the inner edges would overlap, creating an unsightly mess. By using a single polygon, we avoid this problem.

Next, we will loft the roof onto the building. It is an industrial building and will have a concave roof, one where the top surface is lower than the surrounding sides of the building. Lofting is particularly adept at this type of modeling.

First, we will loft the surface skyward about five feet. The next four steps all take place in the Bevel tool window. You will have to reenter the Bevel window after each loft. Enter the Bevel tool window and type 5' in the Shift dialog box. Type 0 in the Inset box and press OK. Next, type 2' in the Inset dialog box, 0 in the Shift dialog box, and press OK. Next, type -3' in the Shift dialog box, and once again type 0 in the Inset box. You can see what we have been doing in Figure 9. Our building now has a concave roof. The last thing to do at this stage is to name the final surface (the top polygon), which I've named Roof, and give it a black, tar-like surface attribute. Save this object as Building.lwo.

We could stop here and apply image maps to the sides to simulate windows, but it's so much more fun to continue to loft!

FIGURE 8 *Lofting the roof.*

FIGURE 9 *Lofting the surface skyward.*

FIGURE 11 *Subdividing the polygons.*

FINISHING TOUCHES

Deselect the roof polygon. There should be no surface normals visible. Now, press W on your keyboard and open the Polygon Statistics window. Under the drop-down menu, select Sides and click on the + sign next to "with Surface:". There should be a number 8 in the dialog box. You will have selected all eight of the polygons with the surface name "Sides". See Figure 10. Next, use the Subdivide tool from under Transform in the Polygon menu. Set Subdivide for Faceted, with a 0.0 Fractal setting, and subdivide the polygons three times on the polygons. You should end up with 512 polygons. See Figure 11. These will become the building's windows, but first, we must create the framework.

With the Side polygons still selected, enter the Surface window and type "Window Frames" in the dialog box. Change the color to a glossy black, with 0% Diffuse and 100% Specularity. This will give the window frames the appearance of being made out of shiny metal. Now, reenter the Bevel tool window, type 5" (inches, not feet) in the Inset dialog box, and 0 in the Shift dialog box. Click OK.

Your final surface is the windows. Reenter Surfaces and type "Windows" in the dialog box. Set the color to pure white, and give the surface 0% Diffuse and 100% Specularity. The windows will now reflect light, as real glass would. See Figure 12.

Congratulations! You've created a building using nothing but lofting techniques. You can continue the lofting process on this building and add doors, a

FIGURE 10 *Polygon statistics window.*

FIGURE 12 *Final windows surface.*

canopy over a walkway, a sidewalk outside the building, an air-conditioning unit on the roof, and any number of other details, all from the polygons already attached to the building.

Plus, since you have given each distinct group of polygons an individual name, it's an easy process to apply detailed, realistic surface maps in Layout. See Figure 13.

By now you should realize that this simple yet very powerful tool can be used to create much more complex and detailed architecture. For instance, try recreating true-life buildings, such as the Empire State Building, or the Twin Towers. Or, recreate an entire city from the same set of polygons! The sky's the limit with Lofting.

FIGURE 13 *Finished product.*

CHAPTER

31

4th of July Fireworks in Lightwave 6

PATRIK BECK

Lightwave 6 has some wonderful new capabilities. The new particle engine and HyperVoxel renderer has much more to offer than the previous versions of Lightwave. Lightwave also has a new working environment, which is forcing many of the old dogs into learning a few new tricks. In this tutorial, we will explore some of the new functions that HyperVoxels 3 and Particle Storm SE have to offer.

(Note that this requires the Lightwave 6a patch, which is available as a free download to owners of Lightwave 6.)

For this tutorial, we will use two different methods to animate the particles and two different HyperVoxels. HyperVoxels has changed the nature of particle animation a bit. Rather than needing thousands of particles to create a voluminous mass, now very few are required to produce clouds and smoke. However, before we get to the particle, let's first build a rocket.

THE BASIC MODEL

This rocket is the kind that coyotes usually order out of a catalog for strapping onto roller skates.

The rocket consists of a cylinder for the body, an inverted cone for the nose cone, and a long rectangle for the stick. The values given here are for reference

purposes; they are not critical, but should be of the scale of about one-meter tall so that the rest of the values match up later.

Open modeler; in the first layer, we start with the tube body. We do this by selecting the Disk tool, activating the numeric menu, and entering the correct values. It is necessary to hit the Return key or the Make button to produce the specified geometry.

The values are (Figure 1):

FIGURE 1 *Disk tool settings.*

Axis = Y
Sides = 24
Segments = 1
Bottom = 300mm
Top = 800mm
Center X = 0
 Y = 550mm
 Z = 0
Radius X = 50mm
 Y = 250mm
 Z = 50mm

This is the main body of the Rocket; the next step is the nose cone. Open a second modeler layer and put the disk object in the background to use as a reference. Select the Cone tool and enter the correct values.

The values are (Figure 2):

Axis = Y
Sides = 24
Segments = 1
Bottom = 800mm
Top = 1 m
Center X = 0
 Y = 900mm

Z = 0
Radius X = 100mm
 Y = 100mm
 Z = 100mm

This places an inverted cone directly on top of the body cylinder that appears in the background, looking very much like a skyrocket. This would be a good time to name the surfaces of the objects. All the polygons of the body and nose cone can share the surface name of RocketRed. You can select both layers as foreground layers by holding down the Shift key and clicking the layer boxes, then hit the Surface button and name all the polygons the same.

The final step is to attach a support stick to the side. Open a third layer and again place the body of the rocket in the background layer. Select the box tool; use the numeric menu.

The values are (Figure 3):

Low X = -10mm
 Y = 0
 Z = 50mm
High X = 10mm
 Y = 500mm
 Z = 70mm

FIGURE 2 *Cone tool values.*

FIGURE 3 *Box tool values.*

Segments X = 1
 Y = 1
 Z = 1

Name the surface of this box object "Rocket-Stick."

There are now three pieces of geometry—a tube, a cone, and a rectangle—in three different layers of the modeler. It is necessary to move them all into the first layer and save it as one complete object. The easiest way to do this is to go to the third layer, hit the x key to copy and delete it, then go to the first layer and hit the v key to paste it back in. Do the same thing to the second layer—x to cut and v to paste—so that the three separate pieces are now all in a single layer. Save this object as Rocket.lwo and go to the layout screen (Figure 4).

FIGURE 4 *Rocket•lwo object.*

Setting Up the Scene

This is the plan: We will keyframe the rocket to shoot up into the sky trailing smoke for 90 frames, then explode into a shower of sparks that will come trickling down for 120 frames. The smoke trail will slowly fade away, and the shower of sparks will change color and sparkle. This will involve creating two different Particle Storm projects, some of the new HyperVoxel options, and some interesting parenting. The first thing to do is to animate the basic

rocket. Load the Rocket object previously created. In the lower right-hand corner of the layout screen, set the total frame count to 210.

Advance the scrub to frame 90 for the next keyframe of the rocket. With the Rocket object selected and the move function in the Actions tab activated, you can enter the values manually in the lower left-hand corner in the area called Position.

Enter these values and create a keyframe at 90:

X=0m
Y=10m
Z=5m

By sliding the scrub bar back and forth, you should see the Rocket object going up and down. We want the rocket to tilt a little bit into the arc, so return to frame 90, and under the Actions tab, activate the Rotate tool. Notice that the number box down in the lower left-hand side of the screen has changed from Position to Rotation.

Enter these values and create a keyframe at 90:

H=0
P=30
B=0

The Rocket object now flies up into the sky, tilting slightly into the wind. Click on the Camera button and keyframe it into a position that is wide enough to see the full path of the rocket's motion with a little extra room on top. Here is a suggested position for the camera:

X=7m
Y=0
Z=-18
H=-20
P=-15
B=0

To make our job a little easier, we are going to parent a null object to the bottom end of our rocket tube. (This null will be used to attach a flare and as reference for a particle emitter later on.) In the Actions tab, click on the Add/Add Object/Add Null button to add a null into the scene. Name this null "RocketNull." We want to parent the RocketNull to

the Rocket, and there are two ways to do this in Lightwave 6. One way is to click the Motion Options button and at the top of the menu, select the appropriate parent object. The other way is to click on the Scene Editor button and bring up the scene editor graph. In the Scene Editor, it is possible to arrange parenting by simply clicking on an item and moving the mouse to just under the object you want as a parent. A yellow line will appear, indicating that a child object is selected, and when the line is in the proper position on the parent, it will shorten slightly to indicate the hierarchy. This takes a little bit of practice, but it certainly makes things much clearer (Figure 5).

FIGURE 5 *Scene editor.*

The RocketNull should be placed at the bottom of the tube of the rocket body. When we made the tube, the bottom of the disk started at Y=300mm, so the RocketNull should be keyframed into position at:

X=0
Y=300mm
Z=0

Now we have "bookmarked" a position exactly in the center of the bottom of the rocket tube, which just happens to be where the fire shoots out.

ADDING SOME FLARE

The first step to making our rocket look realistic is to add a bright spot at the bottom where the exhaust would shoot out. This is most easily done by using our friend, the lens flare.

In the Actions tab, click on Add/Add Light/Add Point Light, and name the new point light "RocketLight." Parent the RocketLight to the RocketNull. The flare should start bright, dim slightly as it rises, and then explode suddenly at frame 90 to indicate the rocket exploding. With the RocketLight selected, click on the Item Properties button to bring up the Light Properties menu. Activate the Lens Flare function and click on the Lens Flare Options button. All we are going to change here is the Flare Intensity by adding an Envelope, so click on the E button to bring up the graph editor (Figure 6).

In the graph editor, directly under the graph there are three buttons for managing the keys. Click on the button that shows a church key with a little plus sign to activate the add keys function. Leave the intensity value at 50% for the first key. Create a second key by clicking as close as you can to frame 89 with a value of 25%. (If you did not hit it right on the nose, you can adjust both the frame and the value in the appropriate boxes in the lower part of the screen.) Add a third key at frame 90 with a value of 100%; the one shortly after that at frame 95 at 0%. This creates a sudden flash at the end of the rocket's flight. If your graphics card is up to it, this is an excellent time to activate the OpenGL Lens Flares option and see the lens flare change in intensity as the scene is played back in layout.

One final step is to have the rocket itself disappear after the explosion. This is done by adding a

FIGURE 6 *Lens flare options.*

dissolve envelope under Item Properties for the Rocket object. With the Rocket object selected and the Item Properties menu activated, go to the Rendering tab and click the E button for Object Dissolve to bring up the Graph Editor. Create a key at frame 90 and another at frame 91. From frame 0 to frame 90, the level of dissolve should be 0%. At frame 91, the dissolve level should be set to 100%, rendering the object invisible.

MAKING SOME SPARKS

First, a word about Particle Storm. Particle Storm has a unique way of dealing with particles within Lightwave. Rather then adding each single-point polygon as a separate object, all the particles are combined into a single object, and a displacement map is applied to the object to push all the particles in the right direction. This makes dealing with thousands of points much more manageable. Two separate files need to be created: the object file that contains all the points, a standard Lightwave lwo file, and the PSM file. PSM stands for Particle Storm Motion and is applied as a displacement map through the PSplay Particle Storm displacement plug-in Lightwave 6 ships with the SE version on Particle Storm, which is missing only a few of the higher-end functions of the full version.

Because the Particle Storm object is at heart a standard Lightwave object, it can be moved, scaled, and keyframed as the occasion calls for it. We will do this with the first Particle Storm project, which will be relatively simple.

Start by activating the Particle Storm interface. In the Layouts Extras tab, under Plug-ins, click on Plug-in Options. In the Plug-in Options box, click and hold the Generics button, and slide down to select Particle Storm2 (SE). This should bring up the Particle Storm (Special Edition) interface. Rather than going through every option, we will just cover the values that need to be changed from the defaults (Figure 7).

Starting near the top of the Items list, click on the third line down, which says "Simulation." In the

FIGURE 7 *Plug-in options.*

field below, set the Stop time to 120f (for 120 frames, or 4 seconds).

Under Particle Groups, select PGROUP. In the fields below, change the Name from PGROUP to Sparkles, and where it says Number of Particles, change it from 1000 to 250. (In the field labeled Effect File Base, there is a button that says File. This sets the path where the particle object and the PSM file will be stored once they are created—remember where you put them so you can find them later.)

The section on Controllers is where it starts getting interesting. Select Fountain; this is where most of the changes will occur. At times it will be necessary to expand the menus to enter the appropriate values, which is done by clicking on the little triangles next to the indicated fields.

Enter these values for the Fountain (Figure 8):

Orientation: Heading =0, Pitch =-90, Bank= 0
Scale; X=1%, Y=1%, Z=1%
Birth Rate = 1000
Minimum Speed =3m/s
Maximum Speed = 6 m/s
Maximum Angle = 90

The next Controller to select is Gravity. Change the strength to 1m/s/s.

Select the Recycler controller, expand the menu, and set it to Off.

FIGURE 8 *Fountain Values.*

Now we need to add a control that is not already there. Select the Controller field, and click and hold the right mouse button to bring up additional Controllers. Select the Drag function and leave the value set to 1.

Hitting the Play button in the preview window should show a sudden burst of particles that slowly fall back to earth. In the menu bar under Particle Groups, right-click and hold on the Sparkles listing, and select Create Effects object. This will create a Lightwave object that consists of 250 single-point polygons all piled on top of each other. Next, the PSM file needs to be generated.

To generate a PSM file, set the preview screen back to the beginning, click on the button on the far right with the small red dot, and click on the Play button. With the Record button activated, the motions of the particles in the preview window will be recorded into the PSM file. Before closing the Particle Storm window, save this project by clicking one of the Save buttons at the top of the menu.

PARTICLES IN LAYOUT

Back in layout, load the Sparkles.lwo object. This object at first appears as a single dot before the displacement is applied. With the Sparkles object selected, click on item properties. Under the Deformation tab, click and hold the button for Add Displacement, and select Particle Storm. Notice that

the Particle Storm displacement plug-in indicates "no PSM file"; the PSM file does not load automatically with the object file. Double-click on the plug-in to bring up the Particle Storm Effect Object Option panel. Click on the Load PSM File button, find where you saved the Sparkle.psm file, and load it. Close the panel and observe the motion of the particles (Figure 9).

Now the Sparkles happen too early, so the particle motion must be shifted 90 frames so that it happens at the same time as the explosion. Go back to the Particle Storm Effect Object Option panel in the Item Properties menu for the Sparkle object. Look under the heading "Scene." The field that says "First Frame" specifies when the particle motion will kick in, and "Last Frame" is when PSM data will stop affecting the particles. Add 90 to both these values (Figure 10).

Start Frame= 90
Last Frame =210

The particle motion now begins at the proper time, but is still sitting on the ground. Move the object to the position where the rocket explodes, the same location as the second key of the rocket.

Enter these values and create a keyframe at 0 for the Sparkles object:

X=0m
Y=10m
Z=5m

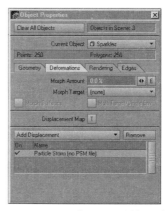

FIGURE 9 *Deformation/Add Displacement panel.*

FIGURE 10 *Particle storm effect object options.*

Now we are getting close. We still need to create the rocket exhaust with a second particle object, and then apply HyperVoxels to the both of them.

Rocket Trail

Go back to the Generic Plug-in panel and select Particle Storm SE once more. This is a new project, so hit the Clear button to remove all the settings from the previous Sparkles project.

Select Simulation at the top of the menu bar; change the Stop Time to 210.

Under Particle Groups, select PGROUP. In the fields below, change the name from PGROUP to RocketSmoke, and where it says Number of Particles, change it from 1000 to 300.

Enter the following values for the Fountain.

Under the Controllers tab, select Fountain. Under Source/Parent, click and hold on the button and move it down to select RocketNull.

Orientation: Heading =0, Pitch =90, Bank= 0
Scale; X=1%, Y=1%, Z=1%
Birth Rate = 100
Minimum Speed =2m/s
Maximum Speed = 2m/s
Inherit Velocity = 25%
Maximum Angle = 20

Select the Gravity controller; change its value to 0.25 m/s/s.

We want the smoke to interact with the ground, so it will be necessary to add a collision object. Right-click and hold on the Controllers listing in the menu and select the Collision option. Enter these values for Collision:

Elasticity=20%
Avoid Time=1s
Avoid Strength=1N
(Expand the Collision Shape tab)
Position X=0, Y=-1, Z=0
Scale; X=300%, Y=100%, Z=300%

Playing the simulation in the preview window, you should see the particles shooting down out from where the rocket object would be and bouncing slightly as they hit the Collision object. Save this project as RocketSmoke.

Right-click on the Rocket Smoke listing under particle groups and select "Create Effects Object." Next, return the simulation to the first frame and hit the little red button to put it into record mode. Hit Play to record the PSM file for Rocket Smoke. Once that is done, return to layout.

Load the RocketSmoke particle object and apply the RocketSmoke PSM file in the Items Properties panel. The PSM file does not need to have any of the values changed. In layout, we can now see a stream of particles shooting out of the backside of the Rocket object (Figure 11).

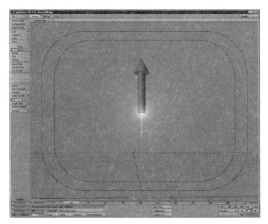

FIGURE 11 *Rocket object.*

TEXTURING THE SMOKE TRAIL

In the Settings tab, under Effects, click the Volumetric button. Click the Add Volumetric button and select HyperVoxels Filter to bring up the plug-in HyperVoxels 3. Double-click on HyperVoxels 3 to bring up the menu (Figure 12).

This is to prove that HyperVoxels do not need to be complex. Select the RocketSmoke object from the listing on the left, and click the Activate button. At the upper right, change where it says "Object Type" from "Surface" to "Sprite."

Advance to about the middle of the animation and click the Open VIPER button. You should see a preview of a cloudy mass that already looks very much like a rocket trail. One thing that should be changed is the size of the particles; they should start small and then expand over time (Figure 13).

Under the Geometry tab of the HyperVoxels menu is a setting for Particle Size. Change this value to 500mm, then click the T button to bring up the Texture Editor-HyperVoxel—Particle Size menu, and enter these values:

Layer Type = Gradient
Input Parameter = Particle Age
Value =10%

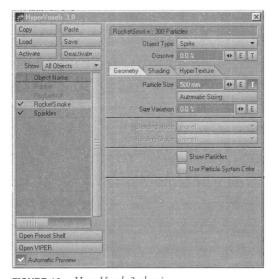

FIGURE 12 *HyperVoxels 3 plug-in.*

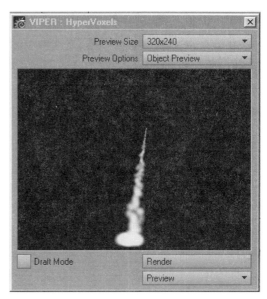

FIGURE 13 *Viper option.*

FIGURE 14 *Adjusting the gradient bar.*

Click the gradient bar to create a second key with these values (Figure 14):

Value = 100%
Parameter = 45

The Value percentage is a percentage of the Particle Size; the Parameter is the number of frames. It

takes 45 frames for the particle to go from 10% of its specified size to 100%. This gives a much more natural look to the rocket exhaust.

TEXTURING THE SPARKLES

While still in the HyperVoxels 3 menu, select and activate the Sparkles object. Change the Object Type from Surface to Volume. Under the Geometry tab, set the Particle Size to 200mm.

We want the color to change over time. Color is under the Shading/Basic tab; click the T button to bring up the Texture Editor-HyperVoxel—Particle Size menu, and enter these values:

Layer Type = Gradient
Input Parameter = Particle Age
Color = yellow
Parameter = 0

Click on the gradient bar to create a second key with these values:

Color = red
Parameter = 15

Create several more keys for the gradient at your discretion, spacing them about 15 or 20 frames apart using bright colors (Figure 15).

FIGURE 15 *Creating more keys for the gradient.*

That is just the start.

This is just the basic setup to walk you through the creation of Particle Storm projects and the application of HyperVoxels. Lightwave 6 has made many things much easier, but some things do take a bit of getting used to. Most of the values given are to get you into the ballpark, and as long as you understand the relationships between the items, you can adjust things to your needs and taste. As an example, you could try using HyperVoxel setting from the preset shelf for the smoke trail, but add the size gradient texture yourself to get the proper look. The scene, object, and Particle Storm project files are included, so feel free to explore.

Final movie.

CHAPTER

32

A Tiny Animation with Maya

KIAN BEE NG

SYSTEM REQUIREMENTS:

- Windows NT or SGI Irix with enough horse-power to run Maya
- Maya version 2.5 or higher
- Skill level: beginner

INTRODUCTION

As we all know, Maya is a state-of-the-art graphics package. From modeling, rendering, and animation, there seems to be nothing that it cannot create. (Well, at least that's what it sounds like from the marketing folks at Alias WavefrontJ.) For many experienced digital artists, Maya represents an exciting and new opportunity to take their imagination a step closer to heaven. From creating physics-based simulation to making realistic furry-looking gorillas, what used to be unattainable is now at their fingertips.

But, does this spell the same for our new digital artists? Is it true that life just couldn't be easier for these new-age, digital-artist wannabes? Well it doesn't seem so to me. Learning Maya is like learning to drive—you don't start by driving a James Bond BMW. If you do, you'll probably be too confused by all the gadgets to even start the engine! And, before long, you will have lost all the excitement and interest to learn the skill.

With that in mind, the purpose of this tutorial is not to overwhelm you with another fantastic, super-complicated project. Instead, we will start small—very small. We will learn how to create a tiny but decent animation: the animation of a microorganism.

AIM

Let's first look at a sample of the animation we aim to achieve. (See CD.) In this tutorial, you will learn the gist of this animation creation: modeling, shading, and setting up the skeleton structure for the animation.

MODELING THE ORGANISM

BASIC CONSIDERATIONS

There is no "best" approach to modeling; however, there are some fundamental guidelines. For example, when modeling, we should at least consider how the models are going to be used in production: animated or still, close-up or long shot, background props or foreground objects, compositing as a single object/layer. We should also know if the approach should be spline based, such as NURBS, or polygonal based; if it is going to be constructed as a single patch object or consist of multiple patches; and if we will construct the model from a network of curves, start from some basic primitives, or (supposedly) the easiest of all, construct from digitized data.

203

MODELING FROM PRIMITIVES

In this tutorial, we'll create the organism from a basic primitive: a sphere. This approach is particularly popular among the die-hard modelers since the early days of PowerAnimator. What you do is essentially start from a basic NURBS sphere primitive with the minimum number of isoparms. From there, you will pull the CVs and add additional isoparms to form the shape that you desire. An example of a head model created using this approach is shown in Figure 1.

For our model, we'll start with a sphere and deform to the shape we desire.

1. Create a default NURBS sphere primitive. The default NURBS sphere should have four U isoparms and eight V isoparms.
2. Press F8 to go into the pick points mode.
3. From here, pick each row of the CVs and interactively translate and scale the CVs to get the desired shape of your model. Figure 2 illustrates the sequence, and Figure 3 shows the final shape.

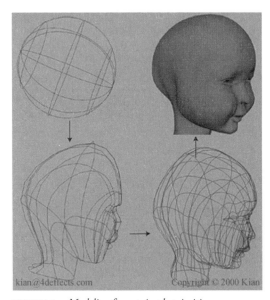

FIGURE 1 *Modeling from a simple primitive.*

FIGURE 2 *Manipulation of CVs to achieve the desired shape.*

FIGURE 3 *Final shape of the model.*

SHADING AND LIGHTING THE ORGANISM

Shading involves two fundamental steps

- Assigning the right surface material
- Setting the desired lighting

Creating a surface material includes deciding what type of surface we would like to depict, and what sort of materials we want to use. Is the surface smooth like a mirror, rough like rock, specularly highlighted at the edges, or has a dispersion of rays across the entire surface? As for the texture of the

material, is it wood, marble patterns, or a typical fabric cloth type?

Maya, like most other 3D applications, provides shading groups such as Lambert, Phong, and Blinn for depicting object surfaces. The roughness of the surface is usually achieved through the use of bump or displacement maps. The material types are created with the help of a wide range of textures, both procedural and ad hoc images.

In this example, we will shade our little creature to make it look genetically organic.

4. Create an Anisotropic shader from the Multi-lister or Hypershade window.

 Anisotropic shader is chosen because it provides more diverse specular highlights than other shaders do. This allows us to create a more organic-looking model.

5. Set the various parameters of the shader as shown in Figure 4.

 a. See Figure 5 for the file texture we want to achieve.

 b. For the ramp texture, set the various parameters as shown in the following table and in Figures 6 and 7.

FIGURE 5 *Use this image for the file texture map.*

FIGURES 6 *Ramp texture parameter settings.*

FIGURES 7 *Ramp texture parameter settings.*

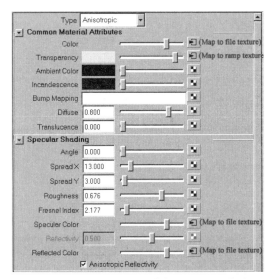

FIGURE 4 *Parameters setting of the Anisotropic shader.*

Ramp Position	Ramp Color		
	R	G	B
0.00	0.0	0.0	0.0
0.20	0.638	0.638	0.638
0.38	0.824	0.824	1.0
0.59	0.83	0.818	0.649
0.755	0.904	0.808	0.808
0.955	0.617	0.617	0.617

Let's take a closer look at the various parameter settings. First, the file texture was obtained from real footage of a genetic video. This texture was chosen because we want our model to render as closely to a real microorganism as possible. Of course, you may choose to use a different image or texture for your object.

Next, to create some consistency of the color spectrum in the scene, the same file texture was mapped to the Color, Specular, and Reflected Color parameters. To create the transparent look, the above ramp was mapped to the Transparency parameter. The ramp values and other parameter settings such as the Fresnel Index were obtained by interactively tuning the image using Maya's IPR. You may end up with different values, depending on the needs of your own scene.

6. Assign the shader to the microorganism model.

LIGHTING

Setting up the lighting for our scene is a rather straight-forward exercise since a microscopic view of the organisms generally lacks depth and shadows. Therefore, setting up one or two light sources that directly illuminate the models should work well.

7. Create a spotlight, and position it so that it is directly behind the camera looking at the model.
8. Create a plane and assign a Lambert shader to it. The plane will be used as a background to the model.
9. Map the image shown in Figure 8 to the Color parameter of the Lambert shader.

10. Translate and Scale the plane model so that it is behind the organism model.
11. Test render the scene.
12. Fine-tune the rendering using IPR.
13. Add in new light sources as necessary.

Your final test render should be something similar to Figure 9.

FIGURE 8 *Image background for the scene.*

FIGURE 9 *Final test render of the model.*

ANIMATING THE ORGANISM

In the animation, the gist of the movement is that wiggling ofits body when it swims. The pace of movement should be in sync with what is shown in Figure 10.

FIGURE 10 *Pace of movement for the organism.*

We'll achieve the animation by writing simple MEL scripts that control the skeleton structure of the model.

SKELETON SETUP

14. From the front view of the model, set up the skeleton structure as shown in Figure 11.
15. Bind the model to the complete skeleton using Rigid Bind.
16. Next, create a curve with the shape as shown in Figure 12. This curve will be used to control the movement of the organism with the help of an IK handle.
17. Create an IK Spline Handle with the option as shown in Figure 13. Make sure that the curve created in Step 16 is used as the handle.

FIGURE 13 *Create Spline IK handle option.*

18. Test the model by moving the CV points of the handle curve. The model should be able to "swim" according to how you move the curve CV.

SCRIPTING THE ANIMATION

We'll now control the animation by writing some expressions. This approach of animation, compared to normal keyframing, will allow us to procedurally modify the motion easily. It is especially useful when we have a large number of models to control.

19. Select CV number 3 (cuve1.cv[3]) of the curve handle.
20. Go to the Deform(ation) menu and create a cluster. You should now have a cluster that consists of only the number 3 CV of the curve handle.
21. Select the cluster and set the pivot point to the origin.
22. Finally, test the movement of animation by rotating the cluster about its pivot point. You should have a nice wiggle movement of the model now (see Figure 14).
23. Next, select the model and group it to itself. This will create a hierarchy group where the organism model is the child. The purpose of creating this group is so that you can perform transformation functions on this parent group, since the organism model itself cannot be transformed given the skeleton binding.

We're now ready to write some MEL scripts to animate our model.

FIGURE 11 *Skeleton set up for the model.*

FIGURE 12 *Curve for use with IK handle.*

FIGURE 14　*Controlling the movement of the model by rotating the cluster.*

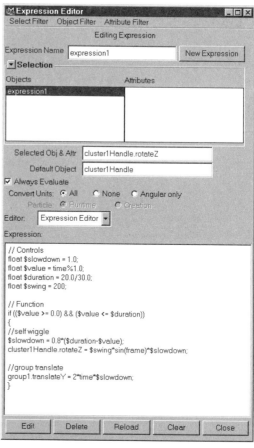

FIGURE 15　*Expression that controls the movement of the organism model.*

24. Open the Expression Editor and enter the following expression as shown in Figure 15. Play back the animation　and you should see that the model wiggles as it moves forward.

Let's go through the MEL scripts in details.

First, we need to restrict the timing so that the model only moves with the beat, similar to the manner in which our hearts beat. This is achieved by restricting the cluster movement within the *if* loop. The timing beat used for the *if* condition is controlled with the help of the *$value* and *$duration* variables. The *$value* variable takes the time of the scene and modulus it so that it always return a value between 0.0 to 1.0. The *$duration* variable assumes that the time defaults to 30 frames per second, thus restricting the movement with a 20 frame out of 30 frame value. If we need to cut short the movement of the beat, we can always reduce the frame from 20 to maybe 15 out of 30.

Next, to allow control how much to wiggle, the variable *$swing* is created. The larger the value, the more the model will wiggle. And, as the wiggling must slow down to almost a halt as the beat ends, the variable *$slowdown* is created. This variable is dependent on the result of the *($duration - $value)*. The result of this expression will be a declining value. Combining this with a multiplication of an arbitrary value, *0.8*, we will end up with a simple and nice decreasing function.

Finally, to control a simple, straightforward movement of the model, the translation parameter of the parent group is animated along with the *$slowdown* and time value.

CONCLUSION

Well, that's the gist of the entire animation! Duplicate this organism model as many times as you want, and set different movement for each model to create an animation similar to what was shown in Figure 1 at the beginning of the tutorial. For those who were lost along the way, don't worry. The scene file is available on the CD-ROM, so review the file again and see what you can scoop from it!

CHAPTER

33 Landing Field with Maya

KIAN BEE NG

- System Requirements: Windows NT or SGI Irix with enough horsepower to run Maya.
- Software Requirements: Maya version 2.50 or higher with Paint FX module loaded.
- Skill level: Beginner.
- Introduction

Maya Paint Effects is a revolutionary tool that allows you to paint images, textures, and particles directly onto a 2D canvas or to a 3D scene object. With Paint FX, you can easily create scenaries of trees, grass, flowers, water, skies, fire, hair, watercolors etc. with the stroke of a brush. With the default preset of hundreds of brushes, making effects has never been easier!

In this tutorial, we will walk through a basic example of using Paint FX to create an animation of a helicopter landing. Before we delve into the details, it is important for you to understand that Paint FX is a very computational-intensive program. Therefore, depending on your hardware, you may experience rather slow response when you interactively paint your scene. Apart from this, if you have no idea on how this wonderful program works, check out the Maya manual on "How the Paint Effects Tool Works."

MOVIE 1 *The final animation—see CD-ROM for file.*

AIM

This tutorial aims to provide an introductory example on the use of Maya Paint FX in creating a realistic-looking animation.

Let's first look at the final animation we aim to achieve.

We will focus only on the creation and animation of the grass using Paint FX. The animation of the helicopter and other details will not be covered.

MODELING THE FIELD

There are several ways of using Paint FX to create a large landing field. One way is to paint directly using the preset brushes. The upside of this is obviously the interactivity, while the downside is the slow response time, especially when the field is large. To avoid the pain of watching your graphics processor struggling to refresh the screen, we'll not adopt this method of interactive painting. Our approach will be to first create the various NURBS curves, and then attach the preset grass brushes to the curves.

1. Create a NURBS circle of 16 sections.
2. Open the Visor… window.
3. Select the grassBlowing2.mel brush. (Figure 1.)
4. Select the NURBS circle again from the Outliner window.

FIGURE 1 *The grassBlowing2 brush.*

5. From the Paint Effects menu, click on Curve Utilities -> Attach Brush to Curves.

A stroke is created with the grass particles attached. If the grass appears to be upside down, select the NURBS circle (not the stroke) and do an Edit Curves->Reverse Curve Direction.

At this point, you may be wondering why you are creating the NURBS circle when we're supposed to create a large landing field for the helicopter. Well, the reason is simple. When we animate the helicopter landing, the movement of the field will be a circular motion spreading outward as the helicopter lands. Take a look at the test animation to get an idea of the circular motion.

MOVIE 2 *A test animation that shows the circular expansion motion of the grass.*

To achieve such circular motion, there are a few approaches. One of them is to create a large field and control the movement with the help of the Stroke Control Curves (refer to the manual for a more detailed explanation of how to use the Stroke Control Curves). Another is to adjust the parameter presets of the brushes. This latter approach allows direct procedural control of the grass movement. Though this may be restrictive in one way, it allows fast and efficient control for our animation. Therefore, we're setting up the grass field for such subsequent animation control.

FURTHER MODELING

We'll do more detail adjustment to the field to get to our desired scene.

6. Select the Stroke and Hide it. This allows a faster refresh display of the scene.

7. Duplicate the Stroke. You should get a duplicated stroke as well as a duplicated NURBS circle.
8. Repeat the duplication until you get a total of 7 Strokes and NURBS circles in your scene.
9. Select the NURBS circle and scale them to get to the desired scene as shown in Figure 2.

When scaling, ensure that you do not scale the Strokes curves but the NURBS circle. Scaling the Strokes curves will result in the scaling of the brushes as well, so you may end up with proportionally larger grass, which may not be desirable.

Next, you'll set the detail Brush parameters.

10. Open the Attribute Editor of each of the Strokes in turn and set the brush parameters as shown in Table 1.

Leave the rest of the parameters as default.

The parameters listed in Table 1 are set to create the grass field with turbulence movement. We'll take a brief look at what the various parameters achieve. (You should refer to the manual for a detailed explanation of the meaning of the various parameters.) First, the Brush Width is set to ensure that the rings of grass overlap and blend well into each other. Viewers should not be able to distinguish the indi-

FIGURE 2 *The arrangement of the NURBS circles viewed from TOP.*

TABLE 1. Parameter Settings for the Brushes

		Strokes1 (inner)	Strokes2	Strokes3	Strokes4	Strokes5	Strokes6	Strokes7
Brush Profile	Brush Width	1.805	2.013	2.013	3.425	3.425	2.525	2.525
Tubes-Creation	Per Step	32.477	30.717	24.717	100.717	100.717	100.717	100.717
	Length Min	0.100	0.500	0.300	0.100	0.100	1.100	1.100
	Length Max	1.593	2.124	2.201	2.000	2.000	2.200	2.200
	Segments	20	20	20	20	20	20	20
	Direction	*Path*	*Path*	*Path*	*Path*	*Path*	*Path*	*Path*
	Elevation Min	−0.354	−0.354	−0.209	−0.243	−0.243	−0.243	−0.243
	Elevation Max	−0.009	−0.009	−0.221	−0.289	0.289	−0.289	−0.289
	Azimuth Min	−0.080	−0.027	−0.150	−0.133	−0.133	−0.133	0.027
	Azimuth Max	−0.027	−0.115	0.027	0.027	0.027	0.027	0.150
Behavior—Forces	Path Attract	0.000	−0.009	−0.009	−0.044	−0.044	−0.044	−0.044
Behavior—	*Type* Turbulence Frequency Speed	*Tree* 0.100 0.748 1.806	*Tree* 0.120 0.823 2.000	*Grass* 0.120 0.748 2.000	*Tree* 0.130 0.748 1.700	*Tree* 0.134 0.748 1.900	*Grass* 0.110 0.748 1.906	*Grass* 0.120 0.748 1.906

vidual rings of grass. The various parameters under the Tubes Creations are set to ensure the grass is generally inclined in our desired upright positions. The rest of the parameters are set to control the behavior of the grass with turbulence.

You should arrive at a similar scene as shown in Figure 3.

If you're working on Maya NT, you may be better off detaching the various subwindows such as the script editors, Visor, Outliner windows, etc., from the main window. This will
TIP
allow you to display and view these windows independent of the main window. This will avoid the subwin-

FIGURE 3 *The complete grass landing field.*

dows being dragged down by the slow response time of the main window. Figure 4 shows where you can detach the subwindows.

FIGURE 4 *Detach the window by unchecking the Attach menu.*

ANIMATION

The animation of the grass being blown and spreading out is straightforward. We'll just need to animate the Azimuth parameters of the brushes to correspond to the landing time of the helicopter.

1. Keyframe the Brush node parameters as shown in Table 2.

If you play back the animation, you may realize that the grass, except those from Stroke 1, will move only from within the keyframe range. Other than that, the grass will appear to be stationary. This should not be the case, since at all times, the turbulence force should have caused the grass to sway accordingly. So, what is missing here is the Time node from the rest of the Brush nodes.

When a stroke is first created, a Time node is linked to the Brush node. When we perform a normal duplicate instruction, only the Strokes, with its brush and the curve geometry, are duplicated. The Time node is left out. We'll now complete the scene by connecting the Time node.

2. Open the Hypergraph window.
3. Set up the connection of the nodes as shown in Figure 5. The connections are achieved by simply dragging and dropping the Time node to the various Brush nodes.

Next, test the movement of one of the rings of grass. You should get a movement similar to the one shown in the next animation. Notice that the grass also moves according to the turbulence you set.

Table 2. Animated Parameter Values

	Azimuth Min				Azimuth Max			
	Frame Start	Values	Frame End	Values	Frame Start	Values	Frame End	Values
Strokes 1	90	−0.07964	120	−0.38052	90	−0.02656	120	−0.23892
Strokes 2	110	−0.02656	130	−0.23892	110	−0.11504	130	−0.43364
Strokes 3	120	−0.15044	140	−0.46904	120	0.02656	140	−0.23892
Strokes 4	130	−0.13276	150	−0.55752	130	0.02656	150	−0.41592
Strokes 5	140	−0.13276	160	−0.55752	140	0.02656	160	−0.38052
Strokes 6	150	−0.13276	170	−0.43364	150	0.02656	170	−0.41592
Strokes 7	160	0.02656	180	−0.38052	160	0.15044	180	−0.20352

FIGURE 5 *The connection of the Time node to all the Brush nodes.*

RENDERING

Rendering the scene is a straightforward task. All you have to do is set up default lighting, such as a large spotlight, to shine on the grass.

4. Create a spot light that shines at the grass.
5. Test render the scene.

When you test render the scene, you may notice the "holes" in between the grass. We can solve this by increasing the density of our grass through higher Tubes Per Step Value. However, this will increase the computational time. A cheaper way is to create a texture map and map it to a plane geometry that act as the ground for the grass.

MOVIE 4 *A sample movement of the grass when blown by the winds from the helicopter.*

6. Create a NURBS plane.
7. Scale it so that it is large enough to act as the ground for the grass.
8. Create a Shader and assign it to the NURBS plane.
9. Map an appropriate texture to the Color value of the Shader.

The texture used could be a simple ramp value with noisy green or even a grass image taken from your garden. Another quick way to generate the tex-

ture is to paint it using Paint FX. The following instructions will briefly show you how to paint using Paint FX.

10. Press "8" to enter paint FX mode.
11. From the Paint menu, select Paint Canvas.
12. Open the Visor… window.
13. Select any of the brushes and paint on the canvas.
14. When done, save the file from the Canvas menu.

Figure 6 shows the texture generated using the Paint FX.

To create a tileable texture, make sure you have turned on the Warp Canvas Horizontally and Warp Canvas Vertically from the menu. And if you desire, you could output the depth of the painting and use it as a bump map as well.

Finally, unhide all the Strokes and render! It is important to note that for Paint FX that comes with Maya 2.50, there are annoying rendering bugs. If you encounter any unexplainable behavior, always refer to the release notes or contact Alias Wavefront

FIGURE 6 *The texture generated using Paint FX and mapped for the ground shader.*

for the updates. But as far as this tutorial is concerned, you should not have any problem in rendering your scene.

CONCLUSION

This tutorial walked you through an introductory example of using Maya Paint FX. There are many FX treasures waiting for you to discover! You could, for example, add in Flowers, Leaves etc., to the scene by simply checking on the default options. As for those who haven't been able to follow the tutorial, don't worry. The completed Maya file is available on the CD-ROM. Feel free to download it and test it out.

CHAPTER

34

Pixels Tutorial: Creating a Head in Pixels:3D

RICK SCHRAND

Pixels:3D is a high-end modeling program available for the Macintosh. Currently, it is in version 3.2, with an update coming out shortly. It features many of the functions found in programs such as Maya and SoftImage such as scripting and sculpting. A limited demo version can be downloaded from the Internet at http://www.pixels.net. At this time, Pixels:3D is available for purchase only from the company Website.

The following tutorial is for intermediate users who are looking for a better way to model a mouth in preparation for creating phoneme morph targets.

BUILDING THE SPLINES

There are numerous ways to create organic creatures in Pixels:3D, but few offer the versatility of Lofting. Lofting creates a "skin" that stretches from one point of a spline to the next. By creating splines with an even number of points, you can model virtually anything. Plus, with Pixels:3D's ability to import JPEG and PICT files, you can create characters based on actual photographs or line drawings once you get used to building your spline "skeleton."

For this tutorial, we'll focus on the lower half of the face (see Figure 1). This is, by far, the most chal-

216 lenging area to model due to all the parts that have to

be accounted for. The upper half of the head consists of a brow ridge, indentations for the eyes, and a forehead; in comparison, creating the chin, mouth, lower nose, nostrils, smile lines, and so forth is a much more complex task.

So, why don't we get right to it. In the Shapes palette, select Cylinder and set the V-Step to 1 (see Figure 2). Now you have a circular spline from which to work (see Figure 3). This will become our Master Spline, so you might want to rename it in such as way as to make it easily recognizable. I have some suggestions, but they'd probably be deleted from the text, so just be creative and name it something like Master_Spline.

FIGURE 1 *Our handsome, highly paid model.*

FIGURE 2 *Select the cylinder tool and set the V-Step to "1."*

FIGURE 3 *Believe it or not, this is our mouth.*

But wait! If we began building from this as it is, we would have a person with a mouth larger than Mick Jagger's. We need to close that puppy. Choose Reshape>Pinch, then turn off the X and Z coordinates so that we don't have a really tiny mouth, and let's close it before flies get in (see Figure 4). You can shut it all the way if you like, but most people, when relaxed, have their lips slightly parted. Now deselect the Y axis, select Z, and pull the ends back slightly.

Once you have the spline reshaped the way you want, create a duplicate (Command+d). Now select Reshape>Push/Pull and the MirU option. From this point, you'll begin to use the Front and Side views (lower left and right windows) for the most part.

FIGURE 4 *Shutting our trap.*

Make sure the X/Y/Z coordinates are all active, and begin the reshaping process (see Figure 5).

As you build, you'll need to be able to visualize what, exactly, each spline will eventually become. In the case of this second spline, we usually make it the middle of the lips, creating that slight curve out when lofted. The next spline would be the outer portion of the lips, next is that area between the base of the nose (whatever that's called!) and the spot prior to the jutting out of the chin (ditto). We'll just call them the Pre-Jut spots for simplicity's sake.

Manipulate each spline to approximate the rough contours of a face (see Figure 6). You can't get too exacting with this; otherwise, it will drive you crazy. We'll modify everything once the Lofting is completed. Usually, for this portion of the face, it takes

FIGURE 5 *Duplicating the spline to create the lip.*

FIGURE 6 *The manipulated splines creating the lower portion of the face.*

FIGURE 7 *Creating the interior of the mouth.*

between five and seven splines to give a good estimation of what your lower head will look like. To do an entire head, you really don't need more than 10 or 11 splines total.

Once you're happy with your work, go ahead and save the file as "Head_Spline."

Here's a little tip: All the top modelers save various model parts for later inclusion in other models. By saving your spline and lofted head files separately, you can go back to the former at a later date, modify the splines, and create whole new people or creatures in less than half the time.

We're almost ready to loft—but not quite. We know you're all anxious to see what your work is going to look like, but we still have two more things to do.

Select the first spline you created and duplicate it. This time, we're going to move it back on the Z-axis (see Figure 7). Select Reshape>Pinch and open this spline up. This will become the interior of the mouth. Duplicate this once more (see Figure 8) and move it back slightly and down. This last spline will be the throat.

Why go to all this trouble to create areas that will more than likely never be seen? As you become more proficient with your modeling and animation skills, there will be times when your character's mouth will be open and the camera is pointing straight in. Maybe you'll have that fly we spoke about earlier fly down your character's throat. By adding this little

FIGURE 8 *Move the spline back and down to create the throat.*

extra detail now, it gives more credibility to your character. Little lifelike details such as adding the uvula (that dingle-dangle thing in the back of the throat) not only help in bringing your character to life, they help you, as a modeler, believe in it as well. Remember: If the viewer sees a closed-off area in the back of the mouth where the throat should be, whatever suspension of belief you're asking that person to have will be shot. It's often the things no one consciously thinks about that turn a good model into a great model.

OK. We're stepping down from our soapbox now. Reality Modeling 101 is over. You all passed with flying colors.

IT'S NOW TIME TO LOFT

All of our splines are in place, so let's see what our character looks like. Choose the very last spline we placed (the bottom of the throat) and work your way back out to the last spline you modified. You need to loft in order or else you'll assign links that won't work well at all. Plus, if you accidentally added any CVs (Control Vertices) to a spline, it will also throw off the Lofting. Each spline has to have the same number of CVs to work correctly. (See Figure 9.)

Once all the splines are selected, choose Re-shape>Loft. Do a quick render (Command+r) to see what he/she/it looks like (see Figure 10). More than likely, purty durn scary! We have yet to have the original loft come out looking like anything but some strange mutant from one of George Lucas' nightmares. But that's okay. No problemo. Don't sweat it in the least.

Rename the model "Head_Form," and then go ahead and save this file as "Lofted_Head" or something equally creative. You can also delete all the splines since they're now officially useless.

Using the same techniques as with the splines, take some time to hone your model. You'll want to add some U and V axes to help smooth things out. When you create a V axis on one side of the model, make sure you add one in the identical spot on the

FIGURE 10 *Move over Freddy, there's a new Nightmare in town!*

other side; otherwise, your MirU function will get all out o' whack and make your job more difficult.

After a little modifying, your model should look something like Figure 11.

FIGURE 11 *Handsome devil, ain't he!*

CREATING MORPH TARGETS

To animate your mouth, you need to create morph targets; keyframes that give the program information on what happens at a given point. If you've worked in other 3D applications that offer animation tools, you're more than likely familiar with keyframing, so we won't go into that.

FIGURE 9 *Select the splines starting with the throat and work your way back to the last head spline you made.*

In most instances, talking doesn't affect jaw placement; it's only when you have your model open its mouth wide that the jaw would drop. Yes, there is some slight movement, but for this workshop we won't worry about that. Those are things you can add in as you become more proficient at morphing. So, now all we really need to do is worry about the lips and that Pre-Jut area we talked about earlier.

With the head mesh selected, open the MorphMaker (Command+m or Window>MorphMaker). The head form is our starting point, so click the button that says Set Reference (see Figure 12). Select Reshape>Pinch, deselect the Z coordinate (because we don't need to pull anything forward), and begin opening the mouth starting from just inside the lips. You'll have to do this to a few U-Rows to make sure nothing funky happens with the lips. Make the changes in small increments; there's no rush, and the more time you take to get it right, the better your animation will turn out. By turning off either the X or Y coordinates, you can mold the mouth into the phonemes that make up speech. With only the X coordinate active, you can create "O" and "U." With the Y coordinate active, you get "A," "E," and "I."

There's more to it than that, but, again, not of concern to what we're doing today.

Once you get your mouth in the position you want it, click the Save Gesture button at the bottom of the MorphMaker screen. A pop-up window will . . . well . . . it'll pop up and ask you to

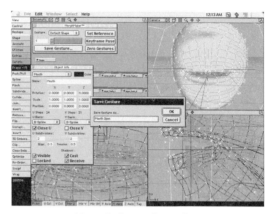

FIGURE 13 *Name the "gesture" something appropriate.*

name the gesture (see Figure 13). Go ahead and do that, and then make sure you keep the MM window open.

Go back to the MorphMaker window, and select Zero Gestures to go back to your original, closed-mouth model.

There's a bar right above Save Gestures (refer back to Figure 12). When you move this back and forth, you'll see your wireframe model move its lips from the starting position to the final position you defined. Somewhere near the middle of the bar, stop and select Keyframe Pose.

Now it's time to open the Timeline window (see Figure 14). Select Window>Timeline or Command+t. On the far right of this screen, you'll see

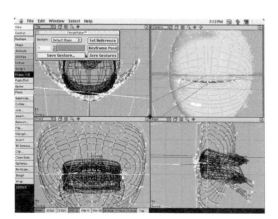

FIGURE 12 *The MorphMaker controls.*

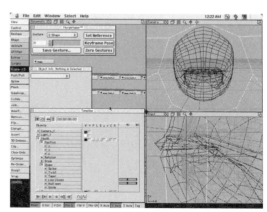

FIGURE 14 *The Timeline window.*

tick marks that represent "the passage of time." Select a frame (10, 15, 20, etc.) and then go back to the MorphMaker. Move that gray bar until your mouth is wide open. (Well, not YOUR mouth, your MODEL's mouth!). Click on Keyframe Pose again. This sets a Keyframe in the timeline. If you want the mouth to close again, move the indicator in the Timeline window farther to the right and repeat these steps.

Once this is done, do a Pencil Test (see Figure 15)—Animate>Pencil Test—and watch your character come to life.

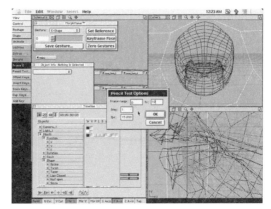

FIGURE 15 *Create a Pencil Test to get a quick look at your animation.*

CHAPTER

35

Rotocruiser 1200 — Using Rhinoceros 3D

RYAN W. KNOPE

SYSTEM REQUIREMENTS

To participate in this tutorial, you will need a Windows-based operating system, with the Nurbs modeling application Rhinoceros 3D 1.0. The suggested RAM is 32MB minimum, and the .3DM file that is created may take from 5–15MB in hard drive space. The system I used for this model is a Pentium II 300, with 128MB RAM, and a small Matrox Millennium II 8MB video card. I use large hard drives so I can make a lot of room for swap space.

INTRODUCTION: THE STORY

In the year 2070, in the world of Futuristica, there is a battle raging on the land, in the air, and at sea. Every nation wants the remaining carnonyte, a deep-black crystal that when crushed and mixed with another solution has 1000 times the power and usability of gasoline. Using carnonyte, star cruisers can run faster and longer. In this world, star cruisers have taken the place of cars. There are no more wheels, and everything is powered by Jet Carnyte or Fusius. To get around in this world, we're going to build our own star cruiser, the Rotocruiser 1200.

TRAITS OF THE ROTOCRUISER 1200

Let's check the general working conditions and the situations that this machine must endure. First, it must be fast, so it's jet powered. It has to be streamlined so that it handles well at high speeds, and it often has a laser cannon attached to the sides or bottom.

CONCEPT SKETCHES

Before we begin modeling the Rotocruiser 1200, we have to do our concept sketches. These sketches are very important and help you plan your creature or object before you begin modeling. This makes the whole process quicker. Of course, you aren't limited to your concept sketch, so if you decide you want to change something later, it's not a problem. The sketches are just the beginning, and your creature or object will evolve in detail as you begin modeling. I frequently create a few concept sketches and then combine them to come up with exactly what I want. All in all, concept sketches really are worth the effort. My sketches have already been finished, so if you

plan to create your own Rotocruiser instead of using my design, you should draw your concept sketches before starting.

MODELING IN RHINOCEROS

Here is where most of the work in this tutorial will take place. You will be making maps outside of Rhino to use, but you will use only Rhinoceros to model the Rotocruiser 1200. You will use a wide range of tools within Rhino, including Loft, Pipes, and Patches. I'm not going to go into a lot of detail on how to use these tools, so it will benefit you greatly to read your user manual to learn what each one does. Figure 1 shows all the buttons/features of Rhino that will used in this tutorial, so be sure you understand these features before beginning this model.

Tool Buttons

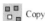

▫▫ Copy

⟋ Interpolated Curve

⟋ PolyLine

◎ Circle

◀▷ Mirror

⟁ Revolve

⟨ Loft

⟨ Pipe

FIGURE 1 *Tool buttons.*

MODELING THE BODY

We will begin with the body of the cruiser. The beginning is a very important step; with a solid beginning, a model will flow more easily. To make it easier on you, I have created a sequence in this step. We will start the main body by drawing splines as seen in Figure 2. To start drawing interpolated

splines, you will use the InterpCrv command. To do this, click in your viewport and start your curves—it's simple and easy.

When you've completed this step, you'll need to draw more splines to add the necessary definition and detail. Figure 3 shows the second set of splines drawn. To do this, use the same method as shown in Figure 2.

After all of the splines are finished, we need to build a surface from them. To do this, we will use the Loft command. This brings up the Loft dialog box as shown in Figure 4. For the best results, use the settings you see in Figure 4.

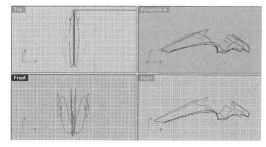

FIGURE 2 *Drawing splines.*

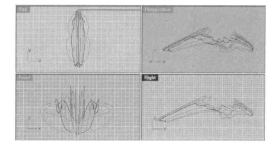

FIGURE 3 *Second set of splines.*

FIGURE 4 *Loft dialog box.*

- The terms and buttons of the Loft dialog box do the following:
- Closed Loft: Closes the surface (in some cases in this tutorial, we don't want to use this).
- Shaded Preview: When quick shade is activated, it shows the current loft in progress in a shaded view. We used this function to preview our loft before we were finished.
- Do not simplify: Uses the current set of points on a spline to determine where isoparms will be located. (There was no rebuild used in this tutorial.)
- Rebuild with **: Rebuilds a surface using ** number of isoparms (** is a number you indicate). (There was no rebuild used in this tutorial.)
- Style: Determines how your surface will be generated. Normal builds it with normal tightness, and so on, while straight sections build a surface with straight sections at each isoparm. We used "normal" in this tutorial.

Next, we will model the window of the cockpit. Draw the four interpolated splines as shown in Figure 5. They are different colors because they are on separate layers. Using different colors is not necessary, but it helps to distinguish the different splines.

Notice that there are three splines selected in Figure 6. Use these splines to create a surface by lofting. Use the Loft as you see the properties in Figure 7. Once you've completed this step, you should have something similar to the preview in Figure 7.

In Figure 8, you will see that we have two more splines selected. Our cockpit has a two-piece window, and this is the second piece. Loft the two

FIGURE 6 *Three splines selected.*

FIGURE 7 *Creating the surface by lofting.*

FIGURE 8 *Lofting the additional splines.*

splines just as you did in the previous step and you should have a model similar to the one in Figure 9.

Now it's time to move on to the tail pipes. We will use several splines, and then Loft them to form our surface. If you look at Figure 10, you will see a set of closed splines in red. These are circles; all you need to do is type Circles at the command line, and then start drawing a circle. Repeat these steps until you have a screen such as seen in Figure 10. Once you're done drawing circles, you then need to Loft these closed splines. Make sure to make a closed,

FIGURE 5 *Four interpolated splines.*

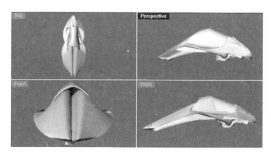

FIGURE 9 *The model so far.*

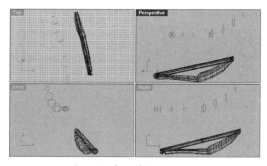

FIGURE 10 *Creating the tailpipe.*

FIGURE 11 *Modeling the thruster.*

FIGURE 12 *Revolve Axis.*

FIGURE 13 *Drawing the Revolve Axis.*

straight loft from the splines. Now you should have a finished tailpipe. To make a closed loft, all you have to do is check "closed" in the loft dialog box that pops up.

While we are on pipes, we might as well model the thrusters. We will do this by revolving some interpolated splines. Take a look at Figure 11 and you will see two different splines, with different colors. These are interpolated splines, which are obviously open. Go ahead and create these splines as you did earlier with the InterpCrv command. Once done, you need to select one and type Rev at the command line and press Enter. In the Top Viewport you will see a line that is drawn. You do not have to draw this; it is a function of the revolve command. It shows where your revolve is being made. To see this line, look at Figure 12. This line is the Revolve Axis, and it will disappear when you finish the revolve command.

Go ahead and draw the Revolve Axis. A dialog box should appear like that shown in Figure 13. Use these settings to Revolve. We will go over the Re-

volve function now. When you check exact, your surface will not be deformable, but if you check deformable, with ** control points, your object will be editable and you can control the amount of detail the formed surface has. Most of the time I have this set to 10, which is the default. You should always want the start angle to be 0, and the end angle to be 360; that is, if you want it to be a complete Revolve

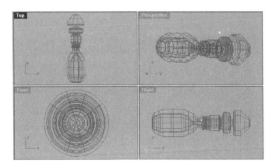

FIGURE 14 *Status of objects.*

360 degrees. At this point, your objects should be the same as those in Figure 14.

In Figure 15, you can see that the ship is coming along nicely, and actually wasn't too difficult to create, although a little time consuming. With many models, it's not that the object is hard to model, it often just involves many small, easy tasks.

Figure 16 shows an interpolated spline that has been drawn to form the under pipes. All you need to

do is draw an open, interpolated spline with a dip in the center. To make the under pipes from this curve, we will use the Pipe command. Go ahead and select your curve, type Pipe in the command menu, and press Enter. You will notice a circle that automatically starts at one end of your spline. This will be the size of your pipe. Pick the size you desire. To pick the size you want, just move your cursor around the circle and you will see it get bigger and smaller. You can see the size that I picked in Figure 17. Once you pick your size for one side, you can either draw another size, or press Enter for the exact same size. To do this you do not have to enter the command again; when you use Pipe, it plans to pipe both ends, so the command will not end until both sides are piped. Once done, you should have a finished pipe as in Figure 18.

Now that you have the pipe, you need four more on the bottom of the Rotocruiser. Once you have it in the desired position, you must use the copy command to duplicate it. To do this, just copy the piped

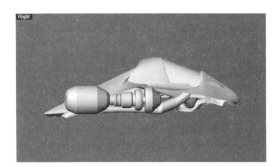

FIGURE 15 *Ship object evolving.*

FIGURE 17 *Sizing the pipe.*

FIGURE 16 *Interpolated spline for under pipes.*

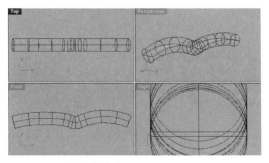

FIGURE 18 *Finished pipe.*

object four times. Look at Figure 19 and you will see the new position of the pipe. Select your object, then type copy at the command line and press Enter. Now drag your cursor around the screen and you will see a copy of it move with your cursor. If you press Shift while moving the cursor, you will notice that your pipe will then be copied in a straight line, which is what you need. Figure 20 shows the final position of the four pipes. Your model should be similar to this.

In Figure 21 there are a number of surfaces selected. Go ahead and select these surfaces by clicking on them, so that we can mirror these over to the other side of the ship. After you have selected these surfaces, you need to type Mirror at the command line, and press Enter. Next, you need to draw a mirror axis. You also need to draw a line straight down the center of the ship's body. Press Shift while doing this, which will ensure that you get a straight line and, therefore, a perfect mirror. (The line will be provided by the Mirror command, just like it was for

FIGURE 21 *Mirroring the surfaces.*

the Revolve command). After mirroring, you should have a screen as seen in Figure 22. In Figure 23, you will see a quick render of the ship up to this point.

Now we are going to model the final objects for the Rotocruiser, so let's begin by building the back fins. We will do this by Lofting a set of three closed polylines. To start drawing the polylines, use the command Polyline and draw what you see in Figure 24. You will notice there are three closed splines that

FIGURE 19 *Positioning the pipe.*

FIGURE 22 *Mirroring completed.*

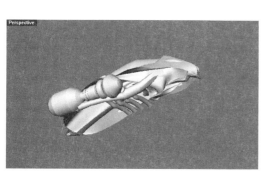

FIGURE 20 *Final position of four pipes.*

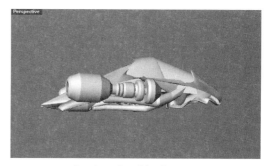

FIGURE 23 *Quick render of the ship.*

FIGURE 24　*Polyline drawing.*

look like narrow rectangles. Once they are drawn, you need to create a surface out of them. Use a Closed Straight Loft for this. Select all of the splines and use the Loft command as you have previously in this tutorial. When you select them, type Loft and press Enter; you should see a screen like Figure 25. Press Enter and make sure you have a closed straight loft. Check the preview box and press Preview, and you should see something like Figure 26.

Now we have just about everything done except for placing the fins. Place the fins as you see them in Figure 27. To place the fins, all you have to do is select them and drag them to where they need to go. We now have all of the pieces modeled, placed, and ready to render. To render, you may want to use an application such as 3D Studio Max or Lightwave 3D. Rhino does not have acceptable surfacing and rendering capabilities. To export to another application, all you need to do is convert your objects to a polygon mesh. To do this, use the Mesh command. This will convert it to polygons. Then go to Save As, which lists a number of formats to save it in. The drawback of this is that you will lose all Nurbs data. The other option is to get one of the .3dm plugins from http://www.rhino3d.com. This will allow a number of applications to open the Rhino .3dm native format, which will preserve your Nurbs.

In Figure 28, you will see the test render with the Nurbs mesh showing in the render. Your Rotocruiser should look like this now. At this point, it

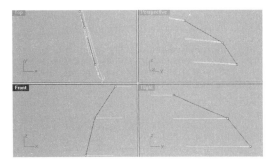

FIGURE 25　*Creating the surface.*

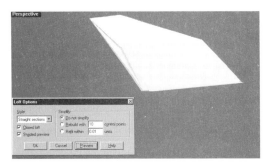

FIGURE 26　*Previewing the surface.*

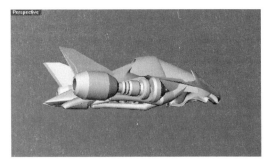

FIGURE 27　*Placing the fins.*

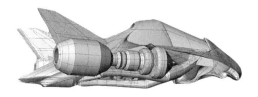

FIGURE 28　*Test render with Nurbs mesh showing.*

is up to you to customize your cruiser to your specifications. Take some time to experiment. It is the best way that you can develop your own style, and style is very important.

CONCLUSIONS

In this tutorial, you learned quite a few functions. This tutorial didn't cover all of the functions Rhino has; no tutorial could or will. It is important that once you do a tutorial, you go and try the things on your own, and create something using the skills you just learned.

36

A Close-Up on Lofting—Using Rhinoceros 3D

RYAN W. KNOPE

SYSTEM REQUIREMENTS

To participate in this tutorial, you will need a Windows-based operating system, with the Nurbs modeling application Rhinoceros 3D 1.0. The suggested RAM is 32MB minimum, and the .3DM file that is created may take from 5–15MB in hard drive space. The system I used to model is a Pentium II 300, with 128MB RAM, and a small Matrox Millennium II 8MB video card. I use large hard drives so I can make a lot of room for swap space.

INTRODUCTION

As with anything, lofting may be a difficult thing to learn, but with the help of this tutorial you should have a much higher understanding of how this function works in most situations and aspects. This tutorial will not teach you how to make an entire object, although it will go over how to do facial features such as lips and a nose from lofting. This tutorial will also touch on all the functions inside the loft command. These functions include closed loft, tight loft, loose loft, straight, as well as just about every other function.

A BASIC UNDERSTANDING

Before you try the loft command, you first have to know what it does. Loft will create a surface from two or more splines. Splines are basically the same thing as lines. Splines are made up of two or more points. The more points there are, the more detailed the spline will be. The points on a spline determine how sharp curves are made, as well as how the spline will react when you move a point by clicking and dragging it with your mouse. Points are the whole basis of splines, just as splines are the basis of lofting a surface. Without splines, the loft tool can't create a surface.

SPLINE TYPES

Now take a look at spline types. In Figure 1, you will see several splines; these are the major types you will need. The first spline (#1) is a Line. The command for this is "line." It is composed of two points, which make it consist of absolutely no curves whatsoever. Spline #2 is a Polyline. To access this tool, you just need to type "polyline," press Enter, and start the spline by clicking and dragging. Polylines have as many points as you specify by left-clicking. Polylines are always quite jagged and have no smooth curves, only sharp edges. Spline #3 is an Interpolated Spline. This is one of the most smooth and organic curves of all that Rhinoceros has. This curve is great for making any organic shapes. Use it often and use it wisely. The Interpolated Curve can also have as many points as the user specifies. To access this tool, use the

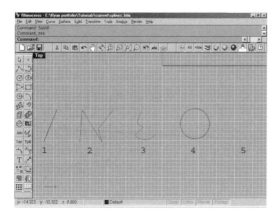

FIGURE 1 *Major splines.*

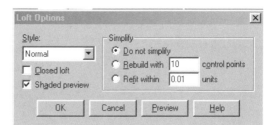

FIGURE 2 *Loft dialog box.*

"interpcrv" command. Spline #4 is a Circle. To access this tool, use the "circle" command and press Enter. Now click and you can draw your circle. The point count on this spline is not user determined. The #5 spline is very similar to the circle. This is an Ellipse. The point count on this spline is not user determined. To access this tool, use the "ellipse" command.

KNOWING FUNCTIONS OF THE LOFT

It is quite important that you get to know the tools you will be using frequently—loft is no exception. Trust me, you will use loft more than you think you will right now. Following is some info on many of the terms and functions inside the Loft dialog box. To see the appearance of the Loft dialog box, check out Figure 2.

The terms and buttons of the Loft dialog box do the following:

- **Closed Loft.** Closes the surface. This continues the surface past the last curve, and back around to the first. This is only available when you have three or more curves to loft from. Check out Figure 3 to view the appearance of an open loft. Figure 4 has a loft that has been closed. Notice that in the two figures (3 and 4), the only difference is that the closed loft has been checked or unchecked.

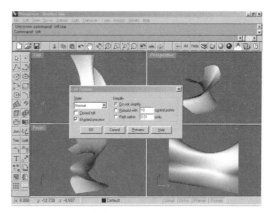

FIGURE 3 *Open loft.*

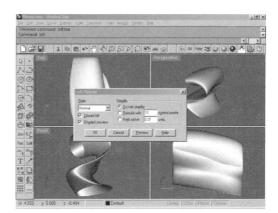

FIGURE 4 *Shaded preview.*

- **Shaded Preview.** When quick shade is activated, it shows the current loft in progress in a shaded view. This is great to make sure your curves are placed correctly. If you look at Figure 4, you will

see that the shaded preview box is checked. This activates the shading that you see in that figure.

- **Do not simplify.** Uses the current set of points on a spline to determine where isoparms will be located.
- **Rebuild with **.** Rebuilds a surface using ** number of isoparms *(** is a number you indicate)*. The lower the number, the less detail your surface will have; the higher the number, you place there, the more detail. Check out Figure 5 to view a surface without rebuild; notice that it is sharp. In Figure 6, you will see a surface that has been rebuilt. It is smoothed. In this figure, it has been rebuilt with 10 control points. This is usually a relatively low amount, and will smooth your object.
- **Style.** Determines how your surface will be generated. In the following sections you will see data that discusses each of the styles and what they look like.

FIGURE 5 *Surface without a rebuild.*

FIGURE 6 *Rebuilt surface.*

STRAIGHT SECTIONS

This creates a straight surface. It is hard to picture, so look at Figure 7. You may also realize later that this is the same as a ruled surface. You see how you get sharp edges that would normally be smooth when done with a regular or standard loft. This is good many times for machinery or mecha models. however, you wouldn't normally want to use this on organic models.

FIGURE 7 *Straight surface.*

- **Normal** This style creates a nice flowing loft that is smooth and it's the one that you will probably use most. It is the most common of the styles and is the default, and it's great for organics.
- **Loose** The loose style creates a very flowing surface, even more so than the normal style. This is great for when a loft doesn't have much detail. If the attempted loft has a lot of detail in it, you will lose some when using the loose style.
- **Tight** In this style, your surface will fit closer to your splines and produce a much tighter, harder surface. This is great for both organics and mechanical.

USING THE LOFT TOOL TO MODEL

Now we will go on to using the Loft tool to create a simple nose, lips, and chin. To start, you will need to

draw a single spline as seen in Figure 8. The spline type that we will use will be an interpolated curve. The command for this is "interpcrv," and you must draw it in the right viewport. This will be one of the starting points of the whole face.

Next, you must mirror the splines over using the "mirror" command. Select your spline, type in the command, and then press Enter. Now you have activated the mirror command. After you get used to the Mirror tool, you need to mirror the spline to look like Figure 9. At this point, the four curves are exactly the same. Once you have gotten to this point, take a short break—the next part is a bit tricky and takes time.

The next step is to edit the four splines so that each of them forms a different part of the face. If you look at Figure 10, you will notice that each of the four curves seen in the previous step is now totally different. This is due to point editing. Learning to edit points in 3D is one of the most crucial parts of the art. Select the four splines that you have and type in "showcv." This is the command that will make your control points appear for you to edit. Now form your splines to look like Figure 10. To edit the points, simply select the point that you desire to move, and drag it.

Now we will check our curves by doing a test loft. To do a test loft, select your curves, enter the "loft" command, and press Enter. Now the Loft dialog box should pop up. In the Loft dialog box, check the Shaded Preview box, and hit the Preview button. You should now have a screen similar to Figure 11.

FIGURE 8 *Single spline.*

FIGURE 10 *Editing the spline.*

FIGURE 9 *Mirroring the spline.*

FIGURE 11 *Test loft.*

Notice that the face doesn't have much detail in the nose, lips, and mouth area. Because of this, we need to add more curves for more detail.

To do this, you need to mirror more curves. Keep the ones you have so far, just mirror some more and edit them so that the curves look like those in Figure 12. The previously created curves are in black. This take some time, but once you get used to it, you will be amazed at what you can do.

Now that you have all of your splines completed, we will check them to make sure that none of them overlap, which can cause undesired folds in your surface. To check the splines, select them, then use the "loft" command, and press Enter. Now the Loft dialog box will pop up and show you a wireframe of what the loft will look like. This, however, will not do you any good at this point; you need a shaded view. To get a shaded view, all you have to do is check the Shaded Preview box and press the Preview button. Now you should have a screen similar to the one in Figure 13. We will go into more depth with the necessities of point editing in the next article.

FIGURE 13 *Shaded Preview box.*

SMALL LOFTING TIPS AND TRICKS

Here are a few small tips and tricks I have learned in the past few years of modeling in Rhino.

When you are drawing splines to loft, it is best to make sure that they all have the same number of control points. We mirror the splines instead of re-drawing them, so that the points match up and make a clean and less-twisted mesh.

In building splines to loft from, make sure that you don't have too many. Too many splines will make it a mess to point edit after lofting, and will also slow down and create a much larger file. Your goal when creating an object is to get as much detail with as little overcrowding as possible. Trust me, this is a good idea.

CONCLUSION

In this tutorial, you have learned a lot about lofting; probably quite a bit more than you knew before. You also learned how to start a face. This face wasn't finished, but we will finish it in the next tutorial, so keep reading and you'll keep learning more and more. Remember, practice makes better.

FIGURE 12 *Adding more curves.*

37

So Many Droids, So Little Time (Strata StudioPro 2.5)

ADAM WATKINS

This droid-making tutorial requires any machine running Strata's StudioPro 2.5.x. I created the tutorial on a Mac; however, the NT version of SSP will work perfectly well. The general techniques and object organization could be used with any 3D application you may be using.

One of the most interesting "dirty" scenes of the Star Wars series is the smelting room of the third (or sixth episode) Return of the Jedi. All those bunged-up, dirtied-down droids are a great example of pulling the futuristic technology of the Star Wars movie into a believable realm.

To me, the smelting operators are some of the most interesting droids present in that scene. These fireproof, lanky, humanoid-like droids with their counterlevered joints and elongated faces make them just human enough to be scary. So without further ado, let's build an 8D8 Smelting Operator in Strata's StudioPro.

FIGURE 1 *Finished Droid.*

GETTING TO IT

To begin with, take a look at the finished droid (Figure 1). Notice that, overall, it is a symmetrical shape, and even the parts of the legs, arms, and torso are carefully lathed-looking objects. One of my favorite features in Strata StudioPro is the ability to create profiles from which to lathe or extrude that are ed-

itable at any given time. Let's start with the "shin" part of the legs.

THE POWER OF THE LATHE

Select the Bézier Pen tool from the Tools palette (Figure 2). This tool functions much like the Pen

235

FIGURE 2 *Bézier Pen tool.*

tool does in Adobe's Illustrator or Photoshop. You can use it to draw straight or curved (with Bézier handles) lines. It allows you to define anchor points to which it connects the dots. It then allows you to use the Bézier handles to define the curve of the line between any two given dots.

To begin drawing the outline of one of the sections of the shin, we want to draw a straight line. Click once and release where you want to begin drawing; this will establish the first anchor point. Drag the mouse downward and click the mouse again to tell SSP where you wish to place the next anchor point (Figure 3). Next, move inward and down a bit, and click and hold this time. With the mouse button down, drag out a bit and watch as the

Bézier handles emerge, allowing you to change the line between the Bézier points to a curved one. Drag the Bézier handles to where they should be, and release the mouse button (Figure 4).

You can continue the same path you just began, by clicking where you want the next anchor point (Figure 5). Since we want the line between this anchor point and the previous one to be straight, click and release. The line between this anchor point and the last needs to be curved, so click and hold where you wish the anchor point to be, and drag the resultant Bézier handles out to create the needed curve (Figure 6). Once correctly defined, double-click on the last anchor point to tell SSP that you are done

FIGURE 4 *Dragging the Bézier handles.*

FIGURE 3 *Drawing the shin.*

FIGURE 5 *Continuing the path.*

FIGURE 6 *Curving the line.*

FIGURE 8 *Lathe tool.*

with this path. SSP will then outline the entire path to let you know it recognized the newly created path (Figure 7).

Now we need to take the path and lathe it to make a 3-D rounded object out of this profile. Select the Lathe tool (Figure 8), and in an isometric view, grab one of the bounding handles (Figure 9) and drag in a circular motion to tell SSP how far to lathe the profile (Figure 10). Figure 11 shows the completely lathed profile, shown by the completed green circle near the center of the object. You won't be able to actually see what the object looks like until you exit the Lathe tool. Click on any other tool in the Tools palette to see the results of the lathe (Figure 12).

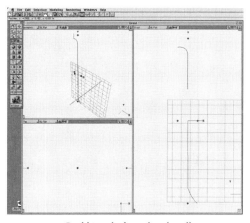

FIGURE 9 *Grabbing the bounding handle.*

FIGURE 7 *Outline of the path.*

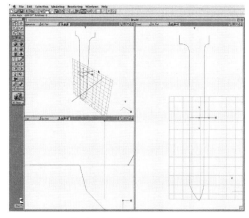

FIGURE 10 *Lathe the profile.*

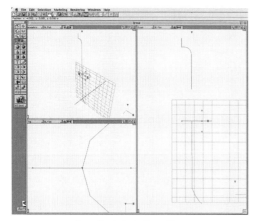

FIGURE 11 *Completely lathed profile.*

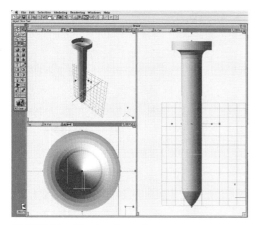

FIGURE 12 *Viewing the results.*

CHANGING PROFILES

The beauty of recent versions of SSP is the ability to change the profile, or the amount the object is lathed. At the top of the screen along the Button palette, you'll see the Reshape tool (Figure 13).

When you click this button, the Tool palette will change to look like Figure 14. By selecting the Pointer tool (shown selected in Figure 14), you can alter the shape of the previously created profile path. Simply click on any anchor point and move it to a new location (Figure 15). You can also use this same

FIGURE 14 *Tool palette.*

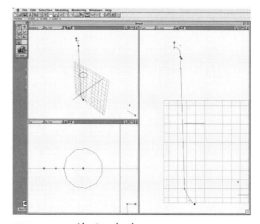

FIGURE 15 *Altering the shape.*

FIGURE 13 *Reshape tool.*

FIGURE 16 *End Reshape/Edit button.*

tool to grab any Bézier handle and adjust the curve of the path. When you have completed all your changes, click the End Reshape/Edit button in the Button palette (Figure 16).

Now that this shape is complete, we can copy, paste, and resize it to create the rest of the shapes of the shin. Figure 18 shows the lathed shape just created (with a cylinder set in the top to cork the hole) and duplicated by using the Object Move tool (Figure 17) to grab a handle (with the Option key held down) and drag a copy to a new location (Figure 18).

Once the copy is created, use the Object Scale tool (Figure 19) to resize the object. By clicking anywhere within the shape (NOT the bounding handles) and dragging left, the shape will reduce proportionally from all directions (Figure 20). Conversely, if you drag right, it expands in all directions.

Repeat this process a couple of times so that your model looks like Figure 21. Figure 21 also shows a primitive sphere created with the Sphere tool (Figure 22) set at the top of the shin to act as a bearing. To connect to the bearing, I want to add a regular cylinder shape that is exactly the same diameter as the sphere. To do this, create a cylinder with the Cylin-

FIGURE 18 *Lathed Shape.*

FIGURE 19 *Resize with Object Scale tool.*

der tool (Figure 23) by clicking and dragging (while holding the Shift key down to maintain square proportions) (Figure 24). The exact size is unimportant, as it can be altered.

Use the Object Move tool to select the sphere (Figure 25). To see the size of any object, go to the Object palette (Figure 26) and click the Size radio button. From my model, I can see that the sphere is

FIGURE 17 *Object Move tool.*

FIGURE 20 *Shape reduced proportionally.*

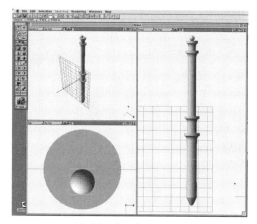

FIGURE 21 *Model reshaped.*

FIGURE 22 *Sphere tool.*

FIGURE 23 *Cylinder tool.*

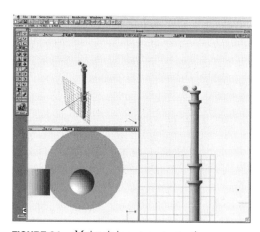

FIGURE 24 *Maintaining square proportions.*

FIGURE 25 *Object Move tool.*

FIGURE 26 *Object palette for resizing.*

.5 inches in all directions. Select the cylinder, and then change the entries in the Object palette to also read .5 inches, for the x and y parameters (Figure 27).

Since I created the cylinder from the front view, SSP created the primitive with the round part facing me. Since it needs to be standing straight up, use the Object Rotate Tool (Figure 28) to rotate the object appropriately (Figure 29). Now use the Object Move tool to move the cylinder into place about halfway through the sphere (Figure 30).

FIGURE 27 *Setting the parameters.*

FIGURE 28 *Object Rotate tool.*

FIGURE 29 *Object rotated.*

FIGURE 30 *Object Move tool.*

ALIGNING OBJECTS

To align these objects, select both (click on one with the Object Move tool, and then holding the Shift key down, click on the other) and press Command-/. This is the Align command and brings up a dialog box as shown in Figure 31. This allows you to align any number of objects along set axes. In this case, I only want to align the Horizontal axis and the Depth axis (Figure 31). As you can see in Figure 32, the two objects are now exactly on top of one another. Option-Drag the bottom sphere to the top end of the cylinder.

FIGURE 31 *Aligning the objects.*

ORGANIZATION

Now that we've begun to amass several objects, we should spend some time organizing them. Since the two spheres and the cylinder will always be together, we should group them. Select all three (Shift-click) and press Command-G (Figure 34). Now that they are grouped, all changes will affect the group as a whole. Select the newly formed group and, using the Object Scale tool, lengthen the entire group to look like Figure 35.

At any time, you can select a group, and with Command-U, ungroup it into its constituent parts. In Figure 36, you can see that I've ungrouped the

FIGURE 32 *Objects aligned.*

Make sure to use one of the bounding handles (either on the top or bottom of the object) to ensure the object doesn't move in any other direction other than up and down. The resulting three shapes should look like Figure 33.

FIGURE 34 *Organizing the shapes.*

FIGURE 33 *Resulting shapes.*

FIGURE 35 *Object Scale tool.*

FIGURE 36 *Ungrouping the parts.*

FIGURE 38 *Lathe tool.*

parts, separated the spheres from the cylinder, and then regrouped them.

Next, I want to create another lathed shape on the top of my group. Using the Bézier Pen tool, create an outline similar to Figure 37. Then, using the Lathe tool, lathe the object one revolution to match Figure 38. If the shape seems wrong, use the Reshape button and the Pointer tool to change the profile's path (Figures 39–40). In Figure 41, I've added another sphere to the bottom of the lathed object and grouped the two together. Then I positioned that group over the sphere-cylinder group and used the Align function to make sure they line up appropriately.

FIGURE 39 *Adjusting the profile's path.*

FIGURE 37 *Bézier Pen tool.*

FIGURE 40 *More adjusting.*

FIGURE 41 *Adding a new sphere.*

The Beauty of the Extrude

Thus far, we have made hollowed-out shapes from creating profiles and lathing them. Now, for the heels and feet of the droid, we'll create a solid profile and extrude it to create a solid object.

Click on the Bézier Pen tool and hold the mouse down to reveal the other tool beneath (Figure 42). This Filled Bézier Pen tool is ideal for creating nonuniform shapes that are filled, rather than the wireframe shape we created earlier.

Using the same ideas discussed earlier (anchor points, Bézier handles, etc.), create a shape similar to that shown in Figure 43. This shape can also be altered with the Reshape button and Point tool (Figure 44).

Once the shape is satisfactory, you can give it thickness with the Extrude tool (Figure 45). To use the Extrude tool, simply click on the red bounding handle on the center of the object (Figure 46) and drag in the direction you wish to extrude the shape (Figure 47). When you release the mouse, you will see the extruded object (Figure 48). I find it easiest to do in an isometric view.

FIGURE 43 *Creating a new shape.*

FIGURE 42 *Filled Bézier Pen tool.*

FIGURE 44 *Reshape button and Point tool.*

FIGURE 45 *Extrude tool.*

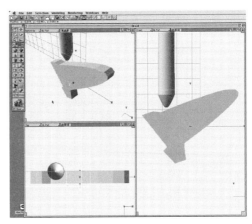

FIGURE 48 *Extruded object.*

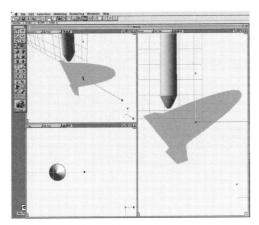

FIGURE 46 *Adding thickness.*

THE PLUSES AND MINUSES OF BOOLEAN MODELING

Strata has a broad though somewhat unreliable set of Boolean modeling tools. To create the inset piece of the ankle begun previously, we'll use Boolean modeling to cut out the hole in the middle, and simply set another thinner version in the center.

To begin, create a shape that you wish to use as the cutting shape. Think of this shape as a cookie cutter. I used the Filled Bézier Pen tool to create the shape I wanted to cut out of the original shape (Figure 49). Once the shape has been cut, I need to ex-

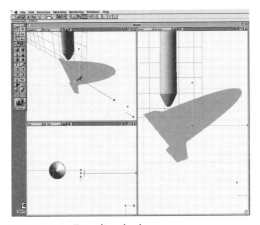

FIGURE 47 *Extruding the shape.*

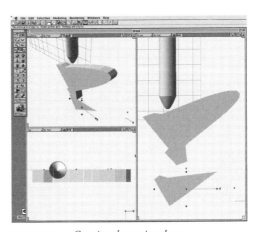

FIGURE 49 *Creating the cutting shape.*

tend its depth so that it is at least as great as the shape I am cutting through. To do this, I used the Extrude tool to give it a very large thickness (Figure 50).

Move the object doing the cutting so that it completely intersects with the object it will be cutting (Figure 51). Make sure that the cutting object completely comes out of both the front and back of the victim object; if you don't, you'll end up with the hole only going part way through. Once the object is aligned to where you want it to be, make a copy (Option-Drag with the Object Move tool) of the cutting object (Figure 52). We're doing this so that we'll have something to plug up the hole we create with an inset. Hide this copy by selecting it and

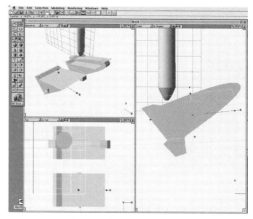

FIGURE 52 *Copying the object.*

pressing Command-5. This hides the object from view, but doesn't delete it.

Now that the stage is set (the object cutting is aligned with the object to be cut, etc.), make sure that you have the Extension palette visible. If it is not, press the Extension button at the top right-hand corner of the interface (Figure 53).

Now select the Subtract Extension tool from the Extension palette (Figure 54). To use this tool, first click on the object you want to use as the cutting piece (Figure 55), and drag to the object you wish to subtract the shape from (Figure 56). When you release the mouse, you should have an object that looks something like Figure 57.

To make an inset plug of this hole, press Command-6. This will reveal the copy of the cutting shape we made earlier. Use the Object Scale tool to shrink the depth of the object to be thinner than the newly created Boolean object, and move it into place in the center of the Boolean object (Figure 58).

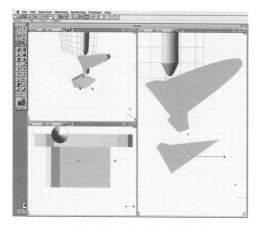

FIGURE 50 *Using Extrude tool to add thickness.*

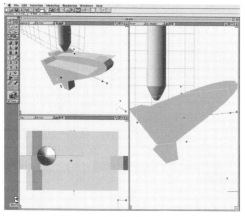

FIGURE 51 *Intersecting the objects.*

FIGURE 53 *Extension button.*

FIGURE 54 *Subtract tool.*

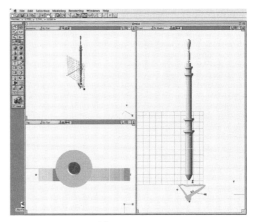

FIGURE 57 *New Object.*

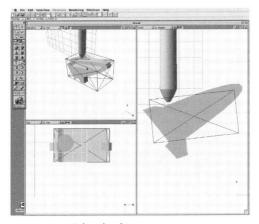

FIGURE 55 *Select the object.*

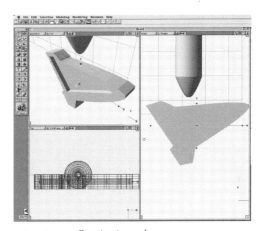

FIGURE 58 *Creating inset plug.*

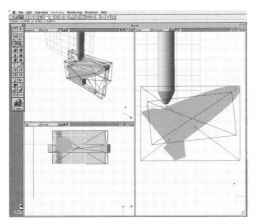

FIGURE 56 *Drag to object you wish to subtract from.*

ATTACHING PARTS TOGETHER

A nice touch to any droid is lots of miscellaneous bolts. Use the Cylinder tool to create lots of different shapes and lay them in as appropriate. My setup now looks like Figure 59.

To attach this ankle to what I have done on the leg, I made a cube with the Cube tool (Figures 60–61), flattened it (Figure 62), copied it (Figure 63), and grouped and rotated it (Figure 64) so that it appeared like a piece of metal on two sides of a pin, which I then added (Figure 65).

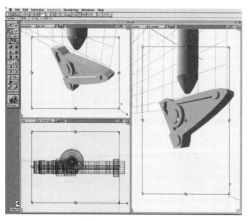

FIGURE 59 *Cylinder tool.*

FIGURE 60 *Cube tool.*

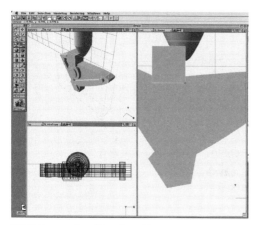

FIGURE 61 *Attaching the ankle.*

FIGURE 62 *Flattening the object.*

FIGURE 63 *Copying the object.*

FIGURE 64 *Grouped and rotated objects.*

FIGURE 65 *Adding the ankle joint.*

FIGURE 67 *Joining the shin and ankle.*

Now it's time to organize again. I grouped the newly created ankle joint, and then grouped the shin part of the leg. This way I can rotate the shin to match the appropriate angle (Figure 66). To complete the connection, I added a simple cylinder to join shin to ankle (Figure 67).

CREATING THE CALF

Creating the calf wasn't a matter of creating at all. Simply Option-drag (copy) the shin and then rotate it 180 degrees. Ungroup the new shin part and leave off the unneeded parts. Adjust the already extant parts into an appropriate position, and then group them again. Move the object into place, and stretch or squash it to an appropriate size (Figure 68).

Figures 69 and 70 show the creation of the top pieces of the calf/thigh section of the leg by creating a flattened cylinder and then using the Bézier Pen tool to create another lathed shape.

FIGURE 66 *Rotating the shin.*

FIGURE 68 *Sizing the object.*

FIGURE 69 *Creating the top of the calf and thigh.*

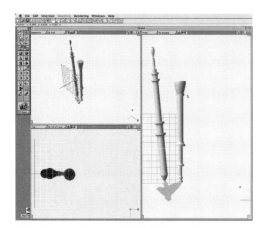

FIGURE 70 *Further calf and thigh creation.*

REPLICATE TO AVOID DUPLICATING EFFORT

On top of the thus far created calf is a shape with lots of smaller notches. This is a perfect job for the Replicate command. To do this, begin by creating one flattened cylinder, and then a flattened thin cube the size you need, and position it appropriately (Figure 71). It's important that these two objects are on the same depth axis. Select both, and use the Align command (Command-/) to align the depths (Figure 72).

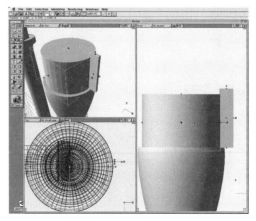

FIGURE 71 *Replicate command.*

Align Objects		
HORIZONTAL	VERTICAL	DEPTH
● No Change	● No Change	○ No Change
○ Right (+X)	○ Top (+Y)	○ Front (+Z)
○ Center	○ Center	● Center
○ Left (–X)	○ Bottom (–Y)	○ Back (–Z)

Cancel

OK

FIGURE 72 *Align objects command.*

Once aligned, make a copy of the flattened cube (Option-drag) and move it across the cylinder to the other side, and group it with the first. You may wish to align this group with the cylinder to confirm the center axis of the two squares is in line with the center of the cylinder.

To replicate the flattened squares, select them and then go to the Edit>Replicate pulldown menus (Figure 73). The resulting dialog box (Figure 74) allows for much freedom in where to place the replicated items. In this case, we don't want them to move, just rotate. Enter 30 for the degrees to rotate around the y-axis, and enter 5 in the Repetitions field (Figure 74). The resulting duplication is shown in Figure 75. After a replication, all the replicated objects (including the original) are selected. Take advantage of this by pressing Command-G to group them. Complete this joint with a series of cylinders as in Figure 76.

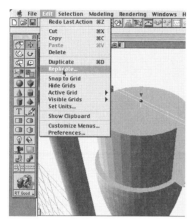

FIGURE 73 *Edit/Replicate menus.*

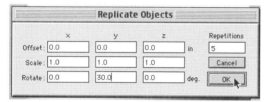

FIGURE 74 *Placement setting.*

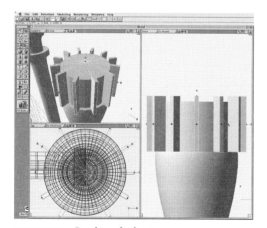

FIGURE 75 *Resulting duplication.*

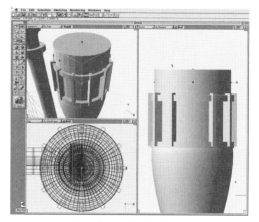

FIGURE 76 *Completing the cylinders.*

BÉZIER OBJECTS

To begin the butt of the droid, we need to create some flattened shapes that can't be found in the primitives shape. To do this, create a flattened cylinder with the round side facing front. Create a flattened cube above it.

We want this cube to be larger on the top than on the bottom. To do this, we must change the nature of the primitive to one that allows for the alteration of geometry. A Bézier shape will allow for just that.

To change a primitive to a Bézier object, select the primitive, and press the Convert... button on the Button palette (Figure 77). From the resulting dialog box, select Bézier Object and press OK. Now select the Reshape button from the Button palette.

Once in the Reshape mode, you can grab individual points on the object (which are now anchor points with Bézier handles) and rearrange them. Figure 78 shows the flattened-box-turned-Bézier-object altered by Option-marqueing around the top corners of the box to select all points in the area and

FIGURE 77 *Convert button.*

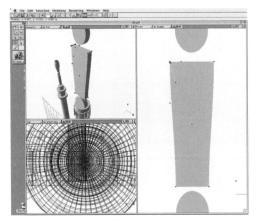

FIGURE 78 *Flattened box turned Bézier object.*

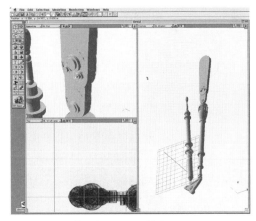

FIGURE 80 *Creating pegs and joints.*

then dragging outwards. Press the End Edit button to return to regular mode.

Once in regular mode, arrange flattened cylinders into place to create a new shape as shown in Figure 79. Duplicate and enlarge this new shape so it overlaps the original. Again, an easy detail touch is to add plenty of cylinders to create pegs and joints (Figure 80).

THE BEAUTY OF PRIMITIVES

Too often, we overdesign. Using all the tricks of the trade available to us, many 3D modelers make shapes far more complex than their computers like or is needed. Figure 81 shows the connection between the ankle and the foot built completely with primitives. Since this area of the model will never be looked at close up, it just makes sense to create a simple, yet representative shape that will convey all the information we need without adding unnecessary polygons.

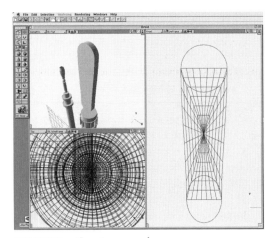

FIGURE 79 *Creating a new shape.*

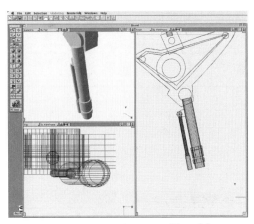

FIGURE 81 *Connection between ankle and foot.*

FEET CREATION

To create the foot, we'll go back to the trusty Filled Bézier Pen tool. Create the shape by placing anchor points and adjusting the Bézier handles to match Figure 82. Then with the Extrude tool, give it some thickness.

To create the outlining metal, instead of using the unreliable Boolean modeling functions, create it using the same Fill Bézier Pen tool, and trace the outline part of the foot you wish surrounded. Then (as part of the same filled path) trace the path a little wider to create the thickness. This filled path, upon extrusion, does what it needs to do (Figure 83).

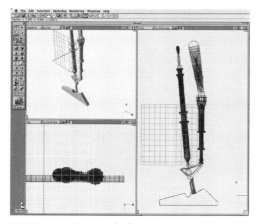

FIGURE 82 *Creating the foot.*

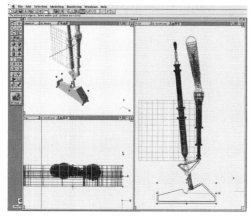

FIGURE 83 *Tracing the outline of the foot.*

The rest of the details on the foot are created with a series of cubes and cylinders rotated into positions to give the foot visual interest (Figure 84). Again, this may not be the most complex solution, but it's the most economical and quickest way to add visual complexity without an exuberant number of polygons.

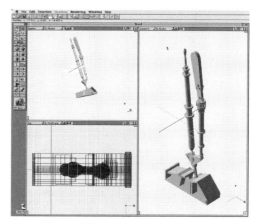

FIGURE 84 *Adding cubes and cylinders.*

SHOOTING FROM THE HIP

The hip joint incorporates many of the things already discussed. At the center of the hip joint where the leg joins the levered part, there is a flower-shaped gear. The basic shape of all the parts of this gear is a cylinder. Create the center part of the gear with simple cylinders as seen in Figure 85. Then, create the first of the "petal" parts of the flower shape with small cylinders as well. Be sure to make two of these "petals" and place them on either side of the gear.

With these petals selected, use the Replicate command with settings similar to Figure 86. This will create cylinders all the way around the center part of the flower.

To create the hip joint that the flower gear is attached to, simply make and group two flattened cylinders on the top and bottom of an elongated cube. Make sure to use the Object palette to ensure that they are all of the same thickness, and use the Align function to line them all up on the same y axis.

FIGURE 85 *Creating the center of the gear.*

FIGURE 87 *Final hip joint.*

FIGURE 86 *Replicate command settings.*

Once created, add the flower gear, and a few extra cylinders to the bottom and voilà, you have a great hip joint as seen in Figure 87.

Duplicate (Option-drag) the hip bone and place the two new hip bones in their appropriate location at the top of the thigh already created (Figure 88).

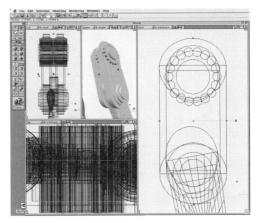

FIGURE 88 *Duplicating and placing the hip bones.*

For the leveraged part of the hip, I chose to simply create the entire object with the Filled Bézier Pen tool, and then extrude the shape. I often find that circumventing Boolean modeling saves lots of time. This newly drawn shape can be extruded, and all's well (Figure 89).

We're getting close to finishing the leg here, so hang on. Figure 90 shows another quick use of primitives (namely cylinders and cubes) to make a part of the model. You'll also notice an extra piece of geometry between the hip bones to add mass to where the hip connects to the leverage joint. This, of course, was built using the trusty Filled Bézier Pen tool/Extrusion combination.

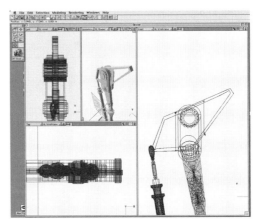

FIGURE 89 *Newly drawn shape.*

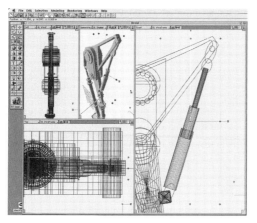

FIGURE 90 *Another use of primitives.*

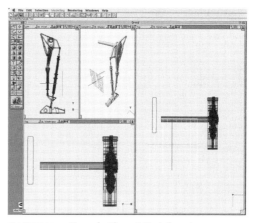

FIGURE 92 *Extrude Along A Path function*

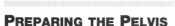

PREPARING THE PELVIS

Now that the leg is done (whew!), we can begin on the pelvic area. I began by placing the post that will connect the two legs. This is a simple cylinder, and the size isn't too terribly important as it will undoubtedly be altered later (Figure 91).

I used the Rounded Rectangle tool (the filled version) to create the cross-section of what will become the upside down ŒU1 part of the pelvis. Draw it from the top view, as we'll be using the Extrude Along A Path function to create this shape, and we need the shape to begin parallel to the ground (Figure 92).

Now, looking at the model from the front, use the Bézier Pen tool to create the path you wish the newly created Rounded Rectangle to follow (Figure 93). Choose the Path Extrude extension from the Extension palette (Figure 94). To use this tool, click on the object you wish to extrude (Figure 95) and drag to the path you wish to extrude it along (Figure 96). The result should look something like Figure 97.

Create the insulation within the pelvic shape with two slightly different-sized flattened cubes grouped together (Figure 98). Find the width of the combined shapes in the Object palette (Figure 99), and enter that in the x field of the Replicate dialog box (Figure 100). Use a negative value to make the

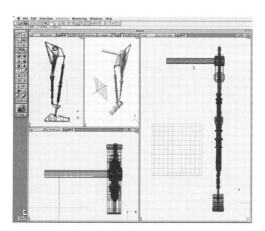

FIGURE 91 *Simple cylinder.*

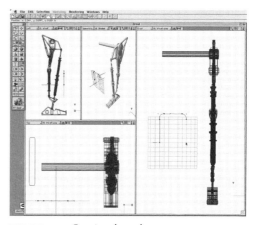

FIGURE 93 *Creating the path.*

FIGURE 94 *Path Extrude.*

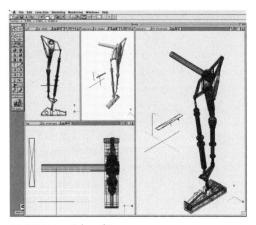

FIGURE 95 *Select object.*

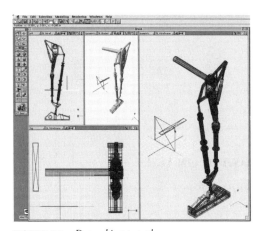

FIGURE 96 *Drag object to path.*

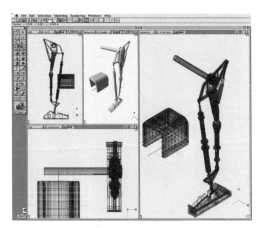

FIGURE 97 *Results.*

FIGURE 98 *Creating the insulation.*

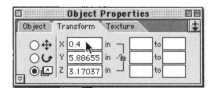

FIGURE 99 *Object widths.*

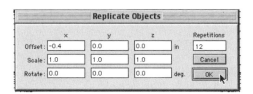

FIGURE 100 *Replicate Object settings.*

replications move to the left. The result should appear as shown in Figure 101; make sure to group (Command-G) them all while they are selected. The model should appear much like Figure 102.

the leg. By clicking on the inside of the leg, SSP will tell me it understands which panel of which object by highlighting it (Figure 104). When you release the button, you'll have a mirrored copy that you can move into position. Remember this tool, as it become tremendously powerful when working on symmetrical objects such as droids or humans.

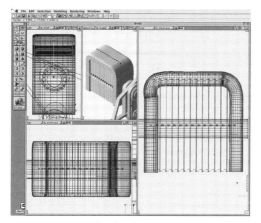

FIGURE 101 *Results of replication.*

FIGURE 103 *Mirror function.*

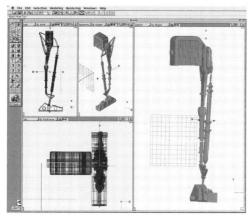

FIGURE 102 *Model.*

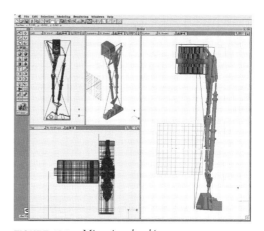

FIGURE 104 *Mirroring the object.*

MIRROR, MIRROR . . .

Now it's time to explore SSP's nifty Mirror function. To use the Mirror function, simply select the extension from the Extensions palette (Figure 103), and click on the side of your object that you wish to mirror. In this case, I want to mirror along the inside of

MOVING ON UP!

The beginning of the torso is created with simple cylinders. Again, the idea is to keep the poly count as low as possible, so primitives are the way to go. The apparent geometry you see in the torso section of the

final rendering was created with textures. If geometry can be defined with a texture, especially in areas that will never be focused on, do it—your computer will thank you.

For the rib section of the droid, we must move away from the simplicity of unaltered primitives into Bézier Surfaces. However, still begin by creating a cube with the Cube tool (Figure 105). Immediately after creating the cube, use the Convert Shape tool to convert the primitive cube to a Bézier Surface (Figure 106). Click the Edit Shape button, and alter the anchor points and Bézier handles as shown in Figures 107 through 115. When you are finished altering the square to give a more rounded organic shape, click the End Edit button to return to the regular set of tools.

FIGURE 107 *Altering the anchor points and Bézier handles.*

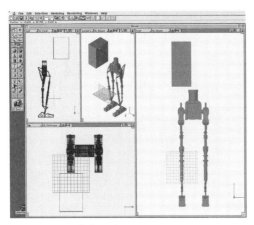

FIGURE 105 *Cube tool.*

FIGURE 108 *Continued . . .*

FIGURE 106 *Convert shape/Bézier Surface.*

FIGURE 109 *Continued . . .*

FIGURE 110　*Continued . . .*

FIGURE 111　*Continued . . .*

FIGURE 112　*Continued . . .*

FIGURE 113　*Continued . . .*

FIGURE 114　*Continued . . .*

FIGURE 115　*End.*

Since there are two identical symmetrical rib sections, use the Mirror Extension to mirror the shape and arrange them to look much like Figure 116. Don't worry about their exact placement here, or even their size. Bézier shapes can be altered at any point later on.

FIGURE 116　*Mirroring the rib section.*

SHOULDERS AND ABOVE

For the shoulder section of the droid, I used the Filled Bézier Pen tool to draw the basic outline (Figure 117). After extruding the shape, I converted it to a Bézier Surface and edited it to look like Figure 118.

FIGURE 118　*Converted and edited shape.*

Figure 119 shows the shoulder mirrored and then altered in size to appropriately fit the rib section.

The hole left in the middle of the torso is filled using the good old two –cylinders-and-a-cube trick, with extra trim built with long flattened cubes (Figure 120).

The extra trim across the bottom of the "stomach" section was built using Boolean modeling. Make a copy of the stomach section so that you have an exact template of the edge of the space needed to fill (Figure 121). Now, ungroup the stomach section and separate away the bottom cylinder. Position a new larger cylinder over the top of the original cylinder (Figure 122), making sure that the original (that

FIGURE 117　*Drawing basic outline of shoulder section.*

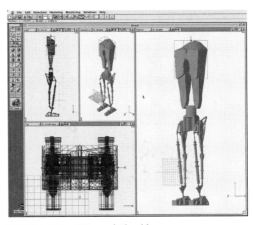

FIGURE 119　*Mirrored Shoulder.*

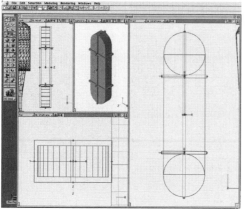

FIGURE 120 *Filled hole.*

is going to act as the cutting piece) is deeper than the new cylinder. Using the Subtract Extension from the Extension palette, first select the smaller original cylinder, and drag to the larger new cylinder. The resulting hollow tube is shown in Figure 123.

Since we only need the bottom half of the tube, create a cube that is at least half the height of the tube (Figure 124). Using this cube and the Subtract Extension, you can cut away half of the tube, leaving a trough-like shape shown in Figure 125. Position it appropriately and onto the arms.

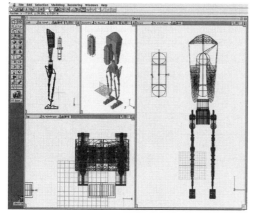

FIGURE 121 *Copying stomach section.*

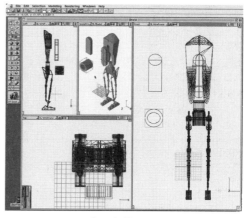

FIGURE 123 *Resulting hollow tube.*

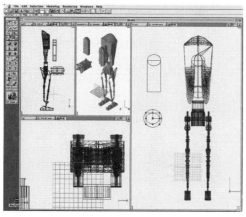

FIGURE 122 *Placing new cylinder.*

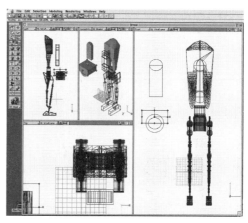

FIGURE 124 *Creating new cube.*

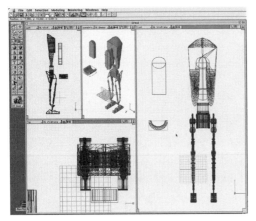

FIGURE 125 *Trough-like shape.*

FIGURE 127 *Continued . . .*

THE ARMS

Figures 126 through 129 illustrate the now familiar Bézier Fill tool creating an outline, extruding that outline, converting that extruded shape to a Bézier Surface, and altering that surface. The only difference is the use of the Bézier Scale tool (Figure 130) to pull the corners of the square in together at a uniform rate.

Mirror and alter this newly created arm beginning and butt it up against the original. The resulting shape (Figure 131) can be further jazzed up with more cylinders (Figure 132). The upper arm was extended entirely using primitives, as shown in Figure 133.

FIGURE 128 *Continued . . .*

FIGURE 126 *Creating the arms with Bézier Fill tool . . .*

FIGURE 129 *Continued . . .*

FIGURE 130 *Bézier Scale tool.*

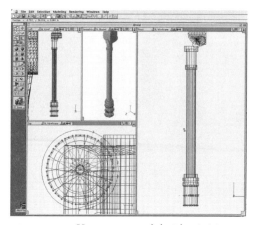

FIGURE 133 *Upper arm extended with primitives.*

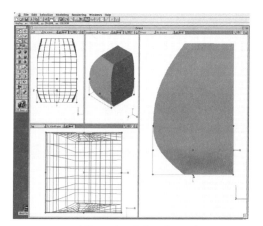

FIGURE 131 *Mirrored and altered arm shape.*

SOME ELBOW ROOM

For the elbows, begin by creating a basic shape like Figure 134. Then, using the Fill Bézier Pen tool, create a border around the entire shape (Figure 135). Extrude this border and it creates a nice lip to the part. Figure 136 shows the lipped part duplicated, adjusted for size, and then grouped to create the top part of the elbow. A duplicate of that elbow was then created with some added cylinders and cubes to complete the elbow construction.

Continue down the forearm with necessary cylinders, with a cone for the wrist (Figure 137). I created

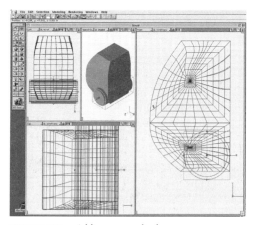

FIGURE 132 *Adding more cylinders.*

FIGURE 134 *Creating the elbow.*

FIGURE 135 *Creating a border.*

FIGURE 136 *Lipped part duplicated.*

FIGURE 137 *Adding more cylinders and a cone for the wrist.*

the hands with extruded filled Bézier regions, and then grouped the hodge-podge together after altering the Bézier shapes (Figure 138). Mirror the arms, and place them where they ought to be on the shoulders.

FIGURE 138 *Mirroring and placing the arms.*

NOW FOR THE HEAD

Creating shapes like the head can be done in several ways. One is using the Skin Extension from the Extensions palette to join a series of Bézier regions created by the Bézier Pen tool (see Figures 139–150). The intricacies of this technique require a different

FIGURE 139 *Creating the head with the skin extension and joining a series of Bézier regions . . .*

FIGURE 140 *Continued . . .*

FIGURE 143 *Continued . . .*

FIGURE 141 *Continued . . .*

FIGURE 144 *Continued . . .*

FIGURE 142 *Continued . . .*

FIGURE 145 *Continued . . .*

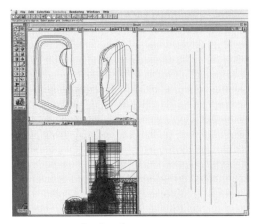

FIGURE 146 *Continued . . .*

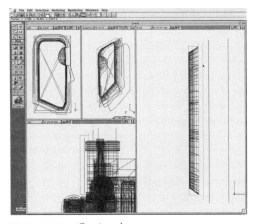

FIGURE 147 *Continued . . .*

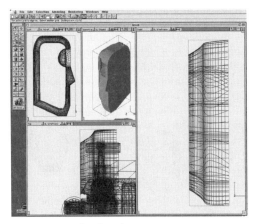

FIGURE 148 *Continued . . .*

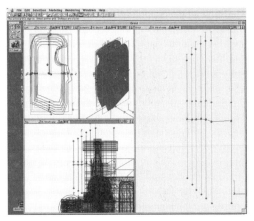

FIGURE 149 *Continued . . .*

FIGURE 150 *Final head.*

sort of thinking, which could take an entire tutorial in itself to explain. So, if you have a burning desire to do it, use the illustrations listed to try it out; otherwise, try modeling the head the second way.

I chose to model the head by first creating a rounded cube with the Rounded Cube tool, and altering it as a Bézier Surface (Figure 151). Then, with the Subtract Extension, I subtracted an elongated sphere to create the eye sockets (Figures 152–153).

The nose was created using a similar process of creating a base shape (in this case, a cube), then subtracting away (with other cubes) the parts I didn't need (Figures 154–157), and then laying the nose into the head. To create the jaw line, I simply subtracted a

FIGURE 151 *Modeling the head.*

FIGURE 154 *Creating the nose . . .*

FIGURE 152 *Creating the eye sockets.*

FIGURE 155 *Continued . . .*

FIGURE 153 *Continued.*

FIGURE 156 *Continued . . .*

FIGURE 157 *The nose.*

FIGURE 159 *Basic head model.*

FIGURE 158 *Creating the jaw line.*

tive head shown in Figure 159. The neck was a simple cylinder from the shoulder to the head.

THE RENDER

This droid is supposed to be made of a high-melting-point off-white material (kevlex, if it matters to you). Because of the terrible conditions within the smelting rooms, they are rarely joined or maintained much by any human counterpart. The result is a dull and dented shell. Creating down-and-dirty textures is the topic of another tutorial, but experiment with something that gives you the feel you need.

The renders shown in Figures 160 and 161 were created using lots of spotlights in colors of amber, red, and yellow set behind the droid with a soft yellow fill light coming from above. The mounds of parts behind him are simple cannibalized parts of the droid model we just created.

Play with these ideas to make your droid more frightening, or more comical. Bézier modeling has all sorts of power, and you can alter that head to be as sinister, or as friendly, as you wish.

cube from the geometry of the head (Figure 158). After laying in a couple of spheres for the eyeballs, placing all the facial features where I wanted them, and then resizing the whole lot, I got a basic but effec-

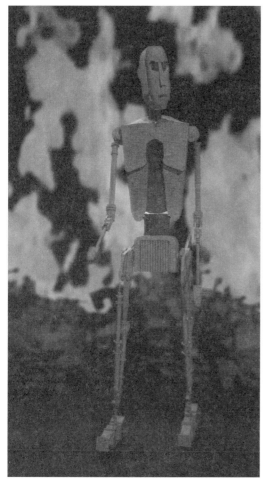

FIGURE 160

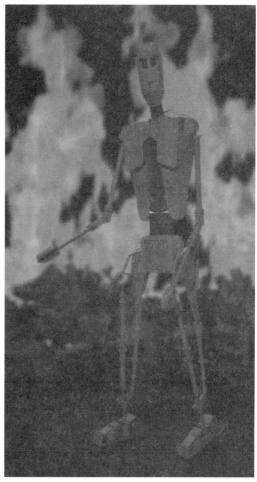

FIGURE 161

Rendered versions with spotlights in colors of amber, red, and yellow.

38

Creating Realistic Ocean Water with trueSpace

BY NICK ROBALIK

THIS TUTORIAL REQUIRES:

trueSpace 4.X, Lightning Software's *Wave Generator* http://www.kinneret.co.il/lgsoft/ —demo available;

Frank Ramsays' *Perlin and Crumple Noise shaders* http://fjramsay.simplenet.com —free download;

Yamenko Studios *Noise shader* http://www.kt.rim .or.jp/~yneko/ —free download.

FIGURE 1 *What we'll learn to create in this tutorial.*

O ne of the hardest effects to create in CG is realistic-looking water. This is a failing in many 3D animations, where something is just "off," but you can't pick out exactly what it is. This tutorial will help you discover exactly what it is, how to avoid it, and how to make the most realistic water possible using trueSpace4.x. Creating realistic water is more than just creating a plane and slapping a picture of water on it; it's a combination of realistic color, transparency, reflectance, and bump mapping. It is the combination of all of these elements (and throw in a bit of vertex animation) that gives us a realistic CG representation of an extremely complicated natural phenomenon called "water" (see Figure 1).

AND THEN HE CREATED WATER— THE BEGINNINGS OF OUR OCEAN

First things first: Let's create a 32×32 plane, from which we'll create our water. Scale it up to about 500 ×500meters (I know, that's really, really big—it's an ocean, after all) so we have a nice big ocean that goes all the way to the horizon. You may still see the edges of the plane, but don't worry about it; we'll be hiding them later using a few clever tricks I've learned in my quest for realistic water.

So, now we have our ocean. Pretty flat, isn't it? Well, that's because we need to add a bit of variation

to the surface. If we were just creating a still image, we could manually go in and, using the object deformation tools, deform the plane as we see fit. What if we wanted this ocean in an animated sequence? Can you imagine trying to animate this plane for even 10 seconds? That would be nearly impossible, especially if we were trying to create realistic movement. Fortunately, we've been given the tools we need to create realistic, believable movement: a plug-in called Wave Generator, created by our friends at Lightning Software. Using this plug-in, we can create what was not possible before; namely, realistic, believable movement for rolling waves, pond ripples, anything that has to do with water. We'll use the available wave types shown in Figure 2 to create enough variation on the plane to give the appearance of rolling ocean waves.

Left-click the 3D plug-ins icon in trueSpace to bring up the plug-ins panel (shown in Figure 3).

Left-click one of the empty plug-in slots, and then navigate to the directory where you have the Wave Generator plug-in installed. Select the file and then click OPEN (see Figure 4).

FIGURE 4 *The plug-in should be named LsWave.tsx.*

The plug-in is now installed into the empty plug-ins slot. *Left-click* the plug-in icon. Here we see the different wave types available (refer to Figure 2 for a graphical representation). Select the *Circular Wave* type, then click PREVIEW. Here we see one frame of the animation sequence that we would create if we clicked APPLY (see Figure 5).

Well, what if we wanted to preview the entire animation before applying the animation permanently to the object? That's simple: Click the *Parameters* tab and turn the *Preview* option on, and the *Default Preview Frame*. Using the arrows, you can now preview every frame in the animation! This is a handy little feature to see how high the waves peak, something not possible using just the default frame.

While we're here, let's set up the parameters we'll need to generate the waves. Set the *Amplitude* to 0.5. This is high enough for us to see the effects of the plug-in without being too drastic and creating unrealistic results. Set the *Frequency* to 16; this will make

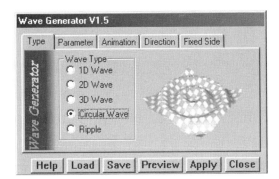

FIGURE 2 *The different wave types available in Wave Generator by Lightning Software.*

FIGURE 3 *The 3D plug-ins icon.*

FIGURE 5 *This is what we get previewing the Circular Wave type.*

the waves come more often. We'll leave the *Velocity* at 2, as we don't want the waves moving too quickly. The velocity is measured in units per second, so if you're in meters, the waves would appear to move 2 meters a second.

Click the *ANIMATION* tab and set the *Animation Duration* to last until frame 60 (see Figure 6).

Click the *KEYFRAMe REDUCTION* button (Auto KFR), which will set the keyframes to every 7 frames. This will cut down on the time trueSpace needs to update between frames, as it does not have a keyframe set for every vertex for every frame. Next, click the *DIRECTION* tab. Here we see a bulls-eye-style window on the left (see Figure 7).

This lets us visually set the center of the wave, which is good because we don't want the wave to start in the middle of the plane, and setting the hotspot manually would be a bit of a pain. Click on the upper left-hand corner to set the hotspot, and

then click APPLY. Processing the plane can take a bit of time because of the number of vertees on the plane. After it's done processing, place the hotspot near the upper right-hand corner of the box, but not exactly in the corner. We're doing this so the waves don't look too regular. Repeat this process for the remaining two corners. As in the ocean, we want our waves to appear to be coming from every direction. If we were near the shore, the waves would appear to come from one direction, but since we're sitting in the middle of the ocean, we just want a nice basic wave motion coming from every direction.

After you've applied all of the waves, look at the result. If you think the waves look too high or too low, you can correct this by scaling the plane down on the Z-axis. Make sure you're doing this at frame zero so it applies the scaling to the whole animation (see Figure 8).

FIGURE 6 *The Animation tab.*

FIGURE 8 *After we've applied the wave settings.*

FIGURE 7 *The Direction tab.*

SURFACING THE WAVES

Now that we have the perfect waves, we need to start working on surfacing them realistically. We could use an image as a texture, but that may end up appearing too blurry and pixelated (see Figure 9). Also, if we increase the tiling to lessen the blur and pixelation, the tiling will become too obvious (see Figure 10).

So, what's the solution? *Procedural texturing* is what we need. Procedural textures are mathe-

FIGURE 9 *Nasty bitmap pixelation.*

FIGURE 10 *The effects of tiling.*

matically calculated fractal images that are generated by the shader at render time, and can be used to surface anything from water to rock, and I've even seen procedural images of circuit boards and eyes (see Figure 11).

What this means to us is that we can have an unlimited resolution, untiling texture with fully keyframeable parameters for detail, noise, velocity (speed of movement) and color. The best part: Procedural shaders are available in tS!

tS ships with some procedural shaders you are probably familiar with—simple wood, marble, solid polka, and solid clouds are some. You can use a procedural shader in any of the four available shader categories: color, bump, reflectance, and transparency.

FIGURE 11 *Procedural dilating eye generated with the DarkTree Simbiont shader in tS.*

Unfortunately, the shaders that will help us don't ship with tS—but they *are* available for tS, and they're free! The shaders we're going to use to create the ocean surface are *Yamenko Noise*, and Frank Ramsays' *Crumple* and *Perlin Noise* shaders. The *Yamenko Noise* shader is available at http://www.kt.rim.or.jp/~yneko/Software/index-e.html along with some of his other free shaders you may be interested in, and Frank's shaders are available at http://fjramsay.simplenet.com. If you've purchased the *pluSpack 2* CD from Caligari (http://www.caligari.com), they're included on the CD. Once you've downloaded the shaders (don't worry, they're small), continue on to the next section.

SHADER SETTINGS

After some research (living by the ocean comes in handy), there are a few things I've noted, one of which is that ocean water does *not* have an even color. There are slight variations all over the surface of the water, and it's emulating these slight "imperfections" that lend to creating the realism we're looking for. These imperfections are also contained in the reflectance and the transparency, caused by dust, dirt, and algae in the water. There is also variation in the ripples on the surface due to the different depths of the water. Now, in the center of the ocean, this isn't nearly as evident as it would be on a lakes' surface, but it's something we should still take into account. To create this effect, we'll combine two different procedural bump shaders, the *Perlin Noise* and the *Crumple* shaders.

BUMP SETTINGS

Left-click on the *Displacement* shader sphere in the *Shader Settings* palette, and select the *Layered Bump* shader. On the bottom-most shader layer, apply the *Crumple* shader (*left-click* the box). We'll be layering the *Perlin Noise* shader on top of the *Crumple* shader, so we'll need to compensate for this by increasing the height of the bump. Set the *Height* to 1.75. This will give us a nice wave crest effect on the plane, and also will help the shader's effect on the plane be visible through the *Perlin Noise*. Select the second shader layer, and apply the *Perlin Noise* shader. Increase the *Turbulence* to 8, which will increase the noise introduced into the fractal pattern to break it up more. Then change the *Blend* to 12, which will ease the transition between the two different noise surfaces in the shader. Change the *Frequency* to 7 on all axes, which lowers the scale of the noise, which we need to do as we have such a big plane for the ocean. Now as we're just using the *Perlin Noise* to break up the displacement created by the *Crumple* shader, we want to decrease the Opacity of the *Perlin Noise* shader, so set the *Transparency* to 75%. This will let most of the *Crumple* shader show through. We're animating the waves, so we want the surface of the water to move with the waves. In *Crumple* shader settings, set the *Velocity* on the X-axis to .5, set it to 3 on the Y-axis, and leave Z at 0. This should make for a nice, subtle wave surface movement (see Figure 12).

COLOR SETTINGS

Earlier in this tutorial, I mentioned that water does not have an even surface color. Here's where we'll put that idea into practice. Load the *Perlin Noise* shader in the *Color* shader. You'll notice it already has the same settings as the *Perlin Noise Displacement* shader. This happens because both shaders use the same settings no matter which shader they are being used in. In this particular situation, it works perfectly for what we're trying to accomplish.

Select *Color 1* on the *Perlin Noise* shader panel (*right-click* the *Color* shader sphere to get this). A window will pop up with a color palette in it. We don't want to use any of the stock colors, so click the *Define Custom Colors* button near the bottom. Another panel will show up on the right-hand side of the window with a color gradients box and text input boxes. This will let us create our custom color. You'll see that the text input boxes let us numerically define the color, which is what we want to do. Set the *Red* to 0, the *Green* to 20 and the *Blue* to 140. This will give us a nice blue-green surface color for the water.

Select *Color 2*. Again, we want to define our own custom color, so click the *Define Custom Colors* button. Set the *Red* to 0, the *Green* to 60, and the *Blue* to 165. The settings aren't very different from Color 1, but they will give us the slight difference we need (see Figure 13).

FIGURE 12 *What we have after we apply the displacement settings.*

FIGURE 13 *After the Color shader is applied.*

TRANSPARENCY SETTINGS

Let's add a bit of transparency. This will help the waves in the distance blend together, and the waves closer to the camera will stand out without appearing to have a hard edge. For this, we'll use the *Yamenko Noise* shader, which will allow us to apply a fractal-based transparency separate from the *Perlin Noise* shader. Load the *Yamenko Noise* shader into your *Transparency* shader, then *right-click* on the transparency sphere in your shader settings panel. Whoa! Lots of options. Luckily for us, most don't apply to the *Transparency* shader, so you can ignore most of the bottom section until we get to the reflectance settings.

First, change the *Noise Type* to 1/f. This will give us control over the *Turbulence* setting. Change the *Turbulence* setting to 3.8, which gives us just a bit more noise in the transparency. Set the *Opacity* of *Material 1* to .95, and the *Opacity* of *Material 2* to .98. It may not seem like much, but it's just enough to give us the blending that we need to do the job right (see Figure 14).

FIGURE 14 *After the Transparency shader is applied.*

REFLECTANCE SETTINGS

Reflectance is the key to making realistic water. We could have the perfect settings for Color, Displace-

ment, and Transparency but the water would still not be convincing if it did not reflect properly. For the Reflectance, we'll use the *Yamenko Noise* shader. I've come up with these settings after playing with trueSpace for quite a while, and I'm going to share them with all of you loyal trueSpace users out there.

Load the *Yamenko Noise* shader into the *Reflectance* shader, then *right-click* on the *Reflectance* shader sphere. This is where we get to play with all of those settings in the bottom section of the shader panel. Just like the *Color* shader where we used the *Perlin Noise* shader to create some variation in surface color, we'll use the *Yamenko Noise* shader to give the water slightly uneven surface reflectivity. A slight difference will be enough, as you'll see once we've applied the settings. Under *Material 1*, set the *Diffuse* to .40. This will help blur the highlights on the water so they do not appear too sharp. Put the *Shininess* to .90, and the *Roughness* to 1. This will create the highlights on the water's surface. Set the *Mirror* to .76. Water is extremely reflective, which gives it the bluish quality—it's reflecting the sky. We don't have a real sky for the water to reflect, which is why we made it blue in the *Color* shader. Under *Material 2*, set the *Diffuse* to .5, the *Shininess* to 1, and the *Roughness* to .9 (see Figure 15).

FIGURE 15 *After the Reflectance shader has been applied. Notice that the ball is being reflected realistically off the surface.*

SUMMARY

We've just achieved some of the most realistic water possible using trueSpace! This takes quite a bit of time to render, as you have to have *raytracing* turned on for the water to reflect properly. If you wanted to put a sky in the image, you can do this using the *Background* shader. As the water now has some sky to reflect, you can decrease the color saturation by taking down the colors in the *Color* shader more toward a black so the water doesn't appear unrealistically blue. Also, make sure you have *Triangulation* turned on by *right-clicking* the *RAYTRACE* button, as trueSpace has the nasty habit of leaving holes in an object's surface if it isn't on.

I've taken great care in these settings, and I've found a good balance between realism and speed, so that even though this may take some time to render on your machine, it will be well worth the wait.

39

Vic Disco—A Study in trueSpace Visual Effects

DARREN L. WASCHOW

This tutorial explains some of the visual effects that can be seen in the short animation Vic Disco, Caligari's July 1999 animation award winner. The video was conceived as an experiment designed to illustrate how special visual effects can be used to create an interesting and entertaining piece of animation without having to include complex character animation or complicated camera moves. Instead, most of the action in the short is nothing more than moving lights and pyrotechnics. All of the footage was created using Caligari's trueSpace (version 4.2) and various plug-ins and custom shaders that are readily available on Caligari's PlusPack2 CD (www.caligari.com). Audio and video editing was done using Ulead's MediaStudio Pro (version 5.2) (www.ulead.com).

I recommend that you download and view the short animation in order to follow the discussions.

THE TOOLS

All of the footage used to create the Vic Disco short was created using Caligari's trueSpace. trueSpace is an excellent 3D modeling and animation application for PCs. It has many of the features that are included in high-end 3D packages (including custom shaders and volumetrics, which we'll be discussing later), and has a price that makes it an excellent choice for beginners who are just entering the 3D graphics market.

In addition to trueSpace's built-in tools, three additional tools were used in order to achieve some of the effects. One of them, a plug-in, was Primal Particles by Primitive Itch (www.primitiveitch.com). The other two were custom shaders: SphereGlow from Windmill-Fraser Multimedia (www.wfmm.com) (the site is temporarily down, though I'm assured that it will be up again soon), and Frank Ramsay's Perlin Noise shader (http://fjramsay.simplenet.com/). The two shaders are free and can be downloaded from their respective Websites. Primal Particles is a commercial plugin that can be purchased from Primitive Itch for $35 (the price at the time of this writing).

Once all of the shots were rendered out of trueSpace, video and audio editing was done using Ulead's MediaStudio Pro. A non-linear editing program similar to Adobe Premiere, MediaStudio provides an excellent interface and powerful features that make it easy to produce impressive video projects.

LIGHT ON RED SILK—THE OPENING TITLE

The "I Love Lucy-esque" opening to Vic Disco was accomplished using tools from both trueSpace and MediaStudio.

THE trueSPACE SCENE

Figure 1 shows all of the trueSpace objects that were used to create the red silk background and the word "Light" in the shot. The animated output from trueSpace would later be used as the background for the frames in MediaStudio.

The red silk fabric was created by subdividing a trueSpace plane primitive until it could be deformed easily using the Sculpt Surface tool (Figure 2). The plane was molded until it looked good, and then the Triangulate Object tool (Figure 3) was applied. This was done in order to smooth the mesh even further and eliminate the possibility of any non-planar faces that might cause problems with the rendered output.

FIGURE 1 *trueSpace objects.*

FIGURE 2 *Sculpt Surface tool.*

FIGURE 3 *Triangulate Object tool.*

The word "Light" was then projected onto the fabric using a Projector Light. The inlay in Figure 1 shows the bitmap that was projected.

The trueSpace scene was rendered out as an AVI file to be used as a background in the next step.

THE HANDWRITING EFFECT SCENE

MediaStudio (and many other video editing packages) provide a tool for performing a Chromakey or "Blue Screen" operation. By making certain colors of a graphic transparent, an underlying graphic can be made to show through. After a frame was created showing the words "An Evening of" and "Music" in their complete state, the words were covered completely with a blue color to make them completely invisible, thus letting the silk background that was rendered in trueSpace show through. Then, using an animated eraser in MediaStudio, the blue covering the letters was removed a little at a time, slowly revealing the letters. Figure 4 shows the blue being removed from the text.

FIGURE 4 *Removing the blue from the text.*

SPARKS

Sparks were used twice in the animation; once exploding out of the Victrola's horn and then, seconds later, flying from the needle. In both cases, the sparks were nothing more than tiny sphere primitives painted with SphereGlow as both its color and its transparency shader. Figure 5 shows the SphereGlow

FIGURE 5 *Sphere Glow settings.*

settings used. Both the explosion out of the horn and the steady stream from the needle were created using Primal Particles.

EXPLOSION FROM THE HORN

In order to easily align the trajectory of the sparks that were to fly out of the Victrola's horn, Primal Particles used a particle emitter object to set the initial positions and movement direction of the spark objects. The emitter was nothing more than the top two sets of faces that had been removed from a sphere primitive (Figure 6). When a particle emitter is used by Primal Particles, the particles' starting points are distributed across the surface of the emitter at its vertices.

Figure 7 shows the Primal Particles flow settings that were used to create the burst of sparks out of the horn. The particles were also given a Floor interactor

FIGURE 7 *Primal Particles flow settings.*

that was set to the same Z elevation as the dance floor. By giving the Floor interactor a setting of Elastic, the sparks bounced as they hit the floor.

STREAMING OFF THE NEEDLE

Figure 8 shows the Primal Particles settings for the even flow of sparks coming from the needle. There was no Gravity interactor defined and the trajectory of the needle sparks were angled upward. This caused them to travel in a straight line and not arc down as the result of gravitational pull.

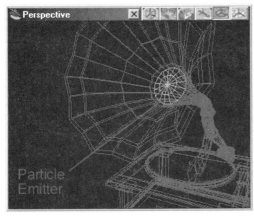

FIGURE 6 *Particle emitter.*

FIGURE 8 *Primal Particles Settings for even flow of sparks.*

THE SPINNING RAINBOW

Of all the effects in Vic Disco, the one that has pro-voked the most questions has been the spinning rainbow in the horn of the Victrola. Many people have speculated that an animated texture was used. Others have guessed that the effect was added in post-production using an overlay. Figure 9 shows that the rainbow was created by placing a projector light directly in front of the horn and then rotating the light throughout the animation. The inlay in Figure 9 shows the bitmap that was projected. Figure 10 shows the Light Properties Panel for the projector light. Notice that the light is set to cast shadows, and that the Project property is set to the name of the projected bitmap.

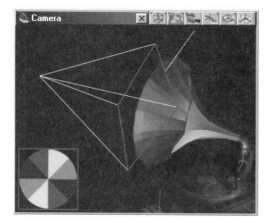

FIGURE 9 *Creating the rainbow.*

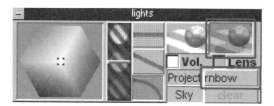

FIGURE 10 *Light Properties Panel.*

THE SPINNING PINWHEEL LIGHTS

The wildly rotating colored lights were another sim-ple yet effective effect. By gluing eight spotlights to-gether, each with its own color, the first part of the

mechanism was completed. However, in order to have the lights spin on two different axes at two dif-ferent rates of speed, an extra step was required. A sphere was created around the lights and painted with 100% transparency (invisible), and set to nei-ther cast nor receive shadows (Figure 11). The light object was then glued as child to the sphere. By doing this, the lights could be animated to rotate around one axis while the sphere rotated around a different axis. And as the lights were glued to the sphere, they would rotate along with it. Figure 12 shows the configuration and rotation axes for the pinwheel lights.

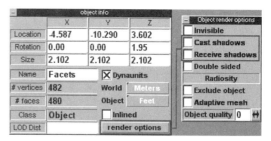

FIGURE 11 *Sphere created around the lights.*

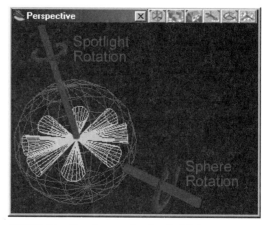

FIGURE 12 *Rotation axes for pinwheel lights.*

THE MIRROR BALL

Due to the limitations of most 3D render engines, light reflected off the surface of a mirror will not act exactly like it would in the real world. Because of

this, the light in a 3D application would not, when reflected off a mirror ball, show beams of volumetric light in the smoky air or reflect the tiny spots of light on the floor. In order to get both of these effects, a mirror ball had to be constructed that could fake these effects.

BUILDING THE BALL

Because we could not use reflections off the facets of the disco ball to create the effects we wanted, it was necessary to create the light inside the ball and project it outward. To accomplish this, a series of 215 separate spotlights, each set to a tight beam, were glued together to create a Spotlight Cluster. Figure 13 shows one of the subsets of lights that was used to create the Spotlight Cluster. The cluster was then placed inside the mirror ball and glued as child to the ball so that the lights would rotate along with the ball. The ball itself was painted with a silver material and set to render facets. Also, the Cast Shadows property of the ball object was disabled in order to let the light cluster project beams through its surface. Finally, a spotlight was placed outside the ball in order to illuminate the facets. Figure 14 shows each of the components of the mirror ball.

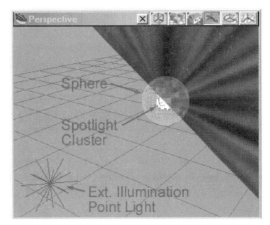

FIGURE 14 *Components of mirror ball.*

VOLUMETRICS

In order to produce the beams of light through the smoky atmosphere, trueSpace's volumetrics was used. Figure 15 shows the settings that were used in the Vic Disco scene. In order for volumetric effects to render properly, Raytracing must be enabled and the Volumetric foreground shader must be set and configured by right-clicking on the Volumetric button. Figure 16 shows the settings that were used.

Because of the large number of lights in the scene, it would have been extremely time-consuming to render the entire scene with volumetrics turned on. To get around this issue, the disco ball was rendered in a scene separately and then laid into the rest of the shot using MediaStudio. The exact same camera path was used in both the mirror ball scene and the master scene, so that when the two were combined it appeared that all of the objects were in the same scene.

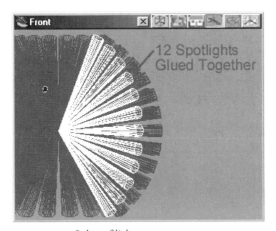

FIGURE 13 *Subset of lights.*

scene render options		
High	RayCast	Adaptive
Quality	Visibility	AntiAlias
Raytrace	Foreground	Volumetric
Postprocess	Background	Color

FIGURE 15 *Settings for Vic Disco scene.*

Volumetric options		
Fog density	0.2	↔
Samples	20	↔
Noise amplitude	0	↔
Noise scale	0.42	↔
Noise gain	0	↔
Source attenuation	0	↔
Surface attenuation	0	↔
Volume attenuation	10	↔

FIGURE 16 *Settings for Volumetric options.*

EXPLODING THE BALL

What special effects project would be complete without a nice fiery explosion? The ball in Vic Disco was blown to smithereens using Primal Particles again. By using the Decompose Object setting (Figure 17), Primal Particles used an existing mesh to produce its particles. By using this tool, the faces of the mirror ball object were sent off in various directions, creating an explosion effect.

To finish the effect, a pyrotechnic AVI was added in MediaStudio. The one used in Vic Disco is from a company called Artbeats (www.artbeats.com) and is included on the CD that accompanies the book Inside trueSpace 4 by Frank Rivera.

FIGURE 17 *Decompose object settings.*

THE LASER SHOW

Like the spinning rainbow in the horn of the Victrola, the blue lasers were a simple effect that achieved an exciting result. The beams themselves were nothing more than long thin cylinders fanned out in a large circle. To create the illusion of the lasers cutting through a smoky atmosphere (an effect used often in rock concerts), a large 50-sided polygon was placed through the center of the array of laser cylinders. After gluing these components together, the entire group was painted with the Perlin Noise shader as both its color and its transparency setting. Figure 18 shows how the objects were assembled. Figure 19 shows the Perlin Noise transparency settings panel and the settings that were used to achieve the effect. The velocity settings in the shader caused the "smoke" to be animated and more lifelike.

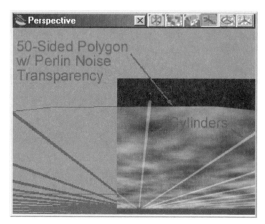

FIGURE 18 *Assembling the objects.*

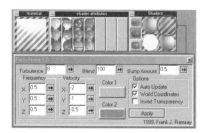

FIGURE 19 *Perlin Noise transparency setting panel.*

THE DOORWAY

In keeping with the rest of the short, the doorway opening into the room was designed to be shown as nothing more than light falling on the floor. In order to do this, a simple set of walls was constructed off-camera and fitted with a sliding "door" that would open to allow light from two point lights to spill into the room. A deformed cylinder "dummy" object produced the shadow representing the person standing in the doorway. Figure 20 shows the layout of each of these components.

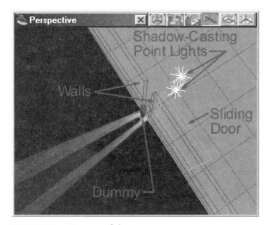

FIGURE 20 *Layout of the components*

FINAL EDITING

Once all the footage was rendered, the individual clips were brought into MediaStudio, where they were arranged to follow the music score and flow into a single animation sequence. MediaStudio also took care of fade transitions and the ending credits. When it was finally time to render out the final animation, MediaStudio allowed the selection of specific animation codecs, sound quality, frame size, etc.

WRAPPING IT UP

3D applications are becoming increasingly popular among hobbyists and home users. trueSpace is an excellent entry-level product that has power and features that allow everyone from beginners to advanced animators to produce fantastic video projects. And as Vic Disco illustrates, even effects that aren't "built-in" to a 3D package like trueSpace can be accomplished through a little trickery and imagination.

SECTION III

Other Topics of Interest

There are two chapters in this section, one on Lighting and the other on Gaming.

Every 3D application around has tools for creating lights and for customizing lighting. The icons for those tools may look different, but the things they do remain similar (if not exactly the same) across the board. You cannot create great computer graphics without knowing something, the more the better, about how to light a scene and an animation. The single piece contained here about lighting is not going to teach you everything, but it's a great start.

J. Brook Monroe's article about Game Creation is sure to please. Most 3D artists and animators have a love of computer gaming, many having begun their fascination with the medium by first becoming master computer gamers. Many of the young people today who aspire to be 3D artists and animators want to work on the development of computer games. Some of the best 3D pros devote their efforts to game development.

Games are judged as much for their artistic merit as for their playability. It's no surprise that 3D artists and animators study games just as their earlier counterparts in centuries gone by went to the galleries to study their peers. Enjoy the following two chapters.

CHAPTER

40

3D Lighting

ARNOLD GALLARDO

We encounter light everywhere. It can affect our moods and how we plan our activities. It can be in natural or artificial forms. We can control and manipulate artificial forms to suit our needs, but we can only modify the way natural light comes to us by using windows, blinds, coatings, etc.

In computer graphics, however, the purpose of lighting is to set the "mood" of a scene. It requires us to think about how we are "seeing." We have to acknowledge and comprehend the way light illuminates an object, the way it textures it, and the way it conveys "perceptible stimuli" that we can "feel," or define as the mood of the scene.

Lighting in a 3D application requires at least a basic command of traditional lighting principles. There are numerous inherent assumptions in computer graphics that most users are not aware of because of their own everyday experience with light. Most people assume that CG light works the way it does in the real world, - light goes from its source and bounces off the surfaces of the objects in the scene and then back to the viewer. CG lights in general are "models" of light transfer called "illumination models." What this means is that the light

behavior has been broken down into a simple process that a computer can follow and do. Since it is a "model" it does not behave as it would in the real world: It has been simplified so the computer can get a "simulation" of light and create an acceptable rendered image.

Surface shadings are approximated to mimic the properties of objects in the real world together with lighting "models." One cannot use a single bright light to simulate the way an overhead projector works; CG light simply does not work that way. There are advanced global illumination models, however, that can do it more easily, but these are not yet available commercially.

In general, there are five kinds of lights in computer graphics. These are *Ambient*, *Point Source/ Omni light*, *Spotlight*, *Area light* and *Infinite/Distant light*. There are other light types but they are just variations of the five main types of light. It is good to be familiar with what each light type does and how they illuminate the scene.

Ambient Light: Ambient light is a kind of light that acts like the objects have their "own light," meaning they are self-luminous. Ambient light could be set

This CG Lighting tutorial was done with Lightwave 5.6 and trueSpace 4.2 on a Dual Pll 400 with 256 megs running on NT 4.0 The principles outlined in this tutorial apply to any 3d CG program with the exception of the dillerences in light names (nomenclature) due to the individual manufacturer's use of terms. Common terms and labels have been used when possible.

globally to affect all the objects, or they could be set individually, with each geometry having its own "ambient term." The Ambient light (or term as it is called in other programs) simulates the existence of a global diffuse light source. This is done to illuminate the objects and let them render quickly.

Point Source/Omni Light: Point source lights are similar to the way real world bare bulbs radiate light. They have no sense of direction and their size can only be conveyed through their intensity. They radiate light uniformly in all directions. These lights are sometimes called omnidirectional lights. Point light sources are generally best for getting specularity on shiny and glossy surfaces.

Spotlights: Spotlights are focused directional lights with position. It creates a concentrated conical area of illumination. Spotlights can create harsh to almost diffuse shadows by varying their position and intensity. These lights are similar to car headlights, flashlights, and theater limelight.

Area Lights: Area lights are large light sources that have direction and position. Area lights illuminate a local region uniformly, and are composed of an array of point source lights arranged in a grid or matrix. The amount of time it takes to compute an area light depends on the number of point source lights used to simulate it. Area lights produce soft diffuse shadows by averaging out the shadows of each light in the matrix array.

Infinite/Distant Light: Infinite lights are also called Directional or Distant Light. Infinite lights behave like the sun on a clear day. They are very bright but far from the point source light. Infinite lights have direction but their position does not affect the geometry as much as the intensity and direction. Infinite lights uniformly affect all the objects in a scene.

Attenuation: There is one property shared by all lights - attenuation. This property explains why the intensity of the light falls off the farther we are from the light source. It follows what is called the Inverse Square Law. The light intensity falls off in proportion to the inverse square of the distance. This is a very important property of light that should be repli-

cated in CG. Most people do not use "attenuation" but instead choose the "linear" light or the "constant" light setting. This creates a very unnatural lighting. It is preferable to light a scene with more lights than to use fewer lights and create an unnatural setting.

The first image shows a light with no fall-off. Notice that the white and gray spheres as well as the black spheres have the same tonality even if they are near or far from the light source. This means that an object that is far would have the same level of illumination as an object that is near the light source. This is very unnatural. The second image shows linear attenuation. It means that the light falloff is proportional to the distance. The spheres change their tonality slightly as they go off into the distance. The

No Falloff

Linear

Attenuation

Small Light

third image shows real world attenuation. The sphere near the light source is brighter than those in the far distance. The light intensity is cut in half for every unit of distance. This is the way light works in the real world.

Scene evaluation and Lighting workflow: Now that the light types have been outlined, the next step is to decide what types of lights are needed in a scene. What does this mean? It means one has to decide if the dominant light in the scene would be a small light source, a medium light source, or a large light source. This requires that you evaluate the scene together with the various light types available in CG.

Small light source: The lights on this image are a single point source with a white color positioned on the right serving as the dominant light and a non-shadow casting fill light on the left side. The shadows indicate the main light direction, and because the key light is a point source, you can see that the shadows are very sharp and dark. The purpose of the fill light in this instance is to lighten the shadow areas for visual clarity.

If it is an outdoor scene, you will have to decide if its sunny, partly cloudy, or completely overcast. Each of these weather conditions will demand different light types. If it is an indoor scene, you will have to decide if the artificial lights are coming from the bare bulbs and whether any light coverings will dif-

Small Light Setup

fuse them. Small light sources make very harsh shadows in real life and this technique in CG is called "hard lighting."

Medium light sosurce: The light setup on this one is a bit different. A small white colored area light was positioned to the left of the camera and was angled towards the subject. This approximates a medium light source. Notice that the shadow has a soft edge to it.

If the scene is indoors and the lights are coming from the windows or the skylights, this will create a medium light source. Medium light sources have dark shadows with soft edges. If there are several medium light sources in a scene then they become large light sources.

Medium Light Source

Large Light Source

Medium Light Source Setup

Hard and soft Light: Notice that the hard light casts a sharp, long shadow while the soft light has a diffuse spread out shadow.

Large light source: This scene is identical to the setup in the medium light source scene with a small change. The same area light is now oriented downwards and is moved closer to the subject. This creates a softer illumination on the subject as well as more subtle shadows. Notice the shadows have umbra (dark inner shadows) and penumbra (outer, lighter soft shadows.)

These kind of lights bathe objects uniformly due to their size and proximity to the objects in the scene. A cloudy day would create a large light source as well as a torchiere lamp that lights the ceiling and diffuses the light. Since large light sources uniformly illuminate the objects, there are almost no shadows but if there are, they are soft and light in tones. A large light source would model the form of an object

all the way around with all the bumps and surface undulations.

The Three Point Lighting System: The quality of light and lighting is controlled primarily by a simple lighting scheme called "Three Point Lighting System." Its principle is very simple; illuminate and accentuate the main subject/s, place them in time and place through lighting, and create an emotion through lighting.

Dominant Light: Dominant lights are the "key lights" in the scene which convey the time of the day, the direction it is coming from and what kind of

Dominant Light: In this image, the dominant light is the only light present.

light it is. So for outdoors, this would be the sun and for indoors it would be the brightest light in the room that directly affects the objects in the room. Dominant lights alone would make the shadow area of the scene too dark which may be desirable for some situations especially for drama but for visual effect it is too drastic, so the dominant light's shadow area is controlled with what's called "fill-in" light.

Fill-In Light: "Fill-in" lights control the tones of the shadow areas by "filling" them with light. Fill lights generally should not create new shadows that counter the shadows created by the dominant light, and using a non-shadow casting light opposite the position of the dominant light will ensure this. Fill

Fill-In Light: In this image, only the fill-in lights illuminate the scene.

lights are generally 50 to 75% the intensity of the dominant light. Fill lights could have color in them to suggest the environment or time of day, but for most purposes they are white. Once the dominant lights and the fill-in lights are positioned, it will make the foreground subject have a dark outline. To prevent this, we need to separate the foreground subject from the background by using a backlight.

Backlight: Backlights are normally positioned behind and above the subject. Sometimes another light is needed to open up the shadows of the foreground subject slightly without competing with the fill lights. These are done using "kicker lights." In photography these are low intensity lights or white bounce cards/panels that reflect light back to the subject. These can be replicated using non- shadow casting area lights.

Backlight: Here is the backlight only, noticed how it creates a halo effect on the teapot and other objects.

Background/Set Light: Background lights or set lights illuminate the backdrop or the set to make it visible and to create depth in the image. The intensity of the background/set light determines how much of the environment is revealed. In CG, the placement of the background lights can be avoided if the set is made to be a little "self-illuminating" through the use of the "ambient term" in the shader/material properties setting. However, a high "ambient term" setting will lessen the contrast of the

geometry set, so the placement of non-shadow casting background lights is still the desired method.

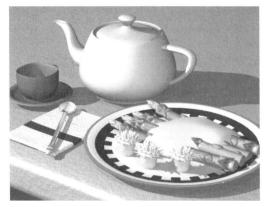

Final Image: In this image, all the major lights are working together, the dominant light, fill lights and the backlights.

This image shows all the lights working together. None of them however have coloration. Meaning all of the lights are white. The key light coming from the left is clearly seen while the shadow area of the teapot and the black cup show the effect of the fill lights. The overhead area lights even out the overall tonality of the upper surface of the teapot as well as the cheese on the asparagus. The scene used to make this tutorial was made very simple so that the effects of the lighting would be obvious.

It is the proper balance and placement of these lights that make successful lighting in photography/cinematography and in CG. The light types are only a guide, however, and a number of each type can exist in one scene. A night scene, for example, can have several dominant light sources. It is the sense of direction and intensity on the subject that make a light a dominant light. Fill lights change the level of the tone of the shadows so whenever there is a dark shadow area that needs to be lightened up, a fill light will be necessary. Backlight and kicker lights are placed depending upon the lighting situation. For most scenes with characters, it is almost always necessary to model the figures well with a kicker light to bring out the skin tones. There is also a special kind

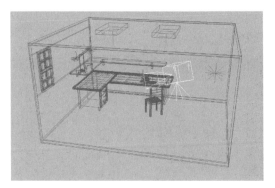

Final Image Setup

of backlight called "hairlights" which model the hair to make it sparkle and shine.

Lighting Workflow: It is a good idea to establish a lighting workflow to see what the effect of each light does in a scene. By following the lighting workflow outline here, you will be able to analyze and make decisions based on the way each light will affect the geometry in your scene.

1. Erase all lights in the scene: This will ensure that any lights you have used for modeling in the scene along with any default lighting schemes will be erased.

2. Place the dominant light(s): Decide which type of light your dominant light will be (is it is coming from a small source, large diffuse light source, or it is a mixed light?), and then decide on the color of the dominant light. The color of the dominant light is easy to figure out if you think in terms of natural and artificial. Is it natural light or artificial? Natural lights are whiter or bluish-white while incandescent light is yellow-orange and fluorescent light is greenish-white.

3. Render and look at the shadow areas and add fill-in light(s): Rendering only with the dominant light will establish the tonal range (white to black) of the image. It will also give you an idea about where to place the fill light(s). Fill lights are generally placed opposite the dominant light's position with less intensity and no shadows.

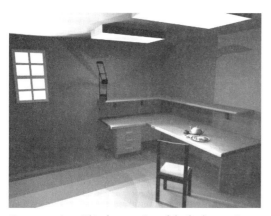

Room overview: This shows setting of the food setup. It shows a room with a window, two overhead diffuse lights and an architect's lamp.

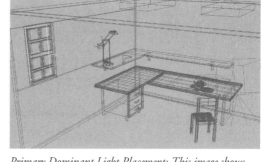

Primary Dominant Light Placement: This image shows the primary dominant light placement. The area lights have not yet been resized to fit the luminaire housing.

4. Place backlights and kicker lights: place the background light and the kicker light(s), if necessary, to model the geometry.

5. Place background/set light: Once you have lighted the subject well, it is time to bring out the background/environment. It might not be necessary if your dominant/fill light combination lights the scene enough but for outdoors and architectural scenes, it is desirable to separately light the scene.

6. Render and tweak the lights: Do another render and tweak the individual light settings to establish the tonal range you want as well as the "mood" of the scene.

Color mood: Once the type of light is decided on, the next step is to evaluate the time of day and the setting of the scene. Is it morning? Is it afternoon, or is it a mixed light situation? Mixed light means you have several kinds of artificial lights, with or without sunlight. The color of the lights combined with the harshness or softness of lighting in your scene will determine the mood of your scene. Another property of light is its "coolness" or "warmth." These properties also convey the mood in a scene.

Once you have decided on the kind of lighting you want to use (such as using warm point source lights); you need to decide how to implement them Now how will you apply your choice to use let's say

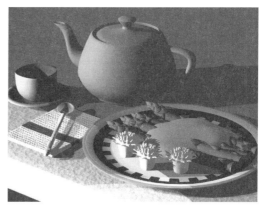

Warm Dominant Light: This shows the effects of the primary dominant light.

a warm point source light in the scene? It can be implemented as "practical lights." "Practical lights" are existing light features in a scene such as a lamp or a sconce that serve as the "dominant" light. They also could be implemented, as you desire without being tied to the real world, as long as the final rendered image looks "realistic" and "natural." If your 3d application offers OpenGL previews then setting up the light while in OGL mode will help you in the light placement. It will aid in getting the overall lighting scheme but it is always wise to do render tests, because real-time displays are always drastically different from the rendered image.

Let us apply this lighting workflow in creating a warm mood.

1. Erase all the lights in your scene. This will ensure that the only lights present will be the ones you will add in this tutorial. Warm lighting requires soft diffuse shadows so area lights will be good to use.

2. The next item is to evaluate the setting and decide the time of day. Afternoon is a nice time for tea. Since the scene is an interior setting, the lighting situation will make it mixed, meaning it will have a natural and artificial light source. We all know that the sun comes from the windows and that the most common artificial light indoors is florescent. Since the window has a small area relative to the size of the room and is quite far from the "food," the window will act like a medium light source that borders on being a small light source due to its distance to the food setup. So the window will need to be simulated using area lights with a slight yellow-orange color. This area light will be the primary dominant light as it is in the real world when daylight is involved. Create and place an area light behind the window and make this area light upright pointing into the room. Set this area light's intensity so that the whites of the room do not get washed out too much. If there are any washed out white tones in the scene, set the intensity so that only those near the light are washed out. However since we are focused on

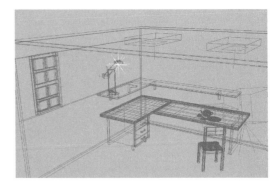

Lamp Setup: This shows the placement of the point source light to mimic a light bulb.

the food setup, the intensity of the light could be increased as long as the visible surfaces around the food do not get washed out too much. Now do a test render and tweak the intensity setting to make it the strong warm light it needs to be. Once you are satisfied with the intensity of the primary dominant light do not change its setting.

3. Now that the primary dominant light has been added, the next step is to add two overhead area lights for the simulation of diffused florescent lights. "Diffused" because it is covered with a material and gives out soft shadows. The two overhead area lights need to be a bit greenish blue. This is to mimic the behavior of unfil-

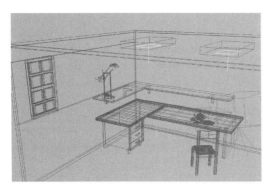

Secondary Light Setup: This shows the placement of the secondary lights.

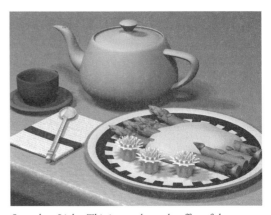

Secondary Light: This image shows the effect of the secondary light.

Primary and Secondary Light: This image shows the effect of both the primary and dominant lights.

Backlight Setup: This shows the backlight placement.

tered, unbalanced florescent lights as seen by video and film. This "cool" coloration will balance well with the yellow-orange of the main light, enhancing the warm colors of the food and lighting. If you make the overhead florescent "white," the scene will still be warm but with less impact. The greenish-blue coloration of the area lights does not mean a stark green-blue color but rather a greenish-blue white color, which is mostly white with hints of green-blue. An intense green-blue area light will make the scene "sickly-looking." Place slightly below the luminaire housing. Resize the CG area light to follow the dimensions of the luminaire housing. Resizing it will make the area light more realistic since it is exactly the same size as the real thing. Initially set the intensity of the secondary dominant lights to 3/4 to 1/2 of the primary light (sun). This will avoid making the artificial light overwhelm the natural light. Do another render and check the effects of the overhead area lights on the scene. It just needs to have a slight cooling effect on the areas not directly illuminated by the dominant light. It also needs to be seen as coming from above with a cool hue of its own.

4. As you can see from the illustration at the beginning of this section, the scene has an architect's lamp on the left side near the window.

This light also needs to be simulated. The best CG light to simulate it is a point source light. Create a point source light and position it slightly under the lamp. The intensity of the point source is 3/4 of the overhead lighting. Why 3/4 of the overhead? So that it would not wash out the effects of the overhead lights and still be visible especially on the teapot's surface. Do another render test and tweak the intensity setting again if necessary.

5. Since the secondary dominant light acts like a fill-in for the shadow area of the teapot and the plate, this scene does not need a fill-in light.

6. The teapot however needs to be separated a bit from the background so a non-shadow casting backlight is necessary. The intensity of the backlight needs to be set in such a way that it does not compete with the primary and secondary dominant light or the hint of the architect's lamp. It just needs to illuminate the back area behind the teapot and the cup. The backlight on this image is placed 1/2 of the height of the teapot but above the desk.

7. Do a final test render and if it is unsatisfactory, change the intensity of the lights one by one starting with the primary dominant light and then the secondary (fill lights) etc. until all the lights' intensities have been changed. Do a final render.

8. This tutorial shows that a dominant light could also act as a fill light in certain circumstances. It also shows the interplay of cool and warm col-

oration and its effect on enhancing the scene. Lastly, it demonstrates that the proper light placement is easier when you have an actual environment to work from, even if its very rudimentary.

Cool Scene: The dominant light is now bluish-white to evoke a moonlit effect and includes fill light made into cyan to make the shadows blue-black. The overhead diffuse lights are turned to greenish white to suggest fluorescent lighting.

Warm light which ranges from white-yellow, yellow-orange to reddish-orange conveys intimacy, romance, and, of course, a sense of security. This is evidenced by the way people feel around a bonfire. Bluish lighting is called "Cool" lighting and denotes, tranquility and purity. It could also denote a stark desolate environment that is cold, unforgiving, and unyielding. Bluish-green lighting is used for dramatic purposes especially for clinical/laboratory situations or industrial settings. This is due to the film's response to fluorescent lights, especially if they are not filtered or color balanced. Scenes with unbalanced fluorescent lights turn sickly green or bluish-green. Full spectra lighting (White) is used for neutral and realistic lighting. No scenes are lighted with only pure white lighting there are exceptions, however, such as spaceship interior scenes and clean room laboratories.

The lighting workflow outlined here is only a guide. It teaches you how to "visualize" and "analyze" a scene through light placement. This workflow approximates the sequence of real- world lighting. The background/set light is naturally turned on in the real world, but in CG you have a lot of choices that the real world does not offer. In CG you can place a light directly in front of the camera or directly behind the film plane. The possibilities are endless, however, with all of this flexibility you must have a great deal of discipline.. There is a tendency in CG to set up the scene quickly without much thought but just as with traditional lighting, where the placement and direction of each light is evaluated thoroughly to ensure that the limitations of the film's sensitivity to light is not exceeded and the proper tones are captured, you must plan just as carefully in CG. Remember that 3d CG is a triad modeling, texturing and lighting. Each aspect has to work well to make the final image work. Of the three, lighting is probably neglected the most. Frequently. Great lighting however will make a bad modeling and texturing job look good, but a great model will always look bad with bad lighting.

Cool Scene Setup

For more lighting tips and techniques check out chapters 5 and 6 of the "Book-of-the-Month." These are specific to Ray Dream Studio, but give you more useful ideas to apply to your creations.

41

On the Web, No One Can Hear You Scream: Tools for Writing Games with Script

J. BROOK MONROE

INTRODUCTION

In order to make the fullest use this tutorial, I have to assume that you have an intermediate-to-expert knowledge of JavaScript or JScript (which I'll just call "script").

- You know how to create a Web page in HTML by hand; that is, without the help of WYSIWYG editors such as Microsoft FrontPage.
- You know a little about the document model provided by the browser; specifically, the document object itself.
- You know a little about doing mouse "rollovers" using script.
- You know how to create an array.
- If your knowledge comes up a little short in one or two listed areas, don't worry. By the time you finish, you will be up to speed (or accelerating)! You should have a good knowledge of HTML, meaning that you know how to embed images and tables in a document. You'll need some software, too:

- An ordinary text editor. This means Windows Notepad, the Macintosh equivalent, or anything else you have handy. What's important is that it doesn't try to do paragraph formatting. If you have an advanced HTML editor such as Home-Site or HotDog, that will be fine, too. Do *not* use Microsoft FrontPage, Adobe PageMill, or any other WYSIWYG editor. These are excellent programs, but not at all suited to this sort of script development.
- A graphics-editing program capable of saving GIF images. This might be Paint Shop Pro, the Microsoft Photo Editor, or any other program you like. The program needs to create GIF images, because JPEG images (the other Web standard) don't support transparency.
- A program that creates animated GIFs is nice to have, but not necessary.
- You'll need the latest Microsoft Internet Explorer or Netscape (now called iPlanet?) Navigator Web browser, too. The 4.*x* version of either browser should be sufficient if you don't have the latest version.

TO BOLDLY SCRIPT

Very few people in the world *don't* enjoy playing some type of computer game. Rarer still are those who like to write them (because you're reading this, I'll assume you're one of them). Now I have some good news and some bad news, and I'll give you the bad news first: Neither of us is likely to be writing the script version of Quake, Unreal, or Half-Life any time soon. The reasons are several:

- None of the available scripting engines has the raw processing power to do those sorts of graphics.
- The document models used by the browsers don't support those sorts of graphics.
- I have only the vaguest idea of how to go about it, so I can't teach you how to do it.

Now the good news: most games aren't first-person shoot-em-ups, and can easily be adapted to run inside browsers and delivered over the Web.

I offer for your inspection the script skeleton of a game: a space-going version of an old game involving battling ships, whose name I won't mention here because of trademark issues. Instead of old-style Navy battles, this game allows the player and the computer to take shots at each other's fleet of spaceships. In order to get some idea of what I mean, see Figure 1. It shows the script running inside an HTML editor I use.

Keep in mind that this is not a complete game. I *might* have developed the perfect algorithm for playing this game, and I'm not inclined to share it. The first point of this tutorial is to introduce you to some powerful techniques that will make writing script-based games easier, but these techniques will work in many scripting situations. They'll make your scripting more efficient, and your HTML pages easier to maintain. The second point is to tickle you into writing some script yourself; if I present the complete game, there's nothing left for you to do!

A FEW WORDS OF CAUTION ABOUT GAME CREATION

First, don't steal the graphics. I don't mean specifically the graphics I used to create this game skeleton, I mean don't steal graphics at all. Just because you saw it on the Web and it looks cool doesn't mean you can use it in your game (or on your Web site).

Second, don't use trademarked images. You might think it would be great to use a top-down view of the Starship Enterprise™ as a playing piece for a game, but it's illegal and not worth the hassle—even if you draw it yourself.

I created the graphics for this tutorial using a variety of programs, including Paint Shop Pro 5, the Persistence of Vision ray-tracer, Moray for Windows (a CAD program for POV), and Diard Software's Universe 1.6. I think the results are good, when you consider how little time it took to create them: two hours. If you're incapable of creating graphics to use in the game, don't worry. It will take you all of 15 minutes of Web or newsgroup surfing to find someone who'd love to create graphics for you, usually inexpensively, and often at no cost.)

Third, don't use trademarked names. Remember that the process of playing a game cannot be trademarked and copyrighted (as in rolling five dice and building poker or rummy hands, or rolling two dice and moving a small shoe around the perimeter of a board). "Monopoly" and "Yahtzee!™" are trademarks, though, and you can't use them. That includes usages such as "Super Monopoly," "Mega Monopoly," and "Extreme Monopoly."

FIGURE 1 *The partially functional game skeleton.*

Finally, avoid clichés like the plague. Use the previous sentence as a negative example. This also includes naming your game with words like "Trek."

HOW TO LAY OUT A GAME

The combination of HTML and script is perfect for creating board games. Most board games have plenty of right angles in their layouts (one obvious exception being that one with the snakes and ladders). They can usually be laid out using tables, and our battling spaceship motif is no exception. If you look inside the body of the HTML file spcships.html, though, you won't see any <TABLE> tags. This is because I'm fundamentally lazy—I think you should be, too.

Each playing board (one for the player's ships, one on which to target the enemy ships) consists of 100 cells, which makes for a lot of typing. This is one of the first tricks of the script and HTML gurus: Let a script grind out the table for you. The script function EmitBoard does just that. It takes 18 lines of script to create the table, which would have been much larger as regular HTML, and much more difficult to maintain. Say, for example, that you wanted to change the graphic used for each cell background. In a purely HTML board rendering, you'd have to do a 100-case search-and-replace operation (if your text/HTML editor supports it). By using script to crank out the table, you make the change to one line, one time. (Being lazy has its benefits.) There's something else that using script allows you to do, and it's not immediately obvious to the casual observer.

You can see that EmitBoard simply writes out the same HTML tags you'd have copied by hand. It also includes some more cryptic items that we'll need to explore at length. The first of these is that in line 64 I assign each image in the document a unique name. This is because I'm going to need to build an array of objects in the script that reference the individual images in the document that comprise the game boards. Writing the table by hand would have included the tedious and error-prone task of naming each image. With script, you merely increment a variable or two, and the job is done. Let's look at the process more closely.

```
document.write("<img
name='img_"+i+"_"+j+"' src='empty.gif'
height='32' width='32'
onClick='place("+i+","+j+")'>");
```

Remember that i and j are variables in a for loop, with j indexing the inner loop.

 For the beginners: You see that I'm writing this HTML tag using document.write. This is how you insert text into an HTML page
TIP *from script. There is also a document.writeln; the difference between them is that the former appends no text (source) line break to what it writes, and the latter does. (This is not the same thing as a break
 tag; what it means is that if you have a browser whose View Source option shows you the emitted HTML, you'll see line breaks in the listing.)*

If you've done any script writing at all, you most likely know that you concatenate strings using the addition operator, so you won't be surprised to see that done here. The emitted tag contains two references to the row and column position of the game board cell, so if we assume i to be 2 and j to be 3, the output of this script line is

```
<img name='img_2_3' src='empty.gif'
height='32' width='32'
onClick='place(2,3)'>
```

This should look familiar, although Netscape (iPlanet?) scripters are scratching their heads looking at it. The Internet Explorer document model supports the onClick event for images (usually reserved for buttons), but Navigator doesn't. A Navigator version of this would require an anchor tag, and look like:

```
<a href='javascript:place(2,3)'
img name='img_2_3' src='empty.gif'
height='32' width='32'
/a>
```

Programming this would require a minor change to the EmitBoard function, and I offer it as an exercise for the reader.

There is a tradeoff involved in writing tables in script; there's *never* a free lunch. Most professional and serious hobbyist programmers know it as the "space for speed" tradeoff. The emitted table takes a little longer to render than the expanded HTML version. Considering the space savings (the script required is much smaller than the expanded HTML table), and the easier maintenance, I think the tradeoff is well worth it.

BUILDING A STRUCTURED ENVIRONMENT

The next guru-level trick involves creating your own objects. You should already know about the Document and Image objects available to the script. If you're a C or C++ programmer, you know about *structures*, and if you're a Pascal programmer, you're familiar with *records*. Script supports the creation of custom objects in a similar fashion. (For the novice: Think of an *object*, *structure*, or *record* as a multipart variable. A standard script variable can hold a string, or a number, but not both at the same time. With objects, you can create complex variables containing multiple pieces of logically related data (called *fields* or *attributes*), such as inventory items, personnel records, or, in our case, game board cells.)

The first function in the script, BoardStruct, isn't really a function at all; it's an object constructor. It creates a three-field object consisting of an Image object, a field indicating what's in the cell, and a Boolean (true/false) value indicating whether the cell has been "hit" by a missile. One constructs new objects in the script by calling BoardStruct behind the operator new:

```
var myBoardCell = new
BoardStruct(someImage);
```

You reference the data fields in the script as myBoardCell.img, myBoardCell.contents, and myBoardCell.hit. Let's ignore the latter two fields for a moment, and concentrate on the image field.

Both major browsers support what is called an *image array*, referenced as document.images. Script supports *Image objects* (as I mentioned previously), which most people use to do hotspot rollovers and other clever Web tricks. We're going to be more clever by far: We'll use Image objects and the image array to manage displaying the spaceships, change the graphics when they're hit, and even provide some animation.

You can access the individual elements of document.images by either numerical index or name. I found early in my scripting experience that using the numerical index was an invitation to trouble: The moment that you add an image to the Web page, all the indexing changes. Luckily, a reference such as document.images["img_12"] works just as well as document.images[19], and that's what I'm using in this script. (You'll note that the index embedded in the image name need not match the actual index in the array.)

The function CreatePlayerBoardArray in the script illustrates this. I've reproduced it here.

```
function CreatePlayerBoardArray()
{
 var i,j;
 var namePfx;
 ply = new Array(10);
 for(i = 0; i < 10; i++) {
  ply[i] = new Array(10);
  namePfx = "img_"+i+"_";
  for(j = 0; j < 10; j++) {
   ply[i][j] = new
BoardStruct(document.images[namePfx+j]);
  }
 }
}
```

This function illustrates more guru tricks. The first is how to create a two-dimensional array in script. Simply create an array and then make each member of the array an array as well. The second is a performance optimization. The value of *i* doesn't change in the inner loop (the one indexed by *j*); that means the first part of each image name in that row will be identical. I can therefore create the prefix of the image name outside the loop, and store it in a

variable (*namePfx*). Then I use the variable in the inner loop. This is faster than having the index to document.images be *"img_"+i+"_"+j*.

After CreateBoardArray finishes, the script has stored references to the images in the player board by board position. The image array provided by the document model is linear, and building our own array with image references allows us to manage the game tasks more intuitively.

If this seems like a lot of work, remember that we're going to all this trouble on purpose! By setting up this array, we can now place a spaceship graphic anywhere on the board with a line like the following:

```
ply[3][2].img.src =
"spaceship_part.gif";
```

For the beginners: That's the nice thing about using Image objects in script: You can assign any image to them at any time. That includes overriding whatever image was assigned to **TIP** *them at the time the browser rendered the HTML.*

The other object type I've created in this script is the ShipStruct. This object contains all the information necessary to draw one of the four spaceship types the game supports. Since, in the game on which this is based, the ships cover more than one grid spot, it's necessary to store information regarding exactly how each ship should be laid out on the board. I chose to make the ships nonlinear; that is, instead of a 1-by-3-cell destroyer I have a 2-by-2-cell fighter bug. I think this makes the game a little more interesting, and takes it a step away from the original game.

Unlike the structure created for board cells, the ShipStruct can't be filled in fully using just a constructor. (Right after I wrote this I thought of a way to do it with just a constructor, but it means using variable-length function-argument lists. The constructor function call and inner logic would have been so hideous it's just better to do it this way. If you're a glutton for punishment, you can write to me and ask to see it.) The constructor function simply takes a number indicating how much area the

ship will cover. That's all—you define the geometry of each ship and the graphics required to draw it using the AddPart function. The code is right here:

```
function
AddPart(ship,offsetX,offsetY,imgRef)
{
  var idx                    =
ship.idx++;
  ship.x[idx]        = offsetX;
  ship.y[idx]        = offsetY;
  ship.part[idx]     = new Image();
  if(typeof(imgRef) == 'string')
   ship.part[idx].src = imgRef;
  else
   ship.part[idx].src = imgRef.src;
}
```

AddPart takes as arguments the object returned by the constructor call, two grid offsets, and an image identifier. The grid offsets specify where to draw the particular part of the ship based on some arbitrary location assigned to be (0,0) for the ship. For the 3-by-3-cell space station, the center point is right in the middle; for the 2-by-2-cell bug, it's the upper-left corner. Here's how I defined the bug:

```
fighter = new ShipStruct(4);
AddPart(fighter,0,0,"b00x.gif");
AddPart(fighter,0,1,"b01_a.gif");
AddPart(fighter,1,0,"b10_a.gif");
AddPart(fighter,1,1,"b11x.gif");
```

In order, the sequence adds ship parts at the origin, one cell to the right, one cell down, and one cell diagonally down and right. The ShipStruct keeps an internal counter of how many parts have been added to the structure, so that each new call to AddPart puts the incoming data in a different array location. This is not the most interesting part of AddPart, though; the interesting part is the type identification code in the last if() clause.

Most script tutorials teach you that script variables are loosely typed. ("Type" is the formal abstract term for class of information, meaning character,

number, or complex data. The opposite of "loosely typed" is "strongly typed.") This is the opposite of variables in C or C++, where once you declare a variable it can only hold values of that type; in other words, once a number, always a number. A script variable can hold a number at one point in the script, a string at some other point, and an object at a third point. The script function typeof() tells you what data type a given variable holds at the time you ask. It returns string values such as "string," "object," and "undefined." By checking the type of the *imgRef* argument to AddPart, the function can tell if you've passed a string or not. This way you could construct a spaceship using GIF file names, or by passing the *src* attribute of another, already-loaded Image object. (I will assume that you and I, as good script developers, won't mess up and try passing in a number. If we do, the script will crash.)

Drawing a ship on the board is takes no more effort than calling the Draw() function and passing it a ShipStruct. The function PlaceSpaceships() in the skeleton script shows how a call to Draw() replaces many assignments into the *ply* array. Draw() doesn't check to make sure you aren't trying to place a ship part out of bounds; you can add this to the code that allows players to drop ships on the grid. (Since the spaceships don't move once placed, adding the overhead of boundary checking to Draw() would hinder performance. Adding the out-of-bounds code I'll leave as another reader exercise.)

LOADING THE DICE

There aren't any dice in this game, but the heading is relevant. At several points in the script, I've loaded graphics that aren't referenced by HTML tags. This occurs, for example, in CreateShips(), CreateBlinkCells(), and LoadImageCache(). Because you have the power to create script Image objects, you aren't limited to just what you can show via HTML. That's why I'm mentioning dice: In a dice rolling game, you'd probably load all six die-face images into an array without ever seeing the image names in an HTML tag.

TRICKS TO MAKE THE GAME APPEAR MORE PROFESSIONAL

One of the nice features you can provide in a game of this type is "damage" to a ship part after it's been hit by a computer meson torpedo. This involves nothing more than replacing the image at the hit site with a different image; the selection of GIF files included with this article includes damaged sections of the green "fighter bug" spaceship. Two of the GIF files display animated electrical arcs, which play up the fact that those sections are damaged, and make the game seem more dynamic. I've used them to create the default views of the bug ship; in a real game, you'd replace those graphics with the "undamaged" images. You pay no extra programming cost for the animation; you simply change the image *src* attribute, and the browser does the rest of the work. (You have no idea how much fun this was to do back in the days of DOS game development.)

I've included a different method of doing animation in this script skeleton as well. Between the two game boards is a small separator, which keeps the boards from running together in the browser view. Originally the space was empty, with just the stars and nebulae of the backdrop showing through. The layout seemed too static. It needed something blinking or moving to provide some visual excitement. The script engines in the high-end Web browsers support a native function called setInterval(). It's the cousin of the more commonly used setTimeout(). Both of these functions wait for a time interval to elapse, then call a script function you provide. The difference is that setTimeout() only calls the script function once (unless you take steps to "re-prime the pump"), and setInterval() calls the function repeatedly. In the function StartAnimation(), I've used set-Interval() to call Animate() once per second. The numerical argument to these timer functions is in milliseconds; hence, the seemingly large value of 1000. (Supposedly, the lowest interval you can use is one millisecond, but I think the practical lower limit is more like 100 milliseconds. More than that, and the browser will spend too much time servicing the timer. Some operating systems don't provide timer

resolution to the nearest millisecond, so it may be impossible to get that kind of accuracy.)

The function Animate() picks one of the 10 spacer table cells, and one of the "blink" images I loaded in CreateBlinkCells(). I don't remember how many blink images I created, and I'm forgetting on purpose. It doesn't matter what the actual number is, since I use *blinkColors.length* in the call to Random(). This way, I can change the number of images in the array without having to rewrite the function call in Animate(). That's another guru trick: Let the array tell you how many items it contains.

Every second, the timer calls Animate(), which changes the contents of one of the images in the spacing area. This gives the illusion of some kind of advanced computer activity, making the presentation a little more professional and dynamic. (It's possible to go too far with this. You're not trying to emulate the Vegas Strip, just liven things up a little. If you *are* trying to emulate the Strip, I don't want to visit your Web page.)

The final issue regarding professional-looking results involves the use of *transparency*. This is why I specified GIF files at the outset, rather than JPEG files. Since under ordinary HTML you're limited to block-style layouts, you have to take steps to keep the end user from noticing how many right angles there are in the game layout. You also need to have some kind of image-on-image capability. Some of the advanced readers might be thinking DHTML divi-sions or layers, but DHTML support in the major browsers differs (harder to script), and some users still won't have downloaded DHTML-capable browsers two years from now! Rather than eliminate potential audience members, it's easier to use methods that are browser independent and backward compatible. Just about every graphic I supplied with this example has some transparency in it. This allows the fancy background to show through, and makes the graphics seem more integrated and three-dimensional.

NOW IT'S YOUR TURN

The skeleton as written accepts mouse clicks on the computer's board, which is where you'd be trying to find the computer's ships. Right now, the script just marks the location as hit, but it won't take much work to make it fully functional. I've left all the original graphics in the downloadable package so you can see how they evolved.

I've put you on the launching pad with the skeleton of this game. Finishing the game from here is at most the work of one or two afternoons—maybe three, if you write a truly brilliant algorithm for the computer's picks. I already have mine written. Perhaps one day you and I will merge both algorithms into one script, and let the two fight it out for domination of the Galaxy.

SECTION
4

Extras

This section contains additional tutorials for you to enjoy. The first two use 3D Studio Max and show you how to create a scary interpretation of a Jack-O-Lantern and create a cartoony elephant model that uses some serious max tools.

The third tutorial is for users, or those interested, in RayDream and Carrara. It takes you through modeling a variety of forms by using 3D Primitives and Boolean processes. This tutorial is especially important for new users of either application, and can also teach you how to model using these same two processes no matter which 3D software you use.

The fourth tutorial wraps up the *Creating a Talking Head Announcer* series of tutorials using 3D Studio Max, and the final tutorial is a handy recipe for creating a DHTML animation.

CHAPTER 42

Jack O'Rachnid (3D StudioMax)

SHAMMS MORTIER

When you create a scary creature, the first thing you should do is to explore your own psyche. Ask yourself, "what scares me the most?", and then proceed to develop a creature design that models your own nightmares. Not only will you be able to breathe more life into your scary design, you'll also be able to explore and perhaps even partially purge some of your own fears.

Aside from not being able to pay my bills, something that causes shivers up my spine are spiders. In Vermont, we have lots of them. They live in the woodpiles and in the basement, secreting themselves away in dark out-of-the-way places. Some are quite poisonous as well, like the famed Black Widow. I remember walking out of my house once and right into a huge web that a spider had woven during the night. The web stuck to my face, and the fat yellow and black spider wound up on the front of my jacket. I'm sure she was as shocked as I was, but I yelled louder than her.

Halloween is certainly the time for spiders, so I could have settled on that model alone, but that wasn't what was calling me. I wanted to fold aspects of the spider, a body, into a more complex and unique model. Being able to create strange composite creatures has always been alluring to me, even when I was a pen and ink illustrator years ago. So I asked myself whet I could possible combine the spider with that would represent Halloween even more,

being both symbolic and frightening. I selected the single most recognizable icon of Halloween, the pumpkin, or Jack-O-Lantern. This would be the head of my creature.

I used 3DS Max as my main modeling engine, version 3.1. Before I begin with the actual tutorial, I want to say a word about max, which is actually applicable to any professional 3D software. Professional 3D modelers are not purists, nor should they be. No professional 3D artist or animator that I know, and I know dozens, relies on any single 3D application to create a finished project, without bringing in one or more applications along the way. Being a 3DS Max artist or animator does not imply using no other 3D application to create your models. Just the opposite, it means being aware of all of the other applications that can handshake with Max and that offer unique modeling capabilities. This starts by being aware of, and owning whenever possible, the 3DS Max plugins that extend your creative options. If Max did not admit plugins by its open architectured design, it would not be as popular or as sought after as a 3D application as it is today. So starting with plugins, and extending to other software that writes to the 3DS format that Max can both write and read, you may use all sorts of software before you 3DS Max model is complete. In this tutorial, in addition to selected plugins for Max, I used PLAY Inc's Amorphium. Let's begin . . .

MODELING JACK'S HEAD

Do the following:

1. Open Max. I always switch Show Grid off in all Viewports, and check Show 2-Sided in the Perspective Viewport Configuration. These actions give me a clearer view of what I am doing.
2. Create a primitive Sphere (Create>Geometry> Sphere) in the Top Viewport.
3. With the sphere selected, go to the Modify Panel, and using the Edit Stack operation, translate the sphere into a NURBS object.
4. Under Display Line Parameters, change the V Lines value to 13. You now have a sphere separated as displayed in Figure 1.
5. Sub-Object>Surface CV, which displays the Control Vertices. Select Column of CVs, and Insert Row. Insert Rows of CVs in the Top Viewport that roughly match the position of the V Lines. You do not have to be exact, because this is not a mechanical construct. See Figure 2.
6. This Jack-O-Lantern will resemble more of a gourd than a pumpkin, because the shape has more personality. Select Points, and by dragging a marquee around every other set of points in the Top Viewport, move the points away from the circular shape. Refer to Figure 3.
7. Switch off Sub-Object, and Edit Stack>Editable Mesh.

FIGURE 2 *Rows of CVs are added.*

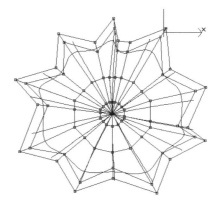

FIGURE 3 *Move alternate points to create a shape something like this.*

8. Now to create some Boolean Cutters. In the Front Viewport, use Create>Shapes>Line to create a equilateral triangle.
9. In the Modify panel, Extrude by a value of 60. Now you have a solid column with three sides. Shift>Move to clone it. These will be the cutters for the eyes. Align the cutters so that they are extend into the Jack mesh, and are where the eyes should be. See Figure 4.
10. Go to Create>Geometry>Compound Objects, and select Boolean. With the Jack mesh selected, use an A-B operation, selecting each of the eye cutters in turn (note that you will have to translate to a Mesh between eye cuts). The result is displayed in Figure 5.

FIGURE 1 *The NURBS sphere has 13 V Lines.*

FIGURE 4 *Place the eye cutters.*

FIGURE 6 *Create a Mouth template with the Shape>Line Tool.*

FIGURE 5 *The eye sockets are created by Boolean cuts.*

FIGURE 7 *The Mouth is cut away from the mesh.*

11. Create a mouth template with the Shape>Line Tool. Make it a closed shape, with Corner as the Initial Type and Smooth as the Drag Type. Yours will be unique, but one example is shown in Figure 6.

12. Extrude as you did with the eyes, and use Boolean subtraction to cut it away from the Jack mesh. See Figure 7.

13. The model is fine so far, except that it looks like it is made of paper-thin material. Select Sub-Object Face in the Modify panel, and select the entire Jack mesh. Go to the More list, and select Face Extrude with a value of 12. Now the model has thickness. See Figure 8.

14. Collapse All to get a mesh again. Select Sub-Object>Face. Select the top part of the Jack mesh, what would amount to a cut-away cap. In the Modify panel, select Detach, and name

FIGURE 8 *Face Extrude gives a model thickness.*

the new object Cap. You have cut off the top of the Jack Mesh and created a new object. See Figure 9.

15. Create a curved line as a Path for the stem, and a closed shape as the cross-section. See Figure 10.

FIGURE 9 *The cap is created.*

FIGURE 10 *Path and Cross-Section.*

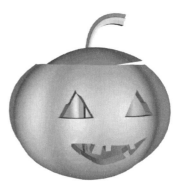

FIGURE 11 *The Jack mesh model is complete.*

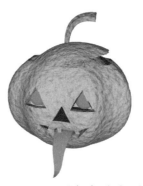

FIGURE 12 *The finished Jack mesh head.*

16. Go to Create>Geometry>Compound Objects> Loft. Select the Path and get Shape by selecting the cross-section to create the lofted stem. In the Modify panel with the Loft selected, use Path Deformations to size the stem so it is about 20% at the base and 70% at the top. Link the Stem to the Cap. Move the cap onto the mesh at a jaunty angle. See Figure 11.

17. Now for Materials. Make sure all of the parts are UVW mapped in the Modify panel. Use spherical mapping for the Jack mesh, and cylinder mapping for the cap and stem. Create an orange material with a Bump Map set at 175, with the Marble procedural used for the bump. Apply this to the Jack mesh and the cap. Map the stem with a dark green material. Create and Link two red eyeballs, and create and Link a lofted tongue. Create another triangle cutter,

and Boolean-subtract for the nose. We'll add some light effects later. Preview the results. See Figure 12.

JACK'S BODY

We will create a few elements for the legs, and then clone them for the rest. Do the following:

1. Draw a profile with the Shapes>Line Tool for lathing, and lathe the form pictured in Figure 13.

2. Select the form and Export Selected (don't just say Export, or the entire scene will be exported) as a 3DS file, and delete the original.

3. Open Amorphium (obviously, you'll have to have purchased and installed it for this step). Import the 3DS model you just saved in Max. See Fig 14.

FIGURE 13 *Create a Lathed form that resembles this one.*

FIGURE 14 *The 3DS model appears in Amorphium.*

4. Use the following modifiers on the 3DS form in Amorphium: Bottle 40%; Bulge 50%; Tsunami 50%; Twirl 10%; Noise 15%; Taper -40%; Noise 30%. You will wind up with a form that resembles Figure 15.

5. Export as a 3DS file, and Import to Max. In Max, select and UVW Map (Cylindrical). Transform>Scale, and set X and Y to 20 and Z to 100 to create a spindly leg part. Map the part. I used the Smallpox texture from the Elemental Texture plugin.

6. Hierarchy>Effect Pivot Only, and move the Pivot Point to the top of the leg section. This is necessary for Linking operations later.

7. Rotate the leg. Get ready to add some hair to it.

8. Now for a great plugin. This one's call Grass-O-Matic from Sisyphus Software (www.sisyphus. com). This plugin is part of their Druid package. It's meant to create grass, but also can be used for strands of hair. Skip this is you don't have it. Select each leg part, and apply the

FIGURE 15 *The modified form in Amorphium.*

Grass-O-Matic plugin (it's under Create> Geometry>Sisyphus. Select the leg as the Distribution Object. Use a Length of 50 and a Width of 3. Set Quantity to 100, and turn Clumps on.

9. Select the leg and make sure it's collapsed to a Mesh. Select the "hairs", and collapse to a Mesh. Select the leg, and use the Attach command in the Modify panel to attach the hairs to the leg. Shift>Rotate to clone another leg part, making sure the Pivot Point is at the end of the first leg segment. Move the second segment so that they resemble 16.

10 Create the mid-body from a squashed sphere, and map it with any yukky Material you like. See Figure 17.

11. In Amorphium, create a tapered sphere, and apply a 30% Waves Modifier to it. Bend it as

FIGURE 16 *A finished two-part leg with hair.*

FIGURE 17 *The mid-body is created.*

displayed in Figure 18. Export as a 3DS model, and Import into your Max scene.

12. Once it is Imported into Max, resize as needed. Optimize.

Amorphium 3DS models usually need optimizing in Max, because the mesh is too dense.

NOTE

13. Apply a UVW spherical modifier, and Map it with the same material as the mid-body. perform Boolean Union on the body parts. See Figure 19.

14. If you are an experienced Max user, you probably guessed what comes next. All the parts have to be put together. The body has to be rotated in the Top Viewport, and the Head Linked to it. The legs have to be Cloned, rotated, and placed relative to the body, then Linked to it. Last, if you have Grass-O-Matic, select the Body as a Distribution Object and place some hairs on it. Use your discretion for the settings. The result just may resemble Figure 20.

Happy Halloween!!!

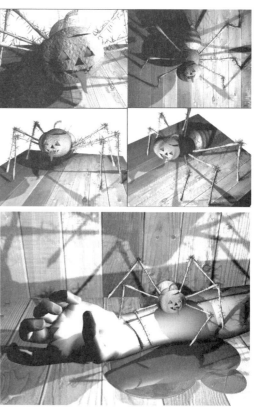

FIGURE 20 *Jack O'Rachnid is ready to crawl on your neck!*

FIGURE 18 *Create this shape in Amorphium, and Export to Max as a 3DS model.*

FIGURE 19 *The body is now complete after the mid-body and Amorphium object are joined by Boolean Union.*

43

Creating Elee Phantoosy with 3D Studio Max

SHAMMS MORTIER

3D Studio max has so many modeling tools, it's almost scary. Each new version seems to add new options and possibilities. Certainly R3 (Revision 3.x) leaves previous versions in the digital dust. When you take on the task of modeling an organic part of the world, like a creature, you need every modeling tool at your disposal, and that means you have to spend some time studying how each tool works and how it is best put to use. No two electronic artists approach the same goal by the same path, so as we go through this tutorial, keep it in mind that you might explore different ways to model the same elements I am describing.

I don't know why or when I got the idea for doing Elee Phantoosy, a packydermish-like elephant-human mix, a character for a children's story perhaps. I know I love elephants, and the way that they are designed. I also know that I have never been satisfied with using computer graphics to model "reality". I prefer to leave that to the photographer and the news reporters. So here we go. Open 3D Studio Max R3, and get ready for a thorough experience in modeling. This tutorial naturally assumes that you are familiar with where Max's modeling tools are located, and that you have gained some appreciation for their use.

ELEE'S TRUNK

When I think of the shape of a trunk-as-nose, I reach immediately for Max's Lofting tools. I design the expanse of the shape with Lofting, then use the Deformation options to resize the cross-sections. Finally, I add a Bend Modifier, and adjust the shape of the finger-like end. See Figures 1 to 4.

Some flare is added to the Trunk by using Vertex Sub-Object editing. Then a Box UV Mapping is applied, with a Concrete Brown Stucco material map and the Bump Channel increased to a value of 100. A test render is done, and the Trunk is set aside. See Figure 4.

FIGURE 1 *The Trunk starts with the elements for a basic Loft, a Circle Spline and a curved Line.*

FIGURE 2 *Go to Create>Geometry>Compound Objects>Loft, and create the Loft.*

FIGURE 3 *Using Scale Deformation in the Loft's Modify panel, the Trunk is given some personality and tapering.*

FIGURE 4 *Some tweaking is applied to the end of the Trunk, and a Material map (Concrete Brown Stucco) is applied.*

THE EAR

The Ear starts as a drawn Shape. Then Modify> Extrude with a value of 4 is applied, and Modify> More>Tesselation is used to break up the surface. Now to add some character to what would otherwise be a flat surface. First Modify>Noise with values of

XYZ = 3, 9, 3 respectively. An elephant's ears have the look of an old crumpled rag. Tow bend Modifiers are applied: -55 on the X, and 35 on the Z. A Planar UV Map with the same Concrete material is applied, and a test render done.

There is a pink cast to the inner part of the ear. This was done by adding a small clone of the ear, with a pinkish diffuse color and a Stucco bump with a UV Planar map. Then the inner part was Grouped with the outer. See Figure 5.

FIGURE 5 *The Ear.*

THE HEAD

For the Head form, we'll start with a Sphere Primitive and transform to NURBS. Then the top of the dome is pulled upward by using the CV's, and extra CV Columns are added, as displayed in Figure 6.

Work for a general profile. You can always tweak the results later. Be careful of stretching as you move the CV's. Check the Perspective viewport to see what the model is looking like as you move the CV's. See Figure 7.

FIGURE 6 *Extra CV's are added.*

FIGURE 7 *The Profile takes shape.*

Convert to an Editable Mesh. Add eye sockets with spheres subtracted by Boolean operations (Create>Geomtry>Compound Objects>Boolean). Make the sockets large, because we want this creature to appear gentle with big eyes. Remember to turn on **Force 2-Sided** in both the perspective viewport configuration and in the Render Setup, so you see the internal facets of the model. Also remember to translate to an Editable mesh after the first Boolean subtraction and before the second one, and then again after the second one. UV Map for a Sphere, and use the same Concrete Material on the head. See Figure 8.

FIGURE 8 *The head takes shape.*

EYES

Use suitable colored spheres for the eyes, and Link them to the head. use a Specular level of 100 and a Glossiness of 33 for the pupil, to give it a highlight. For eyelids, use hemispheres. Link them to the head so you can open and close them if you want to. Map the eyelids with the same Material. Elephants have very long beautiful eyelashes, and our elephant-like

character is no exception. Create an eyelash from a cone. Give it a Bend on the Z axis of -35. Place it in position on an eyelid, and use Shift-rotation to clone about 10 around the eyelid. Use a dark brown diffuse color on them, and Group them with the eyelid. Shift-Move the other eyelid into position, and Link both eyelids to the eye. See Figure 9.

FIGURE 9 *The eyes really give a character personality.*

LIPS

In the Top Viewport, draw a smoothly curved Line that will become the lofting path for the upper lip. Bend it -150 on the X axis. Go to the Loft Deformations, and apply a Deform Curve like the one displayed in Figure 10 to the X axis with Symmetry on. Notice that this curve follows the general shape of the lip. Shift-Move to create a clone for the lower lip, and adjust its Deformation Curve so it is fatter. Flip on the Y axis, and move into place. Don't worry about the edges. We'll address that in a moment. Link the lips to the head. See Figure 11.

FIGURE 10 *The Upper Lip is formed by this Deformation Curve.*

FIGURE 11 *The Lips are placed and Linked.*

TUSKS

The Tusks are created by forming two parts: The Tusk receptacle and the Tusk itself. The Tusk Receptacle is a bent cylinder that has the same material as the head. The Tusk can either be a Lofted Circle on a curved path (my choice) or a Bent Cone. The Tusk and Receptacle are Grouped and then Linked to the head on either side of the Lips. Small Tusks indicate a more demure personality, while larger ones give the character a more dominant appearance. See Figure 12.

FIGURE 12 *Elee with Tusks in place.*

ELEE'S HEAD

OK, time to put the parts together. Resize as necessary. Place the ear and Clone-move the other one into place, mirroring on the X axis. Link the Ears to the head. Move the Trunk into place and Link. Pose as you like and render. Happy MAXimizing. See Figure 13.

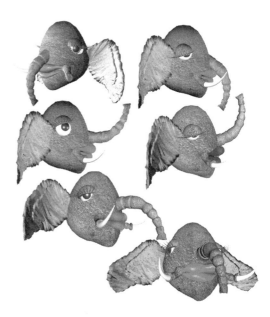

FIGURE 13 *Elee's head is a done deal.*

44 Primitive & Boolean Modeling with Carrara

SHAMMS MORTIER

PRIMITIVE MODELING

By "Primitive Modeling" we are not referring to a craft practiced by ancient peoples, but to the use of Primitives, preset 3D constructs, resident in Carrara and all other 3D applications (though number and type may vary). A modeling "primitive" refers to a 3D structure that can be used as a component, or building block, of more complex structures, or as a stand-alone object. 3D Primitives can be endlessly re-shaped. This can be accomplished by deforming the primitive into a more complex shape, or by joining it to other primitive or non-primitive elements. A sphere, for instance, is a 3D object primitive that can be pushed and pulled with the right tools, until it starts to take shape as a human head. The most common are the sphere, cube, and cone. Carrara contains the following Primitive forms: Sphere, Cube, Cone, Cylinder, Icosahedron, Plane, and Infinite Plane. We will cover all of these except the Infinite Plane in this chapter. Use primitive objects as the foundation elements for constructing more complex objects.

IDEAS FOR USING PRIMITIVES

Here are a few suggestions for using Primitives in your Carrara projects:

- **Sphere:** Use the sphere as is for planets, balls, and spherical components of other objects. Flatten the sphere on one axis to build disks, plates, tires, wheels, UFOs, and other disk-like objects. Alter the sphere in the Vertex Modeler to create more organic forms like human and animal heads. If you elongate a sphere on its vertical axis, it becomes an ovoid. This is perfect for building the arms and legs of creatura, especially if you deform the shape a little to give it some random characteristics.

- **Cube:** Use the cube as is for square blocks, dice, and other cubic forms. Squash it on one axis to create planar surfaces, table tops, walls, and floors. Squash it on two axes to create rectangular tubes, table legs, and rectangular rod elements for composite objects. You can, for instance, build an easy chair or stairs by stacking rectangular blocks together and adding the proper Shader.

- **Cone:** Use a cone primitive as a roof on a castle tower, as an ice cream cone, as a stand-alone spire, or as a component of a composite 3D object. Deformed with the Twist and Bend option, you can create screw-like spikes and other objects.

- **Cylinder:** Use the cylinder primitive anywhere you need a tube, either as is or elongated on its vertical axis. Reducing its vertical axis, you can create coins and other object elements. It also responds well to various kinds of deformations.

- **Icosahedron:** The Icosahedron primitive is more limited than the other basic primitives, though it does make a wonderful jewel. Just apply a Shader that has a 75 percent transparency and a brilliant color, and duplicate it until you have enough to place in a virtual treasure chest. More radical objects result from deforming the Icosahedron.

- **Plane:** Use the Plane as a picture plane for mapping images and animations (this could be a picture on a wall or an animation playing on a television). A large plane can also serve as a ground plane (especially when deformed), a wall, or a tabletop.

WHAT YOU NEED TO KNOW FIRST

You have to know how to do a number of things before you proceed with the tutorials on the use of Primitive objects, the details of which can be found in the Carrara documentation:

- Where to access the Primitive Forms, and how to drag-drop them onto the scene or Insert them (and the difference between these two methods of placement).
- How to re-position Hot Points on objects.
- How to Link/UnLink objects.
- Grouping and UnGrouping.
- Moving, Resizing, and Rotating objects.
- Using the Transform options in the Properties tray.
- Using Shader Presets in the Browser tray as object textures.
- Using the Hierarchy in the Sequencer tray.
- Creating a Color or Bi-Gradient Backdrop.
- Scene Track, Dolly, Pan, and Bank.
- Basic Rendering.

Please note that without this preparatory knowledge the following tutorials will be very difficult to understand, since it is expected **NOTE** *that you have a grasp of the necessary preparatory details and associated terminology.*

OK. Let's begin.

THE PRIMBOT

I have named this composite object a "PrimBot" because it acts like a robotic character and is composed entirely of Primitive objects. There are numerous variations that you could create using this technique which might be far more complex than this one. Do the following:

1. Open a Carrara scene, and go to the Front View in the Assembly Room. Zoom in until the Front Grid fills the Document Window.

2. While in the Front View, place a Sphere as shown in Figure 1. This will be the PrimBot's head.

3. Place a Cylinder at the bottom of the head and rotate it into place. Use an Head Icosahedron for the chest. Resize and place it as shown in Figure 2.

FIGURE 1 *A Sphere is added to the scene.*

FIGURE 2 *The neck and chest are placed into position.*

4. Add two reduced Spheres as shoulders, and a resized Cone as the pelvis. See Figure 3.
5. Add a Cylinder for the right upper arm, and resize and rotate it so that it fits on the right shoulder. Duplicate it for the left upper arm. Add and resize a Sphere for the right hip, and Duplicate and position for the left hip. Duplicate one of the upper arms, and rotate it and position for the right thigh. Duplicate the right thigh, and re-position for the left thigh. Follow the graphic example in Figure 4.
6. Create a Sphere, and resize it to about 70%. Duplicate it three times, and position the Spheres for elbows and knees. Use the same idea to create and place lower arms and lower legs, which are resized Cones. Create the hands and feet from cubes, with the feet being flattened cubes. Check Figure 5 for sizes and placements.

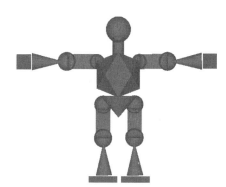

FIGURE 5 *All of the elements are now in place.*

7. Select each part in turn, and rename it according to its body part under the General heading in the Properties tray. This is very import for Linking, which we will perform later.
8. Group-Select the Right Hand, Right Lower Arm, Right Elbow, Right Upper Arm, and Right Shoulder, and go to Edit/Align. Accept the defaults, which will align these objects on the Hot Points. Do the same for the elements of the Left Arm, and the Left and Right Legs.
9. Go to the Left View. See Figure 6.
10. As you can see in Figure 6, the pelvis, chest, neck, and head are out of alignment when seen in this view. Center them so they look right. Reduce the depth of the chest by about 30% in the process. That's better! See Figure 7.

FIGURE 3 *Add the shoulders and pelvis as displayed here.*

FIGURE 4 *The upper arms, hips, and thighs are placed into position.*

FIGURE 6 *help! What went wrong?*

FIGURE 7　*Everything is now aligned in the Left View.*

11. Before we Link the parts, we have to re-position Hot Points. The Hot Point of an object is the point it rotates around and is resized from. By default, an object's Hot Point is at its center, but in order to get our PrimBot to pose correctly, we have to change the placement of most of the Hot Points. Go to the Front View, and select the Bounding Box document render. This causes all of the objects to appear as a outlined box, and their Hot Points become visible. Select each object in turn, and move the Hot Points as follows (make sure you are in the Front View):

Move the Hot Point of the Head straight down to the bottom border of the Bounding Box. Move the Hot Point of the Neck straight down to the bottom border of the Bounding Box. Move the Hot Point of the Chest straight down to the bottom border of the Bounding Box. Leave the Hot Point of the Pelvis at its center, since this will be our main Parent object. For both Arms, leave the Hot Point of the Shoulders centered as they are. Move the Hot Points of each Upper Arm horizontally so that they cross the border of the Shoulder Bounding Boxes. Leave the Elbow Hot Points centered as they are. Move the Hot Points of the Lower Arms horizontally so that they cross the Bounding Box border of the Elbows. Move the Hot

Points of each Hand so that they cross into the Bounding Box of their respective lower Arms. Use this same procedure to connect the parts of each leg. When you are finished, the Hot Points will be placed as displayed in Figure 8.

12. Now it's time to Link the parts. Linking connects objects so that there is one central "Parent" object and a series of attached parents and children. When I use the word "to", as in "Link X to Y", it means select item X in the Hierarchy list in the Sequencer tray, and drop it onto object Y. Object Y then becomes the Parent of Child X. Here we go.

Link Head to Neck. Link neck to Chest. Link Chest to pelvis. Link each foot to its respective Lower Leg. Link each Lower Leg to its respective Knee. Link each Knee to its respective Thigh. Link each Thigh to its respective Hip. Link each Hip to the Pelvis. Link each Hand to its respective Lower Arm. Link each Lower Arm to its respective Elbow. Link each Elbow to its respective Upper Arm. Link each Upper Arm to its respective Shoulder. Link each Shoulder to the Chest. That's it! Carrara makes the complex easy to accomplish. See Figure 9 for the completed hierarchy listing.

Drop any Shader you like on the PrimBot's parts. If you have done everything correctly, you should be able to rotate any part of the Primbot to pose all the Linked parts. Congratulations! See Figure 10.

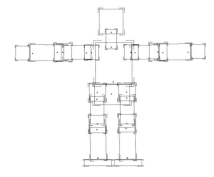

FIGURE 8　*This is how the Hot Points look when you have repositioned them in the Front View with the Bounding Box render switched on.*

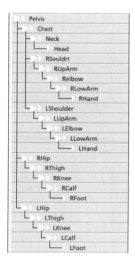

FIGURE 9 *The Prim Bot's hierarchy Listing in the Sequencer tray.*

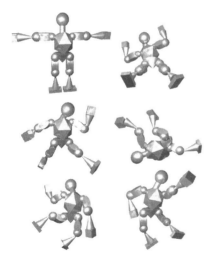

FIGURE 10 *The rendered Primbot, with a Zinc Shader.*

THE SPHERAPOD

 Because you have familiarized yourself with a lot of processes in the last tutorial, the instructions in this tutorial are somewhat more brief.

NOTE

The next model we will create from Primitives is one I call a "Spherapod". It resembles a segmented cater-

pillar. We will use variations of this model as we walk through other modeling options in the chapters ahead, so make sure you save it as a Carrara project. Do the following:

1. Create the form of the Spherapod from nine Spheres in the top view, as shown in Figure 11.
2. Move the Hot Points as displayed in Figure 12.
3. From the left while in the Top View, name them as follows in the Properties tray: Head, 2, 3, Mid, 5, 6, 7, 8, and 9.
4. Link as follows: Head to 2, 2 to 3, 3 to Mid, 9 to 8, 8 to 7, 7 to 6, 6 to 5, and 5 to Mid. The Hierarchy in the Sequencer tray should resemble Figure 13.
5. If everything has been done correctly, selecting the Mid Sphere and moving the critter should

FIGURE 11 *the basic form of the Spherapod, as seen from the Top View.*

FIGURE 12 *Move the Hot Points as displayed here (Top View).*

FIGURE 13 *The Linked Hierarchy should resemble this one.*

move all of the Linked parts. Drag and Drop a Sumatran Tiger Shader from the Animal (Begly) folder in the Browser tray on each Sphere from the Top View. See Figure 14.

6. For the final touches, add the following. Two resized black Spheres as eyes, Linked to each side of the head; two resized Cylinders as antennae, Linked to the head; two Cones as ovipositors, Linked to the last segment (#9). The antennae and ovipositors can be left at the default dark gray. The Hierarchy should look like Figure 15. From the Top View, your Spherapod now resembles Figure 15.

If you have done everything correctly, you will be able to rotate the segments and pose the Spherapod. If you rotate the Mid segment, the whole Spherapod should rotate. See Figure 16.

FIGURE 14　*The Shader is added to each Linked Sphere.*

FIGURE 15　*The Spherapod Linked Hierarchy in the Sequencer tray.*

FIGURE 16　*The Spherapod lives!*

THE BRIDGE

Certainly one of the most used applications of Primitive models is to stack them in one way or another to create a Grouped object. One example of this is represented by the construction of a bridge. Do the following:

1. From the Front View. Build the structure shown in Figure 17 using five cubes. Shift-Select all of the cubes and Group them. Name the Group Half-Arch. Drop any Shader you like on the separate Cubes. See Figure 17.

2. Duplicate the Half-Arch, and Flip it on its X axis. Move the duplicate so that it joins the original. Group both, and name it Arch. See Figure 18.

FIGURE 17　*Half of an archway structure.*

FIGURE 18 *The completed Arch.*

FIGURE 19 *The bridge.*

3. Now duplicate the Arch as many times as you like, and place a resized Cube that spans them all on the top as a roadway. Set it wherever you like, and drive away! See Figure 19.

DRESSER

You can use Primitive objects to create an array of furniture items. Here is one example, a Dresser. In its initial stages, it also can be used as a bookcase. In this example, the last of the objects we'll cover that uses only Primitive elements, the instructions will be very brief. This will give you a chance to use the skills you have learned from previous Primitives modeling, and instead use your observation skills to look at an object and model it. This is a necessary

step in becoming a master modeler with any tools. Do the following:

1. Carefully observe the views of the case in Figure 20. There are three perspectives here. When you have a grasp of the 3D design involved, use only resized Cubes to construct this Case. When finished, Group the elements and save it as Case. See Figure 20.
2. By Duplicating just the Case, you can start to model an entire library or Cases for a museum. See Figure 21.
3. Create a drawer out of Cubes. Group the parts and name it Drawer_Fin. Refer to the illustrations in Figure 22.
4. Carefully place the Drawer in the bottom empty slot in the Case. Resize it until it fits. name the Drawer 1. Move the duplicate up until it fills the next slot. Name it Drawer 2. Hit Duplicate again, and the next drawer

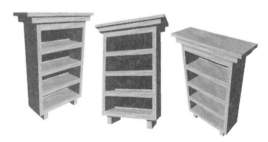

FIGURE 20 *Look at these views of the case, and then set about modeling it with resized Cubes.*

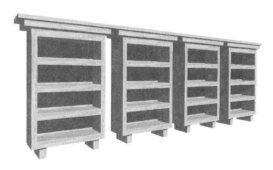

FIGURE 21 *All these cases need is books or other items.*

FIGURE 22 *Refer to these illustrations to create a Drawer. Make it the same size as the drawer space in the case.*

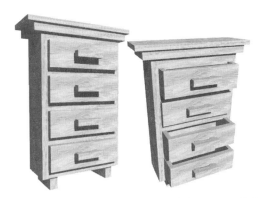

FIGURE 23 *The finished Dresser with drawers installed.*

should automatically fill the next space. Name it Drawer 3. Create Drawer 4 in the same manner. DO NOT GROUP the drawers with the Case, and you'll be able to open them one at a time, and even fill them with other objects. See Figure 23.

BOOLEAN MODELING

OK, time to break out of the Primitives-only mode. In this section, we'll still depend on Primitives, but we'll add another way of modeling them . . . with Boolean operations. You use Booleans when you want to perform operations any of three specific operations on two intersecting objects: Union (combining them into one object), Intersection (creating

an object from the area defined by the intersection of the two objects), and Subtraction (literally subtracting the intersection of the two objects from either one or the other). These can be Primitives or any other objects in your scene. Because we have yet to talk about the other modeling options in Carrara, or about imported object options, we are going to use Primitives to point out Boolean possibilities. This is really the best idea anyway, since it's easier to visually describe what Booleans do when Primitive elements are used. You can then transfer your understanding of Boolean operations to more complex interactions.

WHAT YOU NEED TO KNOW FIRST

You have to know basic Boolean operations before you proceed with the tutorials on the use of Booleans in these tutorials, the details of which can be found in the Carrara documentation:

- Where to access the 3D Boolean operations, and what they basically do.

CUP, BOWL, AND SPOON

In this exercise, using no other modeling tricks other than Boolean operations, we will create a cup, bowl, and spoon for a Carrara table setting.

The Cup

To create a cup using only Boolean operations, do the following:

1. Place a Cylinder and a Cube Primitive in your scene. See Figure 24.
2. Enlarge the Cube by 25%, and reduce its height to 15%. See Figure 25.
3. User the Top and Left Views to move the altered Cube so that it intersects the Cylinder half way through, as displayed in Figure 26.
4. Shift-Select the Cube and Cylinder. Activate the 3D Boolean window in the Edit menu. Click on Intersection, and move the Silhouette Quality slider to a value of 130. See Figure 27.
5. Click on OK. The 3D form you have created is displayed in Figure 28.

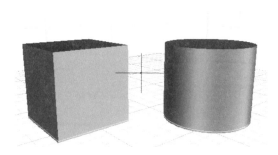

FIGURE 24 *The cup starts with Cube and Cylinder Primitives.*

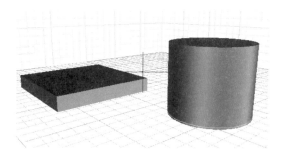

FIGURE 25 *The Cube is enlarged and then resized.*

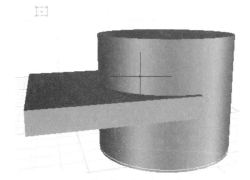

FIGURE 26 *Move the altered Cube so that it intersects the Cylinder as shown.*

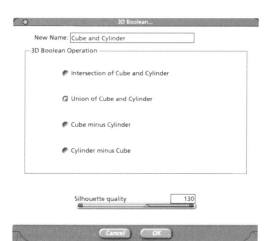

FIGURE 27 *The 3D Boolean settings window.*

FIGURE 28 *This is the result of the Intersection operation.*

6. Place a Cylinder in the scene, and intersect the Boolean model you just created as displayed in Figure 29. See Figure 29.
7. Select both elements, and bring up the 3D Boolean window. Click on Cube and Cylinder Minus Cylinder, and move the Silhouette quality to 130. See Figure 30.

FIGURE 29 *Intersect the Elements as displayed here.*

FIGURE 30 *The next Boolean operation is configured.*

FIGURE 32 *Two Cylinders, with one resized smaller inside the other.*

FIGURE 33 *The result is a cup-like object. You can map it with any Shader preset you like.*

8. Click OK, and the operation commences. In a few seconds, you will see the result. Voila! The Cup handle. see Figure 31.
9. Name this object Cup handle, and save it as a Carrara object. Set the Handle aside for now.
10. Place a Cylinder in the scene. Duplicate it, and raise the duplicated Cylinder vertically so that it sticks up from the original. Reduce the overall size of the Duplicate to 85% in its Properties tray. See Figure 32.
11. With both Cylinders selected, go to 3D Boolean. Subtract Cylinder 2 from Cylinder 1, with a 150% Silhouette quality setting. Click on OK. See Figure 33.

12. Now to add the Cup Handle. Place it so that it intersects the Cup body, select both, and activate another 3D Boolean. Use Boolean Union at a 130% Silhouette quality setting. Click on OK. You'll see that the Shader has been removed, so apply another Shader to the Cup object. Name it Cup_01, and save it to disk. See Figure 34.

The Bowl

Having mastered the construction of the Boolean Cup previously, you'll find the Bowl a snap to create. Do the following.

1. Place a Sphere in your scene.
2. Place a Cube in the scene so that it covers the top half of the Sphere (you'll have to resize it).

FIGURE 31 *The finished Cup Handle.*

FIGURE 34 *The finished Cup.*

FIGURE 36 *The Bowl takes shape.*

FIGURE 37 *The Bowl is complete.*

3. Shift-Select both objects. Use a Boolean operation to subtract the Cube from the Sphere. See Figure 35.
4. Duplicate the hemispheric shape. Name the original Bowl_1 and the Duplicate Bowl 2. Resize Bowl 2 to 95%, and resize it vertically so that it sticks up above Bowl_1. Select both and go to the Edit/Align function. Select the X axis, and click OK. Do the same thing again, this time with the Y axis selected. This aligns the X and Y axis of each object.
5. Making sure both objects are selected, use a Boolean operator to subtract Bowl_2 from Bowl_1, with a Silhouette quality of 150%. The result is the bowl displayed in Figure 36.
6. You could leave the Bowl as is, but I think a Bowl with a rounded base would be rather unstable, don't you? So, let's add a base. Use a flattened Cylinder for the base, and a Boolean Union to connect it to the Bowl. When finished, use a Shader to texture it. See Figure 37.

The Spoon

Part of the Spoon can be created by using same steps that were used to create the Bowl. Do the following:

1. Follow the steps used to create the Bowl previously, but leave off the base. Once you have the Bowl, reduce its size by 60% on the Z axis (vertical), and elongate its X axis by a size setting of 160%. See Figure 38.
2. Resize a Cone in the Left View, until it is in the position and proportion to the bowl of the Spoon displayed in Figure 39.
3. Resize a Cube and place it over the Cone as displayed in the Left View of Figure 40.

FIGURE 35 *The result of the subtraction is a hemispheric object.*

FIGURE 38 *The Bowl has become the bowl part of our Spoon.*

FIGURE 39 *A resized Cone is configured.*

FIGURE 40 *Place a resized Cube over the Cone.*

4. Use a Boolean operation of Cone Minus Cube to create the shape shown in Figure 41.
5. Use a Boolean Union to attach the Handle to the bowl of the Spoon after both have been moved into position. Save the Spoon model to disk. See Figure 42.

FIGURE 41 *Cutting the Cube away reveals this shape after you resize the Z axis of this "handle" by about 50%. You may need to use another Cube to cut away the end of the handle that attaches to the Spoon.*

FIGURE 42 *The finished Boolean Spoon.*

When you are finished with the Cup, Bowl, and Spoon, you can create a test rendering that includes all of them. Make sure to save all of these objects, since we will use them for other purposes in later chapters. See Figure 43.

FIGURE 43 *A composition using all three objects as a partial table setting.*

COMPLEX BOOLEAN MODELING

Boolean modeling has its limits in Carrara. This is especially evident when you attempt to use two Spheres with a Boolean Union operation, When the Quality slider is moved above 30, odds are, no matter the amount of memory allocated to Carrara, the rendering will abort. In this example, we will model a facial form, using multiple Spheres joined together by Boolean Union. By now, you are very familiar with the Boolean operators, so instead of marching you through a series of steps, we will simply present a few Figures that display the outcome. The rules for doing this type of Boolean modeling are straightforward:

• Never Move the Silhouette quality slider above 25% (the lowest setting).
• Use only Spheres to create more organic looking forms.
• Work in the Front View.
• Place all of your Spheres in the scene before doing any Boolean operations.
• Model just one half of a face and then Duplicate and Flip on the X axis to get the other half.

- If you are going to use subtraction operations, do this after all of the Spheres have been Boolean United, but prior to the Duplication/Flipping processes.
- Boolean operations remove applied Shaders, so wait until you are finished (not prior to Grouping) to drag-drop a Shader on each half.
- The last thing you do will be to select both halves of the face and Group them.

 This type of modeling is really best left to Metaballs (Chapter 6), but it is important that you are aware of this alternate method as well.

NOTE

See Figures 44 to 46.

FIGURE 44 *These eight Spheres were placed in the Front View, which makes them all at the same general depth, so they intersect.*

FIGURE 45 *Boolean Union has been done here on all of the Spheres. I also used another Sphere to cut the hole, which will later hold an eye.*

FIGURE 46 *The model is Duplicated and then flipped on the X axis, and the two halves are Boolean Unioned. "Eyes" are then placed in the face. The model is saved to disk for later modification in other parts of the book.*

ARRAY MODELING WITH PRIMITIVES

An Array consists of a number of duplicated elements, set in some type of repetitive geometrical order. A line of toy soldiers is an array, as is a stack of cannonballs or seats in an auditorium. When one object is duplicated to form a member of an array, we say the object is "instanced". This means a great deal in Carrara, since instanced or duplicated objects (and Shaders for that matter) always have a Master source. In later chapters, the idea of editing a Master object and automatically altering all of its instanced duplicates at the same time is covered in more detail. In a sense, although separate object elements are used in an array, the whole array can be seen as the 3D model. With that in mind, here are two ways to model using the concept of arrays.

In order to prepare for these tutorials, it is necessary that you understand how to access and use the Duplicate command in Carrara. Explore the use of this command before doing these tutorials.

STAIRS

When we create a staircase in a 3D application, we have to have some idea whether it will be linear or spiraling. A linear staircase can be created with other

modeling alternative easier than it can with arrays, but if the stairs are to be spiral, than arrays are your best bet. So let's create a spiral set of stairs. All of the basic elements for this exercise are object Primitives. Do the following:

The process for creating things like spiraling smoothly curved railings is another matter. This is best accomplished with the Spline Modeler. See Chapter 3.

NOTE

1. Create a stair constructed from two Cube Primitives. Shift-Select both, and Group them. See Figure 47.
2. Duplicate the Stair. In the Front View, position the Duplicate on top of the original. Move the Hot Point of the Duplicate to the right edge of the Stair. This is the fulcrum around which the Stair will rotate. See Figure 48
3. In the Top View, rotate the Duplicate -30 degrees, as displayed in Figure 49.
4. Now it gets easy. With the duplicated Stair still selected, click on Duplicate as many times as

FIGURE 49 *The Duplicated Stair is rotated -30 degrees in the Top View.*

you like. A new Stair will be added to the spiral stairway in exactly the same relationship as the original has with the first duplicate. Stop when your stairway has the number of stairs required. See Figure 50.

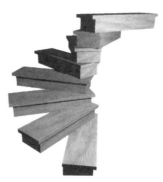

FIGURE 50 *The spiral stairway. You can add whatever additional elements you desire before placement in a room scene.*

FIGURE 47 *The staircase begins with one stair.*

FIGURE 48 *Move the Hot Point of the Duplicated Stair to the right.*

COLUMNS

Here's another array concept that utilizes an additional tool: internal Grouping. Do the following:

1. In the Front View, create a column composed of Cylindrical and Cubic Primitives. Select all elements and Align them on the X and Y axis. Drag-Drop your choice if Shader Presets on the

Column parts. Group this object and name it Column. An example can be seen in Figure 51.

2. From the top View, create a row of Duplicates, following the example set in the previous exercise. Shift-Select all of the columns, and Group. See Figure 52.

3. Remaining in the Top View, with the Grouped Columns still selected, Duplicate again. Move the second Group to the right of the first. Select Duplicate again, which creates three equally spaced rows of Columns. See Figure 53.

FIGURE 53 *Three neatly arranged Groups of Columns are created.*

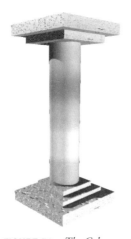

FIGURE 51 *The Column.*

FIGURE 54 *The finished columnar architecture.*

FIGURE 52 *The column is duplicated several times, and all are Grouped.*

4. Create a Roof and Ground with Cubes, and map them with a preset Shader of your choice. A Classic temple is the result. See Figure 54.

ARRAY MODELING WITH IMPORTED MODELS

Any model format that Carrara can read and import can be the source for an array. Larger models may cause problems if you don't have enough RAM to allow instancing, but otherwise, Carrara doesn't care where the array source comes from. An example of this possibility is detailed in the following tutorial.

CHAIR ARRAY

The model used in this short array example Do the following:

1. Import the source model for the array. In this example, the source was a model of a Chair in the 3DMF format (Mac). See Figure 55.
2. From the Top View, Duplicate the Chair and position it. Then select Duplicate again as many times as needed to create a row of chairs. Group all the Chairs and name the Group Chair_Row. See Figure 56.

3. With the Chairs_Row Group selected in the Top View, use Duplicate to position another row. Then use Duplicate again as many times as necessary to create all of the rows you need. See Figure 57.

FIGURE 57 *The auditorium awaits the audience.*

FIGURE 55 *The model is imported.*

FIGURE 56 *A row of Chairs is created by using the Duplicate operation.*

CHAPTER 45

Aircraft Animation With Carrara

SHAMMS MORTIER

This GRC tutorial focuses upon a subject vital to creative digital work, the necessity to think and work across applications when creating computer art and animation. When someone asks a professional computer artist to name their "favorite software", the answer should be another question: "for what purpose?". There is no single software application that addresses all of a computer artists and animators needs. It all really depends upon the project. The work determines the software to be used. Even a project that seems to call for a single 3D application may in fact need to have effects applied that are not contained in the application of choice, no matter how great and full-featured the selected 3D software is. Here is one such project. I am going to use Adobe Carrara for a 3D animated object, Corel Bryce for an animated sky movie, and Adobe After Effects to add more clouds and to put the whole thing together. It doesn't matter if you use other software in place of my choices. What matters is the cooperative principle involved.

Assignment: Design an animation that shows an aircraft flying through some clouds.

DESIGNING THE AIRCRAFT

Note that the assignment does not specify what type of aircraft is to be designed, so you are free to experiment here. I will walk you through my design, using Adobe Carrara as the 3D application. If you are using another professional 3D application, you should be able to utilize the same or similar tools in your design. Carrara users, do the following:

1. Open Carrara, and drop a Spline proxy in the workspace, opening the Spline Modeler.
2. In the Spline Modeler Front View, create an oval about 8x8 grid squares and center it.
3. Go to the Geometry menu, and select Pipeline Extrusion with a Free Envelope. You are going to create the fuselage and tail in one step.
4. From first extrusion plane to last, this model has eight planes. Create 6 planes, and while positioned on plane 7, say Create to make the last point a plane too.
5. Look at the views shown in Figures 1 to 3 and create your fuselage based upon these extrusion points. Name the Spline object "fuselage". See Figure 1 to 3.
6. Drop a squashed sphere into place for the canopy, and name it "canopy". Make the Canopy a child of the Fuselage. See Figure 4.
7. Extrude a shape in the Spline Modeler to act as both a wing and tail section. See Figure 5 and 6.

Congratulations! The plane is finished. Now it's time to animate it in Carrara.

1. Select a color that is not represented in the model, and make it the Background Color (note: background, not backdrop). This will be **333**

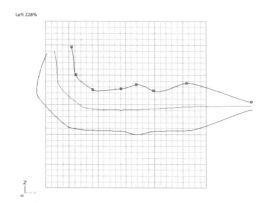

FIGURE 1 *The left profile, showing the placement of points.*

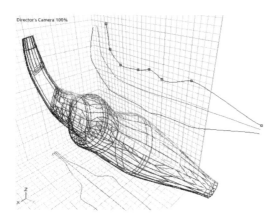

FIGURE 2 *The Director's profile, displaying the overall shape and sizing of planes.*

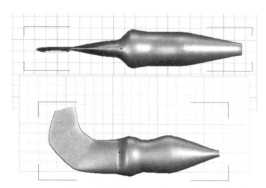

FIGURE 3 *Top and Side views, showing the rendered fuselage.*

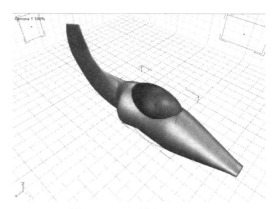

FIGURE 4 *The canopy is added.*

FIGURE 5 *A shape is extruded to be used as both a wing and tail section.*

FIGURE 6 *The wings and tail sections are added, and linked to the fuselage.*

the drop-out color used in After Effects that will make the background transparent.

2. Create a 120 frame animation at 30 FPS that shows the plane from the side (Pitch). Animate it so that it tips one way, than the other. Remember, we don't need a lot of movement, because the background will be moving. Make the last frame position of the plane the same as the first frame. Render as a Quicktime animation, and save to disk.

CLOUDY BACKGROUND

Carrara is wonderful for creating objects, from organic to mechanical, but it lacks the speed and utilities to create believable environments quickly. That's where Bryce shines. Bryce, on the other hand, lacks the standard tools for object creation. So we are using different 3D applications for separate purposes. Bryce can create clouds very fast, even with anti-aliasing switched on. A 120 frame animation, which is what we need, takes about 3 minutes or less (depending upon the configuration of your machine).

In Bryce, set the camera at a 45 degree angle pointing upward. Configure a 120 frame animation at 30 FPS, with a screen size of 320 x 240 pixels. Use standard antialiasing. Place an interesting clouds preset in the scene. Use a sun size of zero, and turn off cloud motion and turbulence (in the Sky Lab). keyframe the camera to rotate on the Y (vertical) axis as follows: 0 at frame 1, 90 degrees at frame 30, 180 degrees at frame 60, 270 degrees at frame 90, and 360 degrees at frame 120. Render and save the animation to disk.

AFTER EFFECTS COMPOSITING

1. Open After Effects, and configure a 120 frame composition at 30 FPS, with a screen size of 320 × 240 pixels.

2. Import the footage of the Bryce Sky Animation as the back layer, and the Aircraft Animation as the second layer.

3. With the Aircraft Layer selected, use a Key Effect (I use Boris FX Linear Color Key) to select the background color, and drop it out by moving the keying slider. You should see the Aircraft floating on top of the Bryce Clouds backdrop. See Figure 7.

4. Now here comes some F/X fun. Create another layer of any color on top of the Aircraft layer. Select that layer, and apply any cloud or smoke effect you like to it. I used the DigiEffects Delerium Clouds effect. See the finished animation.

FIGURE 7 *Both the Bryce Clouds and the Aircraft animations are imported as footage to an After Effects composition.*

CHAPTER

46

Creating a 3D Talking Announcer in 3D Studio Max: Part 3

TOM GRAY

For this tutorial I used a Dell Duel Pentium 866 with a wildcat 4110 intense 3D graphics card with 512 megs of rdram. You do not need a system like this to complete these tutorials. I was using a single Pentium 233 with 256 megs of ram for part 1 and 2 and it worked fine.

Back again with part 3. When we ended part 2 we had just applied the surface modifier to the spline cage and were just getting our model to look something like a head. Part 3 is going to deal with texture mapping the head using a very cool mapping plugin, 'Texture Layers'. We aren't going to paint the maps, we are going to edit the actual bitmaps that we used to create the spline head from. But before we do that we need to clean up the mesh a bit.

I noticed that the scenes that I included in Part 2 of this tutorial were not labeled very clearly as to which scene went to which part of the tutorial, sorry about that. To help make things clearer I will break this tutorial into sections. At the beginning of each section I will save a Scene with a new number that corresponds to the numbered Figures. I hope this helps make it easier to follow along. Figure-1 will show what Scene-1 looks like when you first open it.

Figure-2 will show what Scene-2 will look like when you first open it, and so on. I will save additional Figures as Figure-1a, Figure-2b etc. as they belong with section we are dealing with. I have also saved out the images at 1600 x 1200 which allows better detail. If you don't work with a resolution that high you can pan the image around and see very clearly the relevant areas. So that said, load up Scene-1.

FIGURE-1 / SCENE-1

This scene is where we left off at the end of Part 2 of this tutorial. The spline cage was just completed and the surface modifier was applied. We could continue by adjusting the mesh to more closely match the bitmaps we have on the front and side planes but I want to switch to using the animation of Ali rotating 90 degrees (that we created way back in Part 1) as our reference. This will enable us to get a view from more than just the front and side and help us to define a more accurate representation of the face. I have removed the Front and Side planes since we will no longer need them. The model is still a little rough

FIGURE 1

though so we will fix a few of the rough spots first. The first thing we need to do is match the background animation to the model. We'll set it up in the front view only. The steps to set it up are as follows.

1. Go to the Views menu and select Viewport background.
2. Click on Files… in the Background Source area.
3. When the select Background Image requestor comes up find the file Ali-turning.avi and select it. Click Open.
4. The animation is 44 frames. Check in the Animation Synchronization area and make sure it has a 0 in the Use Frame box and a 43 in the To box and keep Step to 1.
5. In the Aspect Ratio area select 'Match Bitmap'.
6. Make sure Display Background is selected and for now uncheck Lock Zoom/Pan. Select Animate Background.
7. In Apply Source and Display to area Select 'Active Only'
8. In the Viewport dropdown box select 'Front' Click Ok to close the Viewport Background dialog box.

Now click inside the front viewport and type the 'W' key to maximize it. If the animation isn't visible go up to the upper left of your viewport where it says Front and right click over it. A drop down menu will appear, Select Show Background. You should now

see the animation in the viewport. Lets make the animation length in Max the same as the viewport animation we just loaded in. At the bottom of your screen click on the Time Configuration button. When the dialog box opens go down to around the middle of the box and where it says Length type in or use the spinners to change the length to 44. Close the Time Configuration dialog box. We now need to line up the object with the background. Using the Pan and Zoom controls move the model round until it is lined up with the background image. We don't want to resize it. Just move and zoom the view. If the background image is moving and zooming too you need to go back to the Viewport Background menu item again and uncheck Lock Zoom/Pan. Once the model is lined up with the background image go back to the Viewport Background menu item and check on Lock Zoom/Pan. This will keep the model lined up with the background as we work. So now we're ready to clean up our spline cage a little. The first thing we want to do is delete the surface modifier; we will add it again in a minute. Then get rid of the duplicate edges down the center of the face and the top and back of the head. This was due to the mirror we did of the spline in part 2. After the duplicate edges are deleted go to the top view and edit the vertices down the center to take out the crease. figure 1 shows the crease on the front of the face. You might have to first convert them to corner vertices and then back to bezier vertices so the handles

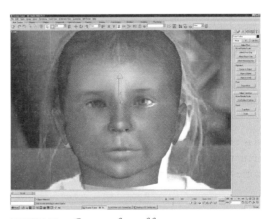

FIGURE 1A *Crease on front of face.*

show up. Once you're happy with the shape, we need to widen the whole face to fit the background animation better. But first we want to apply the surface modifier again and collapse the stack. After this is done use the Xform modifier to widen the face to match the background. When you apply the Xform modifier make sure the Selection Level is set to Sub-Object Gizmo then use the non-uniform scale transform to widen the head; you might have to size it in height a little also. I've tried to get a good match around the eyes, nose and mouth. Once you're close with the Xform modifier collapse the stack again. You'll have to first turn off the Sub-Object Selection. The head will now be an Editable Patch. You can right click on the head, go to properties and select See-Through in the objects Display Properties this will let you see the patch and the background behind it. Edit the patch until you are happy with the match.

FIGURE-2 / SCENE-2

So now this looks pretty good. It isn't an exact match but that is mainly due to the fact that we mirrored half the face to the other half and nobody's face is exactly symmetrical. I'm not going to worry about that here. If you want you can edit the patch further but I'm going to leave it the way it is. Now I'm going to show you why I bothered to set up the rotating ani-

mation in the viewport. Lets match the animation of the model with the viewport animation.

Maximize the front viewport with the animation in it. Play the animation. We want to have the model rotate with the viewport. Turn on the animate button at the bottom of your screen. At frame 0 go to the Motion panel and under PRS Parameters click on Rotation under Create Key. Now click on the Go to End button to take us to the last frame, it should be 44. Now click on the head model and rotate it 90 degrees so it is facing the same way the background image is. Since the Pivot point isn't at the center of rotation we don't get it lined up very good so lets fix that. First turn off the animate button. Now go back to frame 1 by clicking on the Go to Start button in the Animate and Time controls panel. Now in the command panel on the upper right find the Hierarchy tab and select it. Click on the Pivot button and down a little the Affect Pivot Only button. Under that in the Reset section click on the Transform and the Scale button, then click on Center to Object and Align to World under the Alignment section. The pivot is now lined up the way you would expect it to be and won't cause any unpredictable results as we use it. figure 2a shows the pivot correctly aligned. Now go to the last frame again. This time try a different way to get there by typing in 44 in the Current Frame Field. Now in the Hierarchy panel click on Affect Object Only instead of Affect Pivot Only and click on our model and move it to the front to

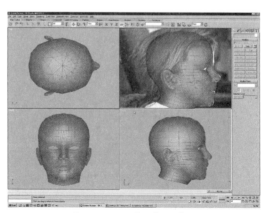

FIGURE 2　*Mirrored face.*　　　　　　　　　　　　　　**FIGURE 2A**　*Pivot correctly aligned.*

closer match the viewport image. It won't be exact but that's ok for now. Turn off Affect Object only. Now turn on the animate button again and go to frame 22. Rotate the model to more closely match the image in the viewport. By now I'm sure you're getting the idea. This is also a good frame to see the usefulness of using this type of reference. The cheeks obviously are not shaped correctly. figure 2b shows what we have at frame 22. Play the animation and see what we have so far. You can see that there is still some adjusting to do but we're getting there.

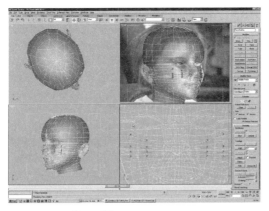

FIGURE 2B *Frame 22.*

FIGURE-3 / SCENE-3

Let's start by going to frame 44 and editing the side profile. Make sure the animate button is OFF! Use the Xform modifier again to scale the depth of the head to better place the ears, then slightly scale the height. I'm just trying to get a little closer before editing the vertices. Once we are happy with that minimize the view so you can see all four viewports. Collapse the stack, right click the model and select Sub-Object/Vertex. Working in the Front viewport (which now contains a side profile of the head.) draw a selection box around the neck and lower jaw an pull out the vertices until they more closely match our background image. Watching all viewports, start moving the vertices in place. I worked mostly around the lips and nose area but fix anything that

doesn't look right to you to get it as close as you want. figure 3a shows the edited profile. Play the animation again to check your progress. It's looking a little better. Now we will pull out the cheeks to finish the modeling of the head and face. Go to frame 22. Rotate one of your views to where you can get a clear view of the vertices on the front of the face. Select the vertices in the area of the cheek. There are 16 in all. figure 3b shows them selected. Press the space bar to lock the selection. Now from the top view, pull out the vertices while watching the view with the image in it. Make sure the animate button is off. Once you have it so it looks close step through the frames one at a time to compare the shape with what you actually have. Once you have them close

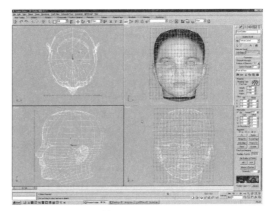

FIGURE 3 *Frame 44.*

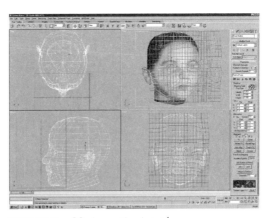

FIGURE 3A *Moving vertices into place.*

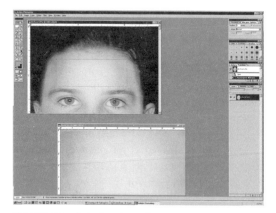

FIGURE 3B *Selecting the vertices.*

unlock the selection so you can further edit them individually. Smooth out the shape until you are happy with it. Play the animation, Not too bad! If you'd like, you could collapse the stack into an editable mesh and edit the mesh further. Now finally it's time to add some texture maps.

FIGURE-4 / SCENE-4

We are going to use the same images for the maps as we used to create the spline cage in part 1. Before we do any editing of the images though let's see what we get using them as is. We are going to use Texture Layers, a very cool Max plugin that makes some of the most complicated texturing fast and easy. If you

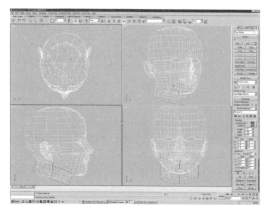

FIGURE 4 *Scene-4.max.*

don't have it you can download a fully working demo at http://www.mankua.com . With it you can follow along with this tutorial.

Open up Scene-4.max. I have collapsed the stack into an editable mesh and cleaned it up a bit by moving vertices around to better smooth out the sharp edges. Select the mesh and go to the modify panel. Click on the More button and find the Tex Lay modifier, click on it to apply it. You will see an orange Planar mapping Gizmo appear around the head and the Texture Layer Parameters in the Modify Panel. Notice the Channels Manager section. Number of Channels is set to 1, Current Channel is 1. Under that is a text box where you can name the Channel. Click in it and type in Front of Face and press Enter. Under that you'll see a few icons. Click on the one on the far right. This is the Show Map Button. This must be checked to allow us to view our bitmap in the viewports once applied.

Stop there for now and open up the Materials Editor. Click in an unused slot and name it Head Maps. Keep the defaults for the Standard map type. Click on the Button next to the Diffuse color box. When the Material/Map Browser requestor opens up scroll down until you see the Texture Layer Composite Map type, double click on it to select it. You will be presented back to the Material Editor. Under Texture Layers Parameters click on the Set Number Button. Change this number to 4. Click on the first button that says None. Select Bitmap and open Ali-Front.jpg. Apply the Material to our head. You should see the bitmap in the Front Viewport. Under Coordinates uncheck both Title boxes. Make sure Map Channel is set to 1. Down in Bitmap Parameters under Alpha Source check None. Now go back to the Modifier panel and to the Mapping section. You will see a small Icon that represents a planar map. Click and hold on it. A flyout will appear, select the icon way at the bottom. This is a freeform mapping type. This is one of the strengths that Texture layers brings to Max. A small requestor will appear asking you to Set Number of Points. Set it to 19 for U Columns and 19 for V Rows. If you find you need more later you can always add them. Click OK. The Mapping Gizmo will now look like a deformer

modifier. Lets move it to the front of the face so we can see all the points. In the Texture Layer modifier panel select Sub-Object , accept the default. It should say Gizmo. Now go to the top layer and move the gizmo to the front of the face until you can see all the points in the front view. Now go to the Front view and move the Gizmo until you have the map better lined up the mesh, you can also use the Non-uniform scale tool to scale the Gizmo for a better fit. Don't worry about the ears just get the eyes, nose and mouth matched up closer. It will help to turn on Edged Face mode in the viewport so you can see the edges of the mesh to line up the map to. Now Maximize the front view and change the Sub-Object in the modifier panel again, this time to FFM Points. You can now move the points around while watching the map. Move the points around until you have a good match in the front view. Figure-4a shows the screen at this point. For the fun of it, try a test render.

Now we are going to use another powerful feature of Texture Layers. Rotate one of the views. The easiest way to do this is to hold down the ALT key and the middle mouse button and drag the pointer around in a view. Make sure the view is in Smooth + Highlights mode so you can see the bitmap. We want to look at how the map projects on the side of the face. Notice that the map is stretching quite a bit. We will map the sides of the face with separate bitmaps but we want to blend them with the front

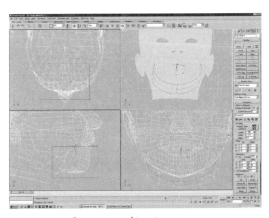

FIGURE 4A *Screen up to this point.*

bitmap. With Texture Layers this is really easy. Notice in the Modifier Panel the section called Attenuation. This very cool feature will basically let you fade the map in 3 dimensions. To see how it works, set up your viewports so you have a top, side and front view. Then click in the On box in the attenuation section of the viewport. Make sure that you have the Sub-Object on and set to Gizmo. This will allow you to see the areas affected as you move the spinners. Now look in the front view and start turning down the U Start attenuation. You will see two lines move from the outside in. This is the starting edge in the U direction. Adjust the spinner until the lines stop at about the outside edge of the eyes. Now move over to the Offset spinner and start turning it up slowly. You will see two brown lines move out from the yellow lines. This is your falloff, at this point the map will not show anymore. Do the same for the V direction. Keep the start point just above the chin and the offset just below the chin. You can only see the affects of the mapping when you render it so try rendering the user view again to see what we have done to this point. Since the neck is narrower than the width of the face we can still see the map projected on the entire neck even though it is deeper in than the front of the face. This is where the W attenuation comes in handy. Now look in the top view and adjust the W spinners. This will change the depth. You can see the yellow and brown lines as you adjust the spinners the same as with the V and U spinners only these show you how deep the map will go. Make the yellow line stop right about at the corner of the mouth and the brown line in just a bit. Try rendering the user view again to see the effects. We will adjust these lines as we go but this is a good starting point. Do a test render again to see the effects of changing the W attenuation. Figure-4b is what my screen looks like.

Now lets add another map. Go back to the Texture Layers modifier panel and where it says Number of Channels click on the # button . When the requestor comes up change it to 2 and click OK. We have now applied another planar map gizmo. These mapping coordinates will be for one of the sides of the face so down in the alignment section click on X.

FIGURE 4B *Test render.*

This will rotate the gizmo to be perpendicular to the side of the face. Now click on the Fit button. Select Sub-Object Gizmo and move the Gizmo in the top view to the left until it clears the mesh. Now change one of your views to a left view and make sure it is in Smooth + Highlight mode. Go to the material editor and in the Texture Layer composite map click on the second button under the one we used for the front and select Bitmap and then Ali-Side.jpg. Click on the Show Map in Viewport button, Change the Map Channel to 2, uncheck both Tile boxes, and under Alpha Source select None. Now using the go to parent arrow go up a level to the Texture Layers Parameters panel. When the map appears in the viewport Select Sub-Object Gizmo and move the gizmo until you have the map lined up better with the mesh. It will help if you turn on edged faces mode in the viewport so you can see where the ear is. You can also use Non-Uniform scale here to scale the Gizmo to the fit the whole side of the face. Now change your mapping type to Free Form like we did in the front, changing the number of U columns to 15 and V Rows to 15. Turn on Sub-Object – FFM Points and tighten up the fit of the map to our mesh. Go ahead and do a render to see what we have. The Map covers our front map, that's because we haven't set any attenuation yet. Go to the modifier panel and edit the attenuation parameters the way we did for the front map. Use the outside corner of the eye for a reference spot for the start attenuation for U, the V

attenuation we can pretty much leave alone. You can also use the outside corner of the eye for the start point for the W attenuation. If you do a test render now you'll notice that we have cut off some of the eyebrow. To fix this lower the U attenuation value. Now you might find that the front map isn't covering enough. All you have to do is in the Modifier panel change the current channel to 1. This will let you edit our front mapping parameters. Turn up the U Attenuation to widen the effective area of the map. This is how you can fine tune your mapping. For the most part this is pretty good for not even editing the bitmaps yet. Now let's add one more for the other side of the head. Repeat the process, adding a channel, aligning the gizmo, loading the map and editing the free form mapping and the attenuation for a better fit. If you don't see the map in the viewport you have probably forgotten to change the map channel in the material editor. We don't have to worry about the hair because we are going to model and map it separately, I am not going to worry about the back of the head either because for what I am going to use this for the back of the head will never be seen. If you did want to map the back of the head you would just repeat the same steps we have already done with another map. Also you will notice that the ears map through to the head. To correct this we could apply a localize map just behind the ears to cover it up but I'm not going to do that in this tutorial either but with the lessons you've learned here you could easily complete those steps on your own. What we do still need to do it map the front of the neck and under the chin.

FIGURE-5 / SCENE-5

We now need to map the neck and under the chin. I'm going to edit the front bitmap to create a new bitmap with just skin texture and color. I will be using Photoshop but any paint program that lets you work with layers will work. Open up your paint program and load in Ali-front.jpg. Create a new image at about 800 x 400 pixels. Create a rectangle selection in the forehead area. Feather out your selection about 5 pixels, copy it and paste it in your new file.

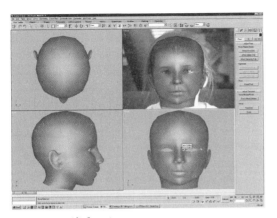

FIGURE 5 *Ali-front.jpg.*

Select all and scale it to fill the whole image. Now I know that this isn't the purest way to do things but it will work. We are mainly concerned about keeping a good color match so it will blend into the rest of the maps nicely. If we were trying to make an exact representation of Allison we would have to take a different approach but for our purposes here this will work fine. Figure-5a shows the selected area we started with and the new edited map. Now we will continue in Max. You can continue from where we left off or open up Scene-5 in Max. We want to apply the neck map now. Select the mesh. Change the Current Channel to 4 in the Texture Layer Parameters. For the Mapping Type we are going to select Cylindrical this time. For Alignment click on X.

Now while in Sub-Object Gizmo mode use the Mapping Length, Width and Height spinners to scale the gizmo to more closely fit the neck. Now move and rotate it into place. U Attention works a little differently with a Cylindrical Gizmo. Click on Attenuation the watch in the top viewport as you lower the U Start values. This will control how much of the cylindrical surface the map will wrap around. Since we have the sides of the neck mapped already we only want to cover the front so lower the U Start valued down to around 30 and set the offset to around .1. Set the V Start and Offset values so we have just the bottom part of the chin covered. We won't be using the W value in this situation. Figure-5b shows the mapping gizmo with the settings I used. Ok, that looks pretty good, now all we have left is under the chin. We will use the same technique that we used for the neck only this time we will set the Alignment of the Cylindrical Gizmo to Z. Move the Gizmo into place, Set your Attenuation Levels, and this time we will set the Overall Attenuation to 10. This makes the entire map a bit transparent. I am doing this because the maps behind the chin are so much darker than the map we are using for the chin. Instead of trying to create a new map that better matches the colorization of the front and side maps at the chin area I am simply telling Texture Layers to let some of the darker maps show through. I could easily write an entire chapter or two on different ways to approach mapping this head

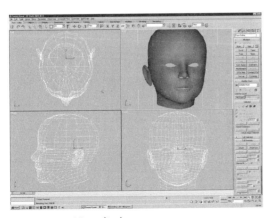

FIGURE 5A *New edited map.*

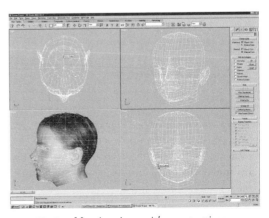

FIGURE 5B *Mapping gizmo with correct settings.*

using much more sophisticated methods but that would be beyond the scope of this tutorial and frankly a little over kill for this project. I have just scratched the surface of the power of Texture Layers. I used only the basics, if you explore it further on your own you'll see that you can achieve much better results and greater levels of detail and realism. At the same time I think you can see that using some very simple methods, without a lot of extra editing and painting you can achieve some pretty impressive

results. Some of the ways to better approach the method we used here would be to simply take more photographs at different angles and use good lighting to eliminate shadows, that way the blending would be even easier.

Well that's it for this installment. I have one more installment in this series of tutorials. You can keep on editing and improving the model and mapping until next time. Hope you learned something from this. Until Next Time....Happy 3Deeeing.

CHAPTER

47

Creating a DHTML Animation Using Netscape

KELLY VALQUI

DHTML stands for Dynamic HyperText Mark-up Language, and pretty much defines itself. The word "Dynamic" of course meaning forever changing, and HTML, well, stands for good ole HTML. Put that all together in developer terms and you have an emerging Web standard that revolutionizes the way Web authors add interactivity and dynamic features to their Web pages.

DHTML is a combination of Web technologies (such as HTML, Cascading Style Sheets, scripting languages, and object-oriented programming languages) that allows Web pages to display animation. Dynamic HTML allows a Web page to change after it has been loaded into a Web browser without any communication from a Web server. For example, a section of text can change from one size or color to another, or a graphic can move from one location to another.

So, will you need to learn the whole aspect of DHTML to create neat animations on your Web page? No, that's what this tutorial is for: to get to the meat. Of course, learning more techniques using DHTML and becoming more familiar with the language could only advance your knowledge in creating more interactive Web pages, but you're here to learn animation.

Since DHTML is basically HTML with a kick (actually, it's a way of integrating existing HTML technologies together), all you will need is a simple text editor such Microsoft's NotePad or Mac's SimpleText to create DHTML. To view the work as you create it, you will need a Web browser such as Internet Explorer or Netscape Navigator. Both Microsoft and Netscape have created a dynamic Web object model (standard) for you to extend the way you use HTML to create your Web pages. However, you will need version 4.0 or later of Netscape Navigator to run this particular DHTML animation technique.

Even though both Netscape Navigator and Internet Explorer have implemented DHTML technologies in their 4.0 versions and later, this does not mean they comply with each other. Microsoft's version of DHTML animation consists of positioning and using ActiveX controls. Netscape's version of DHTML animation is a bit easier to learn, plus Netscape's Web browser is more popular than its counterpart Internet Explorer. Of course, this is not to say you should design your site with only Netscape Navigator in mind. You should always offer an alternative way of viewing your site for viewers who may be using another Web browser.

THE ANIMATION RECIPE

Animation attracts attention, especially when most of the domain is viewed as static. When creating this **345**

attention-getter called "animation with DHTML," you can create animated Web pages using one of many possible avenues. I have chosen to use two techniques to animate text and images on a Web page. One technique is Netscape's layering, and the second is to add an appropriate JavaScript to get it in motion. Assuming that you are not a JavaScript programmer, and do not know a lot about the layering technique, I will describe both techniques and then show you how they work together.

NETSCAPE'S LAYERING

Let me say up front that layering is a Netscape Navigator 4.0 deal. If you create layers on your Web pages, and a viewer displays them using another Web browser application, the images or text will display as regular elements on a Web page. This can wreak havoc on your DHTML Web pages, displaying them less than ideal to your intended design.

A layer acts as an independent unit on a Web page. Layers enable you to define a position where you would like to display an element such as text or images. If any of the elements are layered (positioned) within the same defined area, they will appear overlapped in the order in which each layer was coded in the HTML document.

Take a look at the HTML code for layering elements on a Web page, and then we will break it down into more digestible parts.

```
<HTML>
<BODY>

<LAYER NAME="circle"LEFT=300 TOP=200>
<IMG SRC="circle.gif">
</LAYER>

<LAYER NAME="arrow"LEFT=300 TOP=200>
<IMG SRC="arrow.gif">
</LAYER>

<LAYER NAME="text"LEFT=300 TOP=200>
<font color="orange"size="6">This is
    Netscape 's Layers!<br>
```

```
We are working with three layers.<br>
Two of the layers are transparent
GIFs.<br>
An one layer is just text.</font>

</LAYER>
</HTML>
```

When creating layers, each layer works in order of sequence. For instance, the red circle in the example is positioned at the bottom of the other two layers because it is the first layer defined in the HTML document. Because I positioned all of the layers in the same defined area, they appear overlapping in the sequence I coded them: the circle first, then the arrow, and finally the text. Keep this in mind when layering.

The images in the two bottom layers are transparent. If I had not created them as such, the arrow would have simply covered up the circle because both images are 200 × 200 pixels and positioned exactly in the same place.

Ok, let's get down to the meat of the code.

```
<LAYER NAME="circle"LEFT=300 TOP=200>
```
LAYER_The LAYER tag denotes to the Web browser that this is a layer.
NAME_Names the layer.This is important when you begin to animate the layers.
LEFT_Positions the layer element in pixels from the left of the computer screen.
TOP_Positions the layer element from the top of the computer screen.
```
<IMG SRC="circle.gif">
```
IMG SRC_Inserts an image.
You can also place text in a layer as in the third layer in the preceding example.
```
</LAYER>
```
/LAYER_Ends each layer.

As you can see, positioning layers on a Web page is not difficult to do. When layering images, though,

the ALIGN attribute and the CENTER tag do not work. However, you can add the image size attributes to your images as you layer them to enable faster download time. Layers do not have to be placed in the same defined area; I have done so for demonstration purposes only.

One more important factor to mention is that in the example I positioned the images and text 300 pixels from the left of the screen and 200 pixels from the top of the screen. If I were to continue coding the Web page without using any more layers, I would have to take into consideration the layers I have already positioned. Any elements that I add to my Web page, such as text that spills over into the defined area of the layers, would be overlaid by the existing layers.

ADDING THE ANIMATION

After you have decided how to lay out your layers, you may wish to add some movement to create an animation on your Web page. Using a simple JavaScript can actually get the whole thing in motion. JavaScript is a scripting language that was created by Netscape Navigator and resembles an object-oriented programming language such as Java or C programming, but on a much smaller scale. This makes JavaScript both easy to learn and easy to work with.

The following script is actually added on to the layering that we used as a demo previously. You can "tweak" the code so that you can customize it for your own DHTML animation. Working from the top, I will create the HTML document and then break it down step by step. See Figure 1.

The preceding script is relatively easy, and can be tweaked to create a custom animation by moving text and images around on your Web page. Even though the images and text are not that elaborate, the DHTML adds a neat effect on an otherwise static Web page.

You can actually copy and paste the HTML code and JavaScript and then customize the layers and script. The complete script and HTML code appears at the end of this tutorial. Copy the entire code, paste it in a text editor, save, and then you can tweak

the code. Actually getting in and playing around with the code will enable you to learn rather quickly how to create your own DHTML animation.

Before you begin using this script, there are some important rules to follow:

- JavaScript is case sensitive; the script commands should appear as shown in this tutorial.
- DO NOT break the JavaScript lines of text. Like HTML, a string of JavaScript must remain on the same line. For instance, this string should appear on one line and not be broken:

```
circle.offset(8,-2);
```

If this string of script was written like this:

```
circle.
offset (8,-2);
```

the script will not run.

- Name your layers, and then make sure you denote the names in the beginning of the script (e.g., `var circle = document.layers ["circle"];`). Otherwise, the Web browser will not know which layer to work with.

With that said, let's tear the script apart.

```
<SCRIPT LANGUAGE="javascript">
```

Denotes to the Web browser that the following is a JavaScript.

```
function animate()
```

Names the function. A function is a set of JavaScript commands that do something; in this case, we are creating an animation.

```
{
```

This combines or separates sections of a script.

```
var circle =document.layers ["circle"];
    var arrow =document.layers ["arrow"];
```

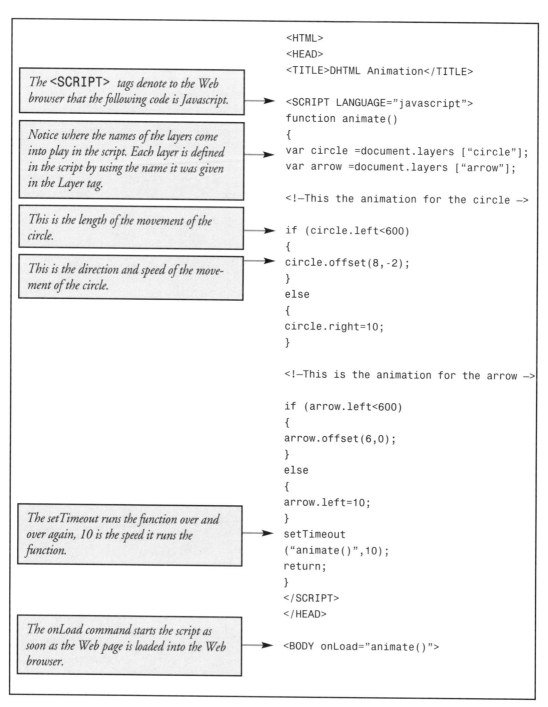

The <SCRIPT> *tags denote to the Web browser that the following code is Javascript.*

Notice where the names of the layers come into play in the script. Each layer is defined in the script by using the name it was given in the Layer tag.

This is the length of the movement of the circle.

This is the direction and speed of the movement of the circle.

The setTimeout runs the function over and over again, 10 is the speed it runs the function.

The onLoad command starts the script as soon as the Web page is loaded into the Web browser.

```
<HTML>
<HEAD>
<TITLE>DHTML Animation</TITLE>

<SCRIPT LANGUAGE="javascript">
function animate()
{
var circle =document.layers ["circle"];
var arrow =document.layers ["arrow"];

<!—This the animation for the circle —>

if (circle.left<600)
{
circle.offset(8,-2);
}
else
{
circle.right=10;
}

<!—This is the animation for the arrow —>

if (arrow.left<600)
{
arrow.offset(6,0);
}
else
{
arrow.left=10;
}
setTimeout
("animate()",10);
return;
}
</SCRIPT>
</HEAD>

<BODY onLoad="animate()">
```

FIGURE 1

Creates a variable that references a layer. Variables represent something or a line of code; in this case, they represent the layers that will be called upon throughout the script.

```
<!—This the animation for the circle —>
```

Comment line. This is regular HTML and does not display to the viewer. Comment lines are used for internal notes to the Web page author.

What's on the CD?

On the CD-ROM that accompanies this book, you will find the following:

- All of the support files for the tutorials including all images, animations, and movie clips.
- **Amapi**. Amapi for both Windows and Mac users is included on the CD. Amapi is a full featured 3D graphics and animation application that handshakes with a number of other 3D file formats.

WHAT IS AMAPI?

www.tgs.com/amapi
Template Graphics Software, Inc.
5330 Carroll Canyon Rd., Suite 201
San Diego, CA 92121
FAX: +1-858-452-2547

Amapi is a fast 3D modeler from TGS, Inc. for polygonal and NURBS design. It is both a stand alone application (for PC and Mac) as well as being available with a plugin connection to 3DS max 2.5 AND 3. Typically you will find that it is an excellent companion to 3DS MAX, in that it significantly speeds up the creation or modification of 3D geometry. An Interactive Training CD is available from Animhouse: www.animhouse.com

AMAPI RESOURCES, TUTORIALS, AND OTHER USERS:

www.staigerland.com/amapi
www.17hours.com
www.chris-stocker.co.uk
www.smart3d.com
www.multimania.com/bretagnolle
http://perso.club-internet.fr/odrion/
www.deepcold.com
http://o.ffrench.free.fr/
www.martindeblois.com

AMAPI ON THE CD

The CD contains

- Full version of Amapi 4.1, and
- Trial version (TE) of the latest Amapi 5.15.
- Large collection of 3D models, materials, tutorials and HTML documentation (user/reference manual).

USING THE FULL VERSION OF AMAPI 4.1

In order to use the full version of Amapi 4.1, do this:

1. Register online at www.tgs.com/amapi (look for 'Register Online')
2. Enter this registration serial number: **A3D10690CRSM1** (serial number on registration form)

351

3. When starting Amapi, you will be prompted for a license password. Enter the following:
 - Serial number (for online registration): **A3D10691CRGRB**
 - Amapi password (full license): **29fab608a8fc7fb26**

This will give you full access to Amapi 4.1 for *free.*

USING AND EVALUATING AMAPI 5.15 TE

In order to evaluate the many new powerful features of Amapi 5.15, install and run the Trial Edition of Amapi 5.15, included also on this CD, along with an extensive presentation of the new features, tutorials, documentation and links to other Amapi users. When using the Trial Edition (TE) of Amapi 5.15, you can operate in demo mode (which is the default) for as long as you want without trial password.

In Demo mode, saving or exporting is disabled, however all other features are enabled, such as rendering to image file, animation files (AVI) and all modeling tools. You can therefore take your time and learn the new features of Amapi at your leisure without rushing into a buy-don't-buy decision. When you need to test the exports, or want to save your current 3D model on disk, or use the 3DSMAX plugin to move data from Amapi back to MAX, then you'll need a trial password. In order to obtain a trial password, which is good for several weeks, do the following:

1. Go to www.tgs.com/amapi
2. Select 'PC Demo'
3. Enter your registration info.
4. Make sure your email address is correct. The trial password will be sent automatically by the server via Email to that address.

5. After registration, an Email message is sent to your email address, with a temporary trial password. You'll then see a choice of sites from which to download the Amapi Demo (Trial Edition). You won't really need to continue at this point, unless a newer version of Amapi is available by that time.
6. Check your mailbox for an email from TGS after a few minutes. It will contain a trial password which is good for a few weeks.

WHAT ABOUT THE 3DS MAX PLUGIN FOR AMAPI?

You can find the installer for the 3DS MAX plugin to Amapi at this web location:

http://www.tgs.com/Support/Tutorials/Amapi/Amapi-3DMax.html

If the location has changed from the time of this printing, go to www.tgs.com/amapi and look for Import/Export options, where you should be able to find a link to the 3DS MAX plugin. The plugin installer (for Amapi 5.1) is available for MAX 2.5 or 3. Amapi 4.1 works with the MAX 2.5 plugin only. For Amapi 4.1, the plugin installer is provided on the CD.

SUPPORT

If you have questions on the use of Amapi, please contact support@tgs.com (In Europe: support@europe.tgs.com). Our dedicated support staff is ready to help. Other contact details are available on our website at www.tgs.com

Vendor Contact Info

B

Here is a list of Web sites representing the software developers covered in the book. Visit them to get the latest information on the software.

Adobe Photoshop/Illustrator/Canoma
http://www.adobe.com

auto*des*sys FormZ
http://www.formZ.com

Caligari's trueSpace
http://www.caligari.com

Carrara
"Ringo Monfort" <RingoM@marvineng.com>

Corel Bryce
http://www.corel.com

CuriousLabs Poser
http://www.curiouslabs.com

Discreet Logic 3DS Max
http://www.discreetlogic.com

ElectricImage
(temporary) http://www.play.com

Hash Animation Master
http://www.hash.com

Maxon Computers Cinema 4DXL
http://www.maxoncomputer.com

Maya
http://www.gwha.com

NewTek's LightWave
http://www.newtek.com

Robert McNeel & Associates' Rhino
http://www.rhino3d.com

Strata Studio
http://www.strata3d.com

Glossary

Aliasing: The "jaggies", apparent imperfections when you zoom in on a texture, also called "stair-stepping".

Alpha Channel: In addition to RGB values, colors can also be given Alpha values in a separate Channel, which are most often associated with opaqueness/transparency.

Animation Path: A straight or curved spline that determines the path an object will take in an animation.

Anti-Aliasing: Smoothing routines for lines and curves that blend several colors. Used to get rid of the "jaggies".

Atmospherics: Adding effects to an image or animation frame that emulate various natural conditions (fog, haze, etc.)

Bluescreen/Greenscreen : A background used to represent transparent parts of a frame or image, used to determine where added backgrounds will become visible.

Channels: Each Channel in a color image holds a discreet amount of data, usually 8 Bits (in a 24 or 32 Bit configuration). The most common Channels are Red-Blue-Green-Alpha. Another way of using the term, however, is as a way of describing a Materials application that maps data to objects. There, Channel data includes Diffuse, Specular, Opacity, Bump, Displacement, and other attributes.

CMYK: Cyan, Magenta, Yellow and Black. CMYK color space describes the inks used in the printing process.

CLUT: The Color Look-Up Table, used in conjunction with the image palette.

Direct3D: Microsoft's standard for 3D graphics. One of the components of DirectX, used mostly for gaming-oriented 3D accelerators.

DirectX: Developed by Microsoft. DirectX is used to access a particular class of hardware devices.

Dithering: The process of adding colors that bridge adjacent colors to create the appearance of other distinct hues. Blending several to create a new color, visible when you zoom in on the texture.

DPI (Dots Per Inch): A unit of measure that describes the resolution of images when targeted to printers and other output devices.

Extrusion: Extruding a 2D object and creating a 3D object (like a square extruded into a cube).

Goraud Shading: A subset of interpolative shading.

IK (Inverse Kinematics): Setting up a hierarchy of parent and child objects, so that the Child object can be used to move the linked Parents.

Interpolative Shading: Assigning each pixel inside a polygon a particular shade, computed by interpolating between the polygon's vertices, or between the polygon's edges.

JPEG (Joint Photographic Experts Group). A common image compression format.

355

Keyframes: Frames of an animation that define the Key or central movements involved.

Layers: Separate parts of an image or animation composite used to hold part of the data used in the final rendering.

Lathing: The process of creating a 3D surface by rotating a 2D spline around a selected axis.

Lighting: Computing the way each vertex of an object interacts with all light sources and qualities in a scene (ambient, diffuse, or specular) given the object's assigned material properties.

Mapping: Attaching an image to the surface of an object. There are several types of mapping that each address the object in a different manner.

Modeling: Creating what appears to be a 3D object that can be translated (moved, resized and rotated) in virtual 3D space.

NURBS (Non-uniform Rational B-Spline): A type of spline that is capable of being used in the shaping of organic objects more effectively than other spline types.

Opacity: The degree to which an indicated Image or Layer or Material can become partially or totally invisible, usually computer in percent.

Open GL: A cross-platform 3D graphics scheme originally developed by Silicon Graphics Inc. Open GL includes specific routines for shading, texture mapping, texture filtering, anti-aliasing, lighting, geometry transformations and more.

Patch: A connected mesh of points that is used to create one element of a finished model when attached.

Phong Shading: A lighting algorithm (equation) for 3D imaging based upon the color of each pixel.

Pixel: Picture Element.

Primitive Objects: Basic 3D geometric objects used in combination to model more complex forms.

Ray Tracing: Computing the light-ray paths from the observer's eye to the objects in a scene and the light sources.

Rendering: Creating the images that result from the elements in a scene.

Resolution: The number of dots per inch (DPI) or pixels per inch (PPI) that can be displayed and/or reproduced on monitors and various output devices. The higher the resolution, the sharper the image quality.

RGB: The Red-Green-Blue "channels" whose data is combined to create a full color image.

RGBA: Red-Green-Blue-Alpha.

Storyboards: A visual display of a story, indicating where motions, narrations, and sound FX and music will occur in time. All serious animation productions start with storyboards.

Tessellation: Breaking polygons down into triangles. This is also a way to achieve a smoother object when done repeatedly.

Texture Mapping: Assigning a given texture (usually a bitmap) to a polygon.

Timeline: A special graph that displays where each keyframe and frame in an animation is placed in time.

Tweaking: making small changes in an element of the scene to achieve a more desired result.

Tweening (in-betweening): Computing the make-up of the frames between two Keyframes.

XYZ: The axis that represent three dimensional space.

Z-buffer: A process used in 3D graphics and animation that allows objects to appear behind each other in 3D space.

Index

A

Adobe products
 Acrobat and Reader, source for, 351
 After Effects, 335
 as industry standard, 1
 See also Canoma (Adobe); Illustrator (Adobe); Photoshop
 (Adobe)
Aircraft, modeling
 Carrara tutorial, 333–335
 Leonardo Da Vinci's flying machine, 118–127
Aluminum, rendering, 19–22
Amapi (TGS, Inc.), 351–352
Andromeda Effects
 Cutlines Photoshop filter from, 61–65
 Mezzotint collection, 64
 Web address, 61
Animation: Master (Hash Inc.)
 antenna modeling with, 40–42
 wing modeling with, 31–39
Animations
 bird flight cycle, 107–117
 Carrara aircraft animation tutorial, 333–335
 circular expansion motion in grass landing field,
 213–214
 DHTML tutorial, 345–349
 fireworks tutorial in LightWave, 194–202
 Freeform *vs.* Character Studio Footstep for flying mod-
 els, 124–125
 hopping, realistic, 101–106
 Maya Paint Effects Tool tutorial, 210–215
 MEL scripts for, 207–208
 in microorganism project, 206–208
 particle animations, 194–202
 in scripted games, 302–303
 Talking Virtual Announcer project, 128–137, 138–148,
 336–344
 Vic Disco tutorial, 277–283
 Web page animations, 345–349
Antennae, insect
 beaded antennae, 31–34
 bristlelike antennae, 34–36
 clubbed antennae, 36–37
 elbowed antennae, 37–38
 feathery antennae, 39
 sawlike antennae, 38–39
 threadlike antennae, 38–39
Anti-aliasing, defined, 22
Architecture, modeling
 arches, 322–323
 ArtBeats City Surfaces, 52
 bridges, 322–323
 columns, 330–331
 fantasy architecture, 188–191
 lofting techniques in LightWave 3D, 188–193
 Primitives and, 322–323
 stairs and staircases, 329–330
Arms
 RayDream assembly process, 88
 RayDream to model, 84–85
 Strata Studio Pro to model, 262–263
Array modeling, 329–332
 with imported models, 331–332

ArtBeats, 52–55
 explosion effects, 282
Aspect ratio, defined, 22
Authors, biographies and contact info, xxiii–xxv

B
Bats, bat-like wings, 119–120
Beaks, modeling, 113, 151–152
Birds
 flight cycle tutorials, 101–106, 107–117
 metaball modeling of, 149–152
 modeling with HyperNURBs, 107–113
Bitmaps, defined, 22
"Blue screen" operations, 278
Board games, JavaScript tutorial on, 297–303
Bodies
 RayDream Studio to model, 81
 spider-like body modeled in 3D Studio Max, 310–312
 Strata Studio Pro to model, 257–260
 Zygote body modules, 91–92
Bolts, modeling in Strata Studio Pro, 247–249
Bones
 bending forms, 103
 HyperNURBs models and, 113–116
Boolean operations
 complex modeling and, 328–329
 Primitives and, 324–329
 Strata Studio Pro modeling, 245–247, 254
BotModels, PrimBots, 318–321
Bowls, Boolean operations and modeling, 326–327
Brightness
 defined, 22
 dynamic range, defined, 23
 Photoshop image processing, 64
Bryce (Corel)
 ArtBeats/Canoma Urban Environments for, 52–55
 BSmooth for Bryce tutorial, 66–70
 exporting models from, 56–60
 landscape images in, 62–63
 media transformation tutorial, 61–65
 Poser and, 43–47, 56–60
 sky images in, 62–63, 335
 Terrain Import with BSmooth operator, 67
BSmooth
 export options in, 67
 landscape projects in, 68–70
 operators in, 67–68
 Preferences in, 66–67

tutorial, 66–70
 Web address, 66
Bump maps
 defined, 22–23
 gray scale and bump mapping, 22–23
 Photoshop and, 21
Busse, Klauss, 66
Butterflies, modeling wings for, 41–42

C
Cage modeling, 107
 form•Z and Patch Tool for, 170–174
Canoma (Adobe)
 Gotham City 3D project, 71–76
 urban landscape development with, 52–55
Carrara (Adobe)
 aircraft animation tutorial, 333–335
 Array modeling in, 329, 331–332
 Boolean modeling operations in, 324–329
 exhaust effects tutorial, 93–100
 Internal Grouping Tool in, 330–331
 3D Primitives modeling in, 317–324, 329–331
 Vertex Modeler in, 89–92
CD contents described, 351–352
Chairs, furniture modeling, 45
Characters, modeling
 Alien 1 RayDream Studio tutorial, 77–88
 blending types thorough Parenting elements, 50–51
 cartoon lion form•Z tutorial, 170–174
 ClayBird project, 149–152
 droid Strata Studio Pro modeling tutorial, 235–269
 "Elee Phantoosy" 3D Studio Max tutorial, 313–317
 "Jack O'Rachnid" 3D Studio Max tutorial, 307–312
 old man Carrara and Poser tutorial, 89–92
 RayDream assembly process, 81–84
 Sumbies (combination Sumo Babies and Bunnies), 50–51
 Zygote Character Library, 43
Chromakey operations, 278
Cinema4D (Maxon Computers)
 bird flight tutorial, 107–117
 hop anatomy tutorial, 101–106
ClayBird project, 149–152
Cloning
 Array modeling to duplicate objects, 329
 to edit source images, 71–73
 in 3D Studio Max, 312
Clothing, Zygote Costume Shop for Poser 4 tutorial, 48–51

Clover, modeling with form•Z, 176–178
CMYK, in image composing process, 4
Color
 ambient color, defined, 22
 CMYK and RGB in the image composing process, 4, 5–7
 color/texture maps, 23
 diffuse color, defined, 23
 Hue/Saturation in Photoshop, 15–16
 lighting and mood, 293–296
 saturation defined, 23
 water and variation in, 274
Columns, modeling, 329–330
Compositing
 composite defined, 23
 in Photoshop, 19
Computer hop, avoiding, 101–106
Concepts, for graphics assignments, 4
Cone primitives, modeling with, 317
Costumes, Zygote Costume Shop for Poser 4 tutorial, 48–51
Courtroom project, 182–187
Crashes, simulating, 126
Creative process
 concepts for graphics assignments, 4
 dreams and dreaming, 30
 history as inspiration for, 118–127
 movies as inspiration, 29, 235–269
 phobias as inspiration, 307
 sketches, preliminary, 77, 222–223
Crumple Noise shaders, 270–276
Cube primitives, modeling with, 317
Cups, Boolean operations and modeling, 324–326
Cutline Photoshop filter (Andromeda), 61–65
Cylinder primitives, modeling with, 317
Cylinders, formula for cylindrical mapping, 19

D
Da Vinci, Leonardo, flying machine model of, 118–127
DEM files, BSmooth operators for, 68
Design process, preliminary sketches, 77, 222–223
DHTML animation tutorial, 345–349
Digimation, Clay Studio Pro, 149–152
Dingbats, 27–28
Disney, Walt, 29
Doorways
 Poser and Bryce to compose, 46
 simulated through use of light, 283

Double helix patterns with Daisy BSmooth operator, 67
Dreams and dreaming, 30
Dresser, modeling with Primitives, 323–324
Droids, Strata Studio Pro modeling tutorial, 235–269

E
Ears, modeling
 elephant-like ears, 314–315
 3D Studio Max techniques, 143–146
 zooms and pixilation, 131
Editing
 nondestructive editing and layers, 7–8
 non-linear video editing, 130–131
 Ulead's MediaStudio audio and video editor, 277, 283
ElectricImage
 BlendModes option, 153–157
 export and Tessellations settings, 168–169
 Tessellation settings tutorials, 158–162, 163–169
 troubleshooting anomalies in, 156–157
 Use-as-Value Option tutorial, 153–157
"Elee Phantoosy" 3D Studio Max tutorial, 313–317
Exhaust effects
 Carrara tutorial, 93–100
 lens flare to simulate, 197
Explosions, mirror ball explosion, 282
Extruding
 Inner Extrude/Extrude combinations, 102–103
 Inner Extrude/Extrude in Hyper NURBs modeling, 107–112
 lofting techniques, 188–191
 operators in BSmooth, 67
Eyes, modeling
 bulging eyes à la Homer Simpson, 172–173
 eyelashes, 315
 RayDream Studio to model, 78–80
 3D Studio Max techniques, 139–140, 315

F
Faces, modeling
 Rhinoceros 3D lofting techniques, 232–234
 Talking Virtual Announcer tutorials, 128–137, 138–148, 336–344
 3D Studio Max techniques, 146–148
 vertex modeling of, 89–92
 zooms and pixilation, 131
 See also Ears, modeling; Eyes, modeling; Mouths, modeling
Fade functions, in Adobe Photoshop, 6

Feet
 birdlike feet, 151
 Strata Studio Pro droid feet, 253
File conversions using Photoshop, 18
Fingers, modeling with RayDream, 86
Fireworks, LightWave 6 tutorial for, 194–202
Flat-mesh modeling techniques, 170–174
Flight
 bird flight tutorial, 107–117
 Carrara aircraft animation tutorial, 333–335
 Leonard's Flying Machine tutorial, 118–127
Fonts
 pattern design with, 24–28
 Zapf dingbats, 27
Form•Z (auto*des*sys)
 character modeling tutorial, 170–174
 landscape creation tutorial, 175–181
 procedural textures in, 178–181
Fountain primitives used in exhaust effects, 93–95
Freeform animation mode, 124–125
Furniture, modeling, 45–46, 323–324
Furniture, modeling with Primitives, 323–324

G

Games, JavaScript tutorial, 297–303
Gaussian Blur operator in BSmooth, 67
Glossaries, 22–23, 355–356
Gotham City, 3D modeling with Canoma, 71–76
Grasses, modeling
 with form•Z, 176–178
 with Maya Paint Effects Tool, 210–214
Grass-O-Matic plug-in (Sisyphus Software), 311–312
Gravity
 stretch and squash in realistic movement, 104–106
 weight of birds in flight, 107, 115–116

H

Hair, modeling with Grass-O-Matic plug-in, 311–312
Hands, modeling with RayDream, 85, 87
Hash, Inc., Animation:Master from, 31–42
Heads, modeling
 form•Z cartoon lion tutorial, 170–174
 Jack-o-Lantern modeled in 3D Studio Max, 308–310
 Pixels:3D tutorial, 216–221
 RayDream Studio to model, 78–81
 Strata Studio Pro droid head, 264–268
 Talking Virtual Announcer tutorials, 128–137,
 138–148, 336–344
 3D Studio Max techniques, 308–310, 314–315

Helicopter landing animation, 210–215
Helixia project, 69
Hierarchies, linking, 59–60, 320–321
 bones in HyperNURBs models, 115–116
Hip joints, Strata Studio Pro, 253–254
History Palette in Adobe Photoshop, 3
Hot Points, 320–321
HTML (HyperText Markup Language)
 DHTML animation tutorial, 345–349
 scripting, 297–303
Humans, modeling, old man project, 89–92
HyperNURBs models
 bird flight cycle tutorial, 107–117
 one-legged hopper model, 101–103
HyperVoxels in LightWave 6, 194, 199–202

I

Icosahedron primitives, modeling with, 318
Illustrator (Adobe)
 pattern creation with fonts, 24–28
 Sweep BSmooth operator to create 3D objects, 67
Image composing process, 3–10
Images
 sources for, 118, 128–133, 216
 trademarked images, 298–299
Inner Extrude/Extrude combinations, 102–103
Insects
 spider-like legs modeled in 3D Studio Max, 311–312
Insects, modeling
 antennae of, 31–39
 wings of, 40–42
Intellectual property, 298–299
Inverse Kinematics (IK)
 animation and, 125
 structures in bird's wing, 114–115
Invisible persons, using animated stand-alone costumes as,
 49

J

"Jack O'Rachnid" 3D Studio Max tutorial, 307–312
Jar Jar Binks, 29
JavaScript
 DHTML animations with, 347–349
 games scripting tutorial, 297–303
Jewels, Icosahedron primitive to model, 318
Joints, Strata Studio Pro modeling of, 253–254, 263–264

K

Kaleidoscopic effects, Polar operator in BSmooth, 68

L

Lamps, modeling, 45–46

Landscapes
 canyon of dreams project, 69–70
 crater lake project, 69
 form•Z photorealistic tutorial, 175–181
 natural environments, 175–181
 scorched earth terrain scene project, 68
 urban environments tutorials, 52–55
 urban scenes, 71–76

Laser beams, 282

Lathing
 operators in BSmooth, 67
 in Strata Studio Pro, 235–241

Layers
 decals and textures, 178–181
 Layer Modes of Adobe Photoshop, 8–10
 Master file of, 22
 in Netscape Navigator, 346–349
 nondestructive editing of images, 7–8
 in Photoshop, 3–10

Legs
 bird-like legs and feet, 151
 RayDream to model, 82–83
 spider-like legs modeled in 3D Studio Max, 311–312

Lens flare, used in exhaust effect, 197

Leonardo's Flying Machine tutorials
 animation of model, 123–127
 model creation, 118–122

Lights and lighting
 ambient light, 287–288
 area lights, 288
 attenuation and distance, 288–289
 backlights, 291
 brightness of, 22
 color mood of, 293–296
 emotion and mood influenced by, 287, 293–296
 fireworks tutorial, 194–202
 glow effects, 95–96
 infinite/distant lights, 288
 key lights, 290–291
 lens flare used in exhaust effect, 197
 in microscopic views, 206–207
 mirror ball reflections, 280–281
 omni light, 288
 pinwheel lights, 280
 point source light, 288
 radiosity in Carrara, faking it, 98–99
 rainbows, spinning, 280

scene evaluation for, 289–290
set (background) lights, 291
shading and, 204–206
shadow and ambient settings, 22
specular highlights, 23
spotlights, 288
3D lighting tutorial, 287–296
three-point lighting, 290
workflow for lighting, 289–290, 292–293

LightWave
 Fireworks tutorial for LightWave 6, 194–202
 lofting used to model architecture in, 188–193
 Particle Storm in, 198–199
 Surface Naming during lofting process, 190–191
 3D procedural texture map tutorial, 182–187

Linking, hierarchical, 59–60, 320–321

Lips, 3D Studio Max modeling, 315–316

Lofting
 architecture modeling with, 188–193
 defined and explained, 230
 LightWave 3D techniques, 188–193
 Pixels:3D techniques, 219
 Rhinoceros 3D techniques, 223–225, 228, 230–234
 Rhinoceros 3D tutorial, 230–234
 splines and, 230
 3D Studio Max techniques, 313–314
 tips for, 234

Lucas, George, 29

M

Mandelbrot fractals with BSmooth operator, 67

Maps and mapping
 bitmaps defined, 22
 bump maps, 21–23
 Canoma ready-mapped basic objects, 53–54
 color/texture maps, 23
 to create realistic surfaces, 121
 cubic mapping, defined, 23
 cylindrical mapping, defined, 23
 diffuse maps, defined, 23
 displacement maps, defined, 23
 procedural texture maps, 182–187
 reflection maps, 20
 terrain maps for urban landscapes, 54
 Terrain Maps in Bryce, 56–60
 Texture Layers plug-in tutorial, 340–344
 3D Studio Max texture mapping tutorial, 336–344
 vector grayscale maps used to create Bryce terrains, 56–60

Maxon Computers Cinema4D, 101–117
Maya (Alias Wavefront)
 microorganism animation tutorial, 203–209
 Paint Effects Tool tutorial, 210–215
 rendering and Pain Effects Tool, 214–215
 scripting animation in, 207–208
MediaStudio Pro (Ulead), 277, 283
Media transformation tutorial, 61–65
Memory
 Boolean operations and, 328
 History Palette and, 3
Meshform Modeler in RayDream, 89–92
Metaballs, Clay Studio Pro ClayBird project,
 149–152
MetaCreations
 Canoma, 52–55
 Poser 4, 43–47
Mezzotint collection from Andromeda Effects, 64
Mirror balls, simulating, 280–281
Moths, modeling wings for, 41–42
Motion studies
 bird flight cycle, 107–117
 "computer hop," avoiding, 101–106
Mouths, modeling
 cage modeling of cartoon lion, 171
 Pixels:3D modeling techniques, 216–219
 Rhinoceros 3D lofting techniques, 232–234
 3D Studio Max techniques, 142–143, 315–316
Muybridge, Eadweard, 103–104

N
Netscape Navigator
 DHTML animation for, 345–349
 layering in, 346–349
Noise Shader (Yamenko Studios), 270–276
Noise used to enhance random organic textures, 14
Noses, modeling
 beak-like noses, 113
 of cartoon lion, 174
 elephant-like trunks, 313–314
 Rhinoceros 3D loft techniques, 232–234
 3D Studio Max techniques, 140–142
 zooms and pixilation, 131
NURBs
 flying machine wings modeled with, 118–120
 HyperNURBs modeling techniques, 101–103, 107–113
 NURBs data, preserving, 228
 überNURBs in ElectricImage Modeler, 166

O
Ocean tutorial, 270–276
Organic textures and shapes
 bark texture tutorial, 11–17
 noise to enhance random quality, 14
 rocks, modeling with form•Z, 176
 tree stumps, 183–186

P
Particle primitives, exhaust effects and, 93–94
Particle Storm in LightWave, 198–199
Patch Tool tutorial, 170–174
Paths, creating template with Photoshop and 3D Studio
 Max, 131–135
Patterns, fonts used to create, 24–28
Pelvis, Strata Studio Pro modeling, 255–257
Perlin Noise shader, 270–276, 277
Phoneme morph targets, 216, 219–221
Photography and motion studies, 103–104
Photos, importing, 18
Photoshop (Adobe)
 Canoma templates created with, 52–53
 Cutlines filter for, 61–65
 file conversions and, 18
 History Palette in, 3
 as industry standard, 1
 Layer Modes in, 8–10
 layers tools and effects in, 3–10
 media transformation tutorial, 61–65
 Paths Tool used with 3D Studio Max, 131–135
 pixels and, 11–17
 3D applications, 18–23
 undos in, 3
Pixels
 defined, 11
 pixel-based graphics, 1
Pixels:3D Tutorial, 216–221
Pixilation, avoiding when zooming, 131
Plane primitives, modeling with, 318
Plants, modeling with form•Z, 176–178
Poser (Curious Labs)
 and Bryce, 43–47
 Carrara export into, 91–92
 Conform To option used in costuming, 48–51
 importing models from Bryce, 56–60
 Zygote Costume Shop tutorial, 48–51
Primal Particles plug-in (Primitive Itch), 277
Primitives, modeling with, 317–324

arches, 322–323
Array modeling, 329–332
 bridges, 322–323
 microorganism project, 204
 particle primitives for exhaust effects, 93–94
 PrimBot composite model, 318–321
 Spherepod model, 321–322
 Strata Studio Pro techniques, 252
Procedural textures, 272–273
 LightWave 3D tutorial, 182–187
 used in natural landscapes, 178–181
Props, Dress Props *vs.* Costume Dress, 49
Psychology
 influences of, 29–30
 phobias as inspiration, 307

R
Radiosity, faking in Carrara, 98–99
Rainbow, spinning effect, 280
RayDream/Carrara
 Alien 1 tutorial for, 77–88
 Meshform Modeler in, 89–92
Reflections
 gray scale and reflection mapping, 21–22
 mirror ball reflections, 280–281
 reflection maps, 20
The Render Engine Web addresses, xxv
Replication
 in Strata Studio Pro, 250–251
 See also Cloning
RGB, in image composing process, 4
Rhinoceros 3D
 lofting functions in, 231–232
 lofting techniques, 223–225, 228, 230–234
 Mirror command in, 227
 NURBs data, plug-in to preserve, 228
 Pipe command in, 226–227
 Revolve function in, 225–226
 star cruiser modeling tutorial, 222–229
 straight sections and lofting, 232
 Tools in, 223
 tutorials, 222–229, 230–234
Ripples, circular expansion motion in helicopter landing
 animation, 211
Rockets
 exhaust effects for, 93–100, 197
 firework rockets modeled in LightWave, 194–196
Rocks, modeling with form•Z, 176

Ropes, modeling with metaballs, 150
Rotocruiser 1200 project using Rhinoceros 3D, 222–229

S
Scripts and scripting
 JavaScript for DHTML animations, 347–349
 JavaScript games scripting tutorial, 297–303
 MEL scripts for animation, 207–208
 variables in, 300–302
Shaders
 Crumple Noise, 270–276
 Noise Shader from Yamenko Studios, 270–276
 Perlin Noise, 270–276, 277
 SphereGlow from Windmill-Fraser Multimedia, 277
 trueSpace 3D compatible, 273
Shading, surface and lighting steps in, 204–206
Shadows
 ambient area, 22
 3D lighting and scene evaluation, 289–292
Shoulders, Strata Studio Pro modeling of, 260–262
Sketches, preliminary, 77, 222–223
Skies
 Bryce (Corel) images, 62–63, 335
 Corel Bryce sky movie animation, 335
Smoke
 light beams through smoky atmosphere, 281–282
 rocket trail in LightWave, 200–202
Smoothness, BSmooth operator to alter, 67
SnagIt (Techsmith), 138
Snakes, modeling with metaballs, 150
Sparks
 LightWave to create, 198–199, 202
 SphereGlow to create, 278–279
Speech synchronization
 modeling mouths for, 216
 video references for, 129–130
SphereGlow, 277, 278–279
Sphere primitives, modeling with, 317
Spiders, modeling Jack O'Rachnid, 307–312
Splines
 Clay Splines in Clay Studio Pro, 150
 lofting and, 230
 modeling techniques, 138–148
 Pixels:3D modeling and, 216–218
 Rhinoceros 3D techniques, 230–231, 234
Spoons, Boolean operations and modeling, 326–327
Stairs and staircases, modeling, 329–330
Star cruiser project using Rhinoceros 3D, 222–229

Starcruiser tutorial for Rhinoceros 3D, 222–229
Star Wars, droid model inspired by, 235–269
Strata Studio Pro
 alignment of object in, 241–242
 Bézier objects, 251–252
 Boolean modeling, 245–247, 254
 droids tutorial, 235–269
 extruding in, 244–245
 grouping and organizing objects in, 242–244, 249
 lathing techniques in, 235–241
 Mirror function in, 257
 profile changing in, 238–241
Sumbies (Sumo Babies / Bunnies hybrids), 50–51
Surfaces
 maps and mapping for realistic, 121
 shading and surface, 204–206
 surface textures, 19–20

T

Tables, furniture modeling, 45
Tadpoles, modeling with metaballs, 150
Talking Virtual Announcer
 modeling template tutorial, 128–137
 3D Studio Max modeling tutorial, 138–148
 3D Studio Max texture mapping tutorial, 336–344
Templates
 cross-planes and, 135–137
 Paths Tool in Photoshop used to create, 131–135
 Talking Virtual Announcer template tutorial, 128–137
Terrain maps for urban landscapes, 54
Tessellation settings in ElectricImage Modeler
 Cell Aspect Ration, 165
 Edge Tolerance setting, 168
 Isoparms settings, 167–168
 Max Edge Length, 165
 Max Grid Lines, 164–165
 Normal Tolerance, 163–164
 Parametric Grid option, 158–162
 Spline Segment setting, 168
 Spline Tessellation setting, 166–167
 Surface Tolerance, 163–164
 U and V settings, 166, 167–168
 Uniform Tessellation (überNURBs), 166
 Weld Vertices for Outline Shading option, 166
Text, frou-frou fonts used to create patterns, 24–28
Texture Layers plug-in, 340–344
Textures
 layers and decals, 178–181
 Photoshop for creating and manipulating, 18
 procedural textures, 178–181, 182–187, 272–273

random, organic textures, 11–17, 183–186
realism and detail, 183–186
selecting and applying appropriate, 121
simplified geometry and, 257–258
surface textures, 19–20
3D Studio Max (Discreet Logic)
 animation tutorial, 123–127
 "Elee Phantoosy" tutorial, 313–317
 Jack O'Rachnid modeling tutorial, 307–312
 Leonardo's Flying Machine tutorials, 118–127
 modeling templates tutorial, 128–137
 Photoshop Paths Tool and, 131–135
 Revision 3.x advances, 313–317
Torsos, Strata Studio Pro modeling of, 257–260
Trademarks and trademarked images, 298–299
Transparency
 GIF files and, 303
 water simulations, 275
Trees, modeling
 bark texture tutorial, 11–17
 tree stumps, 183–186
TrueSpace 3D (Caligari)
 ocean tutorial, 270–276
 Vic Disco visual effects tutorial, 277–283
 volumetrics in, 281–282
Tusks, modeling in 3D Studio Max, 316

U

ÜberNURBs in ElectricImage Modeler, 166
Uniform Tessellation (überNURBs) in ElectricImage Modeler, 166
Use-as-Value Option tutorial, 153–157

V

Vector images, 1
Vendors, contact information, 353
Vertex Modeler in Carrara, 89–92
Vic Disco
 exploding mirror ball, 282
 laser beams effect, 282
 mirror ball reflections, 280–281
 pinwheel lights, 280
 sparks created with SphereGlow, 278–279
 spinning rainbow effect, 280
 trueSpace tutorial, 277–283
Vision and illusion, 11

W

Wasps, modeling wings for, 40–41
Water

color variation, simulating, 274
ocean tutorial, 270–276
reflections, simulating, 273, 275
transparency, simulating, 275
Wave Generator (Lightning Software), 270–276
Wave propagation with BSmooth operator, 67
Web addresses
 Amapi related, 351–352
 Andromeda Effects, 61
 BSmooth, 66
 Graphics Resource Club, xxiv
 Mankua (Texture Layers plug-in), 340
 Pacific Data Images, 71
 Pixels:3D, 216
 Ramsay, Frank, 270
 the Render Engine, xxv
 Ryan Knope's Rhinoceros education site, xxiiii
 Sisyphus Software, 311
 of Steve McArdle (AKA the Iguana), xxiv
 Techsmith, 138
 Ulead, 277
 vendors, 353

Yamenko Studios, 270
Zygote, 48
Weight
 of birds in flight, 107, 115–116
 stretch and squash in realistic movement, 104–106
Wind and air movement, simulating, 125–126
 helicopter landing animation tutorial, 210–215
Wings
 insect wings, 40–42
 ribbed wing structures, 119–120
 See also Birds
Woodcuts, Andromeda Cutlines filter for, 64–65
Wood textures, creating, 183–186

Z
Zapf dingbats, 27–28
Zygote
 body modules, 91–92
 Zygote Character Library, 43
Zygote Costume Shop
 installation caveat, 48
 Poser 4 tutorial, 48–51